HIT MAKERS

HIT MAKERS

The Science of Popularity in an Age of Distraction

DEREK THOMPSON

PENGUIN PRESS

NEW YORK

2017

PENGUIN PRESS
An imprint of Penguin Random House LLC
375 Hudson Street
New York, New York 10014
penguin.com

Portions of this book first appeared in *The Atlantic* under the following titles:
"The Global Dominance of ESPN," "Turning Customers Into Cultists,"
"The Shazam Effect," "Why Experts Reject Creativity," "Presidential
Speeches Were Once College-Level Rhetoric—Now They're for Sixth-
Graders," "Hollywood Has a Huge Millennial Problem," and "Facebook
and Fear." Copyright © 2013, 2014, 2016 by Derek Thompson
(as first published in *The Atlantic*).

Credits for graphs
p. 11: Courtesy of Barak Orbach; p. 12: Courtesy of Matthew Ball; p. 61:
Karim R. Lakhani; p. 78 (also on p. 94): Courtesy of Diana Deutsch; p. 288:
Courtesy of McKinsey

ISBN 9781101980323 (hardcover)
ISBN 9781101980347 (eBook)

Printed in the United States of America
1 3 5 7 9 10 8 6 4 2

Designed by Amanda Dewey

To my parents:

Schlaf nun selig und süß,

schau im Traum's Paradies.

CONTENTS

INTRODUCTION

The Song That Conquered the World

Marco Polo describes a bridge, stone by stone.
 "But which is the stone that supports the bridge?" Kublai Khan asks.
 "The bridge is not supported by one stone or another,"
Marco answers, "but by the line of the arch that they form."

—Italo Calvino, *Invisible Cities*

The Cartographers Guilds struck a Map of the Empire whose size was that of the Empire, and which coincided point for point with it. The following Generations, who were not so fond of the Study of Cartography as their Forebears had been, saw that that vast Map was Useless, and not without some Pitilessness was it, that they delivered it up to the Inclemencies of Sun and Winters. In the Deserts of the West, still today, there are Tattered Ruins of that Map, inhabited by Animals and Beggars . . .

—Jorge Luis Borges, *On Exactitude in Science*

The first song I loved was my mother's. Each night, she would sit on the left side of my bed and sing the same lullaby. Her voice was sweet and small and shaped to fit inside a bedroom. On trips to my maternal grandparents' house in Detroit, my *Momi* would sing the same tune in a lower register, with a scratchier timbre and German

lyrics. I didn't know what the words meant, but I loved them for their ancient mystery in the old house: *"Guten Abend, gute Nacht . . ."*

I used to think the song was a family heirloom. But in first grade, at one of the first sleepovers in my Virginia hometown, a young friend turned the dial on the small music box by his bed and digital chimes tinkled to a familiar tune.

I learned that my mother's melody was not a family secret. It was astonishingly common. There is a strong possibility that you have heard it dozens of times, and perhaps thousands. It is Johannes Brahms's lullaby "Wiegenlied"—"Lullaby and good night, with roses bedight . . ."

Millions of families all over the world have sung a version of Brahms's lullaby to their children, every night, for more than a century. It is one of the most common melodies in the Western Hemisphere. Considering that a lullaby is sung every evening for hundreds of days a year for several years in a child's life, there is real possibility that Brahms's lullaby could be one of the most heard songs in the Western Hemisphere, if not the world.

"Wiegenlied" is undeniably beautiful and simple and repetitive— all necessary elements of any song produced for infants from the throats of tired parents. But a melody so universal is also a mystery. How did a nineteenth-century German tune become one of the world's most popular songs?

Johannes Brahms, born in 1833 in Hamburg, was one of the most well-known composers of his time. "Wiegenlied" was his most immediate success. Published at the height of his popularity in 1868, the song was written as a lullaby for an old friend to sing to her new baby boy. But it soon became a hit throughout the continent, and the world.

One of Brahms's tricks for replenishing his deep well of pretty melodies was genre blending. He was a student of local music and a subtle thief of catchy choruses. When he traveled Europe, he would often visit

a city's library to go through its folk song collections to study reams of sheet music and transcribe his favorite bits. Like a savvy modern songwriter sampling another artist's hook for his own music—or a clever designer stealing flourishes from other products—Brahms would incorporate far-flung folk tunes into his art songs.

Several years before he wrote his famous lullaby, Brahms fell in love with a teenage soprano in Hamburg named Bertha. She sang many songs to him, like Alexander Baumann's Austrian folk song "S'is Anderscht." Some years later, Bertha married another man, and they named their son Johannes after the composer. Brahms wanted to show his gratitude—and, perhaps, his lingering affection. He wrote the couple a lullaby based on the old Austrian folk song that Bertha used to sing to him. For the lyrics, Brahms took a verse from a famous collection of German poems, *Des Knaben Wunderhorn*:

Good evening, good night;
with roses bedecked,
with clove pinks adorned,
slip under the blanket. In the morning, God willing,
you will waken again.

In the summer of 1868, Brahms sent the family sheet music for the lullaby with a note. "Bertha will realize that I wrote the Wiegenlied for her little one. She will find it quite in order . . . that while she is singing Hans to sleep, a love song is being sung to her." The song's first major performance came one year later, on December 22, 1869, in Vienna. It was a huge commercial success. Brahms's publisher rushed to make fourteen arrangements of the song—the most of any Brahms piece by far—including for four-part men's choir, three-part piano, the harp, and the zither.

"A lot of Brahms's melodies are beautiful, but 'Wiegenlied' uniquely fits the standard structure that modern music listeners recognize in

hooks," said Daniel Beller-McKenna, a Brahms scholar who serves on the board of directors at the American Brahms Society. "It has the key elements of repetition and then gentle surprise," he went on, humming the tune intermittently as we spoke. "Wiegenlied" was an original. But it was also surprisingly familiar, an assembly of folk song allusions and Hamburg memories. One music historian said the piece so resembled Baumann's original folk song that it amounted to a "veiled but identifiable parody."

But this history still doesn't answer the most important question about the lullaby: *How did it spread around the world?* In the twentieth century, most pop songs became popular because they played on the radio or on other mass media broadcasts again and again. Songs pushed their way into audiences' ears through car speakers, television sets, and movie theaters. To like a song, you first had to find it; or, from another perspective, the song had to find you.

In the nineteenth century, however, songs by famous composers may have hopped between concert halls, but there was no adequate technology to quickly move a song around the globe. To appreciate the slow pace at which culture traveled in Brahms's day, consider the leisurely transatlantic voyage of Beethoven's Ninth Symphony. It debuted at the Kaerntnertor Theater in Vienna in 1824, when Beethoven was reportedly so deaf he could not hear the thunderous applause. But the first performance in the United States wasn't for another twenty-two years, in New York City, in 1846. It took nine more years for the symphony to first play in Boston.

Imagine if every artistic masterwork took thirty-one years to cross the ocean today. Michael Jackson's album *Thriller* debuted in 1982, which means Jackson would have been dead for four years by the time Londoners could hear the title track and "Billie Jean" in 2013. *Please Please Me*, the first album by the Beatles, was released in March 1963 in the UK, so Americans would not have met the Beatles until the mid-

and bedecked it with concert hall grandeur. His lullaby was an instant success not because it was incomparably original, but because it offered a familiar melody in an original setting.

Some new products and ideas slip into the well-worn grooves of people's expectations. In fifteen out of the last sixteen years, the highest-grossing movie in America has been a sequel of a previously successful movie (e.g., *Star Wars*) or an adaptation of a previously successful book (e.g., *The Grinch*). The power of well-disguised familiarity goes far beyond film. It's a political essay that expresses, with new and thrilling clarity, an idea that readers thought but never verbalized. It's a television show that introduces an alien world, yet with characters so recognizable that viewers feel as if they're wearing their skin. It's a piece of art that dazzles with a new form and yet offers a jolt of meaning. In the psychology of aesthetics, there is a name for the moment between the anxiety of confronting something new and the satisfying click of understanding it. It is called an "aesthetic aha."

This is the first thesis of the book. Most consumers are simultaneously *neophilic*—curious to discover new things—and deeply *neophobic*—afraid of anything that's too new. The best hit makers are gifted at creating moments of meaning by marrying new and old, anxiety and understanding. They are architects of familiar surprises.

The "Wiegenlied" was a familiar surprise for its German audience. But that alone didn't make it one of the most popular songs in the whole Western Hemisphere. Without the wars that rocked central Europe in the 1870s and 1880s, millions of Germans wouldn't have emigrated and perhaps millions of children who know the song by heart today would never have heard it. Brahms's musical genius gave the song its appeal. But German emigration helped to give the lullaby its reach.

The way that ideas spread, both to groups of people and within those groups, is deeply important and widely misunderstood. Most people don't spend a lot of time thinking about all the songs, books, and products they've never seen. But a brilliant article in an obscure journal

goes unread, a catchy song with no radio play withers in obscurity, and a moving documentary without a distribution deal can be doomed to oblivion, no matter how brilliant. So the first question for people with a new product is: *How do I get my idea to my audience?*

The "Wiegenlied" was played live only for several thousand people. Yet today millions of people know the tune. The song spread far beyond the shadow of the Vienna opera house, through families and friendships and a variety of social networks around the world. So the deeper question for people with a new product or idea is: *How can I make something that people will share on their own—with the audience of my audience?* There is no formula here. But there are some basic truths about what brings people together and makes people talk—like why selling a dating app requires the opposite strategy of selling a hipster fashion line, and why people share bad news with friends and good news on Facebook. Making beautiful things is critical. But understanding these human networks is equally essential for hit makers.

Some people disdain distribution and marketing as pointless, boring, tawdry, or all three. But they are the subterranean roots that push beautiful things to the surface, where audiences can see them. It is not enough to study products themselves to understand their inherent appeal, because quite often the most popular things are hardly what anybody would consider the "best." They are the most popular everywhere because they are, simply, everywhere. Content might be king, but distribution is the kingdom.

It's interesting to compare the story of the "Wiegenlied," an old-world hit, to the story of a quintessentially new-world hit, the photo-sharing app Instagram, to look for the common themes of familiarity and the power of networks.

If the marketplace for nineteenth-century piano music was crowded,

the emporium of photo-sharing applications in the last few years is downright mayhem. In 1999, the world took eighty billion photos and bought seventy million cameras, according to Kodak's 2000 annual report. Today, the world shares more than eighty billion photos every month on several billion phones, tablets, computers, and cameras.

Like several other apps, Instagram lets users take photos and add retro-cinematic filters. The design was close to perfect for its purpose: simple and beautiful, with intuitive ways to edit and share images from people's lives. But there were many simple, beautiful apps in this space, and Instagram did not invent the idea of filters. What was so special about Instagram?

The app's success owed equally to art and dissemination. Before Instagram debuted, its founders gave early versions of the app to San Francisco tech tycoons like entrepreneur Kevin Rose, journalist M. G. Siegler, tech evangelist Robert Scoble, and Twitter cofounder Jack Dorsey. These tech celebrities posted several Instagram photos on Twitter, where they collectively had millions of followers. By tapping into massive networks that already existed, Instagram reached thousands of people before it even launched.

The day Instagram debuted, on October 6, 2010, twenty-five thousand people downloaded the app, which soared to the top of the App Store. Many iPhone users who had seen Dorsey's Instagram photos in their Twitter feeds eagerly downloaded the app when it became public. Silicon Valley writers said they had never seen a start-up get so much promotion and attention from tech blogs before launch. Instagram's success was about a clean, fun, and simple product. It was also about the network it launched into.

Whether the vector is a transatlantic voyage or a San Francisco Twitter account, the story of a product's distribution is as important as a description of its features. It is rarely sufficient to design the perfect product without designing an equally thoughtful plan to get it to the right people.

————

In Brahms's time, if you wanted people to hear your symphony, you needed to find musicians and a concert hall. Commercial music was scarce, and the music business belonged to the people who controlled the halls and the printing presses.

But today, something interesting is happening. Scarcity has yielded to abundance. The concert hall is the Internet, the instruments are cheap, and anybody can write their own symphony. The future of hits will be democratic, chaotic, and unequal. Millions will compete for attention, a happy few will go big, and a microscopic minority will get fantastically rich.

The revolution in media is clearest in the last sixty years in moving pictures and video. When the biblical blockbuster *Ben-Hur* premiered on November 18, 1959, before a celebrity audience of more than 1,800 at Loew's State Theatre in New York City, the movie industry was the third-largest retail business in the United States, after groceries and cars. The movie set Hollywood records for the largest production budget and the most expensive marketing campaign ever, and it became the second-highest-grossing movie in history at that time, behind *Gone with the Wind*.

The twinkling of camera flashes at that premiere might have blinded some movie executives to the fact that Americans' monogamous relationship with the silver screen was already ending. Television proved an irresistible seductress. By 1965, more than 90 percent of households had a television set, and they were spending more than five hours watching it every day. The living room couch replaced the movie theater seat as the number of movie tickets bought per adult fell from about twenty-five in 1950 to four in 2015.

Television replaced film as the most popular medium of visual storytelling, along with a massive shift in attention and dollars—from weekly movie tickets to cable bills, whose monthly payments have supported a

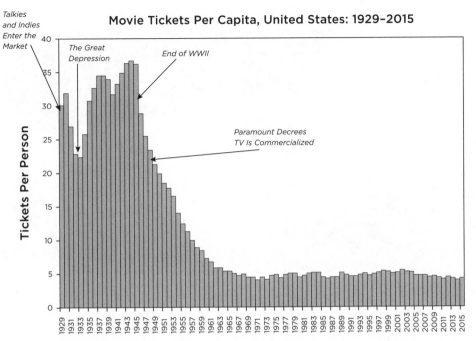

Movie Tickets Per Capita, United States: 1929–2015

Talkies and Indies Enter the Market

The Great Depression

End of WWII

Paramount Decrees TV Is Commercialized

Tickets Per Person

* Source: Barak Orbach (2016)

vast ecosystem of live sports, both brilliant and formulaic dramas, and endless reality shows. The most famous moviemaking corporations in the world, like the Walt Disney Company and Time Warner, have for years made more profit from cable channels like ESPN and TBS than from their entire movie divisions. In the early twenty-first century, every movie company is not so secretly in the television business.

But today television is merely the largest screen in a glittering world of glass. In 2012, for the first time ever, Americans spent more time interacting with digital devices like their laptops and phones than with television. In 2013, the world produced almost four billion square feet of LCD screens, or about eighty square inches for every living human being. In developing regions—like China, Indonesia, and sub-Saharan Africa—audiences skipped the era of desktops and laptops altogether and started with computers in their pockets.

11

Share of Media Advertising Spend by Medium (US Only)

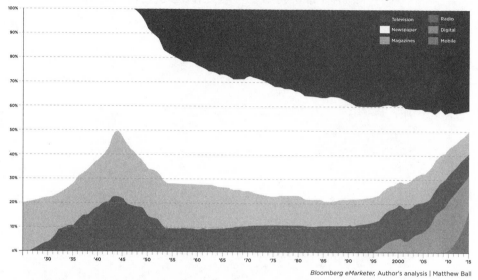

Bloomberg eMarketer, Author's analysis | Matthew Ball

In the big picture, the world's attention is shifting from content that is *infrequent*, *big*, and *broadcast* (i.e., millions of people going to the movies once a week) to content that is *frequent*, *small*, and *social* (i.e., billions of people looking at social media feeds on their own glass-and-pixel displays every few minutes).

As late as 2000, the media landscape was dominated by one-to-one-million productions, on movie screens, television screens, and car radios. But ours is a mobile world, where hits, like *Angry Birds*, and empires, like Facebook, thrive on tiny glassy plates. In 2015, the technology analyst Mary Meeker reported that one quarter of America's media attention is devoted to mobile devices that did not exist a decade ago. Television is not dying so much as it is pollinating a billion video streams on a variety of screens, most of which people can carry in their hands. Television once freed "moving images" from the clutches of the cineplex; in the historical sequel, mobile technology is emancipating video from the living room.

As the medium changed, so have the messages. Traditional broad-

cast television was live, ad supported, and aired once a week. This made it a perfect home for dramas and crime procedurals that relied on several cliffhangers per episode (to extend viewership throughout the commercials) and pat endings. But streaming television, which is often commercial-free, rewards audiences who watch for several hours at a time. People don't have to stop after one episode of *House of Cards* on Netflix or *Downton Abbey* on Amazon Video; they can watch as much as they want. Combining the aesthetic of film, the episodic nature of traditional television, and the "binge" potential of a novel or Wagnerian opera, the near future of television isn't bound by the straitjacket of one-hour blocks. It's "long-form"—or, perhaps, *any-form*.

Meanwhile, smaller content is eroding television from the bottom. In April 2013, Robby Ayala, a Florida Atlantic University senior, posted several videos making fun of the campus's abundance of raccoons on Vine, a defunct social network of six-second loops that, for millions of young people, made for better television than television. When he amassed more than one million followers a few months later, he dropped out of law school and went to work for a Twitter-owned network for Vine stars. He amassed 3.4 million followers and a billion total views of his videos and earned a living by performing in sponsored posts for companies like HP. Actors used to go to Los Angeles or New York because those cities housed the gatekeepers who owned the distribution of media. But now any person with a phone or computer could be next week's viral sensation. In this moment of gate-crashers and global attention, anybody can be a hit maker.

Technology has always shaped entertainment—and our expectations of what sort of content is "good." In the eighteenth century, audiences who attended symphonies paid for a long evening's performance. In the early twentieth century, the music industry moved into the business of radio and vinyl. The first ten-inch vinyl records could comfortably hold about three minutes of music, which helped shape expectations

that a modern pop single shouldn't be more than 240 seconds. Today, a Vine is just six seconds.

Is six-second entertainment ludicrously brief? It is—if you were raised on Schubert, Brahms, and concert halls. It's not—if you were raised on Robby Ayala, Facebook, and the 3.5-inch screen of a smartphone. For better and for worse, people tend to gravitate toward the familiar, and technology shapes these familiarities.

The screens are getting smaller, and they're also getting smarter. We used to merely consume content. Now the content consumes us too—our behaviors, our rituals, and our identities. Before the 1990s, the music industry had no daily information on who was listening to songs in their homes and on the radio. Today, every time you play a song on your phone, the music industry is listening, too, and using your input to guide the next hit. Facebook, Twitter, and digital publishers have tools that tell them not only what story you click on, but also how far you read and where you click next. We used to just play the hits; now the hits play us back.

These smart devices have injected a measure of science into the work of building hits and helping companies crack that ultimate code for consumers and audiences: What do we pay attention to, and why?

A book that seeks to explain the tastes of billions of people and the success or failure of millions of products is going to make some assumptions that, while defensible in the aggregate, fail to account for some exceptions. I've tried to avoid making sweeping statements that aren't supported by a significant body of evidence. But taking great care to avoid wrongness is not the same as always being right.

A few months before I started writing this book, I found two quotes that I liked. I copied them to a note on my computer that I could always see. They are the quotes at the beginning of this chapter.

The first quote comes from Italo Calvino's book *Invisible Cities*. It

is an ode to complexity. Kublai Khan asks if there is a single stone that supports a bridge. Marco Polo responds that a bridge stands not because of one solitary rock, but because of an arch drawn through many stones.

The nonfiction genre has, in the last few decades, seen a bonanza of small books about life that are subject to a common criticism. They oversimplify the shape of the human mind, which, like Polo's bridge, is not explained by one stone or another, but by the interaction of an uncountable number of supportive elements. This book, too, is asking some unwieldy questions: *Why do some ideas and products become popular? What factors draw the line between hits and flops?* The effort to find satisfying answers to these questions will naturally require some generalization. But throughout the process, I've tried to remember that people's tastes are not ruled by a single concept or biological law. Rather, the shape of an individual's preferences is an arch supported by many stones.

That Calvino quote alone would be a good argument against a book like this, which seeks grand theories for how the world works. But that's where the second quote comes in.

Borges describes an empire with a cartography guild so advanced that it designs a life-size map. Yet the people reject this achievement of exactitude, and the map's tatters ultimately serve to clothe beggars in the desert. There is virtue in simplicity. A paper map that is the exact size of the empire it describes is *"Useless,"* because a map is only of service if it is small enough for somebody to hold and read it. The world is complex. But all meaning comes from wise simplification.

One of the themes of this book is that audiences are hungry for meaning, and their preferences are guided by an interplay between the complex and the simple, the stimulation of new things and a deep comfort with the familiar. Rather than find shortcuts that oversimplify the reasons why some cultural products succeed, my goal is to tell a complex story in a simple way. The spine of this book is too small to hold Marco Polo's bridge. At best, I hope to find good stones, to draw a fine map.

POPULARITY AND THE MIND

THE POWER OF EXPOSURE

Fame and Familiarity—in Art,

Music, and Politics

On a rainy morning one fall, I was walking alone through the impressionist exhibit of the National Gallery of Art in Washington, D.C. Standing before a wall of renowned paintings, I was struck by a question that I imagine many people wonder quietly in a museum, even if it's rude to say out loud in a company of strangers: *Why is this thing so famous?*

It was *The Japanese Footbridge* by Claude Monet, with the blue bridge arching over an emerald green pond that is gilded with patches of yellow, pink, and green—the iconic water lilies. It was impossible not to recognize. One of my favorite picture books as a kid included several of Monet's water lily paintings. It was also impossible to ignore, on account of several kids scrambling through the geriatric crowd to get a closer look. "Yes!" a teenage girl said, holding up her phone in front of her face to take a picture. "Oh!" exclaimed the taller, curly-haired boy behind her. "It's that famous one!" Several more high school

students heard their shouts, and within seconds a group had clustered around the Monet.

Several rooms away, the gallery held a special exhibit for another impressionist painter, Gustave Caillebotte. This was a quieter, slower affair. There were no students and no ecstatic exclamations of recognition, just a lot of *mmm-hmm*s and solemn nods. Caillebotte is not world famous like Monet, Manet, or Cézanne. The sign outside his exhibition at the National Gallery called him "perhaps the least known of the French impressionists."

But Caillebotte's paintings are exquisite. His style is impressionist yet exacting, as if captured with a slightly more focused camera lens. Often from a window's view, he rendered the colorful urban geometry of nineteenth-century Paris—the yellow rhomboid blocks, the pale white sidewalks, and the iridescent grays of rain-slicked boulevards. His contemporaries considered him a phenomenon on par with Monet and Renoir. Émile Zola, the great French writer who drew attention to impressionism's "delicate patches of color," pronounced Caillebotte "one of the boldest of the group." Still, 140 years later, Monet is one of the most famous painters in history, while Caillebotte is relatively anonymous.

A mystery: Two rebellious painters hang their art in the same impressionist exhibit in 1876. They are considered of similar talent and promise. But one painter's water lilies become a global cultural hit— enshrined in picture books, studied by art historians, gawked at by high school students, and highlighted in every tour of the National Gallery of Art—and the other painter is little known among casual art fans. Why?

For many centuries, philosophers, artists, and psychologists have studied modern art to learn the truth about beauty and popularity. For understandable reasons, many focused on the paintings themselves. But studying the patches of Monet and the brushstrokes of Caillebotte won't tell you why one is famous and the other is not. You have to see the deeper story. Famous paintings, hit songs, and blockbusters that

seem to float effortlessly on the cultural consciousness have a hidden genesis; even water lilies have roots.

When a team of researchers at Cornell University studied the story of the impressionist canon, they found that something surprising set the most famous painters apart. It wasn't their social connections or their nineteenth-century renown. It was a subtler story. And it all started with Caillebotte.

G ustave Caillebotte was born to a wealthy Parisian family in 1848. As a young man, he veered from law to engineering to the French army in the Franco-Prussian War. But in his twenties, he discovered a passion and immense talent for painting.

In 1875, he submitted *The Floor Scrapers* to the Academy of Fine Arts in Paris. In the painting, white light coming through a window illuminates the bare white backs of several men working on their knees, scraping the dark brown floor of an empty room, as the skinned wood curls into spirals beside their legs. But the painting was rejected. One critic later summed up the scornful response when he said, "Do nudes, but do beautiful nudes or don't do them at all."

The impressionists—or, as Caillebotte also called them, *les Intran-sigents*—disagreed. Several of them, including Auguste Renoir, liked his quotidian take on the floor scrapers and asked Caillebotte to exhibit with their fellow rebels. He became friends with some of the era's most controversial young artists, like Monet and Degas, buying dozens of their works at a time when few rich European men cared for them.

Caillebotte's self-portraits show him in middle age with short hair and a face like an arrowhead, angular and sharpened to a point, with an austere gray beard. A grave countenance colored his inner life as well. Convinced that he would die young, Caillebotte wrote a will instructing the French state to accept his art collection and hang nearly seventy of his impressionist paintings in a national museum.

His fears were prescient. Caillebotte died of a stroke in 1894 at the age of forty-five. His bequest included at least sixteen canvases by Monet, eight by Renoir, eight by Degas, five by Cézanne, and four by Manet, along with eighteen by Pissarro and nine by Sisley. It is not inconceivable that his walls would be valued at several billion dollars in a twenty-first-century Christie's sale.

But at the time, his collection was far less coveted. In the will, Caillebotte had stipulated that all paintings hang at the Musée du Luxembourg in Paris. But even with Renoir serving as executor, the French government initially refused to accept the artworks.

The French elite, including conservative critics and even prominent politicians, considered the bequest presumptuous, if not downright ludicrous. Who was this scoundrel to think he could posthumously force the French government to hang dozens of blotchy atrocities on its own walls? Several art professors threatened to resign from the École des Beaux-Arts if the state accepted the impressionist paintings. Jean-Léon Gérôme, one of the most famous academic artists of his time, blasted the donation, saying, "For the government to accept such filth, there would have to be a great moral slackening."

But what is the history of art if not one great slackening after another? After years of fighting both the French state and Caillebotte's own family to honor the bequest, Renoir persuaded the government to accept about half the collection. By one count, the accepted paintings included eight works by Monet, seven by Degas, seven by Pissarro, six by Renoir, six by Sisley, two by Manet, and two by Cezanne.

When the artworks were finally hung in 1897, at a new wing in the Musée du Luxembourg, it represented the first ever national exhibition of impressionist art in France, or any European country. The public flooded the museum to see art they'd previously savaged or simply ignored. The long battle over Caillebotte's estate (the press called it *l'affaire Caillebotte*) had the very effect he must have hoped: It brought unprecedented attention, and even a bit of respect, to his *intransigents* friends.

One century after the exhibition of the Caillebotte collection, James Cutting, a psychologist at Cornell University, counted more than fifteen thousand instances of impressionist paintings to appear in hundreds of books in the university library. He concluded "unequivocally" that there were seven ("and only seven") core impressionist painters, whose names and works appeared far more often than their peers. This core consisted of Monet, Renoir, Degas, Cezanne, Manet, Pissarro, and Sisley. Without a doubt, this was the impressionist canon.

What set these seven painters apart? They didn't share a common style. They did not receive unique praise from contemporary critics, nor did they suffer equal censure. There is no record that this group socialized exclusively, collected each other's works exclusively, or exhibited exclusively. In fact, there would seem to be only one exclusive quality the most famous impressionists shared.

The core seven impressionist painters were the only seven impressionists in Gustave Caillebotte's bequest.

Exactly one hundred years after Caillebotte's death, in 1994, James Cutting stood before one of the most famous paintings at the Musée d'Orsay in Paris and had a familiar thought: *Why is this thing so famous?*

The painting in question was Renoir's *Bal du Moulin de la Galette.* Standing about four feet high and six feet wide, the artwork shows scores of well-dressed Parisians clustered in an outdoor dance hall, waltzing, drinking, and huddling around tables in the dappled light of a Sunday afternoon in the Montmartre district of Paris.

Cutting instantly recognized the work. But he wondered what was so inherently special about the painting, apart from the fact that he recognized it. Yes, the *Bal du Moulin* is absorbing, he granted, but the artwork was not obviously better than its less celebrated peers in adjacent rooms.

"I really had an aha moment," Cutting told me. "I realized that Caillebotte had owned not only the *Bal du Moulin*, but also many other paintings at the museum that had become extremely famous."

He returned to Ithaca to flesh out his eureka. Cutting and a research assistant went through about one thousand books of impressionist art in the Cornell University library to make a list of the most commonly reproduced artists. He concluded that the impressionist canon focuses on a tight cluster of seven core painters: Manet, Monet, Cézanne, Degas, Renoir, Pissarro, and Sisley—the Caillebotte Seven.

Cutting had a theory: Gustave Caillebotte's death helped to create the impressionist canon. His bequest to the French state created the frame through which contemporary and future art fans viewed impressionism. Art historians focused on the Caillebotte Seven, which bestowed prestige on their works, to the exclusion of others. The paintings of the Caillebotte Seven hung more prominently in galleries, sold for greater sums of money to private collectors, were valued more by art connoisseurs, were printed in more art anthologies, and were dissected by more art history students, who grew into the next generation's art mavens, eager to pass on the Caillebotte Seven's inherited fame.[1]

Cutting had another theory: The fact that Caillebotte's bequest shaped the impressionist canon spoke to something deep and universal about media, entertainment, and popularity. People prefer paintings that they've seen before. Audiences like art that gives them the jolt of meaning that often comes from an inkling of recognition.

Back at Cornell, Cutting tested this theory. He gathered 166 people from his psychology class and presented them with paired works of impressionist art. In each pair, one of the paintings was significantly

1. In the final gift to the French state, Renoir added two Caillebotte paintings. But they were largely overlooked by the most influential art historians, perhaps due to their last-minute inclusion. John Rewald's monumental *History of Impressionism*, published in 1946, considers Caillebotte for the legacy of his bequest, but it lists the familiar seven as the exclusive masters of impressionism and scarcely mentions Caillebotte's artistic prowess.

more "famous"—that is, more likely to appear in one of Cornell University's textbooks. Six times out of ten, students said they preferred the more famous picture.

This could have meant that famous paintings are better. Or it might have meant that Cornell students preferred canonical artworks because they were familiar with those paintings. To prove the latter, Cutting had to engineer an environment where students were unwittingly but repeatedly exposed to less famous paintings the same way that art audiences are unwittingly but repeatedly exposed to the impressionist canon from a young age.

What came next was quite clever: In a separate psychology class, Cutting bombarded students with obscure artworks from the late nineteenth century. The students in this second class saw a nonfamous impressionist painting *four times* for every one time they glimpsed a famous artwork. This was Cutting's attempt to reconstruct a parallel universe of art history, where Caillebotte never died prematurely, where his legendary bequest never created an impressionist wing, and where the Caillebotte Seven never benefited from a random historical accident that elevated their exposure and popularity.

At the end of the second course, Cutting asked the 151 students to choose their favorite paintings among fifty-one pairs. The results of the popularity contest turned the canon upside down. In forty-one of fifty-one pairs, the students' preference for the most famous impressionist works disappeared. The emerald magnetism of Monet's gardens, the electric polychrome of Renoir, and the genius of Manet were nearly nullified by something else—the power of repeated exposure.

It's extraordinary that Caillebotte's bequest helped to shape the canon of impressionism because he purposefully bought his friends' least popular paintings. Caillebotte made it a principle to buy "especially those works of his friends which seemed particularly unsaleable," the art historian John Rewald wrote. For example, Caillebotte served as a buyer of last resort when he purchased Renoir's *Bal*

du Moulin de la Galette. Today, the painting that Caillebotte rescued from obscurity and that inspired Cutting's famous study of art psychology is considered a masterpiece. When it sold at auction for $78 million in 1990, it was the second most expensive artwork ever purchased. You may find Renoir's painting to be inherently beautiful—I do—but its canonical fame is inseparable from its absurd good fortune to be among the Caillebotte collection.

Mary Morton, the curator of French paintings at the National Gallery of Art, organized the museum's 2015 Caillebotte exhibit. She told me that a lack of exposure might account for Caillebotte's anonymity for another reason: Impressionism's most important collector didn't try to sell his art.

One of the most important behind-the-scenes figures in impressionist history is Paul Durand-Ruel, a French collector and dealer who served as a one-man clearinghouse for impressionist paintings before they became world famous. His exhaustive efforts to sell work by Monet and others created and sustained the movement while the French salons and European aristocracy considered their patched style a heinous affront to French romanticism. Durand-Ruel found more success among American collectors. "As the industrial revolution and income growth cranked up, newly wealthy people inhabited big new apartments in Paris and New York City," Morton told me. "They needed decoration that was affordable, beautiful, and widely available, and impressionist paintings were all three." New wealth created the space for new tastes. Impressionism filled the void.

But Caillebotte does not fit into this story of impressionism's popularity among the nouveau riche. He was a millionaire, as the heir to a large fortune in textiles, and he had no need to make money from a painting hobby. There are more than 2,500 paintings, drawings, and pastels attributed to Monet. Despite his severe arthritis, Renoir produced an astonishing 4,000 works. Caillebotte produced about 400 paintings and made little effort to distribute them to collectors or mu-

seums. He faded into obscurity in the early twentieth century while his peers hung in crowded galleries and private collections, as the echoing power of Caillebotte's gift rolled through history.

When today's high school students recognize Monet's water lilies, they're seeing more than a century's worth of exposure and fame. Caillebotte is the least known of the French impressionists. But it's not because he's the worst. It's because he offered his friends a gift that he was willing to withhold from himself: the gift of exposure.

For centuries, philosophers and scientists have tried to reduce the vast complexity of beauty into a pat theory.

Some argued for forms and formula. Going back to ancient Greece, philosophers have proposed that beauty is quantifiable, hidden in the fabric of the observable universe. Others inclined to mystical explanations proposed that a precise number—1.61803398875 . . . , otherwise known as "the golden ratio"—could explain the visual perfection of objects like Greek flowers, Roman temples, and modern devices from Apple. They have suspected that the world is ripe with such secrets and equations. Plato proposed that the physical world was an imperfect replica of an ideal realm. Even the most ingenious art or the most dazzling sunset was merely striving toward the unachievably perfect form of Beauty itself. In the 1930s, the mathematician George David Birkhoff went so far as to propose a formula for writing poetry: $O = aa + 2r + 2m - 2ae - 2ce$.[2] (It is unlikely that any person has ever used the formula to write a poem worth reading.)

Is there really an equation lurking in the calculus of the universe that explains why we like what we like? Many weren't so sure. There were the skeptics, and they argued that beauty is always subjective, residing

2. In the poetry formula, *aa* refers to alliteration and assonance, *r* is rhyming, *m* is musicality, *ae* is alliterative excess, and *ce* excess of consonant sounds. Before using it as a model to write your own sonnet, take note that this is the sort of equation that would rank Dr. Seuss above Walt Whitman and Frère Jacques over most of e. e. cummings.

in individuals rather than in math. The philosopher David Hume said that "to seek the real beauty, or real deformity, is as fruitless an enquiry, as to pretend to ascertain the real sweet or real bitter." The philosopher Immanuel Kant agreed that beauty was subjective, but he emphasized that people have aesthetic "judgment." Imagine listening to a beautiful song or standing before an exquisite painting. Losing oneself to wonder is the opposite of brainlessness. Pleasure is a kind of thinking.

The long debate between the formula hunters and the skeptics was missing an important voice: the scientists. Hard data did not enter this discussion until a nearly blind German physicist named Gustav Theodor Fechner came along in the middle of the nineteenth century and, in the process of investigating artistic taste, helped to invent modern psychology.

In the 1860s, Fechner was determined to discover the laws of beauty for himself. His methods were unique, because few had thought to do the simplest thing when approaching a question about people's preferences: Just ask people what they like. His most famous experiment involved shapes. He had subjects of various ages and backgrounds point out which rectangles they considered most beautiful. (It was early days in science.) He noticed a pattern: People enjoyed rectangles that had the proportions of the golden ratio, with the long sides about 1.6 times longer than the short sides.

It would be lovely to report that the first study in psychology's history was a triumph. Alas, science is a long journey out of wrongness, and Fechner's conclusion was fabulously wrong. Subsequent scientists repeatedly failed to replicate it. Not all founding fathers have worshipful ideas.

Fechner's finding was a dud, but his first instinct was brilliant: Scientists should study people by asking them about their lives and ideas. Over time, this principle yielded all sorts of fruitful conclusions. In the 1960s, the psychologist Robert Zajonc conducted a series of experiments where he showed subjects nonsense words, random shapes,

and Chinese-like characters and asked them which they preferred. In study after study, people reliably chose the words and funny shapes that they'd seen the most. It wasn't that some rectangles were perfectly rectangular. It wasn't that some Chinese-like characters were perfectly Chinese-like. People simply liked whatever shapes and words they saw the most. Their preference was for familiarity.

This discovery is known as the "mere exposure effect," or just the "exposure effect," and it is one of the sturdiest findings in modern psychology. People don't just prefer friends over strangers or familiar smells over unfamiliar odors. Across hundreds of studies and metastudies, subjects around the world prefer familiar shapes, landscapes, consumer goods, songs, and human voices. People are even partial to the most familiar version of the thing they should know best in the world: their own faces. The human face is slightly asymmetric, which means that a photograph captures a slightly different face than a mirror. People sometimes wince when they see photographs of themselves, and several studies show people prefer the face that they glimpse in a reflection. Does a glassy surface reveal your countenance at its objectively most beautiful? Probably not. It's just the face you like, because you're used to seeing it that way. The preference for familiarity is so universal that some think it must be written into our genetic code from back when our ancestors trawled the savanna. The evolutionary explanation for the exposure effect is simple: If you recognize an animal or plant, then it hasn't killed you yet.

The philosopher Martin Heidegger once said, "Every man is born as many men and dies a single one." There are a handful of preferences shared by almost all infants—for example, for sweet foods and harmonies without dissonance. But adult tastes are diverse, in large part because they're shaped by the experience of life, and each person enjoys and suffers life in a different way. People are born average and die unique.

There is nothing more important to the preservation of the hunter-gatherer groups than having sex and moving from place to place safely. So let's consider these two pillars of their psychology—What makes a face beautiful? What makes a landscape desirable?—to see the potential origins of a bias toward the familiar.

It's commonly said that people like faces that are symmetrical. But horizontal equivalence alone isn't the best predictor of beauty. Think about it: Can't you tell how attractive somebody is by just looking at one side of their face? And making an unappealing face perfectly symmetrical doesn't suddenly create a supermodel. The more scientifically rigorous explanation for beauty is that people are attracted to faces that look like lots of other faces.

When it comes to looks, average is truly beautiful. Several studies using computer simulations have shown that blending many faces of the same gender creates a countenance more attractive than its individuals. If you blend a lot of extremely good-looking people together, the composite is even more bewitching. What's so beautiful about an average face? Scientists aren't quite sure. Perhaps it's evolutionary, and a face-of-many-faces suggests genetic diversity. In any case, the appeal is universal and perhaps even innate. In studies of adults and children, based in China and throughout Europe and the United States, the most average faces are judged to be the most attractive.[3]

Beyond averageness, however, tastes diverge wildly. There is no universal attraction to lip plates, lipstick, or bangs, although you can find thousands of people around the world who find each to be seductive. Many people think glasses are sexy, but this is quite evolutionarily backward. Requiring precisely calibrated glassware technology to go about your day signals bad genes for vision. Ancient hunter-gatherers probably wouldn't have been smitten by wires resting on the nose and

3. You may write your beloved a Valentine's Day note saying, "Your face is perfectly average in every way." But in those precious few seconds before he or she leaves you forever, please don't mention that you got the idea from this book.

ears to balance optical lenses in front of one's eyes, but this doesn't diminish the popularity of the sexy-librarian fantasy. If biological preferences for faces exist, they are soft clay, and culture can mold it into myriad shapes.

Another place to see the branching of adult preferences from a common origin is in scenery. A global study of landscape pictures—like rain forests, savannas, and deserts—found that children around the world seem to prefer the same topography. It looks like a savanna with tree cover, which happens to resemble the East African landscape where the *Homo sapiens* species may have originated. It would appear that humans are born with what the professor of philosophy of art Denis Dutton calls a "pervasive Pleistocene taste in landscape."

But adult tastes for scenery are neither pervasive nor Pleistocene. They're all over the place. Some people prefer the sharp canine tooth of the Matterhorn peak, some love a Maine pond painted pink by the sunset, and others are partial to Morocco's burnt orange ergs. Some landscape details seem to be universally appealing. For example, people around the world are drawn to the presence of clean-looking water, an ancient and eternal necessity for life. There is some evidence that onlookers from various backgrounds and cultures are attracted to mountains divided by snaking rivers and forests cut by trails that slink away toward a vanishing point. These details signify something human ancestors would have loved to see: a navigable path through the chaos of nature. But as adults see different movies, calendars, magazines, photographs, and vistas, their impression of the "perfect" landscape branches off in a million directions.

In the final analysis, beauty does not reside in forms, or cosmic ratios, or even in the standard-issue wiring of humans' minds, hearts, and guts. It exists in the interplay between the world and people—which is to say, in life. People adapt. To paraphrase Tennyson, they are the sum of all they have met. They are born average and die unique.

————

Before there were social media feeds, before there were cable networks or television broadcast stations, and even before there were modern national newspapers, there were public museums. Not counting the amphitheater, the public museum was arguably the first technology to distribute artistic works—what is now collectively known as "content"—to a mass audience. It is strange, perhaps, to think of the museum as anything like a modern innovation, since to many it brings to mind antiquity, mothballs, and young children announcing that they have to pee. But like so much technology, from steam engines to smartphones, the public museum democratized a market—artworks and artifacts—making available to the masses that which was previously accessible only to the rich.

Although crowds have gawked at publicly displayed art for millennia, most art collections throughout history have been private and closely guarded by royals. The modern public museum was an invention of the Enlightenment and its radical notion that ordinary plebes deserved an education. The first national public museum was the British Museum, which opened in 1759 as a "cabinet of curiosities," including artifacts from ancient Egypt and flora from Jamaica. National museums flowered throughout Europe and across the Atlantic in the next few decades. The American polymath Charles Willson Peale founded America's first modern public museum in Philadelphia in 1786, with thousands of species of plants and paintings of animals from his collection.[4] The Louvre opened in Paris in 1793, and the Prado, in Madrid, followed in 1819. The Caillebotte bequest graced the walls of

————

4. Peale's life has nothing to do with this book, but it surely deserves its own museum exhibition and more. His career, which began in poverty in Maryland, was a long string of first-ever's. He opened the first modern American museum, painted the first portrait of George Washington in 1772, organized the first U.S. scientific expedition in 1801 to dig up fossils in New York, displayed the first mastodon skeleton in any museum in the world, and owned the American patent to the first version of the copy machine back when it was called a polygraph (not to be confused with a modern lie detector). He also named most of his children after famous painters and scientists, which has considerable relevance to Chapter 6.

the Musée du Luxembourg at the height of this craze for new public museums in Europe. In the second half of the nineteenth century, one hundred museums opened in Britain alone.

If public museums have been, for several hundred years, the most important real estate in art, then radio has been the public museum of pop music, the great hallway of mass exposure. Airplay was so critical to building popularity for new music in the mid-twentieth century that music labels developed elaborate "payola" schemes to directly pay radio stations to play their songs. Even into this century, omnipresent airplay is critical to make a hit. "Every bit of consumer research we've ever done shows only one consistent thing: Radio is the number one driver of sales and the biggest predictor of a song's success," says Dave Bakula, senior vice president of analytics at Nielsen, which tracks music sales and airplay. "You almost invariably see the biggest songs hit radio first, then pick up [in other platforms]." Public exposure on radio can be even more powerful than "mere" exposure, because a song's presence on a Top 40 station offers other cues about its quality, like the sense that tastemakers and other listeners have already heard and endorsed it.

Even at the dawn of the American music business, to make a song a hit, a memorable melody was secondary to an ingenious marketing campaign. "In Tin Pan Alley, what publishers understood was that no matter how clever, how catchy, how timely a song, its [success] depended on its system of distribution," music historian David Suisman wrote in *Selling Sounds: The Commercial Revolution in American Music.* In New York City near the end of the nineteenth century, writers and publishers near a part of Union Square nicknamed "Tin Pan Alley" developed an elaborate process of plugging new music. They would pass out song sheets to local musicians, who would play each tune in different neighborhoods, from the Lower East Side to the Upper West, and report back on which songs clicked. The American standards that came out of this period—such as "The Band Played On," "Take Me Out to the Ball

Game," and "God Bless America"—were the products of an elaborate testing and distribution strategy that ran on sheet music and shoe leather.

Tin Pan Alley's pluggers gave way to radio, and now radio is giving way to new forms of distribution that are more open, equal, and unpredictable. Today's hits break off TV commercials, Facebook posts, and online videos. A Spotify playlist by Napster cofounder Sean Parker is widely credited with launching Lorde's "Royals," the surprise hit of 2013. Two years earlier, a Canadian singer-songwriter, Carly Rae Jepsen, released a peppy song, "Call Me Maybe," that debuted at ninety-seven in the Canadian Hot 100. By the end of the year it still wasn't in the top twenty. But another Canadian pop singer, Justin Bieber, heard the song on the radio and then praised it on Twitter. In early 2012, Bieber made a YouTube video of him and several friends with fake mustaches, including pop star Selena Gomez, dancing to it. That video now has more than seventy million views, and it helped launch "Call Me Maybe" (which itself has more than eight hundred million views on YouTube) to become one of the biggest pop songs of the decade.

Music—and, for that matter, all culture—attaches itself to such moments, and now that moment can come from anywhere. Terrestrial radio still holds great distribution power—after all, that's how Bieber first heard "Call Me Maybe"—but it no longer has a monopoly on exposure. Every social media account, every blogger, every website, and every promiscuously shared video is essentially a radio station.

It would be nice to think that in a cultural market like music, quality is everything, and each number-one hit is also the best-in-class. Plus, it seems awfully hard to prove otherwise. How do you demonstrate that a song nobody has heard of is "better" than the most popular song in the country? You would need something crazy: a parallel universe to compare where thousands of people have listened to the same songs and come to different conclusions without the power of marketing.

In fact, that parallel universe exists. Music labels consult it all

the time. It is the universe of HitPredictor and SoundOut, online song-testing companies that ask thousands of people to evaluate the catchiness of new songs before the general population has formed an opinion about them.

As the name suggests, HitPredictor (which is owned by iHeart Media, the largest owner of FM and AM radio stations in the United States) "predicts" what songs will be hits by playing a hook from a new song to an online audience three times without telling them too much else about it. The point is to capture the song's pure "catchiness" in a vacuum. Audiences give the song a numerical rating: A song can score high into the 100s, but any score above 65.00 is considered eligible to be a breakout hit. Sixty-five is the threshold: Above that level, a track has the intrinsic appeal to be one of the top songs in the country.

Here are the HitPredictor ratings of several extremely popular songs that entered the top five on the Billboard Hot 100 in the fall of 2015:

"Hotline Bling," Drake: 70.25
"The Hills," The Weeknd: 71.39
"Stitches," Shawn Mendes: 71.55
"Sorry," Justin Bieber: 77.14
"What Do You Mean?," Justin Bieber: 79.12
"Hello," Adele: 105.00

Study those numbers for a second. Do you notice something weird? A song can theoretically score in the 100s, but most of these massive hits—and they were all massive hits—are just a few notches above the 65.00 threshold. There is nothing at 80.00 or above, except for the incredible outlier of "Hello." Keep that mystery in the back of your head for a few paragraphs, because there is something deceptively powerful about all these hits scoring "only" in the 70s.

SoundOut is a similar company based out of the UK, which

tests about ten thousand tracks online each month. Each new song is randomly streamed to more than one hundred people, who rate it after at least ninety seconds. At SoundOut, the magic number is 80, and any song scoring above that threshold—about 5 percent of tested music—is deemed sufficiently catchy to be a hit. The best-performing recording in SoundOut history was Adele's sophomore album, *21*, which included three worldwide number one hits and won the 2012 Grammy Award for Album of the Year. "Every song on the *21* album scored above an 80," SoundOut founder and CEO David Courtier-Dutton told me in late 2015. "We've never seen that before, and we've never seen it since."

Both HitPredictor and SoundOut find that, yes, there *is* such a thing as quality or catchiness. Melodies that fail to hit their magic numbers tend to fail in the real world as well.

But look back at the top hits of late 2015: Songs in the 70s routinely beat dozens, if not hundreds, of songs that scored in the 80s and 90s. Above a certain level, catchiness doesn't make a song a monster hit. Exposure does.

"For every great song that makes it into the charts and has months of airplay, there are a hundred other songs that are just as good, if not better, which, if sung by the right artist with the right marketing, would be a smash hit," SoundOut's Courtier-Dutton said. "It is absolutely, categorically true that there are thousands of songs out there that will never see the light of day because they will never get the distribution they require to catch in the market, even though they scored above 80."

What's holding back the success of thousands of catchy-enough songs? Sometimes they simply lack the marketing might of a label, or the luck of a viral online video, or the support of a celebrity like Justin Bieber. Sometimes DJs don't care about the artist or the song doesn't fit their playlist. Perhaps the band is recalcitrant and a total pain to market. Perhaps it's several of these things at once. But the point is that

every year hundreds of songs won't become hits, and it will have very little to do with the fact that they weren't "catchy enough."

It is the Caillebotte effect all over again: Two pop songs come out. Independent surveys determine they are equally catchy. But one song becomes a massive hit—ubiquitous in coffee shops, praised by mainstream music sites, adored by high school students, and even parodied on YouTube—while the second song is widely ignored and ultimately forgotten because, for some reason, it never received that crucial moment of public consecration. There are simply too many "good-enough" songs for every worthy hook to become a bona fide hit. Quality, it seems, is a necessary but insufficient attribute for success.

Critics and audiences might prefer to think that markets are perfectly meritocratic and the most popular products and ideas are self-evidently the best. But the universes of HitPredictor and SoundOut prove that for every hit song you've ever heard there are hundreds of equally catchy, but relatively anonymous, melodies that you haven't. Beyond a certain level of songwriting genius, how many times audiences have heard a melody matters more for its popularity than how inherently catchy it is.

In a world of scarce media—just one public French museum, or just three local radio stations—popularity is more top-down. Hits are easier to control and easier to predict. But today there are more than eighty museums in New York City alone. On streaming sites, like Pandora, Spotify, and Apple Music, there are millions of public and personalized radio stations. The power of the press belongs to anybody with a smartphone. In this bottom-up world, where cultural authority shatters into a million channels of exposure, the hits are harder to foresee—and authority is harder to protect.

Consider the nation's most solemn arena for popularity contests: political elections. "Politics as entertainment" is a common phrase in

the press, but the truth might be one letter off; for better or worse, politics is entertainment.

Every political campaign is a media organization. Political campaigns spend half their money on advertising. Elected representatives spent 70 percent of their time engaged in what any sane person would recognize as telemarketing—directly asking for money, asking other people to ask for money, or building relationships with wealthy people, which is a politely indirect way to achieve the same goal.

Even governance is showbiz: One third of the White House staff works in some aspect of public relations to promote the president and his policies, according to political scientists Matthew Baum and Samuel Kernell. The White House is a studio, and the president is its star.

But the star power of the presidency has shrunk in the last few decades at the same time that the channels of exposure have grown.

The most successful way for a president to shape public opinion is to speak directly to voters. Owning the public's attention used to be a simpler task. In the 1960s and 1970s, CBS, NBC, and ABC accounted for more than 90 percent of the TV audience. It was a heyday for the bully pulpit: In 1970 alone, President Richard Nixon delivered nine prime-time addresses to the nation. The typical address of both Nixon and his successor, Gerald Ford, reached half of all television-owning households.

As the television channels grew, however, the American president became easier to ignore. Ronald Reagan, whose telegenic skills were legendary, reached less than 40 percent of households on average, and Bill Clinton's loquacious charm got him only to 30 percent. Meanwhile, the average presidential sound bite on the news shrank from forty seconds in 1968 to less than seven seconds in the 1990s. Cable created the golden age of television, but it ended the golden age of presidential communication.

The president is shrinking, and so is the political party. For the

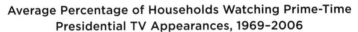

Average Percentage of Households Watching Prime-Time Presidential TV Appearances, 1969–2006

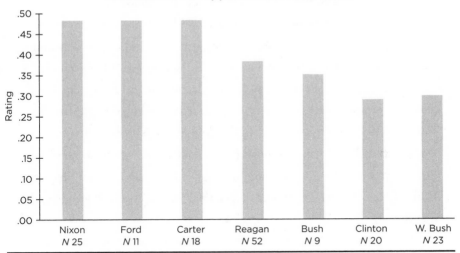

* Source: Nielsen Media Research

Note: "Rating" is a commonly reported variable that Nielsen Media Research defines as the percentage of households owning televisions that are tuned in to an average minute of a given program.

past half century, the best predictor of a political candidate's electoral success was the so-called invisible primary of endorsements from politicians, party leaders, and donors. According to one theory called "the party decides," it is Democratic and Republican elites, not voters, who decide on their favorite candidates, and these authority figures send signals through the media to the obedient rank and file. It is quite like the old information flow of the music industry: Authority figures (labels and DJs) blasted their preferred products (songs) through scarce and powerful channels of exposure (radio stations) and consumers typically obeyed (bought albums).

But in the 2016 primaries, the apparent power of advertising all but vanished. The GOP candidates with the most elite support, Jeb Bush and Marco Rubio, spent about $140 million on television ads through early 2016, but they both flamed out. The GOP candidate with the least

elite support, Donald Trump, spent less than $20 million on advertising. But he still won the exposure primary in a landslide, because his outrageous statements and improbable candidacy were such irresistible fodder for networks and publishers desperate for audiences. Through the summer of 2016, Trump had earned $3 billion in "free media," which was more than the rest of his rivals combined. With the rise of alternative media sources, party elites lost their ability to control the flow of political information to voters, and an unprecedented figure of single-minded celebrity, authoritarian bluster, and nativist bombast ran away with the Republican primary.[5] The party didn't decide. Rather, like the concentration of political media itself, it seemed to dissolve.

In politics, as in any industry, there is a product, a marketing strategy, and a buying opportunity—a politician, a campaign, and a vote. In both politics and business, research shows that advertising is most powerful when consumers are clueless. Political advertising, for example, is most potent when voters are ignorant of politics in general or with the choices in one particular election (that's one reason why the influence of money tends to be greater in local elections that voters don't follow as closely).

Similarly, corporate brands are most powerful in markets where consumers have little information, according to Itamar Simonson, a marketing professor at Stanford, and Emanuel Rosen, a former software executive. It could be because the product is somewhat technical (e.g., toothpaste, since most consumers don't actually know what gel is

5. The source of Donald Trump's popularity is a multifaceted mystery whose full explication would have to include: the economic and cultural anxieties of white middle-class Americans (particularly men); the latent racism of many voters; widespread frustration with Washington politics; and Trump's singular ability to monopolize a fragmented media that disproportionately covered his campaign because it was newsworthy, shocking, and good for ratings. It's my personal belief that Trump's massive exposure was a double-edged sword: It maximized his support (which was shockingly large) *and* inflated his unfavorable numbers, the highest of any general election candidate on record. It's difficult to hold up Trump as a simple example of exposure effect, in part because many Americans were widely exposed both to the candidate himself and to so many arguments about the dangers of his candidacy.

best for their enamel) or because the product is refined (e.g., wine, where studies have found that consumers prefer any vintage they think is expensive).

But just as cable and the Internet have washed away the power of political authorities, challenging the theory that the party decides, the Internet's flood of information is also diluting the brand power of several consumer products. Consider the market for flat-screen televisions: There are only a few relevant details about a big screen that projects images, like width and resolution. Anybody can find those details online, so who needs to consult the plastic name at the bottom of the screen? No wonder, then, that the business of selling flat-screen televisions has been a disaster: The price of TVs declined 95 percent between 1994 and 2014. In that same period, Sony's television unit lost money every single year.

When consumers don't know the true value of the products they're looking for, they rely on corporate iconography to guide them. But when they can figure out the absolute value of a product on their own, they ignore advertisements and brands. That's why Simonson and Rosen have named their theory "absolute value." The Internet, they say, will be a brand-assassinating technology, flooding the world with information and drowning out the signal of advertising for many products.

In the 1890s, a single museum had the power to set an artistic canon. In the 1950s, a handful of television channels had the power to brighten every living room with a vision of the president.

No more. Cable television drowned the bully pulpit. Social media is eroding the parties. The Internet drowns out corporate branding. In all sorts of markets—music, film, art, and politics—the future of popularity will be harder to predict as the broadcast power of radio and television democratizes and the channels of exposure grow. Today, there are so many platforms that nobody—not the president, not the Republican

Party, not Coca-Cola—can hope to own them all at once. The gatekeepers had their day. Now there are simply too many gates to keep.

The power of exposure is pervasive—from art and music to politics and brands—but its origin is elusive. How does familiarity shapeshift into pleasure, so that "I liken this to something else" becomes simply "I like this"?

In his 1790 treatise *Critique of Judgment*, Immanuel Kant proposed that pleasure can arise from a "free play" of the mind. When a person discovers an attractive idea or story, it triggers a dialogue between imagination and understanding, each quickening the other. According to free play, beautiful art, music, and ideas offer a kind of cognitive tease: They dangle the promise of comprehension but never provide the full satisfaction of *getting it*.

Free play is a lovely idea: How pretty to think that our thoughts and feelings have dancing partners. And perhaps it is more than philosophical poetry.

Two centuries after Kant's treatise, psychologists developed the idea of "metacognition." They proposed that there is a level of thinking above thinking. People have thoughts about their thoughts, and feelings about their feelings.

Have you ever heard somebody say, "This is hurting my brain"? It's often a joke, but it acknowledges something quite real. In a way, we can feel our thoughts. Some of them feel easy: like imagining words that rhyme with "hat," listening to simple repetitive music, or hearing an eloquent argument for a political position one already agrees with. But sometimes thinking feels like work: like imagining words that rhyme with "strategy," listening to avant-garde electronica without a time signature, or processing a complex argument for a political position one considers abhorrently wrong.

There is a psychological term for thinking that feels easy, and fortunately it's easy to remember, too. It's called "fluency." Fluent ideas and products are processed faster and they make us feel better—not just about ideas and products we confront, but also about ourselves. Most people generally prefer ideas that they already agree with, images that are easy to discern, stories that are easy to relate to, and puzzles that are easy to solve.[6]

One of the most important sources of fluency is familiarity. A familiar idea is simpler to process and place in the mental map. When people see an artwork that reminds them of something they've been taught is famous, they feel the thrill of recognition and attribute the thrill to the painting itself. When they read a political argument that reflects their biases, it fits snugly into their story of how the world works. Thus, familiarity, fluency, and fact are inextricably linked. "That idea sounds familiar," "That idea feels right," and "That idea is good and true" spill into each other in one mental mush.

But not all thinking feels so easy. Some ideas, images, and symbols are more difficult to process, and the term for hard thinking is called "disfluency." Just as the mental mush conflates fluency with good ideas, people tend to consider disfluency a sign that something is wrong. There is a play-it-at-home game to explain this effect. Follow these four steps:

1. Think of the last movie, play, or TV show that you finished: Whisper it to yourself.
2. Between 1 (awful) and 10 (perfect), imagine how you might rate it.
3. Now think of *seven specific things* you liked about the

6. Did you read this sentence and say, "Wait, I like hard puzzles!" I do, too. I'm getting to you, I promise.

movie or show. Count them on your fingers and don't stop
until you hit seven.

4. Finalize your rating of the show.

This sort of game is famous because something curious often happens: Between steps 2 and 4, the rating typically goes *down*.

Why should one's opinion of a show decline as you think of more reasons to like it? After a few easy examples come to mind, the effort to dig out more examples becomes palpably difficult. People experience disfluency. And sometimes, they misattribute the feeling of disfluency to the quality of the show itself.

This is the "less is more" or "less is better" effect. It means that less thinking leads to more liking. A cheeky UK experiment found that British students' opinion of former prime minister Tony Blair sank as they listed more of his good qualities. Spouses offer higher appraisals of their partners when asked to name fewer charming characteristics. When something becomes hard to think about, people transfer the discomfort of the thought to the object of their thinking.

Almost every piece of media people consume, every purchase they make, every design they confront lives on a continuum between fluency and disfluency—ease of thinking and difficulty of thinking. Most people lead lives of quiet fluency. They listen to music that sounds like the music they've already heard. They look forward to movies with characters, actors, and plots that they recognize. They don't heed political ideas from opposing parties, particularly if these ideas also seem painfully complicated. As we'll see in the next chapter, this is a shame, because the greatest joys often come from discovering fluency in places you didn't expect.

Fluency's attraction is obvious. But there is a quieter truth: People need a bit of its opposite. They want to be challenged, shocked, scandalized, forced to think—just a bit. They enjoy what Kant called free play—not just a monologue of fluency, but a dialogue between "I get it"

and "I don't" and "I want to know more." People are complicated: curi-ous *and* conservative, hungry for new things *and* biased toward the familiar. Familiarity is not the end. It's just the beginning.

This might be the most important question for every creator and maker in the world: How do you make something new, if most people just like what they know? Is it possible to *surprise* with familiarity?

THE MAYA RULE

"Aha" Moments—in Television,
Technology, and Design

Decades before he would be known as one of the great hit makers of the twentieth century, Raymond Loewy was a French orphan aboard the SS *France* in 1919, with a personally tailored army uniform and forty dollars in his pocket. His parents had died during the influenza pandemic. World War I had ended. At the age of twenty-five, Loewy was looking to start fresh in New York—perhaps, he thought, as an electrical engineer.

As he was crossing the Atlantic Ocean, a gentle nudge from a stranger redirected his career. Several passengers were auctioning off some of their possessions for easy money. Owning nothing of value, Loewy contributed a pen-and-ink sketch of a female passenger strolling along the promenade deck. The drawing sold for 150 francs to the British consul in New York, who gave the young Loewy a contact in the big city—Mr. Condé Nast, the prestigious magazine publisher. The more Loewy thought about the invitation, the more intrigued he was by the idea of pursuing art as a living.

When Loewy reached Manhattan, his older brother Maximilian took him to 120 Broadway. One of New York's largest structures in the early 1900s, the Equitable Building is a neoclassical skyscraper with two connected towers that ascend from a shared base like a giant tuning fork. He rode the elevator to the observatory platform forty stories up and took his first look down the gaping mouth of New York City and its toothy skyline.

The engineer in Loewy was astonished by what he saw. New York was full of new *stuff*: towers, trolleys, automobiles, and boats. He could hear ferries whistling from the Hudson River. But when the artist looked closer, he was crestfallen. New York was a grungy product of the machine age—greasy, crude, and hulking. He had imagined such different shapes aboard the SS *France*—simple, slender, even feminine.

The world below would soon reflect Loewy's dreamy vision. Within a few decades of his arrival, he would be widely known as the father of modern design. He would help remake the sports car, the modern train, and the Greyhound bus; he would design the Coca-Cola fountain and the iconic Lucky Strike cigarette pack. His firm put its imprimatur on products as prosaic as the pencil sharpener and as ethereal as the first NASA orbital workshop. In 1950, *Cosmopolitan* magazine wrote, "Loewy has probably affected the daily life of more Americans than any man of his time." Today, it is hard to walk through some cities, offices, or homes without seeing a product designed by Apple. In the 1950s, it was equally impossible to move through America without bumping into something designed by Loewy and his firm.

At a time when American tastes were in violent flux, Loewy had what must have seemed like an ineffable sense of what people like. He also had a grand theory of it. He called it MAYA. People gravitate to products that are bold, yet instantly comprehensible—"*Most Advanced Yet Acceptable.*"

Unbeknownst to the now deceased Loewy, this insight has since been validated by a fleet of studies in the last hundred years. It's been

used to explain earworms in pop music, blockbusters in movie theaters, and even the success of memes in digital media. It is not merely the feeling that something is familiar. It is one step beyond that. It is something new, challenging, or surprising that opens a door into a feeling of comfort, meaning, or familiarity. It is called an aesthetic aha.

Raymond Loewy arrived in Manhattan at a key moment in the collision between economics and art. Artisans and designers of the nineteenth century had struggled to make enough stuff to meet the growing demand of consumers. But modern factories—with their electricity, assembly lines, and scientifically calibrated workflow—produced an unprecedented supply of identical cheap goods by the 1920s. It was an era of mass production, yielding an abundance of self-same products. Henry Ford's Model T was a symbol of its age, and from 1914 to 1925 it was available only in black. Companies did not yet worship at the altars of style, choice, and design. The era's capitalists were monotheistic: Efficiency was their one true god.

But in the 1920s, art made a comeback, albeit for commercial reasons. It had become clear that factories could make more than consumers could buy. Americans were still *neophobic*—afraid of the new—and resistant to change. Capitalists needed buyers to be *neophilic*—attracted to the new—and so hungry for the next big thing that they'd spend their month's income on it. It was a period when American industrialists were learning that, to sell more products, you couldn't just make them practical. You had to make them beautiful—even "cool."

Executives like Alfred Sloan, the CEO of General Motors, recognized that, by changing a car's style and color every year, consumers might be trained to crave new versions of the same product. This insight—to marry the science of manufacturing efficiency and the

science of marketing—inspired the idea of "planned obsolescence." That means purposefully making products that will be fashionable or functional for only a limited time in order to encourage repeat shopping trips. Across the economy, companies realized that they could engineer turnover and multiply sales by constantly changing the colors, shapes, and styles of their goods. Technology enabled choices and choices created fashion—that perpetual hype cycle where designs and colors and behaviors appear suddenly cool and then suddenly anachronistic.

It was an age of new things, a birth of American neophilia. Artists, once silenced by the whir of assembly belts churning out identical products, played a starring role in the new mass production economy. Designers became the conjuring artists of the consumerist American Dream.

For many people today, craving the next hit from Nike, Apple, or Disney feels as natural as awaiting the turning of the leaves. But this is no ancient Darwinian itch. For millennia, the ancestors of today's fashionistas wore the same clothes, and the sons of each generation didn't seem to mind wearing the tunics of their great-grandfathers. Fashion, as we know it, was not written into human DNA. It is a recent invention of mass production and modern marketing. People had to be taught to constantly crave so many new things, and Loewy was one of neophilia's first great teachers.

Paul Hekkert, a professor of industrial design and psychology, received a grant several years ago to develop a grand theory for why people like what they like, a Unified Model of Aesthetics. Hekkert's grand theory begins with two competing pressures. On the one hand, humans seek familiarity, because it makes them feel safe. On the other hand, people are charged by the thrill of a challenge, powered by a pioneer lust. Our ancestors didn't just walk out of Africa; they also walked out of the Middle East, and out of the Balkans, and out of Asia,

and out of North America. Humans have climbed the peak of Mount Everest and descended to the nadir of the Mariana Trench. They have radical curiosity crossed with conservative minds. This battle between discovery and familiarity affects us "on every level," Hekkert said—not just our preferences for pictures and songs, but also for ideas and even people.

In studies, Hekkert and his team asked respondents to rate several products, like cars, telephones, and teakettles, for their "typicality, novelty and aesthetic preference"—that is, for familiarity, surprise, and liking. The researchers found that neither measure of typicality nor novelty alone had much to do with most people's preference; only taken together did they consistently predict the designs that people said they liked. "When we started the study, we didn't even know about Raymond Loewy's theory," Hekkert told me. "It was only later that somebody told us that our conclusions had already been reached by a famous industrial designer, and it was called MAYA."

Raymond Loewy dreamed of forward motion. Doodles of cars and trains filled out his childhood sketchbooks. Even in the trenches of war, the darkest corners of life received his light touch. As a twenty-one-year-old private in World War I, Loewy had decorated his dugout with "flowered wallpaper and draperies," according to *Time* magazine. When the French military's standard-issue trousers didn't fit to his liking, he sewed himself a new pair of pants because, in his words, "I enjoyed going into action well dressed."

But in the United States, Loewy initially felt stuck. In the early 1920s, he worked as a fashion illustrator for Condé Nast, the magazine publisher, and Wanamaker, the department store. For several years, he was overworked and lonely—"never a date, never any fun," he wrote. He spent long hours sketching in his studio apartment on West Fifty-

Seventh Street, often until dawn, when the familiar clomping of the milkman's horses served as a reminder to lay the pencils to bed.

Loewy had devoted himself to drawing, but he felt his attention wandering back to engineering—to polish the grimy city that stretched out before him on his first afternoon in New York. He was fixated on the heinous design of a mass-produced world—its boxy cars, its dusty refrigerators. "Why manufacture ugliness by the mile," he wrote, "and swamp the world with so much junk?"

Finally, in 1929, he received his first design request from Sigmund Gestetner, a British manufacturer of early printers known as mimeographs. Gestetner asked if Loewy had any ideas to tweak the machine's appearance. Naturally, Loewy had more than a few suggestions. His initial reaction to the duplicator was visceral disgust:

> Unwrapped and standing naked in front of me, it looked like a very shy, unhappy machine. It was a kind of dirty black and it had a rather fat little body perched too high on four spindly legs that suddenly spread out in panic as they approached the earth . . . What looked like four hundred thousand little gadgets, spinners, springs, levers, gears, caps, screws, nuts, and bolts, were covered in a mysterious bluish down that looked like the mold on tired Gorgonzola.

Given only three days to operate, Loewy got to work. He redesigned the crank and the tray, chopped off the four spindly legs, and covered as much of the machine as possible in a removable shell made of plastic clay. Loewy had never used a duplicator before he was instructed to fix decades of bad engineering in seventy-two hours. But when Gestetner saw the clay model, he immediately shipped it to UK headquarters. The company didn't merely accept Loewy's design; it kept him on retainer for the rest of his career.

Loewy's approach belonged to an emerging philosophy called "industrial design," which had a dual mandate to make mass-manufactured products more efficient *and* more lovely. A great industrial designer served as both engineering consultant and consumer psychologist—equally aware of assembly routines and shopping habits. But the concept of industrial design itself required a bit of familiarization for machine-age companies. Loewy spent much of the 1930s traveling to Toledo, Cleveland, and Chicago to beg small midwestern factories to look at his sketches. In aspirin-fueled business trips, Loewy would present his ideas before dozens of manufacturers, most of whom ignored him. His personal motto was that success is "25 percent inspiration and 75 percent transportation."

Loewy's first break was in duplication, but his first coup was in refrigeration. In 1934, Sears, Roebuck and Co. asked him to redesign their Coldspot fridge. Loewy accepted $2,500 and spent three times that amount moving the motor and installing the first ever rust-free aluminum shelves. The new design was a sensation: Within two years, Sears's annual sales quadrupled from 60,000 fridges to 275,000.

His next breakthrough came in locomotives. The president of Pennsylvania Railroad approached the young designer with a deal: If Loewy could come up with a better way for passengers to dispose of waste at its grand New York City terminal, Pennsylvania Station, he would get the chance to design the trains themselves. Loewy accepted enthusiastically. The young man who fussed over wartime wallpaper was more than equipped to beautify a train station's trash cans. He spent three days immersing himself in amateur anthropology at Penn Station, studying the waste-disposal habits of its violent current of passengers and staff. Pennsylvania Railroad enthusiastically welcomed his suggestions and awarded him the opportunity to redesign the company's most popular locomotive. He suggested eliminating thousands of rivets by welding a shell—a single smooth,

chromatic skin for the whole machine. His train designs are now iconic, the round head and slender body, the shape of a bullet fired through water.

His talents stretched to logos. In the early months of 1940, George Washington Hill, the president of American Tobacco Co., bet $50,000 that Loewy couldn't improve Lucky Strike's iconic green and red cigarette packaging. Loewy sketched an alternative that kept the font, the red target, and the slogan "It's Toasted." He then replaced the green background with white and copied the logo on the reverse of the cigarette pack so that the company seal would always show faceup, doubling its brand impressions. That April, Loewy invited Hill back to his office and showed him the new designs. He won the bet on the spot, and the white Lucky Strike design lasted the remainder of the century. In the next few decades, Loewy's firm would go on to design several of the most famous logos in America, including Exxon, Shell, and the U.S. Postal Service.

These successes with Gestetner, Sears, Pennsylvania Railroad, and Lucky Strike opened his firm's doors to all varieties of design projects—ferryboats, furniture, toothpick wrappers, bridges, coffee cups, menu designs, and store interiors. Loewy was mad for all sorts of undulations, but the prettiest curve, he liked to tell executives, was a sales curve that swept up and rightward.

Loewy's most memorable designs were the body shells of his cars. Early in his career, Loewy had patented a sketch of a sedan. The prevailing style of cars in the 1920s was upright and boxy—a stagecoach with an engine. But the silhouette of Loewy's early car sketches anticipated the automobile's future. They featured a subtle forward *lean*, as if the upright Model T were set in italics. Even standing still, Loewy said, a car ought to have "built-in forward motion." In the 1950s his work with the auto manufacturer Studebaker produced perhaps the most famous work attributed to him. The Starliner Coupe—nicknamed

the "Loewy Coupe"—is one of the most famous automotive designs of the twentieth century. The body of the car, long and angular, rises to present two wide-open eyes for headlights. It is exactly as the younger Loewy imagined cars might one day look—set in motion, even when sitting still.

In March 1962, he witnessed President John F. Kennedy's plane landing at the airport near his home in Palm Springs. That evening, he told a friend and White House aide that the plane looked "terrible" and "gaudy." Someone took the hint, and Loewy was invited to the White House. He presented some livery sketches of America's most famous airplane to the president. Kennedy looked across the designs and selected a red and gold variety, with one special request. Kennedy asked that the design be rendered in his favorite color, blue. Loewy took the president's suggestion. The blue version of the livery he showed President Kennedy adorns the Air Force One 747 to this day.

As the designer laureate of midcentury America, Loewy and his firm touched every station in the life cycle of American appetites: They designed International Harvester tractors that farmed the Great Plains, merchandise racks at Lucky Stores supermarkets that held the produce, kitchen cabinets in suburban homes that kept the food, the Frigidaire ovens that cooked the meals, and the Singer vacuum cleaners that ingested the crumbs of dinner. As a designer for Soviet companies in the depths of the Cold War, Loewy's design instincts transcended ideologies and hemispheres.

At the end of his career, he was not even bound by the atmosphere. NASA asked Loewy's firm for help in designing the habitat inside its first space station, *Skylab*. Loewy's company conducted extensive habitability studies and concluded that orbiting astronauts would appreciate a reminder of the most familiar thing on earth—earth itself. It was Loewy who insisted on the inclusion of a viewing porthole, so that astronauts could sneak a peek at their pale blue home. And so the designer's career ended as it began—looking down from a great height and imag-

ining something more beautiful. Loewy's final contribution to design was, literally, a new way to see the world.

R aymond Loewy's shop was, as much as any modern music label or Hollywood studio, a hit factory of his time. Photographs from the mid-1950s show a world sheathed in smooth chrome. Loewy wanted to clothe the sharp man-made protuberances of the machine age with nature's smooth shells. The Studebaker coupes, pencil sharpeners, and locomotives of the era all hold the same ovular style.

This was purposeful. Loewy thought the egg was nature's time-tested pinnacle of design and function, a structure of such precise curvature that a shell less than one one-hundredth of an inch thick could resist twenty pounds of applied pressure. Once you know Loewy's north star, it's impossible to stop seeing eggs—or eggish curves—throughout his firm's designs.

The breadth of Loewy's success raises a question: How did one man—or, more realistically, one man's firm—develop a philosophy for what millions of Americans wanted, in everything from toothpicks to space stations?

Loewy himself offered two answers—one tactical and anthropological, the other grand and psychological.

Loewy's personal style was effete—his suits and cars were each fussily self-designed—but his business philosophy was hard-nosed. He believed in ethnography as an entry point for design: First, understand how people behave; second, build products that match their habits.

When the meatpacking company Armour & Co. hired him to redo its eight hundred different products, Loewy sent employees on a six-month talking tour to speak with hundreds of housewives about Armour meats. (Their conclusion: The packaging came in way too many colors.) To redesign Pennsylvania Railroad's locomotive, Loewy rode its trains for thousands of miles, talking to passengers and crew mem-

bers to discover the machines' most subtle deficiencies. Although he is most celebrated for throwing a chromatic coat over the locomotive, his hours of travel also revealed acute design failures, like the absence of toilets for the crew. So he installed those, too.

Loewy was an excellent teacher of consumer preferences in part because he was an obsessive student of consumer habits. He piggybacked off people's behavior rather than design products that would force them to change their lives.

But Loewy felt that his sensitivity to the familiarities of his consumers connected to a deeper layer of psychology. His MAYA theory—Most Advanced Yet Acceptable—spoke to the tension between people's interest in being surprised and feeling comforted. "The consumer is influenced in his choice of styling by two opposing factors: (a) attraction to the new and (b) resistance to the unfamiliar," he wrote. "When resistance to the unfamiliar reaches the threshold of a shock-zone and resistance to buying sets in, the design in question has reached its *MAYA* stage: Most Advanced Yet Acceptable."

Loewy understood that attention doesn't just pull in one direction. Instead, it is a tug-of-war between the opposing forces of neophilia versus neophobia, the love of the new versus the preference for the old; people's need for stimulation versus their preference for what is understandable. A hit is new wine aged in old oak, or a stranger who somehow feels like a friend—a familiar surprise.

The last chapter explained how one of the most powerful forces in popularity is the power of exposure. Exposure breeds familiarity, familiarity breeds fluency, and fluency often breeds liking.

But there is such a thing as *too much* familiarity. It's everywhere, in fact. It's hearing a catchy song for the tenth time in a row, watching a movie that is oh so predictably uncreative, or hearing a talented

speaker use overfamiliar buzzword after buzzword. In fluency studies, the power of familiarity is discounted when people realize that the moderator is trying to browbeat them with the same stimulus again and again. This is one reason why so much advertising doesn't work: People have a built-in resistance to marketing that feels like it's trying to seduce them.

Instead, the most special experiences and products involve a bit of surprise, unpredictability, and disfluency. Imagine entering a room full of strangers. You look around for somebody you know but you cannot find a single recognizable face. And then suddenly there is a parting in the room, and through the crowd you see her—your best friend. The warm feeling of relief and recognition bursts through the clouds of confusion. That is the ecstasy of sudden fluency, a moment of eureka.

Pop culture is a parade of these eureka moments large and small. Crossword puzzles design for confusion followed by coherence—*aha*. Great storytellers excel in creating tension followed by a cathartic release—*aha*. In 2013, several researchers asked people to rate paintings by cubist artists, a group that includes Pablo Picasso, Georges Braque, and Fernand Léger. First the researchers recorded people's reactions to the paintings alone; they weren't very good. But then the scientists included clues to the paintings' meaning, or brief histories of the painters themselves. With these clues, audience ratings improved dramatically; suddenly, the abstract paintings were not like the inscrutable backs of strangers, but rather like a new friend, reaching out to take their hand. "The creation of meaning itself is what's rewarding," researcher Claudia Muth told me. "An artwork doesn't have to be 'easy' to appeal to its audience." People like a challenge if they think they can solve it. She calls this moment where disfluency yields to fluency the aesthetic aha.

Audiences appreciate aha moments so much that they also enjoy

simply *expecting* them, even if the moment never comes. Somebody can enjoy a long book or television show that offers no answer for hours and hours if the genre itself promises a resolution. When the popular, mystic television show *Lost* ended, many fans erupted in indignation that the showrunners failed to resolve the series' many puzzles. This deprived careful viewers of the final aha moment they thought they'd been promised. Some people surely felt like they'd wasted cumulative weeks, even months, of their lives waiting for answers. But their final disappointment didn't retroactively change the sincere thrill they'd felt throughout the series. *Lost* was a monster hit for many years because audiences enjoyed the experience of anticipating answers, even though the writers were just stockpiling riddles without resolutions. Many people will put themselves through quite a bit of disfluent anguish if they expect fluent resolution at the end.

Video games, too, are often puzzles whose interactivity offers the wondrous click of recognition or jolt of accomplishment. The most popular video game of all time is Tetris. Alexey Pajitnov was a twenty-eight-year-old computer scientist working at a Soviet R&D center in Moscow when, after buying a set of funny-shaped dominoes, he got an idea for a video game. On June 6, 1984, he released an early version, which he named by combining "tetra," after the four square blocks of each game piece, with "tennis," his favorite sport. Before long, the game spread across Moscow, hopped over to Hungary, was nearly stolen by a British developer, and went on to become the bestselling video game of all time, selling four hundred million copies. The game is a dance of anticipation and completion. Many novels and mystery stories may be *analogous* to falling puzzle pieces clicking into place, but Tetris is explicitly just that.

The second bestselling game of all time is Minecraft, where users build shapes and virtual worlds from digital bricks. Minecraft is a kind of cultural inheritor to Lego, which was itself an "heir to the heritage of playing with blocks," as tech journalist Clive Thompson wrote. But

whereas Lego sets often come with a detailed set of precise instructions, Minecraft is more open-ended. The most popular games for smartphones, where the level of play must be simple enough to execute with a stray thumb, are often puzzles, too, including 2048 and Candy Crush. The point of these games is neither to make players tear out their hair nor to give away the secret too easily, but rather to design what the neurologist Judy Willis calls an "achievable challenge." *Most advanced yet achievable*—MAYA.

Smaller aha moments—the sort that make you simply smile rather than sprint naked through the neighborhood—are all around us. There is a popular online video called "4 Chords," with more than thirty million views, in which the musical comedy group the Axis of Awesome cycles through dozens of songs built on the same four chords—I–V–vi–IV.[1] This chord progression is the backbone of dozens of classics, including oldie hits (the Beatles' "Let It Be"), karaoke pop (Journey's "Don't Stop Believin'"), country sing-along (John Denver's "Take Me Home, Country Roads"), arena rock (U2's "With or Without You"), animated musical (*The Lion King*'s "Can You Feel the Love Tonight"), acoustic pop (Jason Mraz's "I'm Yours"), reggae (Bob Marley's "No Woman, No Cry"), and modern dance pop (Lady Gaga's "Paparazzi"). In 2012, Spanish researchers released a study that looked at 464,411 popular recordings around the world between 1955 and 2010 and found the difference between new hits and old hits wasn't more complicated chord structures. Instead, it was new instrumentation bringing a fresh sound to "common harmonic progressions."

Several music critics use videos like "4 Chords" to argue that pop music is simply derivative. But this seems backward. First, if the purpose of music is to move people, and people are moved by that which is sneakily familiar, then creative people *should* aspire for a blend of originality and derivation. Second, it's simply wrong to say that all I–V–vi–

1. In the key of C-major, that progression is C–G–Am–F.

IV songs sound the same. "Don't Stop Believin'" and "No Woman, No Cry" and "Paparazzi" don't sound anything alike. These songwriters aren't retracing each other's steps. They're more like clever cartographers, each given an enormous map, plotting new routes home.

The aha effect isn't bound to arts and culture. It's a powerful force in the academic world as well.

Scientists and philosophers are exquisitely sensitive to the advantage of ideas that already enjoy broad familiarity. The history of science is a long story about good ideas facing rejection after punishing rejection until enough scientists become acquainted with the concepts, at which point they become law. Max Planck, the theoretical physicist who helped lay the groundwork for quantum theory, said: "A new scientific truth does not triumph by convincing its opponents and making them see the light, but rather because its opponents eventually die, and a new generation grows up that is familiar with it."

In 2014, a team of researchers from Harvard University and Northeastern University wanted to know exactly what sort of proposals were most likely to win funding from prestigious institutions, like the National Institutes of Health—safely familiar proposals or extremely creative ones? They prepared about 150 research proposals and gave each one a novelty score. Then they recruited 142 world-class scientists to evaluate each project.

The most novel proposals got the worst ratings. "Everyone dislikes novelty," lead author Karim Lakhani explained to me, and "experts tend to be overcritical of proposals in their own domain." Extremely familiar proposals fared a little bit better, but they also received lower scores. The highest evaluation scores went to submissions that were deemed *slightly new*. There is an "optimal newness" for ideas, Lakhani said—advanced yet acceptable. The graph of optimal newness looks like this:

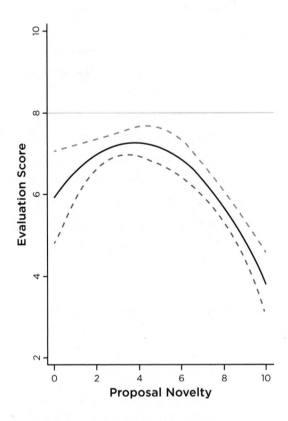

This appetite for "optimal newness" runs throughout the hit-making world. Film producers, like NIH scientists, have to evaluate hundreds of projects a year but can accept only a tiny percentage. To grab their attention, writers often frame original ideas as a fresh combination of two familiar successes using a "high-concept pitch"—like "It's *Romeo and Juliet* on a sinking ship!" (*Titanic*) or "It's *Toy Story* with talking animals!" (*The Secret Life of Pets*). In Silicon Valley, where venture capitalists also sift through a surfeit of proposals, high-concept pitches are so common that they're practically a joke. The home rental company Airbnb was once called "eBay for homes." The on-demand car service companies Uber and Lyft were once considered

"Airbnb for cars." When Uber took off, new start-ups took to branding themselves "Uber for . . ." anything.

Creative people often bristle at the suggestion that they have to stoop to market their ideas or dress them in familiar garb. It's pleasant to think that an idea's brilliance is self-evident and doesn't require the theater of marketing. But whether you're an academic, screenwriter, or entrepreneur, the difference between a brilliant new idea with bad marketing and a mediocre idea with excellent marketing can be the difference between bankruptcy and success. The trick is learning to frame your new ideas as tweaks of old ideas, to mix a little fluency with a little disfluency—to make your audience see the familiarity behind the surprise.

For the last decade and more, the most valuable brand in media has been ESPN. For many years, the sports network has accounted for half of the Walt Disney Company's annual profit and more than its entire movie division.

Much of ESPN's lucre comes from the quirky economics of sports and the modern TV business. The "traditional" TV audience—the one with a remote control, a cable box, and a live menu of shows—has taken a gut punch in the last decade. Between 2010 and 2015, the amount of time eighteen- to thirty-four-year-olds spent watching traditional cable TV declined by about 30 percent. To get people to sit down in front of a live show (and be present for the live advertising), executives have doubled down on entertainment that must be seen *now*. That includes live musicals, live variety shows, live game shows, live singing shows, and, most important, live sports. Sports are the keystone of the cable TV arch. Without them, the whole thing collapses.

Every month, your cable company sends about one half of your cable bill straight to the TV networks you can see on the menu. These fees range from a penny to a few dollars. ESPN gets about six or seven

dollars per pay TV customer per month, whether that household watches zero minutes of ESPN or one hundred hours. This is the equivalent of tens of millions of households buying six movie tickets a year to the same film—even if they don't watch any of the movie.

But the network's financial ascent in the last decade was more than a clever bank shot off the economics of TV bundling. It also has to do with engineering familiarity.

At the network's New York City headquarters on West Sixty-Sixth Street in 2014, I sat with Artie Bulgrin, ESPN's director of research, in a wood-paneled conference room as he swooshed through slides of a massive annual presentation that he'd prepared for the company since 1998. He stopped at what he called "the money chart." It showed the results of a survey asking men for their favorite cable networks.

"Men have named us their favorite channel for fourteen straight years," he said. "Other networks need to create hits. We don't. People tune in to ESPN without even knowing what's on."

The worldwide leader in sports didn't always enjoy such dominance. At the turn of the century, the network was in crisis. In the late 1990s, ESPN found itself languishing after a decade of out-of-control growth. "As we grew, we tried to be everything to everyone," ESPN sales and marketing VP Sean Bratches said, sitting to Bulgrin's right in the Sixty-Sixth Street conference room. "We had bass fishing and cheerleading and salsa dancing and scripted dramas and comedy shows," he said. "We tried to promote every single thing rather than focus on a few things."

To guide the turnaround, ESPN tapped an unlikely new leader. John Skipper, a magazine editor with no experience in television, arrived at Disney after serving as president of the music magazine *Spin*. In his fifteen years at ESPN before becoming president in 2012, he oversaw Disney-branded magazines and books, launched *ESPN The Magazine*, and managed the website ESPN.com. ESPN had lost a sense of its core, Skipper told the company's leaders at one of the first

executive meetings. Rather than being great at serving one perfect product, like a steakhouse, it had become a network that served lots of mediocre fare, like a cheap diner.

Skipper started the turnaround by focusing on *SportsCenter*, ESPN's unavoidable collage of the day's news. Rather than serve many audiences across the sports spectrum, from college squash to Indian cricket, he said *SportsCenter* should spend more hours covering mostly the most popular story lines. Why? To maximize the odds that whenever a fan tuned in, he could expect to see a team, player, or controversy that he recognized—like the New England Patriots, LeBron James, or Olympic doping scandals. *SportsCenter* would become, he decided, an entertainment steakhouse, serving up new takes on the same core sports, stars, and scandals—over and over and over. After that, Bulgrin said, things "started to change rather dramatically." *SportsCenter* had become the thing every sports fan quietly craves: a news machine for delivering new takes on familiar stories. Ratings soared, and ESPN has been the favorite network of American men every year since.

In the last few years, CNN has taken the same approach, devoting more time to fewer stories, like terrorist attacks and disappearing airplanes. This makes for pretty repetitive TV, if you watch all day long. But who would want to watch CNN all day long? The typical television news viewer watches about five minutes of cable TV news per day. CNN is doing something smart—maximizing viewers' expectations that they will see a story they recognize no matter when they tune in.

Throughout the 2016 election, the CNN spotlight trained its white-hot focus on Donald Trump, who reportedly referred to network president Jeff Zucker as his "personal booker." Media critics sighed over CNN's singular obsession, but the strategy paid off, at least in the most literal sense. In 2015, CNN saw its highest viewership in seven years and enjoyed the strongest rate of advertising growth of any cable news network. Journalists mocked the network's Trumpist worship, often

with good reason, but television economics is not a morality play. Trump and Zucker's relationship proved to be fantastically profitable.

ESPN and CNN have discovered what Top 40 radio has known for several decades: Most people tune in to a broadcast to hear more of something they already know. Radio audiences can't anticipate what the next song will be. But as every car driver and radio executive will affirm, people mostly just want to hear songs they recognize. For decades, DJs on pop music radio stations have considered unfamiliar songs to be "tune-outs" because audiences tend to spurn new music. These listeners want to be surprised—that's why they play the radio rather than a CD or playlist—but they want to be surprised by the feeling of familiarity.

The age of old-school television, with one dominant screen and one live stream, is giving way to an age of social video networks with billions of screens and zillions of personalized feeds. From 2010 to 2015, the average viewership of *SportsCenter* fell by almost 40 percent among eighteen- to thirty-four-year-olds. The most valuable piece of glass for ESPN today might be the smartphone screen. In an average week, ESPN delivers more than seven hundred million alerts to tens of millions of phones. When something big happens in sports, more than seven million people get a notification from ESPN in their pockets and purses; that's more than ten times the typical *SportsCenter* audience. One and a half million people—a sizable audience for a TV show—have signed up for news alerts for a single basketball team, the Golden State Warriors. When the Bay Area squad does something newsworthy, ESPN buzzes on the home screen of more people than the combined city populations of San Francisco and Oakland.

Technology is quickly changing the delivery of news, but not necessarily the philosophy of what people want from it. Consider a news ecosystem quite opposite from ESPN and cable news: Reddit, a community news site created entirely by anonymous users.

On Reddit, each piece of content is two parts: a headline and an article link. Users can promote links with "upvotes" or register their dissatisfaction with "downvotes." Several years ago, a team of computer science researchers at Stanford University submitted and resubmitted thousands of images to Reddit with different headlines and controlled for network effects to see if the Reddit community had a clear preference for certain titles. They wanted to understand a question that I think about all the time: *What makes a great headline?*

In my time at *The Atlantic*, I've developed, refined, discarded, and revived countless pet theories about what makes a perfect headline. When I was younger, I used to say a great headline should be "definitive or delightful." That is, it should try to make a clear and superlative statement ("One Graph Explains Why the United States Is the World's Best Place to Start a Company") or it should be obviously funny or cute ("I Can't Stop Looking at This Baby Tiger Play with Yarn").

Several years ago, the Internet was awash with an exotic species of headline based on something called the "curiosity gap." That is, the writer tells the reader enough to pique interest and then, like a cheap magician, says, "You Won't Believe What Happens Next." These head-lines conquered the world (well, *my* world) for several months, then fell out of fashion for the same reason that people tire of every marketing gimmick: When you're savvy to the source of fluency, you tend to dis-count the stimulus as boring or manipulative. When the audience knows the formula, a magic trick isn't magic anymore; it's just a trick. After the curiosity gap year, however, *The Atlantic* continued to find great success with stories about the mind and body—essentially, psy-chology and health—and my personal headline motto changed, again, to: "A reader's favorite subject is the reader."

Meanwhile, these Stanford computer scientists were putting empir-ical meat on the bare bones of my headline writing theories. They con-cluded that the most successful headlines on Reddit presented novel images or stories while "[conforming] to the linguistic norms of the

community to which it is submitted." A good headline, they said, is not overly familiar, but rather *familiar enough*; a welcome surprise expressed in the vernacular of its intended audience; a promise to advance understanding in a broadly acceptable subject—MAYA.[2]

If a television is a piece of furniture, a mobile device is an appendage— not just familiar, but personal and even intimate. A one-screen world targets the mainstream. But now people get music, news, and everything else from the piece of glass in their pockets. This billion-screen world, not bounded by the limits of linear programming, is tailored to individuals. And although everybody has an appetite for the familiar, appetites can vary.

With more than eighty-one million listeners and twenty-one billion hours of played music each year, Pandora is the most popular digital radio app in the world. Name the bands you like, and Pandora builds a radio station around their sound. If I say I like the Beatles, Pandora will play the Kinks, the Rolling Stones, and newer bands with a Beatlesy vibe. Users can make the station better by signaling the songs they love or by skipping the songs they don't.

These interactions give Pandora's scientists a bird's-eye view of how tastes work. Pandora's algorithm isn't best thought of as one formula. It's more like an orchestra of dozens and dozens of formulas that are conducted by a metaformula. One of the most important instruments in this algorithmic symphony is familiarity.

"The most common complaint about Pandora is that there is too much repetition of bands and songs," said Eric Bieschke, the first chief data scientist at Pandora. "Preferences for familiarity are much more individual than I would have thought. You can play the exact same songs

2. Please do not confuse this reflection of quantitatively successful headline strategies with qualitatively successful journalism. The best journalism can be quite indifferent to acceptability, because it seeks, above all, to be true. The hunt for quantitatively successful content has led many writers and media companies away from the truth.

to two people with the same tastes in music. One will consider the station perfectly familiar, and the other will consider it horribly repetitive."

There are two fascinating implications here. The first is that neophobia, or preference for the familiar, is not a universal human constant. Rather, there is a spectrum between people who like things that are extremely familiar and people who like things that surprise: a Beatles fan who wants to hear only the Beatles versus a Beatles fan who wants to hear only new songs with John Lennon inflections; a family that likes going to the same place for each vacation versus a family that never goes on the same vacation twice. The most significant neophilic group in the consumer economy is probably teenagers. Young people are "far more receptive to advanced designs," Loewy wrote, because they have the smallest stake in the status quo. "The dream of the alert industrial designer would be to design for teen-agers . . . Whether or not they fall periodically for some silly fad that does harm to no one, their basic taste remains fundamentally correct."

The second implication of Pandora's analysis is that familiarity-as-a-taste can vary by genre. Some people are music hipsters (they love hopping between esoteric bands) but information moles (they read only one local liberal blog). Others are the opposite, musically conservative but adventurous about reading political columns by writers they disagree with. As Loewy understood, neophilia and neophobia are not isolated states, but rather warring states, constantly doing battle both within the mind of every buyer and within an entire economy of buyers.

I recently visited Spotify, the large online streaming music company, to talk to Matt Ogle, the lead engineer on a new hit product called Discover Weekly, a personalized list of thirty songs delivered every Monday to tens of million of users.

For about a decade, Ogle had worked for several music companies to design the perfect music recommendation engine. His philosophy of music was that most people enjoy new songs, but they don't enjoy the

effort that it takes to find them. They want effortless, frictionless musical revelations, a series of achievable challenges. In the design of Discover Weekly, "every decision we made was shaped by the notion that this should feel like a friend giving you a mix tape," he said. So the playlist was weekly and included only thirty songs.

Here's how it works. Each week, Spotify bots hunt through several billion playlists from users around the world to see what songs are typically grouped together. Imagine that Song A, Song B, and Song C often appear together in the same playlist. If I often listen to Songs A and C, Spotify guesses that I'll probably like Song B—even if I've never heard of its band. This way of predicting tastes by aggregating millions of people's preferences is known as "collaborative filtering"—*collaborative* because it takes many users' inputs, and *filtering* because it uses the data to narrow down the next thing you want to hear. It's conceptually similar to the algorithms that power the related-items sections of Amazon and other shopping sites: If many people purchase a certain chair with a certain table, buyers of that table will be prompted to buy the chair.

At the end of our interview, Ogle and I talked about how most music fans (but not all) are fundamentally conservative. They like what they like, and they don't want to be too challenged by music. "The line from psychologists is, if you've seen it before, it hasn't killed you yet," I joked.

Ogle's face lit up. "I have a story for you," he said. The original version of Discover Weekly was supposed to include only songs that users had never heard before. But in its first internal test at Spotify, a bug in the algorithm let through songs that users already knew. "Everyone reported it as a bug, and we fixed it so that every single song was totally new," he said.

But after his team fixed the bug, something unusual happened: Engagement with the playlist *fell*. "It turns out having a bit of familiar-

ity bred trust, especially for first-time users. If we make a new playlist for you and there's not a single thing for you to hook onto or recognize, to go, 'Oh yeah, that's a good call!' it's completely intimidating and people don't engage."

The original bug was actually an essential feature. Discover Weekly was a more appealing product when it had even one familiar band or song. "I think users wanted to trust the feature, but they were waiting to see some sign that it knew them, too," Ogle said. Spotify users wanted a fresh taste. But they also wanted to make sure it wouldn't kill them.

By the 1950s, Raymond Loewy could reasonably claim that the most iconic car, the most used locomotive, and most famous airplane in midcentury America all sprung from the sharpened tip of a Loewy pencil. So what can he teach today's artists about how to make a hit? MAYA offers three clear lessons.

First: *Audiences don't know everything, but they know more than creators do.* The most successful artists and entrepreneurs tend to be geniuses. But the paradox is that they are both smarter than their median consumer and dumber than all of their consumers because they don't know how their consumers live, what they do every day, what annoys them, or what moves them. If familiarity is the key to liking, then people's familiarities—the ideas, stories, behaviors, and habits with which they are fluent—are the keys to their heart. Loewy had his own theories of beauty, his eggshells and his chrome finishes. But he knew that designing for strangers was, at the beginning, like fumbling through a dark tunnel toward a tiny speck of light. He was obsessed with understanding the people he was designing for.

Second: *To sell something familiar, make it surprising. To sell something surprising, make it familiar.*[3] At the far reaches of radical

3. David Foster Wallace once said realistic novels can serve two purposes: "Making the strange familiar [and] making the familiar strange, again."

thinking, it's critical for artists and entrepreneurs with wild ideas to heed the pull of familiarity and remember Max Planck's warning: Even the most brilliant scientific breakthroughs face initial skepticism when they are too far from mainstream thought. Great art and products meet audiences where they are.

But the fact that people gravitate to fluency in art and design is no excuse for dumb simplicity. The central insight of MAYA is that people actually prefer complexity—up to the point that they stop understanding something. Many of today's museumgoers don't just stare at the water lilies. They enjoy strange and abstract art that gives them a feeling or a jolt of meaning. TV viewers don't just watch reruns. They like complex mysteries with narrative puzzles that come to completion. Theatergoers love familiar revivals, but the most influential Broadway smash hits are ones, like *Hamilton*, that tell a familiar story in an ingeniously new way. The power of fluency, after all, is strongest when it emerges from its opposite, a challenging period of disfluency, to create an aha moment.

Third: *People sometimes don't know what they want until they already love it*. Loewy and his ilk were constantly pushing tastes forward among an audience of midcentury Americans who didn't know they wanted anything new. In the final pages of his memoir, Loewy relays an old joke about a Boy Scout and his scoutmaster discussing the day's mandatory Good Deed.

> *"And what good have you done today, Ray?"*
>
> *"Walter, Henry, and I helped a lady across the street," the boy says.*
>
> *"Very nice. But why did it take three of you?"*
>
> *"The old lady did not want to cross."*

If Loewy had been a Boy Scout, he would have been like his namesake, Ray: pushy while playing within certain rules. He had taught

drowsy, machine-age consumers to be neophiles of the highest order. He nourished an appetite for surprise to go with their taste for the familiar. The young man who surveyed New York City in 1919 from the top of the Equitable Building at 120 Broadway saw the other side of a street and carried the country across. He did not ask for permission.

3

THE MUSIC
OF SOUND

The Power of Repetition—

in Song and Speech

avan Kotecha knows the number by heart: *one hundred sixty.* It is
the number of rejection letters he keeps in a folder at his parents'
home in Austin, Texas. The signatures include the names of some
of the famous labels and music publishers in the country. Each one
came to the same conclusion. Kotecha's songs just weren't good enough.

Today, Kotecha's reputation hangs on larger numbers. Two hundred
million, for example, is the number of copies of Kotecha's songs that
have sold worldwide. As a writer and producer for pop stars like Ariana
Grande, Justin Bieber, Usher, Maroon 5, Carrie Underwood, and One
Direction, Kotecha has become one of the most prolific young pop
music writers in the United States and a contributor on more than a
dozen top ten songs in the U.S. and UK, including several number one
hits like "Can't Feel My Face" by The Weeknd and "What Makes You
Beautiful" by One Direction.

When he was a boy, Kotecha's father worked for IBM, which moved
the family all over the country. In Austin, where they finally landed, he

slept on the living room couch of his parents' small apartment. One day he wandered into his sister's room and discovered a keyboard. He sat down to play with it. Something lit up inside him. From that day on, Kotecha says, he was obsessed with every dimension of writing and performing music. He taught himself to play piano while studying music theory. He sang in both the school choir and in a boy band. He devoured books about the history of pop music and explanatory guides about music labels and music publishers.

As Kotecha dreamed of a life writing songs that soak the airwaves, his practical studies suffered. He might have gotten into more trouble for skipping classes, but his choir teacher recognized the young kid's talent as something potentially extraordinary. When Kotecha's mother would phone the school, this music instructor would often take the call and cover for him with an excuse for his absences. "My parents were freaking out," Kotecha told me about his early music habit, quickly offering by way of explanation, "They were very traditional Indian parents."

He sent out hundreds of demo tapes and received more than one hundred dismissive letters, which he deliberately saved, like pelts of rejection. When he graduated and insisted that his future was still in an industry that had so consistently offered nothing but spurning, Kotecha's dad gave his son an ultimatum. "He said I had two years to be a loser and then I had to go to college," he recalled with a laugh.

Kotecha hustled his way into music festivals. At South by Southwest, Austin's music-and-everything-else festival, he would drive downtown to the DoubleTree and other hotels, slink into the lobby, and pass out demo tapes to every A&R scout who walked through the doors. The DoubleTree kicked him out several times. Kotecha learned to pack multiple disguises. When hotel management showed him the door, he would return several minutes later in a new shirt, only to be kicked out again (and return, again, in another new outfit with more demos).

Finally, in 1999, Kotecha caught a break. A New York music executive with deep connections in Stockholm gave him instructions that would change his life: "Go to Sweden."

If pop music were a global technology, Sweden would be its Silicon Valley. Sweden and Swedish expats are the world's inexhaustible fount of catchy melodies. Led by Max Martin, the legendary superproducer responsible for dozens of number one singles by the Backstreet Boys, Katy Perry, and Taylor Swift, the small Scandinavian country has been exporting contagious music to the world since ABBA debuted in the 1970s.

Why Sweden? The answer involves a mix of policy, history, and the magnetizing effect of talent. First, the Swedish government actively promotes public music education at a time when many countries have no such policy ("I have public music education to thank for everything." Martin said in 2001). Second, Sweden has a musical culture that promotes major-chord melodies over lyrics, which makes their songs highly exportable to audiences who don't speak Swedish.

Third, since ABBA's heyday in the 1970s, Sweden has built a national industry dedicated to writing, producing, and selling pop music, which attracts some of the best pop talent in the world—like a gifted Indian American teenager from Austin, Texas. Economists sometimes call this magnetizing effect "agglomeration," and it's why similar companies have a tendency to congregate in the same cities.[1] When geographers at Uppsala University studied Sweden's music industry, they said that it followed a model that economist Michael Porter calls "industrial clustering." The same way that talented entrepreneurs go to San Francisco to be around people like them in the software industry, songwriters gravitate to Swedish power centers.

1. "Agglomeration" shares a root with "conglomerate," which comes from the Latin *glomus*, "ball-shaped mass." So you can think of the agglomeration effect like spooling a ball of yarn. As the stray thread loops back to the center, the ball gets bigger, stronger, and more tightly packed. That is the clustering effect: power from proximity.

"In Sweden, I met up with RedOne, Lady Gaga's songwriter, and his whole crew," Kotecha recalled. "Through another connection there, I met Simon Cowell and became involved with *The X-Factor*, which made me the lead coach and songwriter for One Direction. A few years later, I met Max Martin. And then everything really exploded."

Kotecha is rapturous about Martin, who, for several decades, has been at the core of this spool of Swedish songwriters. In an interview with the *Hollywood Reporter*, he compared Martin to the Michael Jordan of pop music.

The comparison fascinated me. I can see clearly what makes Michael Jordan a great shooter and defender. I wondered if the originator of the analogy could apply a bit of rigor to the ineffable art of songwriting. So I asked Kotecha: "If Michael Jordan is Michael Jordan because he can score efficiently, what makes Max Martin his industry's Michael Jordan?"

Kotecha did not hesitate to answer. "That's easy. He has the best ear for catchy melodies—maybe the best in pop history," he said. "He can write great melodies, he understands what's wrong with other people's melodies, he's a genius song doctor, an amazing arranger, and an amazing finisher."

"What did Max Martin teach you?" I asked. "That great pop music is very, very structured," Kotecha continued. "The construction of a pop song is something almost mathematical. Max taught me that each part has to speak to the other parts. If the verse starts on the one [the first beat], the pre-chorus should start on the one. Melodies need to get to the hook quickly and then repeat. That's what makes it catchy."

What is that thing—catchiness? What is it about a line of melody that makes a hook irresistible? Even the best songwriters sometimes cannot explain the anatomy of a great hook. Like many artists quizzed on the specific mechanics of their process, they react the way an ordinary person would if asked to explain the finer details of breathing. The skill is so intrinsic that the mechanics become invisible.

THE MUSIC OF SOUND

To understand the basic elements of catchiness—why we like what we like from song and speech—it's worth starting at the beginning.

How does a sound become a song?

O ne morning in the spring of 2009, Walter Boyer, a fifth-grade music teacher at the Atwater School in Shorewood, Wisconsin, asked his eighteen fifth-grade students to listen to a recoding of a woman speaking. As they sat still, a lilting voice came over the air.

The sounds as they appear to you are not only different from those that are really present, but they sometimes behave so strangely as to seem quite impossible.

This was a topsy-turvy sentence for a group of unsuspecting fifth-graders. Some crinkled their faces, as if the words were ancient German. But they kept listening. As the recording continued, several words played again.

. . . sometimes behave so strangely . . .

And again.

Sometimes behave so strangely.

Again.

Sometimes behave so strangely.

As these four words looped over and over, something quite strange happened. Through repetition, the spoken words seemed to develop a rhythm and even a melody. Smiles broke across the children's faces.

"Try it," Mr. Boyer suggested, and suddenly, as if reading sheet music, the students broke into song, in perfect unison. "Sometimes behave so strangely," they sang together. Many giggled at the shock of ordinary words transforming, as if by magic, into music. Some of them even danced in their seats.

Mr. Boyer stopped the recording. "Did you hear the melody?" he asked the class.

"Yahhhh," they replied, in the lazy drawl of kids forced to answer an obvious question.

"Was she ever really singing, though?"

"Noooo," they said.

"So, why do you think it happened?" The class was silent.

Several weeks later, Diana Deutsch, a psychologist at the University of California, San Diego, received a video of Mr. Boyer's fifth-grade class. Deutsch was hosting a dinner party at her home in La Jolla. She nearly cried at the sight of eighteen children singing with a voice—her voice—as it transformed from speech into music by mere repetition.

Deutsch is a detective of musical illusions. Her most famous discovery is the phenomenon witnessed in Mr. Boyer's music class. It is the "speech-to-song illusion." If you take a spoken phrase and repeat it at a common interval, the spoken words can evolve to sound like music. When Deutsch plays the "sometimes behave so strangely" phrase to her own research subjects, they invariably sing back a melody so precise that it has a key, time signature, syncopation, and rhythm. If you can read music, it sounds just like this:

sometimes behave so strangely

"When somebody is talking, there is a central executive in the brain that makes decisions about whether a phrase is spoken or sung," Deutsch told me. "Repetition is a clue. It tells the brain to listen for music."

More than an illusive trick, repetition is the God particle of music. Humpback whales, white-handed gibbons, and more than four hundred American species of birds are considered singers, and animal researchers reserve the term "sing" for only specific sounds that repeat at common intervals.

The power of repetition in human music is fractal, appearing at every level. Repetition of rhythm is necessary to build a musical hook. The repetition of hooks is necessary for choruses. Choruses repeat several times in each song, and people often honor their favorite songs by putting them on repeat. As every parent can attest, children love hearing the same songs again and again. But grown-ups aren't so different. Ninety percent of the time people listen to music, they are listening to a song they've already heard.

Occasionally people will hear music on loop even when they don't want to, for example when a song gets stuck in our heads. This phenomenon is called an "earworm," and it is an old and global scourge. The English term comes from the German *Ohrwurm* (literally "ear worm") while the French call it *musique entêtante*, or "stubborn music." Thomas Edison invented the phonograph in 1877, one year after Mark Twain published a story in *The Atlantic Monthly* about young students haunted by an irresistible jingle. This is one cultural affliction that critics cannot blame on technology. The fault is in our brains.

Therein resides the real mystery. Earworms are stranger than they appear. If you show a friend one quarter of a Claude Monet painting, she will not spend the next thirty minutes complaining that she cannot stop seeing the other three quarters. (If she does, take her directly to a research hospital.) Why do people get earworms, but not, pardon the imagery, eyeworms—or noseworms or tongueworms, for that matter?

Earworms are like a keyhole into music's manipulation of time's past and future. The earworm-infested brain is stuck in a loop between repetition (*I want to remember how this goes*) and anticipation (*I want to know how this ends*). This very entanglement—the pull of repetition versus the push of anticipation—defines the catchiest songs.

I think back to my favorite hooks and how they often seem to break in half—a fall and a rise, a question and its answer. Swinging down at "bye bye" and swinging up at "Miss American Pie"; low at "With the lights out" and high at "it's less dangerous"; rising at "she loves you" and falling at "yeah, yeah, yeah"; a step down at "Hey, I just met you" and a step up at "and this is crazy."[2]

A great musical hook is a great question with an answer that asks to repeat the question. "People like new and surprising melodies," said Elizabeth Margulis, a musicologist at the University of Arkansas Music Cognition Lab. "But when we feel like we can accurately make tiny predictions about how a song is going to go, it feels really good." It takes no effort to recall a catchy tune; the melody is self-remembering.

When a song gets stuck in your head, it can drive you crazy. But since the affliction is universal, timeless, and self-inflicted, it must say something about our internal circuitry. An earworm is a cognitive quarrel. The automatic mind craves repetition that the aware brain finds annoying. As we saw in previous chapters, perhaps the unconscious self wants more repetition—wants more of the old, wants more of the familiar—than the conscious self thinks is "good."

This is not merely a theory about the annoying jingles that you can't get out of your head. The underrated allure of repetition is a fundamental basis of the entire pop music economy.

The Billboard Hot 100 is the standard register of popularity in

2. Answer key: Don McLean's "American Pie"; Nirvana's "Smells Like Teen Spirit"; The Beatles' "She Loves You"; Carly Rae Jepsen's "Call Me Maybe."

American music. It has counted down the top songs in the United States every week since 1958. But the Billboard list has been built on lies, half-lies, and made-up statistics. For decades, there was no way to accurately measure what songs played most on the radio, and there were also no reliable ways to know which albums sold the previous week at record stores. Billboard would rely on the honesty of radio stations and store owners, and neither party had much reason to be honest. Music labels nudged or outright bribed radio DJs to plug certain records. Record stores didn't want to promote albums that had sold out. The industry was biased toward churn. The labels wanted songs and albums to enter and exit the charts quickly so they could keep selling new hits.[3]

In 1991, Billboard ditched this patchy honor system and started collecting point-of-sale data from cash registers. "This was revolutionary," explained Silvio Pietroluongo, Billboard's director of charts. "We were finally able to see which records were actually selling." Around the same time, the company started monitoring radio airplay through Nielsen. The Hot 100 become a lot more honest in the span of a few months.

This had two major implications. First, hip-hop surged in the rankings while old-fashioned rock slowly began to fade. (Perhaps an industry dominated by white guys hadn't paid enough attention to the music interests of minorities.)[4] On June 22, 1991, the week after Billboard updated its chart methodology, *Niggaz4life* by N.W.A. beat *Out of Time* by R.E.M., marking the first time a rap group had the most popular album in the country. A recent study of the last fifty years in U.S. pop music named the 1991 ascension of rap "the single most important event that has shaped the musical structure of the American charts."

3. You might say the twentieth-century music industry excelled in planned obsolescence. Just as Alfred Sloan showed you can make people want more GM cars by constantly changing their color and model, the music industry manipulated turnover in number one hits to encourage people to buy new records.

4. Which is ironic, since pop music's gatekeepers in the 1950s initially considered rock and roll "jungle music"; by 1980 powerful white men were protecting a genre that the previous generation of powerful white men considered a threat.

In markets where popularity matters, information *is* marketing. When music listeners learned how popular hip-hop really was, it made hip-hop even more popular.[5]

Something else happened to American music preferences: They got a lot more repetitive. Without the music labels manipulating the charts, Billboard was a more perfect mirror of American tastes, and the reflection in the mirror said: *Just play the hits!* The ten songs that have spent the most time on the Hot 100 were all released after 1991. Since the most popular songs now stay on the charts for months, the relative value of a hit has exploded. The top 1 percent of bands and solo artists now earn about 80 percent of all recorded music revenue. And even though the amount of digital music sold has surged, the ten bestselling tracks command 82 percent more of the market than they did a decade ago.

As Billboard's Pietroluongo summed it up: "It turns out that we just want to listen to the same songs over and over again." It's part of the fractal force of repetition: People want to hear the same rhythms repeated within hooks repeated within choruses repeated within songs—and, left to our own devices, we put those songs on repeat.

But nobody wants to hear the exact same thing over and over forever. Too much repetition causes monotony. The question is, how do songwriters and their ilk know how to balance repetition and variety?

David Huron is a prominent musicologist at Ohio State University, and if you ask him about pop music, he'll tell you about mice.

Take a mouse and play a loud noise—call it B. The mouse will

5. The same thing has arguably happened in U.S. news with the #BlackLivesMatter movement. Facebook and Twitter have directed enormous readership to articles about racism and violence against black communities in America. The underlying facts haven't changed much; blacks have faced oppression and suffered police brutality for years. But newsmakers' interest in covering these stories *has* changed. Social media has made it unavoidably obvious that these shootings are happening and that millions of people want to learn more about them. The illumination of previously under-covered stories is probably a good thing, overall. But a dispiriting implication is that the news media—which remains disproportionately white—played down these stories for decades, somewhat like the music labels (also dominated by white men) overlooked the rise of hip-hop.

freeze. Perhaps he'll turn that tiny pointy white face in a look of sheer surprise. Play B again, and again he will be adorably startled. But eventually the mouse will stop reacting. The noise will no longer interest him. He'll become "habituated."

Habituation is common with music. Repetition might be the God particle, but it's far from the only particle. You probably don't want to hear "Three Blind Mice" right now, and you certainly don't want to hear it seven times in a row. You liked the song once—when you were five?—but now it does nothing for you. That's habituation, and it happens with every song and almost any stimulation. It's the brain's way of saying, "Been there, done that."

In many aspects of life, habituating is normal and good. If you can't focus at work because of construction noise but you soon forget it's there, you'll be more productive. But in entertainment, habituation is death. It's "I've seen enough dark and shadowy comic book movies— no, thanks." It's "This new rap album is interchangeable with the artist's last two albums, so nope." If it's true that audiences like repetition, and it's true that audiences can be bored by too much repetition, *how do you get people hooked without making them habituated?*

Let's return to our poor mouse. Rather than play B notes to the little guy forever, scientists can play several B notes in a row and then, just as he's about to figure out the pattern, hit him with a new sound—C!

The C note will startle the mouse, too. But more important, the introduction of a new note will make the mouse forget a little bit about the B. This is called "dishabituation." The single serving of C preserves the potency of the B stimulus. Eventually, the mouse will become habituated to both the B and the C. But that's okay. Scientists can further slow the habituation process by introducing a third note—D![6]

6. According to Huron, there are two ways to get around habituation. The first is variety, or dishabituation. The second is time. Let's say you listen to "I Will Survive" twenty times in a row. The next day you'd rather hear nails on a chalkboard than any more Gloria Gaynor. But several weeks later the song comes on the radio and you realize you want to hear it again. Huron calls this "spontaneous recovery": You think you've had enough of Gloria, but after some time you want another hit of "I Will Survive."

To scare a mouse for the longest period of time with the fewest notes, scientists have found success with variations on the following sequence:

BBBBC–BBBC–BBC–BC–D

Huron's research has found that this sequence of repetition and variation reflects global music patterns—from European sonatas to Inuit throat singing to American rock. "Across the world, music is consistent with early repetition," he said. "The idea is to be repetitive up to the point where people might pull their hair out, and then change things subtly. From a composer's perspective, to make something simple and beautiful, you could think, 'What's the minimal amount of material I can compose to entertain my audience for the longest period of time?'"

I'm particularly drawn to the final snippet of the sequence, which is this:

BBC–BC–D

This structure might not seem obviously familiar to you. But let's call B a verse, C a chorus, and D an alternate verse, or bridge. Replace the notes with their corresponding words and you get the following song structure. I think you'll recognize it, because it might be the most common pattern of the last fifty years of pop music.

Verse-verse-chorus—verse-chorus—bridge[7]

The answer to the question *How do I scare a mouse with the fewest notes for the longest period of time?* turns out to be a specific pattern

7. Huron noted that just because many modern American pop songs share the same verse-chorus structure does not mean that this is the biologically ideal structure for a song. It's just the most familiar way to balance repetition and variety for modern Western audiences. There are many iconic songs that don't have choruses, like Bruce Springsteen's "Thunder Road" and Queen's "Bohemian Rhapsody." These songs still have several melodies that repeat with variations.

that anticipates the way so many modern pop songs are written. Early repetition sets up a C-chorus theme. The verse and chorus passages pass the baton back and forth. To avoid boring an audience, the artist introduces a D-bridge to dishabituate the listener from both verse and chorus and set up the final musical sequence.

Is a pop song just an elaborate mouse dishabituation study? Critics of modern pop might welcome such simplification, but the wiser conclusion here is more complicated and less incendiary.

When one stops to think about how repetitious people's favorite pop songs are, how they reliably alternate verses, choruses, verses, choruses, bridges, and amplified choruses, it's undeniable that great music offers anticipation within specific lines of expectation. "People find things more pleasurable the more times you repeat them, unless they become aware that you're being repetitive," Huron said. "People want to say, 'I'm not seduced by repetition! I like new things!' But disguised repetition is reliably pleasurable, because it leads to fluency, and fluency makes you feel good."

Huron is unpacking the psychology of habituation, not offering a home assembly kit for writing the next great pop song. Repetition and variation do not make any piece of music great on their own. Instead, they establish clear rules within which great songwriters work. Writing poetry without rhyme is "like playing tennis without a net," the poet Robert Frost once said. In music, repetition is the net.

Music may be more elemental than language. Song precedes speech—both in a human's life and in human history. Infants can make singsong nonsense long before they can explain exactly why they deserve more candy. In the beginning of human language, speech and music were nearly the same—simple sounds uttered by groups, in repetition.

Before cuneiform or broader literacy, memory was a civilization's

library. It is little wonder, then, that many of the oldest literary classics—including *Beowulf,* Homer's *Odyssey* and *Iliad,* Ovid's *Metamorphoses,* Virgil's *Aeneid,* and Geoffrey Chaucer's *Canterbury Tales*—are considered epic poems. Each uses repetition, rhythm, rhyme, and alliteration to lock itself in the next storyteller's memory bank. In some ways, repetition *is* memory—"prosthetic memory," to borrow Alison Landsberg's wonderful phrase. A song "remembers" its hook, on the listener's behalf, by repeating it. Shakespeare's sonnets "remember" their sounds by repeating them as rhymes.

For many people, it is easier to remember words when they're attached to rhythms and melodies. Stroke victims and other sufferers of aphasic language disorders who struggle to speak can often still sing. Gabby Giffords, the Arizona congresswoman shot in the head in an assassination attempt, has struggled to regain her verbal ability. But in February 2015, she starred in an emotional and widely shared online video of her nailing every word in a passage from "Maybe," a song from the musical *Annie.* Aphasia often comes from damage to the parts of the left brain that control language, but fMRI studies have shown that music therapy activates the right hemisphere's melodic intelligence.

This suggests that repetition is powerful, not only for music, but for all communication. Music is like memory candy. Musical language helps people remember words, and it signals to people that some words are worth remembering. For thousands of years, writers and orators have persuaded audiences with their own "speech-to-song" effects—by coating their spoken words with repetition's sweet syrup.

And they still are.

On July 27, 2004, the speechwriter Jon Favreau introduced himself to Barack Obama by asking the future president to stop talking.

Favreau was a twenty-three-year-old graduate of the College of the Holy Cross in Massachusetts working for Senator John Kerry's presi-

dential campaign. Obama, an Illinois state senator, was rehearsing the keynote speech he would deliver at the Democratic National Convention in Boston's FleetCenter later that evening. Favreau interrupted the rehearsal and asked if the senator might consider tweaking a quip about red states and blue states. It was too similar to one of Kerry's applause lines. Obama was reportedly furious; it was one of his favorite parts of the speech. He changed it anyway.

It was hard to say which man was the bigger imposter at the Fleet-Center stage in the summer of 2004. The keynote speaker, Obama, had never held national office. The young Favreau had the good fortune to become a speechwriter only because Kerry's campaign had been such a disaster before the Iowa caucus that more experienced advisers had abandoned it. "They couldn't find anyone who wanted to come in when we were about to lose to [former Vermont governor Howard] Dean," Favreau told *Newsweek*. "I became deputy speechwriter, even though I had no previous experience."

Three months later, Kerry lost the presidential election, and Obama had become a national political celebrity in need of a speechwriter. In January 2005, Favreau met Obama in the Senate cafeteria in the Dirksen Office Building on Capitol Hill. The senator asked, "What's your theory of speechwriting?"

"It's interesting," Favreau told me ten years after that meeting, "because what attracted me to Obama at first was not the soaring rhetoric, but his authenticity. I think a lot about empathy as a speechwriter. I always try to imagine the audience: Where are they coming from? What base of knowledge are they starting from? How do we both connect to where they are and lift them up a little bit?" He got the job. When Obama announced he was running for president several years later, Favreau became one of the youngest chief speechwriters of a presidential candidate in American history.

Three years later, in early 2008, Obama's presidential campaign seemed charmed as it stormed into New Hampshire with a double-digit

lead after winning the Iowa caucus. But he lost the primary to Hillary Clinton by three percentage points. On January 8, 2008, he took the stage at Nashua High School South, thanked his supporters, and delivered, in a loss, perhaps the most quoted speech of his career. He structured the address around a phrase so simple that he once rejected it for being too corny: *"Yes, we can."*[8]

> *For when we have faced down impossible odds, when we've been told we're not ready or that we shouldn't try or that we can't, generations of Americans have responded with a simple creed that sums up the spirit of a people: Yes, we can. Yes, we can. Yes, we can.*
>
> *It was a creed written into the founding documents that declared the destiny of a nation: Yes, we can.*
>
> *It was whispered by slaves and abolitionists as they blazed a trail towards freedom through the darkest of nights: Yes, we can.*
>
> *It was sung by immigrants as they struck out from distant shores and pioneers who pushed westward against an unforgiving wilderness: Yes, we can.*
>
> *It was the call of workers who organized, women who reached for the ballot, a president who chose the moon as our new frontier, and a King who took us to the mountaintop and pointed the way to the promised land: Yes, we can . . .*

"It is the simplest phrase you can imagine," Favreau said, "three monosyllabic words that people say to each other every day." But the speech etched itself in rhetorical lore. It inspired music videos and memes and the full range of reactions that any blockbuster receives online today, from praise to out-of-context humor to arch mockery.

8. Obama thought the phrase "too corny" when his adviser David Axelrod proposed it during his first U.S. Senate run, Axelrod told the *New York Times*. They both deferred to Michelle, who determined it was "not corny."

Obama's "Yes, we can" refrain is an example of a rhetorical device known as epistrophe, or the repetition of words at the end of a sentence. It's one of many famous rhetorical types, most with Greek names, based on some form of repetition.

There is anaphora, which is repetition at the beginning of a sentence (Winston Churchill: "We shall fight on the beaches, we shall fight on the landing grounds, we shall fight in the fields"). There is tricolon, which is repetition in short triplicate (Abraham Lincoln: "Government of the people, by the people, and for the people"). There is epizeuxis, which is the same word repeated over and over (Nancy Pelosi: "Just remember these four words for what this legislation means: jobs, jobs, jobs, and jobs"). There is diacope, which is the repetition of a word or phrase with a brief interruption (Franklin D. Roosevelt: "The only thing we have to fear is fear itself") or, most simply, an A-B-A structure (Sarah Palin: "Drill baby drill!"). There is antithesis, which is repetition of clause structures to juxtapose contrasting ideas (Charles Dickens: "It was the best of times, it was the worst of times"). There is parallelism, which is repetition of sentence structure (the paragraph you just read).

Finally, there is the king of all modern speech-making tricks, antimetabole, which is rhetorical inversion: "It's not the size of the dog in the fight; it's the size of the fight in the dog."

There are several reasons why antimetabole is so popular. First, it's just complex enough to disguise the fact that it's formulaic. Second, it's useful for highlighting an argument by drawing a clear contrast. Third, it's quite poppy, in the Swedish songwriting sense, building a hook around two elements—A and B—and inverting them to give listeners immediate gratification and meaning. The classic structure of antimetabole is *AB;BA*, which is easy to remember since it spells out the name of a certain Swedish band.[9] Famous ABBA examples in politics include:

9. I highly doubt they intended their name to have anything to do with Greek rhetorical devices, but "antimetabole is ABBA" is a convenient heuristic.

- "Man is not the creature of circumstances. Circumstances are the creatures of men." —*Benjamin Disraeli*
- "East and West do not mistrust each other because we are armed; we are armed because we mistrust each other."

 —*Ronald Reagan*
- "The world faces a very different Russia than it did in 1991. Like all countries, Russia also faces a very different world."

 —*Bill Clinton*
- "Whether we bring our enemies to justice or bring justice to our enemies, justice will be done." —*George W. Bush*
- "Human rights are women's rights and women's rights are human rights." —*Hillary Clinton*

In particular, President John F. Kennedy made ABBA famous (and ABBA made John F. Kennedy famous). "Mankind must put an end to war, or war will put an end to mankind," he said, and "Each increase of tension has produced an increase of arms; each increase of arms has produced an increase of tension," and most famously, "Ask not what your country can do for you; ask what you can do for your country."

Antimetabole is like the *C–G–Am–F* chord progression in Western pop music: When you learn it somewhere, you hear it everywhere.[10] Difficult and even controversial ideas are transformed, through ABBA, into something like musical hooks.

Obama and Favreau did not lean quite so heavily on any one device, but they made a powerful combo in part because they thought about speeches the way Savan Kotecha and other songwriters think about songs—as requiring hooks, choruses, and clear structures.

10. "When you learn it somewhere, you hear it everywhere" is an example of another Greek rhetorical structure, *chiasmus*, which is like antimetabole but plays by looser rules. It's still structurally symmetrical, but you don't have to invert the exact same words. Kennedy's inaugural address begins with an orgy of chiasmus: "We observe today not a victory of party but a celebration of freedom—symbolizing an end as well as a beginning—signifying renewal as well as change." If you removed all the chiasmus and antimetabole from Kennedy's most famous speech, you'd be left with a list of conjunctions.

They often drew on the speeches of Martin Luther King for inspiration, which were biblical, rhythmic, and propelled by a musicality that was explicit in the black preaching tradition. In *The Hum: Call and Response in African American Preaching*, the theologian Evans Crawford compared sermons to blues riffs, "characterized by improvised free rhythms and idiomatic counterpoint." The perfect sermon would "start low, go slow, climb higher, and strike fire."

Favreau, a self-taught pianist who studied classical music in college, delights in the comparison of his work to pop song writing. "A good line in a speech is like a good piece of music," he said. "If you take a small thing and repeat it throughout the speech, like a chorus in a song, it becomes memorable. People don't remember songs for the verses. They remember songs for the chorus. If you want to make something memorable, you have to repeat it."

When they worked together on the most important addresses, Obama and Favreau would ask: "What's the 'spine' of this speech?" The spine was the hook, the theme, or the rhetorical chorus that held a speech together.

In 2008, four years after their first meeting, the former Illinois state senator and former Kerry deputy speechwriter were back at the Democratic National Convention, this time as the historic nominee and his celebrated head speechwriter. Days before the address, the future president told Favreau that his speech wasn't quite right. It needed a spine.

"He said, 'Let's think of something that can carry through the speech,'" Favreau recalled. "We ended up using the concept of the 'American Promise' as the thread. It held the speech together." In the official transcript of the speech, Obama repeats the word "promise" thirty-two times.

U.S. political rhetoric might be getting more musical over time. In the 1850s, most presidential addresses were delivered with college-level rhetoric when judged by the Flesch-Kincaid readability test, a method developed for the U.S. Navy in the 1970s to ensure the simplicity of

military instruction manuals. But since the 1940s, presidential addresses have been more like a sixth-grader's level.

It's tempting to see this trend as the dumbing down of the American audience. But the United States is considerably better educated than it was in the 1800s. The increased simplicity of political rhetoric is really a sign that political speeches aim to reach a broader audience and so are emulating other populist forms of mass entertainment, like music. In the early republic, when only white men could vote, "presidents could assume that they were speaking to audiences made up mostly of men like themselves: educated, civic-minded landowners," said Jeff Shesol, a historian and former speechwriter for Bill Clinton.

But as voting rights expanded, presidential appeals broadened. The major shift toward simpler presidential speeches happened around 1920, which coincides with at least four positive developments: the Seventeenth Amendment allowing direct election of senators in 1913; the Nineteenth Amendment giving women the right to vote in 1920; the movement to make public education mandatory in the 1920s; and the spread of radio, which passed 50 percent penetration among U.S. households by the 1930s. (Television would get there twenty years later.) Simple political rhetoric didn't undermine American democracy. The growth of American democracy made political rhetoric simple.

M usical language is mercenary. It cares about winning an attention war, and truth can be left bleeding on the field. People trust beautiful words, even when they're wrong.

A cousin of the "speech-to-song" illusion is the "rhyme-as-reason" effect. Just as repetition of words can create the illusion of singing, musical language can create the illusion of rationality. Studies show that people consider rhyming quips—like "What sobriety conceals, alcohol reveals" or "Woes unite foes"—more accurate than their nonrhyming

versions—like "What sobriety conceals, beer unmasks." Repetition and rhythm are like flavor enhancers for language: They can make bad ideas seem extraordinarily clever, because listeners don't think too hard when they hear pretty words. They often just assume the words are true.

One good indication that musical language is a poor, even negative indicator of truth is that we often use it to say things that aren't literally true. There are several famous aphorisms, like "An apple a day keeps the doctor away," that are wrong but broadly accepted because they seem nice to say, while other sayings, like Johnnie Cochran's infamous defense of O. J. Simpson, "If it doesn't fit, you must acquit," are memorable yet misleading. But it is precisely because of their musicality that we accept these statements, broadly constructed, as truths. People process the rhyme, and then they seek the reason.

For better or worse, this very book belongs loosely to a genre of nonfiction that a critic might call a "gospel of success." Most of these books resell common sense. The author takes a piece of conventional wisdom that the reader has already intuited and repackages it inside fresh stories. It's a bit like "intuition regifting": *You already know this lesson, but here it is in new wrapping paper.* In Dale Carnegie's 1936 bestseller *How to Win Friends and Influence People*, many of the most shared lines are musical, particularly playing with antithesis and chiasmus. (I've bolded the repetition and italicized the alterations, to accentuate the repetitious effect.)

- "Don't be **afraid** of *enemies who attack* you. Be **afraid** of the *friends who flatter* you."
- "Happiness doesn't **depend** on *outward* **conditions**. It **depends** on *inner* **conditions**."
- On winning arguments: "If you **lose** it, **you lose it**; and if you *win* it, **you lose it**."
- "To *be interesting, be interested*."

It would seem that the key to catchy writing is simple. Just write in pairs. Or, to honor Carnegie's legacy: "To be remembered, be repetitive." Or if that's not sticky enough, invoke the rhyme-as-reason effect: "To write a line that people use, make your idea break in twos."

There is good and bad in this. By turning arguments into spoken music—and making poetry out of policy—antimetabole and its cousins can make important and complicated ideas go down easily. But they can also wave a magic wand over frivolous and dubious ideas, turning something questionable into something catchy.

How exactly does repetition make music out of sound? I had a theory, and I called Diana Deutsch. Perhaps, I proposed, music is an illusion conjured out of the cacophony of sound by repetition. Just as the rhyme-as-reason effect can create meaning out of meaningless tripe, perhaps repetition makes listeners hear something that isn't there.

To my surprise, Deutsch insisted that the opposite is true. In her studies of that now famous phase "sometimes behave so strangely," the people who listened to the most repetitions were also the best at imitating its real sound. They weren't singing a song that appeared out of thin air. Instead, repetition helped them hear the rhythm and tone of the spoken sentence more clearly. Deutsch was not trying to sing, and yet her voice produced this musical verse.

As Deutsch spoke to me, I listened for the furtive music in her sentences. But I couldn't hear it. Ordinary listeners struggle to pay explicit

attention to the tones and rhythms of their interlocutors. They devote more of their focus to the rest of the "speech stream"—the meaning of the sentences and the intent of the speaker.

Repetition redirects attention to the sound of speech itself—the pitch of the voice, the rhythm of the stops, the secret melodies of conversation. The speech-to-song effect is considered an illusion, but if there is a hidden melody embedded in all language, then it's cacophony that is the illusion. The strange truth is that all speech is composed of microscopic melodies and undiscovered songs. It just takes a little repeating to hear the music.

INTERLUDE

The Chills

R unning up and down your arms, just beneath the surface of your skin, amid the veins, glands, arteries, vessels, and nerves, there is a smooth thin muscle gripping the bottom of each hair. It is called the arrector pili muscle, and it is activated by the sympathetic nervous system. This means you cannot control it, or flex it impressively on cue, like a bicep.

Instead, something outside of the body must summon the arrector pili to attention. For example, if a furry animal feels the chill of cold air, the muscles pull back and make thousands of hairs come up all at once in a follicular standing ovation. These upright hairs trap warm air near the surface of the skin to build a thin atmosphere around the body. A strong emotion, like terror, can trigger the same warming reflex.

Hominids were hairier once. Now most of our furriness is gone. But the muscles remain, and so do their reflexes. When we feel cold, feverish, or deeply emotional, our hairs pucker up and create a raw and lumpy texture along the skin, like a freshly plucked bird. People around the world have named the effect after various fowl. In Chinese, they call

it "lumps on chicken skin." In Hebrew, they say "duck skin." In English, they're called "goose bumps."

A few years ago, at a college reunion, I was walking through the south stretch of campus on a golden fall day in Evanston, Illinois, and I suddenly felt an urge to listen to songs by Jeff Buckley. I hadn't heard Buckley in many years, perhaps since graduation. Most famous for his lovely and widely mimicked cover of "Hallelujah," he recorded only one major album before he died in a drowning accident. I had this album on loop the entire summer of 2004, into my September preorientation, and through my first month of college.

Replaying his music nine years later, it was like opening a time capsule and watching its treasures react to fresh oxygen. Inside the songs, there lived the memories of my first college crush, the anxiety of my first journalism class, and my first four a.m. political debate in the study area with blue felt couches, the aroma of chemically buttered microwave popcorn, and the alarmingly sticky floors. But the song also held the conclusions to these anxieties—the knowledge of a failed romance, a magazine job I loved, and the fact that my four a.m. friend was about to get married.

Walking around the campus and hearing the music playing within the memories, or the memories playing within the music, the song triggered an ancient hominid response. I got the chills. A feeling slipped beneath the skin and yanked a thousand little muscles, and there I was, walking around my old stomping grounds, covered in goose bumps.

"Art is not, as the metaphysicians say, the manifestation of some mysterious Idea of beauty or God," Leo Tolstoy wrote in a small (for Tolstoy) 1897 book, *What Is Art?* He continued:

> *It is not, as the aesthetical physiologists say, a game in which man lets off his excess of stored-up energy; it is not the expression of man's emotions by external signs; it is not the production*

of pleasing objects; and, above all, it is not pleasure; it is a means of union among men, joining them together in the same feelings, and indispensable for the life and progress towards well-being of individuals and of humanity.

To Tolstoy, art is feelings; the transmission of feelings; a communications protocol written in the language of feelings. Everybody knows that letters are just shapes, that serifs are pointless, and that the spaces between words are mere emptiness. But books still produce tears and adrenaline. When people read, they hear voices and see images in their head. This production is total synesthesia and something close to madness. A great book is a hallucinated IMAX film for one. The author had a feeling, which he turned into words, and the reader gets a feeling from those words—maybe it's the same feeling; maybe it's not. As Peter Mendelsund wrote in *What We See When We Read*, a book is a coproduction. A reader both performs the book and attends the performance. She is conductor, orchestra, and audience. A book, whether nonfiction or fiction, is an "invitation to daydream."[1]

When I started daydreaming about this book, I spent a lot of time talking to psychologists about fluency—ease of thinking. But as I reflected on my own favorite books and songs and movies, I came to see that what I like most aren't the easy things, but rather the reward that something difficult has become comprehensible.

These aha moments are not just the sensation of easy thinking. They are the ecstasy that comes from the work of figuring something out. I have loved Shakespeare's plays since I was too young to understand the words. *Hamlet* is one of the few books I have on my desk—an excruciating cliché for any visitor, but there it is. My devotion to Shakespeare is such that I would never include an observation about hits that

1. Some people cannot see images in their heads when they read or listen to words because they struggle to conjure mental pictures at all. This is aphantasia, the inability to imagine in pictures, and, either fittingly or ironically, I myself cannot imagine having it.

did not first apply to him: His source material is familiar, but his style was an innovation, a mixture of aphoristic poetry and low humor that is, as Ben Jonson wrote, "not of an age, but for all time!" Shakespeare had few original plots. He was, like George Lucas in the next chapter, a master assembler of old allusions. Even Hamlet is both singular and derivative; he's based on a thirteenth-century Norse myth, Amleth. The play is confounding, and maddeningly ambiguous, but the few answers that it yields are, for me, the finest kind. They offer a heightened version of the language that I use to think about the world. My thoughts move through the play the way sound moves through a bullhorn, starting life-size and finishing with new volume. "I could be bounded in a nutshell and count myself a king of infinite space," Hamlet says. I have sometimes felt this way about the play: It would be all right if literature were confined exclusively to *Hamlet*. It is infinite enough.

All of my favorite books perform this trick. Initially, they seem to immerse me in another life, but ultimately they immerse me in me; I am looking through the window into another person's home, but it is my face that I see in the reflection. I imagine, but can never be sure, that everybody feels the same way about books. Tolstoy did. Art is the universal window, he said, a collective view into "the oneness of life's joys and sorrows."

On the other end of the spectrum from *Hamlet*, there is *Dumb and Dumber*, a comedy whose title leaves no doubt about its intellectual depth. I've seen *Dumb and Dumber* maybe a hundred times, but it is never redundant. On repeat viewings, I find myself focusing on smaller and smaller details, a snow hat, a pointed pause, or one of Jim Carrey's rubber-elastic expressions. Going back to the same books and movies for seconds, thirds, or thirtieths is a common practice. I have friends who cannot count the number of times they've reread *Harry Potter* or seen *The Shawshank Redemption*.

"Why do people do the same thing over and over?" is a common scientific inquiry. Anthropologists study rituals and psychologists

study patterns of behavior. But in entertainment and media, where there is so much pressure to be aware of the next new thing, there is something special about the past that is more than mere habit. People enjoy repeating cultural experiences, not only because they want to remember the art, but also because they want to remember themselves, and there is joy in the act of remembering. "The dynamic linkages between one's past, present, and future experiences through the reconsumption of an object allow existential understanding," Cristel Antonia Russell and Sidney J. Levy wrote in their study of nostalgia and culture. "Reengaging with the same object, even just once, allows a reworking of experiences as consumers consider their own particular enjoyments and understandings of choices they have made."

It would be absurd to draft Kant, Loewy, or metacognition to serve in the argument that *Dumb and Dumber* is a Good Film. It may not be good, and frankly, it's no longer just a film for me. I've quoted it so many times with my friends that the movie's movieness is secondary. Above all, it has become a language of remembrance, a glossary of old friendships.

This keeps happening to me. I synesthesize my favorite shows and songs, mix them up with moments, give them dimensions they don't have. My favorite books are also daydreams. My favorite songs are also places. My favorite movies are also friends.

When Bertha Faber sang Johannes Brahms's lullaby to her son in the winters of nineteenth-century Austria, she occupied two worlds— she put her husband's child to sleep with the music of a past romance. Psychologists have found a linkage between thinking about the past and feeling good—even feeling warm. People who hear songs and lyrics from their younger days are more likely to say they feel loved, or to say "life is worth living." Nostalgia and goose bumps have that in common: Triggered by coldness, they're there to warm us up.

Some books, songs, shows, and art have a certain force. They infect

and deepen. They give people the chills. A full explication of this phenomenon is beyond my grasp. But that's okay. It is not essential to understand each goose bump. It is a secret, after all, a neural whisper shared between the sympathetic nervous system and invisible muscles; a feeling that slips beneath the skin and, without permission, pulls on you, from the inside.

THE MYTH-MAKING MIND I: THE FORCE OF STORY

The Sum of a Thousand Myths

George Lucas wrote on a desk made of three doors. It is rare for doors to unite in the form of a desk, but evidently this assembly served him well. On this table's surface, Lucas wrote much of the first six *Star Wars* movies, whose financial empire—including global box office, television reruns, video games, toys, books, and other products—has amassed more than $40 billion in the last four decades.

To complete a script, Lucas would sit at his desk-of-doors for eight hours a day, even if the session produced nothing useful. His goal was five pages before nightfall. Often the first page came with excruciating slowness and the last four flew by in a panicked rush; it was important for him to finish in time to catch the *CBS Evening News* with Walter Cronkite. "I did terrible in script writing," Lucas said in 1981, of his college work. "I hated stories, and I hated plot, and I wanted to make visual films."

He set out to conquer these fears through fastidious ritual. Drafts of his first three movies—*THX 1138*, *American Graffiti*, and the first *Star Wars* films—were written by hand with number 2 pencils on blue-and-green-lined paper. To exercise his frustrations, which were constant, he would snip locks of his hair with a pair of scissors. His secretary once reported seeing "tons of hair" in the trash, as if Chewbacca were molting into his creator's waste bin. Overliteral emulators could be forgiven for thinking the secret to inventing the most iconic franchise of the twentieth century is obsessive-compulsive barbering.

Lucas grew up in Modesto, California, at a turning point between two forms of visual entertainment: the movie serial and the television show. The year he was born, 1944, the television, as a piece of hardware, had not taken off. Meanwhile, something quite like a modern television show—an episodic, twenty-minute feature, pitting familiar characters against new challenges—was popular among young adults and children. It was the motion picture "serial."[1]

In the days of weekend matinees, ten cents got an afternoon's admission to several cartoons, a short, a feature film, and a serial. The serials ended in suspense, with the hero grasping for survival, often at the edge of a dangerous precipice. These routinely anxious conclusions inspired a new word for audiences in the 1930s: "cliffhanger."[2]

The paragon of this new genre was Flash Gordon. Adapted from Alex Raymond's popular comic strip, Flash was a blond hero swashbuckling in space. The serial was so successful that it kicked off the first superhero craze in motion picture history (the second being the entire twenty-first century). In response, studios chased down

1. So serials emerged from radio, moved into local theaters, settled on the smaller screen, and crawled back into radio in the form of the podcast, including one literally called *Serial*. Culture is nothing if not self-referencing or self-repeating.

2. In fact, serials had several etymological gifts. At the end of the 1912 serial *The Adventures of Kathlyn*, the heroine ends up in a lion pit and this text appears on the screen: "Does she escape the lion's pit? See next week's thrilling chapter!" This was perhaps the first preview in movie history, and it inspired copycats eager to lasso audiences back into the theater each weekend. But coming at the end of the film, these previews were called "trailers." Today, however, trailers come before the movie and the word has lost all literal meaning.

The Adventures of Captain Marvel, Batman, Superman, Dick Tracy, The Shadow, The Green Hornet, and *The Lone Ranger* for weekly episodes.

In the 1950s, *Flash* appeared on television each evening at six fifteen p.m. in Modesto, and his influence on Lucas is unmistakable. Like *Star Wars*, the serial *Flash Gordon Conquers the Universe* includes exposition that rolls up into the top of the frame and ends in ellipses; there are screen wipes between scenes; and the story concerns a male hero leading a great rebellion against an evil emperor fought with "laser swords, ray guns, capes and medieval garb, sorcerers, rocket ships and space battles," wrote Michael Kaminski, the author of *The Secret History of* Star Wars.

If *Flash Gordon* sounds a bit like the movie Lucas made, that's because it is the movie Lucas wanted to make.

In 1971, he sought to buy the film rights to the Flash Gordon franchise from King Features Syndicate. They rebuffed him for a more established director, the Italian Federico Fellini (who would never make the movie). After the failed meeting, a deflated Lucas met with his friend Francis Ford Coppola at the Palm Restaurant in Manhattan. He decided over dinner that if he couldn't own his favorite space fantasy, he'd invent one instead. And so *Flash Gordon* was doubly responsible for *Star Wars*: Not only did it inspire Lucas to direct a space fantasy, but its unavailability also forced Lucas to write his own.

This kicked off a period of considerable hair-chopping anguish. Lucas plunged back into his childhood habits. He inundated himself in science fiction books, war films, westerns, and fairy-tale mythology to fill out the story. In the comic series *The New Gods*, he discovered a hero who channels a power called "the Source" and a villain (who turns out to be the hero's father) dressed in black armor and named Darkseid. He read Joseph Campbell, the famous twentieth-century mythologist, who argued that the world's most famous stories share the same basic

narrative arc—a "monomyth" containing Moses, Jesus, Buddha, and Beowulf (not to mention just about every comic book hero ever).[3]

Westerns, war films, and international politics poured into the *Star Wars* stew. In one of his first interviews, Lucas described his film as "a western movie set in outer space," citing the influence of John Wayne. World War II dramas like *The Dam Busters* (1955) and *633 Squadron* (1964) included aerial dogfights that inspired, almost beat for beat, the final sequence of the climactic battle in the first *Star Wars* movie, where a single heroic shot destroys the enemy's entire headquarters. As Michael Kaminski writes in his extraordinary history of the films, scenes from these war movies "were used by Lucas as shot placeholders for the incomplete special effects when editing the rough cut." The Vietnam War provoked Lucas to see his movie as a technological empire pitted against a small group of freedom fighters. Lucas, who was initially slated to direct Coppola's harrowing classic *Apocalypse Now*—one of movie history's greatest what-if moments—converted his planned empire-versus-rebel epic into a space fantasy.

Lucas and those who have most closely studied his work have variously described *Star Wars* as a space western, a space opera, a mixture of *Lawrence of Arabia* and James Bond, an Errol Flynn movie set in the ether, an adaptation of the Japanese film *The Hidden Fortress*, a jambalaya of science fiction and comic references, a mystical examination of Eastern religion, a dramatic expression of a millennia-old myth formula, and, most consistently, an homage to *Flash Gordon*, that 1950s TV serial that enraptured a young George from his living room in Modesto. The final product was an original compilation. "It's all the things that are great put together," Lucas once said. "It's not like one kind of ice cream, but rather a very big sundae."

And the world licked the bowl clean. The reception to *Star Wars* was

3. As we'll see in the next chapter, the proverbial "he" is historically fitting for Campbell's monomyth, but also deeply unfortunate.

without modern precedent. *Jaws* (released two years before, in 1975) might be considered the first modern blockbuster, but *Star Wars* shattered its domestic and global box office records. Radio call-ins reported spending entire days at the movie theater to see it again and again, like children with their two-cent candy bags at a 1930s Saturday matinee. Within a month of the movie's release, the stock price for its distributor, 20th Century Fox, nearly doubled. In inflation-adjusted dollars, the movie has grossed more than $2.5 billion through its rereleases—half a billion dollars more than any franchise film in history.

Lucas's comic-space-western-fantasy cocktail was inescapably unique. Nobody had ever done anything like it. But it was also fathoms deep with allusions to the most common storytelling themes of the early twentieth century and the many millennia before. Was *Star Wars* the hit of the century because it was like nothing that had come before it? Or was it popular because, at its heart, it is the sum of a thousand stories?

Vincent Bruzzese is a scientist of storytelling. As a veteran Hollywood script analyst, his job is to review screenplays and determine whether they contain the elements of a hit. When he was a young kid on Long Island, he was obsessed with science fiction. He especially loved the Foundation trilogy by Isaac Asimov, who imagined a new discipline called "psychohistory," which would allow the greatest mathematicians to predict with astonishing clarity the rise and fall of civilizations many millennia into the future.

Bruzzese was born on the opposite end of the country from George Lucas, and it might as well have been a different star system. When he was five years old, he lived out of a car. His family was so broke that his regular birthday present was a movie ticket. "For two hours every year, I wasn't broke or homeless," he told me in his Los Angeles office. He wore a Sex Pistols T-shirt and a black blazer. Between sentences, he

buried a hand in an enormous Tupperware of candy worms on his desk. "I was in a movie theater, transported to somewhere else."

Several decades and professional degrees later, Bruzzese worked his way up to become a professor of sociology and statistics at Stony Brook University in New York. His background was in mathematics, but his interests leaned toward Hollywood. His dream was to build the ultimate prediction machine to improve the way movie studios forecast hits and flops.

Typically, there are two classic ways to measure audiences. First, there are screenings. People see a movie, or scenes from a movie, and say what they think about the characters, relationships, and plot. This advice goes back to the film's custodians to improve the film (if they wish to take it). Second, there is tracking. A research firm will contact thousands of people and read a list of movies. People respond if they've heard of the movies, want to see them, or even consider them "must-see." This method is used to predict box office revenue (or, increasingly, fail to predict it).

Bruzzese felt he could improve the process with better information and more sophisticated math. He moved to Hollywood and oversaw more than a decade of audience research with several companies using his own algorithms to improve box office predictions. He also made friends with producers who sent him scripts to get his advice. One afternoon in 2010, reading a friend's draft, he realized that perhaps Hollywood had hit prediction backward. Audience research was typically used to evaluate filmed scenes. But wouldn't it be even more valuable, he thought, if you could build a prediction engine to evaluate the scripts—the raw *stories* themselves—before studios spent tens of millions of dollars filming them?

Bruzzese built a team to pore through millions of audience data points from hundreds of movies that he'd tested over more than a decade of research. He was looking for patterns. What were audiences really saying about the types of stories and characters that they liked

and didn't like? And could Bruzzese take their suggestions to build a prediction engine that could detect hit movies just by looking at their stories?

Several links connect Bruzzese and George Lucas. The first is science fiction. A leather-bound copy of Asimov's Foundation trilogy rested on the black bureau behind Bruzzese in his office. His favorite character is Hari Seldon, the "psychohistorian" who can predict the future of the galaxy. Seldon cannot foresee what individuals will do, but he can explain the aggregate behavior of civilizations across the galaxy hundreds of years into the future. Asimov came up with the idea for psychohistory in a chemistry class. "The individual molecules of a gas move quite erratically and randomly, [and] nobody can predict the direction of motion of a single molecule at any particular time," Asimov said. But "you can predict the total behavior of the gas very accurately, using the gas laws." For example, when volume decreases, pressure rises. That is not a fifty-fifty bet on the future of molecules; it is a scientific fact. Asimov daydreamed about the ability of a mathematician to observe entire civilizations, as if in a beaker, governed by undiscovered laws of social nature. A scientist might not be able to predict the future of every little life, but he might foresee the fall of empires as confidently as a chemistry student can predict a chemical reaction.

"I became obsessed from childhood with the idea of being able to predict human behavior," Bruzzese said. His first love, like Asimov's, was physics, which offers a cosmic version of prophecy. "But I gradually became more interested in the physics of society, like Seldon," he said. Perfectly predicting audience behavior might still be the realm of science fiction, but "if you can anticipate how people behave at an early enough stage, you can change their behavior." On the wall, there hung a 2013 *New York Times* story that anointed Bruzzese a pioneer of statistical script analysis and "the reigning mad scientist of Hollywood."

The second link is Joseph Campbell, whose 1949 book *The Hero with a Thousand Faces* is perhaps the closest any theorist has come to

a universal formula for storytelling. Campbell reached back thousands of years to show that, since before human beings could write, we have been telling the same heroic story over and over, changing mostly the names and settings. In this universal myth, the seemingly ordinary man goes on a journey, crossing over from the known world to the unknown. With help, he survives several key trials, only to face down an ultimate challenge. With this final victory, he returns to the known world as the hero, the prophet, the One, the Son. It is the story of Harry Potter and Luke Skywalker, Moses and Muhammad, Neo in *The Matrix* and Frodo in *The Lord of the Rings*, and, of course, Jesus Christ.[4]

The specific beats of Campbell's arc aren't as important as its three primary ingredients: inspiration, relatability, and suspense. First, a hero must inspire, which means the story must begin with a flawed character whose journey leads to both victory (Frodo Baggins and Samwise Gamgee succeed in seeing the One Ring destroyed . . .) and salvation (. . . Frodo finds his courage, and Sam's loyalty repeatedly saves their lives). Second, it must be relatable, since audiences want to imagine themselves as heroes. That means the heroes cannot be invincible or obnoxiously eager to achieve invincibility. They have to struggle with their destiny (one does not simply walk into Mordor, after all) before accepting its charge. Third, Campbell's formula comes with prepackaged suspense. The road to glory is pockmarked with small defeats that keep audiences anxious and alert.

Ultimately, what the hero's journey provides is the threat of chaotic suspense grounded in empathy. A familiar character who faces no obstacles is boring, and an incomprehensible character is confusing no matter what the challenges are. But a character plucked from the natural world to go on a supernatural adventure that leads through struggles

4. The principal objection to Campbell's monomyth is that it's too broad, like saying the key to every great love story is an attraction shared between protagonists. I think the dismissal of Campbell is overly skeptical, and his work offers (if not answers) a good question: Why do we tell the stories we tell the way we tell them? But I'm not a mythologist, and it's important to acknowledge that the theory of a universal story is not universally renowned.

to transcendence opens a door just big enough for the audience to step inside and feel the hero's glory as their own.

The Hero with a Thousand Faces has been adapted so many times that Campbell himself has become something like a monomyth.[5] His ideas formed the basis of the 1988 PBS show *The Power of Myth*, which became one of the most watched public television series ever. His formula has received the Hollywood treatment several times over, notably in a 1985 memo from the Disney story consultant Christopher Vogler, which became the screenwriting textbook *The Writer's Journey*. Its most recent reincarnation is *Save the Cat*, the modern bible of screenwriting, which seemingly every person with a screenplay on a laptop has read, claimed to have read, or pointedly (and often fictitiously) claimed *not* to have read so as to seem rebellious.

"*Snow White and the Seven Dwarfs, Sunset Boulevard, The King's Speech, Guardians of the Galaxy*, and *Saw* all hit the beats in *Save the Cat*," said B. J. Markel, the book's editor and an adviser at the screenwriting workshop it inspired. "It's not that Walt Disney and his writing staff were sitting there thinking, 'All right, typically in a movie like this, the bad guys come in now.' The point is that good storytellers intuitively understand that audiences relate to classically structured stories."

The hero's journey is not a white straitjacket, uniform and constricting. It's more like a men's suit: Even if the cut is relatively standard, it leaves wide latitude for customization, rarely looks messy, and looks smart done right. The most formulaic and ultimately predictable plots tend to be animated films, which are often critically acclaimed blockbusters. In *Zootopia*, Disney's 2016 animated hit, a little bumpkin bunny becomes a metropolitan police officer in a city where animals live like modern humans. After several stumbles, the eager whipper-

5. So it is reasonable to wonder if Campbell's influence has become a self-fulfilling prophecy, as audiences have been taught to expect hero's journey stories from storytellers who have convinced themselves that there is one meta-hero-journey story.

snapper proves her worth, suffers a crisis of confidence that sends her back to her family, and returns to the city to identify and vanquish the ultimate criminal. It is an ingeniously clever string of gags about motley animal species doing human jobs—elephants scooping ice cream with their trunks; sloths running the DMV—layered on top of surprisingly profound lessons about how marginalized groups are trapped by cultural expectations of their behavior. But the fundamental scaffolding of the story is a straightforward hero's journey.

Joseph Campbell was not, strictly speaking, a scientist. He was a mythologist, proposing a recipe for fables and deriving its ingredients. His philosophy of stories is basically deductive—top-down.

But Vincent Bruzzese is a scientist, and his theory of stories is inductive—bottom-up. Bruzzese studied millions of survey answers from thousands of people watching thousands of movies. It turned out that Campbell was right. There are rules to successful storytelling in popular films. The typical audience member couldn't tell you explicitly what those rules are, but collectively audiences have been telling moviemakers for decades.

Bruzzese's grand theory will look familiar to readers of the first three chapters of this book: Most people love original storytelling, provided that the narrative arc traces the stories we know and the stories that we want to tell ourselves.

If Bruzzese is a cultural scientist, he is a cinematic taxonomist. Within Campbell's epic monomyth, he's discovered hundreds of what you might call mini-myths—species within each genre class. For example, within hero movies, some heroes are born with powers (Superman) and other heroes acquire powers (Spider-Man); some heroes are tragic (Batman) and others are boastful (Iron Man). Each of these subgenres has unique specific narrative patterns, Bruzzese says, and audiences have been subtly revealing them across decades of testing.

Bruzzese's first significant breakthrough was in the suspense genre. Bruzzese saw that audiences respond to scary movies with a predictability that would please Hari Seldon. "Horror might be the easiest genre to break down," he told me. "Horror movies are either a haunting or a killer. A haunting movie has either a ghost or demon. The demon is either randomly targeting the lead actors or summoned by the leads."

These subtle distinctions can have a big effect on audience reactions. "One of the main factors with a horror film is that the audience wants to put themselves in the situation, to internalize the characters' fears," he said. "But if the lead actors summon a demon, many audiences say they weren't so scared, because they personally would never summon a demon." These distinctions also have predictable box office implications. Random ambient terror befits a horror film. But when the killer has a known motive, it tends to be seen as a thriller, which is less of a lure for teenagers.

Relatability is key to horror, but it's not the only element. Another is power. "In a movie where a demon is targeting people, like Jason in *Friday the 13th* or Freddy Krueger in *A Nightmare on Elm Street*, the story is built around a simple question: Can anybody stop him?" Bruzzese said. "That's why the trailers for these films often include a triumphant shot of the killer. Whether people realize it or not, the killer is the hero."

Another genre that yields to simple classification is the apocalypse. There are two species of apocalypse movies, Bruzzese says: Stop the Apocalypse and Survive the Apocalypse. In Stop the Apocalypse movies, like *Armageddon* and *Deep Impact*, a ragtag team of experts takes on the threat and a sacrificial suicide saves the world.

Even casual moviegoers acknowledge that *Armageddon* and *Deep Impact* are eerily the same movie. Survive the Apocalypse movies are more diverse, but they're also of a piece. In *2012*, *The Day After Tomorrow*, and *San Andreas*, disaster strikes in the form of Mayan portent, global warming, and a massive earthquake, respectively. But

despite the varieties of calamity, the central drama in these films is the same. A father is fighting to reunite with his family; meanwhile, the selfish perish, the generous survive, and the dad makes up for his past mistakes with acts of heroism. Deep down, these apocalypse movies are all traditional family dramas about the challenges of fatherhood.

Some critics say Bruzzese's own version of psychohistory encourages moviemakers to mimic what's come before them, which seems like a fair point. Indeed, the first time I spoke to Bruzzese, I came away feeling like my favorite films weren't pieces of art so much as feats of scalable engineering, like similar homes in a neighborhood cul de sac based on the same architect's blueprint.

But Bruzzese insists that he isn't drawing blueprints at all, nor is he arbitrarily painting a bright line between good and bad storytelling. Instead, he's showing moviemakers the subtle lines audiences have been drawing on their own. If writers and producers understand the boundaries of audience expectations, he says, it will make Hollywood storytelling more satisfying. Viewers are not just nostalgic, yearning for old feelings and familiarities to resurface. One might say they are also *prostalgic*, obsessed with predicting the future of everything and satisfied when their expectations are met in the right way.

"People have certain expectations about cake," Bruzzese told me, in one of several metaphors he employs to explain his work. "There are all different types of cake that a good baker can make, but there are also rules. For example, nobody wants a ton of salt in a cake. This is a good rule. But you can find a purposeful exception. It's called salted-caramel cake. A great baker can find the exceptions *because* he understands the rules."

The rules extend even to characters. Even though most audiences might not initially see the similarities, there is substantial overlap between the trio of Captain Kirk, Spock, and Leonard "Bones" McCoy in *Star Trek*; the trio of Harry Potter, Hermione Granger, and Ron Weasley in *Harry Potter*; and the *Star Wars* group of Luke, Yoda, Han Solo,

and Leia. On the surface, these characters aren't alike and certainly don't live in the same fictional world. But in all cases, the hero is the synthesis of his friends. The thinking Spock and the feeling McCoy are two halves of Captain Kirk. The brilliant Hermione and the sensitive Ron balance out Harry Potter. Luke Skywalker combines Han's bravery and Leia's conscience. In all stories, the hero is the average of his friends, and the hero's journey is a challenge to unite these ingredients in victory—Might and Right.

I left Bruzzese's office to have lunch with a Hollywood producer. I told him about Bruzzese's theory, the surprising inflexibility of audience expectations, and the unconscious biases that shape storytelling. He smiled. "You want to know what I think is the secret of it all?" he said. Naturally, I said yes.

"You take twenty-five things that are in any successful genre, and you reverse *one* of them," he said. "Reverse too many, and you get genre confusion. It's a muddle, and nobody knows how to place it. Invert all the elements, and it's a parody." But one strategic tweak? Now you've made something that is perfectly new, like a classic western adventure story, but set in space.

Every few years, a theory emerges from some frothy part of the Internet that *Star Wars* was meticulously and comprehensively planned from the start, as if handed down to Lucas on the Mount (or handed down by Lucas Himself). But Lucas was a student of the Johannes Brahms school of hits. Neither progenitor nor thief, he was above all an assembler, a master blender.

In addition to Flash Gordon, one of the most famous early inspirations for *Star Wars* was *The Hidden Fortress*, the 1958 Japanese adventure film directed by Akira Kurosawa in which peasants escort a princess and a general through violence to safety. But neither of Lucas's

chief inspirations was perfectly original; *Star Wars'* ancestors were also descendants of other works.

Flash was an adaptation of the 1912 pulp fiction character John Carter, created by Edgar Rice Burroughs (who also created Tarzan). Carter's character was a Civil War veteran fighting evil aliens on Mars. In the 1930s, King Features Syndicate, which owned several comics, tried to buy the rights to John Carter, but Burroughs turned them down. So King Features invented their own extraterrestrial warrior: Flash Gordon. Several decades later, when George Lucas tried to buy Flash Gordon, King Features said no and Lucas made *Star Wars*. Interestingly, both refusals inspired a yet more popular space fantasy franchise.[6]

John Carter's cinematic offspring are the stuff of legend. He directly inspired Flash, distantly inspired *Star Wars*, and reportedly inspired James Cameron's 2009 billion-dollar blockbuster, *Avatar*. But the 2012 film *John Carter* was a historic flop for Disney and one of the most costly cinematic catastrophes of all time. Apparently, John Carter at the movies is like an inedible goose that cannot stop laying golden eggs.

Kurosawa's *Hidden Fortress*, too, is an echo of epics. It was loosely based on another Kurosawa film, *The Men Who Tread on the Tiger's Tail*, which was derived from a famous nineteenth-century Japanese play, *Kanjincho*. It doesn't end there: *Kanjincho* was the Kabuki version of an older Noh-style drama, *Ataka*, whose characters were adapted from folktales about a medieval samurai named Minamoto Yoshitsune. I am surely missing some links in this multi-millennia chain of influence, but, at the very least, one can reasonably say that if *Star Wars* is a child of Kurosawa, it is the great-great-great-grandchild of Japanese mythology.

6. From the annals of "if you strike me down . . . ": The newspaper and television mogul Rupert Murdoch was once interested in acquiring the cable news network CNN. When its owner Ted Turner spurned him, Murdoch created his own news channel. That invention, Fox News, soon eclipsed CNN as the most-watched political news network in the United States.

Is it depressing that the most famous stories of modern day tend to be the latest incarnation of past generations' myths? Maybe not. Anticipation is a great pleasure of film and television, "but it's not the only one, and frankly, it's probably the cheapest," the critic and author Adam Sternbergh wrote in *New York* magazine. "In my experience, the second viewing is always more satisfying than the first," he said, "because you notice all the things you missed while you were busy waiting for the twist." Not all spoilers are equal: *The Sixth Sense* and *The Usual Suspects* are carefully designed traps to spring the concluding surprise. But it hardly ruins *Citizen Kane* to learn that its protagonist dies, and it's still easy to appreciate the movie's genius after learning that his dying word, "Rosebud," is an allusion to (spoiler) his childhood sled.

One might wince at the claim that spoilers don't actually spoil many stories, but Sternbergh is on to something. In the 2011 study "Story Spoilers Don't Spoil Stories," scientists asked eight hundred college students from the University of California, San Diego, to read mysteries and other tales by writers like John Updike, Roald Dahl, Agatha Christie, and Raymond Carver. Each student got three stories, some with "spoiler paragraphs" revealing the twist, and some without any spoilers. They rated their stories on a ten-point scale.

Readers "significantly preferred" spoiled stories over unspoiled stories, the researchers concluded. "A novel that can be truly 'spoiled' by the summary of its plot is a novel that was already spoiled by that plot," the *New Yorker* book critic James Wood wrote. For once, the social scientists and the art critics are in unison.

Every great story is more than its plot. It is a self-enclosed universe of life, or as Tolstoy wrote, a vehicle for the delivery of all feelings from sorrow to ecstasy. But if these vehicles are powered by the drama of not knowing what comes next, why might some people prefer a story when they can guess the ending? Perhaps it goes to the heart of Bruzzese's

and Campbell's work. Audiences need an element of safe predictability in order for the feelings to hit with their full weight. Compelling stories, as one cliché goes, are "emotional roller coasters." But the joy of a roller coaster isn't the imminent threat of death. It's the tension between "This thing will make me think I'll die" and "I know exactly where I'll disembark alive."

There are several ways to tell the story of how *Star Wars* nearly wasn't conceived, bought, or filmed. But the most fundamental near miss was that Lucas himself barely survived the streets of Modesto. He made it to his twenties by the grace of a faulty seat belt.

When he was a teenager, Lucas's father bought him a Bianchina. It was a stout Italian minicar with a short body and perky roof, like a baby turtle on wheels. Lucas outfitted it with a seat belt from an air force jet and raced it around the tight corners of his hometown.

The first accident flipped the car, damaging the shell so badly that Lucas tore off the roof. That was prelude to a more violent accident months later. Lucas collided with a Chevy and his car plowed into a walnut tree. The force of the crash tore his makeshift seat belt and threw him clear through the open roof. Years later, Lucas would reflect that his luck was nearly cinematic. If he hadn't replaced the seat belt, the tree would have killed him instantly. If he'd replaced the seat belt without tearing the roof off, he might have broken his neck in the car. Instead, he left the Modesto hospital after two weeks.

The crash changed his life. "It gave me this perspective on life that said I'm operating on extra credit," he told Oprah Winfrey in 2012. "What I'm getting is bonus material."

Star Wars, too, exists only by a confluence of impossible coincidences. Several studios neglected to pick up the movie. Had King Features been kinder to the American director, Lucas would have simply

made a Flash Gordon franchise. Without *American Graffiti*, Lucas's surprisingly successful second film, 20th Century Fox might never have agreed to distribute it. Without prodding from friends to rewrite the script numerous times, the film might have been (as some initially predicted) a disastrous jumble of nonsense plot and wooden dialogue. The very existence of the weighty *Star Wars* franchise hangs by a fragile cosmic thread.

It was only because Lucas couldn't buy Flash Gordon or remake *Hidden Fortress* that he was forced to nourish his story with the thousand references that make *Star Wars* the iconic universe it is. Today the story appeals equally to ten-year-old boys and semiotics nerds. It is simple enough to summon adrenaline from the pituitary yet so deeply referent that it invites fans to plumb it for religious significance, like a visual Talmud.

Directors like George Lucas are "semiotically nourished authors working for a culture of instinctive semioticians," the late and great writer Umberto Eco once wrote. That is, *Star Wars* is not a single movie, nor a lonely cliché floating in ether. It is "movies," the gathering of hundreds of clichés from several genres, celebrating a reunion in outer space.

A story that alludes to just one story is derivative. A story that alludes to nothing in cinema or literature is incomprehensible. *Star Wars* traces the thin overlap between never-before-seen and aha-I've-seen-this-before. It is an original because it is a bundle of never-before-bundled allusions. Each one swings open to reveal other worlds and far-flung mythologies. Like the table it was written on, *Star Wars* is made of many doors.

THE MYTH-MAKING MIND II: THE DARK SIDE OF HITS

Why Stories Are Weapons

Any book about popularity, hits, and the media requires a story about vampires. They have haunted pop culture for centuries, from Bram Stoker's *Dracula* and the silent film *Nosferatu* to fresher interpretations like *Buffy* and *Twilight*. But consider an equally significant vampire story: the history of "real" vampires.

One of the most popular universal myths in the world is the belief that the dead can bring death. The threat of maliciously thirsty corpses has animated the fantasies of several civilizations, from Transylvania to China. A belief in vampires continued to haunt Europe well into the Great Enlightenment, even earning what was presumably a sarcastic entry in Voltaire's *Philosophical Dictionary*: "It was in Poland,

Hungary, Silesia, Moravia, Austria, and Lorraine, that the dead made this good cheer."[1]

As Voltaire suspected, the dead did not make good cheer in any of those places. But until the late nineteenth century, most civilizations knew practically nothing about disease or decomposition. Villages were confounded by the riddles of death. Why did people seem to get sick in clusters? Why did some corpses look alive when their graves were opened weeks later? And what was with their long fingernails?

The last 150 years of science have answered most of these macabre questions. We know that people die in clusters when they're exposed to a common disease. We know about rigor mortis and decomposition. But the medical examiners of antiquity were less than MD level, and farmers knew nothing of viruses. Everything about death was a mystery, and compelling myths rush toward mysteries like air into a vacuum. So in Europe, China, and Indonesia, disparate societies settled on a common story that explained all of these puzzles at once: *The dead can bring death.*

Vampires were a plausible medical diagnosis, and a belief in the blood-sucking dead mixed with local values to create bespoke folktales, as Paul Barber explains in his history *Vampires, Burial, and Death.* In eastern Europe, the usual suspects for "revenants"—people returning from the dead—included the ugly, the quarrelsome, the alcoholic, the atheist, the unchaste, and all seventh children. In China, a dog or cat leaping directly over a grave could add one more vampire to the world. Albanian vampires ate intestines, while their Indonesian brethren merely drank blood. In Pomerania, the southern coast of the Baltic Sea now perhaps most famous for its adorable eponymous dog, possible victims were advised to drink an inoculating brandy made from the blood of the dead.

1. Voltaire went on, with delicious snark: "We never heard a word of vampires in London, nor even at Paris. I confess that in both these cities there were stock-jobbers, brokers, and men of business, who sucked the blood of the people in broad daylight; but they were not dead, though corrupted. These true suckers lived not in cemeteries, but in very agreeable palaces."

In the early 1700s, vampire hysteria gripped eastern Europe, particularly in modern Serbia, Hungary, and the part of Romania known as Transylvania. The Habsburg monarchy sent officials to several towns to report on this frenzy of vampire attacks and the stakings that came with them. When these reports were translated from German, they helped to popularize the vampire folklore even among literate societies that were not seemingly overrun by bloodsuckers. The *Oxford English Dictionary* dates the adoption of the word "vampire" in English to around this time, with the earliest known occurrence in 1741.

Fictional vampires are tall, thin, gaunt, sly, and patrician. Dracula is a count with a large castle, and *Twilight*'s Edward is extremely handsome. But history's true—that is, truly believed—vampires were opposites in almost every way. Plump, dirty, loud, foul-smelling peasants, they were more Renfield than Dracula.

One of the most famous official vampire reports from the 1720s in Serbia concerned an old man named Peter Blogojowitz. A few months after he passed, nine village neighbors died following short illnesses. On their deathbeds, some claimed to see Blogojowitz, or his ghost, mount them and strangle them at night. Villagers insisted on digging up his grave to check for the telltale signs of vampirism.

When a Habsburg bureaucrat went to Blogojowitz's grave with a priest to attend the exhuming of his corpse, he reported that it looked quite alive. "The body . . . was completely fresh," he wrote. "The hair and beard—even the nails . . . had grown on him. I saw some fresh blood in his mouth, which, according to a common observation, he had sucked from the people killed by him." That settled things: Blogojowitz was definitely a vampire, and he would have to be rekilled. Villagers sharpened a stake and ran it through his chest with such force that blood spurted out of his ears and mouth, which seemed to offer more proof of life. Then they burned the body until it was nothing but ash and pronounced Blogojowitz and his vampire avatar really, truly, and finally dead.

Stakes alone couldn't kill vampires, but scientific skepticism

eventually did the trick. When Habsburg empress Maria Theresa sent her personal physician to investigate the frenzy, the doctor concluded that vampires were an unfounded public hysteria with no evidence to support their actual existence. Following his report, she passed laws in the 1770s prohibiting the exhumation of corpses and the burning of bodies. In the next hundred years, scientists gradually realized that common illnesses like cholera were probably at the root of many vampire outbreaks. Epidemiology was advancing into the shadows of superstition and, like a beam of sunlight in so many movies, killing the undead for good.

It's tempting to say that the belief in vampires was downright silly. But the truth is that vampires were a perfectly coherent story.

Vampirism accounted for *every observable detail* surrounding death. It explained why families got sick at the same time, why friends died after friends, and why the buried dead looked the way they looked. It's not coincidence that, for many centuries, these myths stalked villages separated by tens of thousands of miles. The walking-dead theory of disease answered a mystery with a narrative that had meaning, suspense, and agency. It explained the chaos of life with a spectacular tale. It empowered villagers by telling them that everybody had the capacity to fight evil—with potions, garlic, prayers, chastity, stakes, swords, and fire (and, if all else failed, sanguinary brandy). Vampires were the perfect story.

A great narrative catches listeners in its slipstream. Every chapter in this book has started the same way—with a story. I'm daydreaming about Monet's water lilies in an impressionist exhibit . . . Raymond Loewy designs the 1950s . . . George Lucas writes the most commercially successful metamyth of all time. It is the convention of this book's genre to build chapters like narrative Trojan horses, wheeling out a captivating tale to hide the scientific lessons within. I would be dishonoring the first lessons of the book if I tried to break too many of the genre's conventions. But I would be dishonoring the science of

the book to not warn readers against putting too much stock in a great yarn.

Stories are a kind of sorcery. Like repetition and anaphora, they can seduce the mythmaking mind and can suppress the kind of deeper thinking that is also quite necessary to understand the truth of things. A great story that serves the wrong purpose is a dangerous thing.

In the 1980s and 1990s, Geena Davis was a model, an actress, and even a semifinalist for the 2000 U.S. Olympics team in archery. She might be most familiar to American audiences as the older sister in *A League of Their Own*, the preternaturally gifted catcher in the World War II era All-American Girls Professional Baseball League. Between 1986 and 1992, Davis starred in several hit movies, including *Beetlejuice* and *Thelma & Louise*, and won an Academy Award for Best Supporting Actress in *The Accidental Tourist*.

At the age of forty-six, she gave birth to her first child, Alizeh. When Davis watched movies and TV with her daughter, she was struck by the lack of strong women in children's entertainment. As Alizeh absorbed the G-rated movies, Davis would sit behind her, quietly counting female characters. The arithmetic was disappointing. Even worse was the behavior of the female characters, who seemed either hypersexualized or sidelined. "This is children's programming," she thought. "This is supposed to teach our kids about the world." But these movies seemed to only reflect old and chauvinistic biases against women.

Counting characters on the couch was enough to construct a hypothesis, but Davis wanted to build a movement. In 2009, she met with Madeline Di Nonno, another entertainment veteran, whose career was as diverse as Davis's in its own way, spanning film, events, and marketing. Di Nonno shared something else with Davis: an abiding disappointment in female role models in Hollywood. In 2009, they founded the Geena Davis Institute on Gender in Media and Di Nonno became

the CEO. The goal was gender equality in children's entertainment—and not just numerical equality, but qualitative equality.

One reason why sexism is pervasive and enduring, they suspect, is that children around the world are being, in their words, "encultured" by entertainment to see that men should be strong heroes and women should be pretty damsels in distress. Moving pictures are hardly the only influence in a young child's life, but they are a powerful one. Children spend hundreds if not thousands of hours of their most impressionable years watching stories that have the cumulative effect of teaching them how to behave and what is normal. Repeated exposure to sexist entertainment makes young people fluent in discrimination, so that gender bias feels as automatic as breathing oxygen.

Certain skills and tastes are shaped during a "sensitive period" in a person's life. A child's early years are key to the development of language, motor skills, and behavior. It is far easier to learn a second language as a child than as an adult, and deaf kids who don't learn sign language in early life struggle to become proficient, even if they practice for decades.

There may be sensitive periods for taste as well. Most children are born hating the flavor of broccoli. Scientists believe the vegetable evolved to produce a foul-tasting compound called goitrin so that animals wouldn't eat it into extinction. But one 1990 study found that it was possible to make young children fall in love with the bitter taste of broccoli—by serving it over and over again, with more pleasant foods. The good news is that getting your child to like broccoli is possible through repeat exposure. The bad news is that familiarizing broccoli is an expensive chore for parents, requiring up to fifteen servings for kids to accept the bitter vegetable.

Different tastes seem to have different sensitive periods. Teenagers in general are known for experimenting with all manners of identity, appearance, and pharmaceutical chemistry. The most important years for developing music tastes seem to be between the midteens and early

twenties. By the time adults reach their early thirties, most of them stop seeking out new music entirely. A 2015 study of Spotify data pinpointed the precise year that listeners stop listening to new artists: thirty-three. Political opinions seem to crystallize around the same time. Young people who grew up during popular Republican administrations—like Dwight Eisenhower's—lean Republican for the rest of their life, while those who grew up during Franklin Roosevelt's administration leaned left for decades. After most people are in their twenties or thirties, the soft clay of taste and ideology has hardened.

The Geena Davis Foundation believes that childhood entertainment shapes adult expectations, too. This is the heart of what psychologists call "unconscious bias," the effortless and automatic bias that infects even the well-intentioned. Unconscious bias in media can spread like a disease: Moviemakers are the carriers, film is the vector, and kids are the victims. Watching too many female characters play lesser and subservient parts subtly teaches a generation of girls to apologize about being assertive. As generations of kids grow up in the glow of stories that say women can't behave like men without being punished for it, those kids grow up to teach the next generation the same bad lesson, and the vicious cycle continues.

Di Nonno wanted to show producers and directors just how chauvinistic the Hollywood megamyth had become. The foundation funded one study analyzing gender roles in 120 popular films between 2010 and mid-2013 in the United States and several other countries, including Brazil, China, and the UK. They paid graduate students to evaluate each speaking role or named character for demographics, sexualization, occupation, and career. They discovered:

1. Less than one third of 5,799 speaking/named characters were female (just 29 percent in the U.S.).
2. Just 23 percent of films had a girl or woman as a main character.

3. Just 14 percent of the 79 executives shown across the sample were female. (This was almost precisely the share of female executives in the U.S. in 2014. But gender equality is one area where one would hope for art to guide life rather than imitate it.)

4. Just 12 women were shown at the highest levels of local or national governmental authority, versus 115 males, a gender ratio of 9.6 to 1. (Since Margaret Thatcher accounted for 3 of those 12 women, just 10 unique female characters were shown in political authority out of 5,799 speaking characters.)

5. Eighty-eight percent of characters with a job in science or technology were men.

Most troubling might be the overt, and dreadfully one-sided, sexualization of young female characters. Girls and women were twice as likely as boys and men to be shown in sexually revealing clothing, and five times as likely to be called out for their good looks. In the world of film, women account for less than one third of the workforce while they represent two thirds of its sex objects.

This study was no outlier. Women accounted for just 30 percent of all speaking or named roles in the top one hundred scripted films in the United States between 2007 and 2015, according to a report from the University of Southern California. Only 20 percent of those female characters were between forty and sixty-four. In blockbusters, it seems, there are three types of women: doe-eyed lover, harping mother, and Meryl Streep.

It is typical—and reasonable—to blame the absence of gender balance and racial diversity in movies on the overwhelming whiteness, maleness, and straightness of Hollywood's producers, directors, and studio executives. Indeed, this was the target of the #OscarsSoWhite campaign, a public protest against the fact that, for the second consec-

utive year, the 2016 Oscar acting nominees were entirely white. These nominations were partly a reflection of voting demographics. The members of the Academy of Motion Picture Arts and Sciences were 94 percent white and 77 percent male, according to a 2012 survey published in the *Los Angeles Times*.

But according to Vincent Bruzzese, there's another group that fights quietly against gender equality in movies. It's us—the audiences. Moviegoers hold men and women to a double standard in movies, where if women act too much like men—or if men act too much like women— test audiences complain, and producers adhere to old stereotypes rather than fight them.

Take romantic comedies, for example. The typical rom-com has three acts. In the first act, the couple explores the possibility of a relationship. In the second act, they appear to come together. But before the third act, some sort of crisis threatens to destroy the relationship. This is a key feature of storytelling, because it sets up the final rush of good feelings when the couple gloriously comes together in act three.

After this critical breakup scene, the two characters go back to their lives, their friends, or their families. If the lead male character sleeps with somebody else during this break, the audience will ultimately forgive him when he reconciles with the lead actress, Bruzzese said. But if the female lead sleeps with somebody during this temporary breakup? *Even the women in the audience will stop rooting for her.* Hollywood's formulas have created an unconscious bias in romance. For men in movies, sex and romance are separate. But if you're a woman, sex with multiple people disqualifies you from a Hollywood ending.

These double standards aren't exclusive to romantic comedies. Perhaps most concerning is the expectations gap in movies about business. "With a tough, effective female executive, the audience will describe her in almost strictly negative terms," Bruzzese said. "But if you take

the same character and make him a man, he'll be described in mostly positive terms." Mean and powerful men are badass; mean and powerful women are bitchy.

"With hard women, the audience wants to believe that the hard side is not the real person," he continued. So the screenwriter is encouraged to include several scenes where the female executive's steely exoskeleton cracks and audiences can glimpse the vulnerable softness underneath. Miranda Priestly, the Machiavellian editor in chief played by Meryl Streep in *The Devil Wears Prada*, has a visible breakdown over her marriage before ultimately triumphing in the film. Compare that with another ethically dubious boss, Gordon Gekko, the oily financier played by Michael Douglas in *Wall Street*, who enjoys cult worship despite being a relentless and unrepentant crook. Alec Baldwin's "Always Be Closing" speech from *Glengarry Glen Ross* is one of the most glorious asshole moments in film history. But according to Bruzzese's research, audiences would be less inclined to embrace a foulmouthed woman from downtown.

If Bruzzese is right, Hollywood storytellers are caught in a trap of their own design. Audiences expect and prefer vulnerable female characters, having been instructed by the history of film that likable women ought to be feminine. The only way to break the cycle is to break expectations. Forward-thinking writers should just write kickass female leads and stop asking audiences for their permission.

There is a precedent for sudden and brisk cultural change on a social justice issue. In 1996, just 27 percent of Americans said they supported the right of gay people to wed. In 2015, 73 percent of people under thirty-five said they supported gay marriage. So, in less than twenty years, the idea of marriage equality went from absurdly radical to freshly mainstream to boringly obvious. The Supreme Court recently ruled in *Obergefell v. Hodges* that the right of gay men and women to marry wasn't just a mild cultural preference; it was a funda-

mental constitutional right. It is exciting to think that, even now, there may be a handful of utterly radical ideas that, in less than twenty years, will be considered so deeply obvious that few will be willing to publicly question them.

Notably, the decline of antigay prejudice occurred among adolescents and twentysomethings. Between 1996 and 2015, support for marriage equality grew 24 points among eighteen- to thirty-four-year-olds, the most of any age group and more than twice as much as the boomer generation. This goes straight to Madeline Di Nonno's thesis: It is easier for a young person to learn a social norm than for a middle-aged adult to change his or her mind.

When people say "history" they tend to mean something that really happened, and when they say "story" they mean something made up. But the word "story" comes from the Latin *historia*. History is always a story, a narrative that provides both the benefits of fictional tales— temporal connectedness, a satisfying cause-and-effect plot, and drama with meaning—and their downsides. Indeed, many histories are essentially "vampire stories"—narratives so compelling that few bother to study if they're actually true.

Prejudice is a story that people learn about how the world works, and new generations can always learn new ways to see the world. There is little genetic difference between an eighteenth-century farmer who wants to decapitate vampire corpses to stop them from killing his family and his twenty-first-century descendant who considers this behavior horrifyingly stupid. Nor is there a biological difference between somebody who came of age in antebellum Georgia and a liberal student at a college campus today, even though the former believed that blacks and gays were practically subhuman while the latter would consider both positions abhorrent. There is no question that, decades from now, audiences will look back on several modern blockbuster books and Hollywood movies as if troglodytes had produced them. Cultures evolve

and surround their children in an environment that reflects familiar values. Bigots are made, not born. But deep compassion also requires teaching, and a great story can be a persuasive lesson.

Several years ago, I heard a story—I hope it was true—from a friend who worked at 21st Century Fox. In the late 1990s, the world's largest television manufacturers contacted the Fox News Channel to pass along a bizarre complaint from some of the network's most devoted viewers. Older Americans who watched the conservative news outlet all day long said the Fox News logo had seared itself into the screen. Even when viewers tuned in to other channels, a ghostly image of the Fox News emblem haunted the bottom corner of the picture. Today, the Fox News logo rotates slowly in the bottom corner of the screen in part to prevent the insignia from charring television pixels.

Indeed, many of us suffer from ideological "burn-in"—the unfortunate imprinting of biases from stories and exposure. Liberals cocoon themselves in left-leaning websites, and people who get their information from Twitter can design a news stream that perfectly suits their prior opinions. Intelligent formulas govern Facebook, Pandora, Netflix, and other media, which tailor the universe of options to fit a person's prior preferences and the favorites of her in-group. This hunt for fluency and familiarity is natural, but it leaves people open to a host of dangerous biases.

The power of the press is not only to report and render judgment on important issues, but also to determine which issues are worthy of coverage in the first place. That decision of emphasis has its own consequences. In the press, familiar falsehoods can be seen as positive facts, even if they're often presented as myths. In one study of myth-busting news, old and young participants read several dubious assertions, such as, "Shark cartilage is good for arthritis." (It is not.) Immediately after, most participants correctly identified the untrue

statements as myths. But several days later, researchers checked back with their subjects and found that older adults were significantly more likely to say: *Yes, shark cartilage really does help arthritis!* The brute force of repetition had familiarized the connection between shark cartilage and arthritis, and older participants, with worse explicit memory, failed to separate familiarity—"That statement feels right"—from fact—"The statement is correct."

This suggests that myth busting in the media can unwittingly become myth propagation for some. A classic cable TV segment asks two people with opposite viewpoints to debate a topic. Although this approach has the appearance of objectivity, it might have the effect of obfuscation. Hosting debates on issues of settled science, like evolution, repeatedly exposes people to arguments that aren't true, even if they're debunked. The mere repetition of a phrase or idea, even one labeled false, might confuse many people in the long run, because it is so easy to conflate familiarity with truth.

"It's useful to think of attention as a budget that chooses to buy certain pieces of information," says Adam Alter, a professor of marketing at the Stern School of Business at New York University. "Fluency implies that information comes at a very low cost, often because it is already familiar to us in some similar form. Disfluency occurs when information is costly—perhaps it takes a lot of effort to understand a concept, or a name is unfamiliar and therefore difficult to say."

If there is a dark side to fluency, might there be a bright side to its opposite, disfluency? Alter's work suggests there might be. In one of his studies, he printed a simple, easy-to-read question: "How many animals of each kind did Moses take on the ark?" Many respondents said two. But when the question was printed in a harder-to-read font, respondents were 35 percent more likely to recognize that it was *Noah*, not Moses, who built the ark. The less legible font made people more careful readers.

Alter has replicated this finding in several deceptively simple que-

ries. Try this one: "If a baseball and a bat cost $1.10, and the bat costs 100 cents more than the ball, how much is the bat?" It's an elementary school math question. But the phrasing is designed to lure people into giving a fast and wrong answer—that the bat is $1.00 and the ball is 10 cents. The difference between $1 and 10 cents is 90 cents, not 100 cents. The correct answer is that the bat costs $1.05 and the ball costs 5 cents. Alter has found that if research subjects see the question in a font that is harder to read, they are more likely to answer accurately.

Unlike the mere exposure effect—one of the most replicated findings in psychological history—the benefits of disfluency are less well understood. But Alter's work suggests that hard-to-read fonts create just the right amount of brow-furrowing deliberation for people to see the trick within these trick questions. Disfluency is like a subtle alarm, piercing the calm of automatic processing, summoning a higher level of attention.

There is a dark side to fluency—for both makers and consumers. When creative people are too familiar with their own projects, it hurts their ability to evaluate them. For writers like me, the implication is quite clear: Being too familiar with my own writing makes it impossible to be an assiduous judge of its quality. I am my own best editor only when I take enough time away from my work to read it with fresh perspective.

But the deepest seduction is for audiences. Rhyming aphorisms are alluring, and antimetabole is enchanting; it's ravishing to read an essay that explores an idea you've already decided is correct, and a great narrative that upholds your theory of the world feels good to share with friends. These are all stalks branching from the same root, the easy fluency with which most people want to process the world. It falls to consumers and audiences to separate the vampire stories from the science. It is precisely because great narratives seduce us that the best stories deserve the greatest skepticism.

THE BIRTH OF
FASHION

"I Like It Because It's Popular."

"I Hate It Because It's Popular."

The tricky thing about studying popularity and why people like what they like is that at least three inextricable factors are always getting in the way: choices, economics, and marketing.

Choices: If I were writing this book in 1918, a year when the Model T car came only in black, it would be obvious to note that everybody likes black automobiles. The idea that people might prefer more polychromatic cars would have been hard to defend, and there would have been little evidence to support the idea. But today's cars come in hundreds of models, colors, styles, and sunroof options, and the streets flow vividly with nonblack vehicles in a variety of sizes. Choices changed people's tastes in ways that would have made 1918 "taste explainers" quickly seem silly.

Economics: In the summer of 2007, when Abercrombie & Fitch was one of the most successful fashion retailers in the United States, it would have seemed prudent to hold up the company as the code breaker of teenage fashion. By the end of 2008, however, the United States had

fallen into deep recession. Teenage unemployment spiked and parents who lost, or were at risk of losing, their jobs closed the allowance spigot. Abercrombie's stock fell by more than 80 percent in a year, and *Time* magazine named it the country's "worst recession brand" as many high schoolers moved on to less conspicuously labeled clothes and discount stores. Abercrombie's style didn't change, but America's economy did. Economics changed the definition of cool.

Marketing: In 2012, Super Bowl XLVI set the record for the most watched U.S. television program ever (although it would soon hand off the record to another Super Bowl). There is nothing quite like the National Football League's championship game as a universal marketing blast in an otherwise fragmented media environment, and indeed this game cemented at least one historic hit. A jaunty Chevy commercial featured the five-month-old song "We Are Young" by New York indie pop band Fun. The very next week, the song climbed thirty-eight spots to number three on the Billboard Hot 100 and eventually hit number one, where it remained for six weeks. The next year, Billboard named "We Are Young" one of the one hundred best-performing songs in music history. The song's sudden success wasn't about economic circumstances, since its price and availability hadn't changed. It was just about marketing—the power of the right song, in the right place, with the right product, in the middle of the Super Bowl, that supreme emperor of advertising platforms.

So choices, economics, and marketing are always shaping tastes. But what if you could study popularity in a market without any of those things—in a store with infinite options, universal prices, and no advertising?

For example, imagine a national clothing outlet that carried every size and design of shirts, pants, and shoes. But this national chain had no labels or ads to promote one style over another. Every possible article of clothing simply *existed*, and they were all the same price. This chain would be a social scientist's dream. Researchers could use it to

study why certain fashions rise and fall without trying to control for the brutal power of advertising and distribution.

In fact, such a marketplace exists. It's the marketplace for first names.

Choosing a first name is like shopping at an infinity store where every product costs zero dollars. First names are often a cultural product, like music or clothes. Parents select them for both deeply personal reasons (*"Maria* is my grandmother's name") and for more aesthetic reasons (*"Maria* sounds nice"). News still carries influence— in the 1930s, the name Franklin soared in popularity while Adolf vanished—but there is nothing like direct advertising for names. No organization or company benefits from more sons named Michael, Noah, or Dmitri.

The weird thing about first names is that, even though they're free and infinite, they follow the same hot-and-cold "hype cycle" of many other products that do have finite choices, diverse prices, and lots of advertising. Just like clothes, first names are a fashion. Some names are cool today (Emily) while some once popular names now sound out-of-date (Ethel), even though the names Emily and Ethel are as Emilyish and Ethelian as they've always been. Nothing about the quality of the names has changed—just their popularity.

In the last decade of the twentieth century, the top three baby girl names were Jessica, Ashley, and Emily—none of which were in the top one hundred a century earlier. Meanwhile, the popular girl names from the early 1900s have all but disappeared. Ruth, Marie, Florence, Mildred, Ethel, Lillian, Gladys, Edna, Frances, Rose, Bertha, and Helen: All of these names were in the top twenty at the turn of the twentieth century, and none were still in the top two hundred by the century's end.

It wasn't always this way. For hundreds of years, first names were more like traditions than fashions. Parents would select names from a

small pool of options and often recycle the same ones across genera-
tions. Between 1150 and 1550, practically every English male monarch
was named Henry (eight of them), Edward (six), or Richard (three).
Between 1550 and 1800, William, John, and Thomas accounted for
half of all English men's names. Half of England's women went by Eliz-
abeth, Mary, or Anne.

The trend was transatlantic. In the Massachusetts Bay Colony of the
mid-1600s, half of the baby girls were named Elizabeth, Mary, or Sarah,
and early records from Raleigh County, established in 1587, show
that forty-eight of the ninety-nine men were named William, John, or
Thomas. It was not just an English-speaking tradition. Germany,
France, and Hungary had a similar concentration of popular names.
São Paulo baptismal records from the late 1700s show that half of all
girls were named Maria, Anna, or Gertrude.

Then, quite suddenly, in the mid- to late-nineteenth century, the
list of most popular names embarked on a period of accelerating turn-
over, in both Europe and the United States. Girls' names, in particular,
cycle in and out of popularity faster than summer dress styles. Emma
and Madison, two of the most popular names of the last decade, weren't
in the top two hundred just thirty years ago.

This leads to two mysterious questions about names, whose an-
swers carry broad implications for just about any trend—cultural, eco-
nomic, or political. First, how does something go from being a *tradition*,
where the distinction between old and new hardly exists, to a *fashion*,
where new customs are constantly pushing out old ones? Second, how
do things become cool—even in markets with infinite variety, no
prices, and no advertising?

The uptick in first name turnover started in England and spread
through the Western Hemisphere in the middle of the nineteenth
century, Stanley Lieberson finds in his marvelous book on names,

A Matter of Taste. This is a familiar trajectory. Something else started in England and spread around the world in the 1800s. It was the industrial revolution.

There are several possible connections between industrialization and first names. First, factories encouraged workers to move from small rural farms to dense urban centers, and urbanization introduced them to new names. Second, education rates soared in the early twentieth century, and literacy exposed people to an even wider variety of names in books and international news reports. Third, as people moved from one-family settlements to cities, the ties between nuclear families and extended family networks weakened. The melting pot of denser cities put a new emphasis on individualism. On a small family farm, having a familial name made you a part of the family, but in the city a name set you apart from other cultures, ethnicities, and classes.

This period of change didn't just erase a batch of old names and replace them with a fresh batch. It forever changed the way people thought about names as identities, creating a virtue around newness where formerly none had existed. The turnover rate of first names soared not only in the United States and the UK, but also in Hungary, Scotland, France, Germany, and Canada. A fashion was born.

This sudden metamorphosis of fashion has historical parallels. For most of human history, people didn't change the way they dressed from year to year, or from millennium to millennium. In Europe, men covered themselves in long tunics extending to the knees from the Roman times to the 1200s.[1] As late as the Middle Ages, the concept of clothing "fashion" didn't really exist in most of the world. In India, China, Japan, and across Europe, clothing and costume styles were frozen in time. Even in seventeenth-century Japan, a shogun's secretary claimed with pride that the empire's clothing style had not changed in one thousand years.

1. Some of my best friends would welcome fashion tastes so static that a single wardrobe would last several millennia. Ironically, they tend to work in the technology industry, which embraces, and even pushes, change in just about every other category of life.

But by the 1600s, fashion was a central part of European culture and economics. King Louis XIV of France strutted around Versailles in high heels, while his finance minister claimed that "fashions were to France what the mines of Peru were to Spain"—not just a game for peacocking royals, but an economic stimulus and an international export. At one point during Louis's reign, the clothing and textile industries employed one third of Paris workers, according to the fashion historian Kimberly Chrisman-Campbell.

When did clothes become fashionable, and why? The historian Fernand Braudel said that trade churned the "still waters" of ancient fashion:

> *The really big change came in about 1350 with the sudden shortening of men's costume, which was viewed as scandalous by the old . . . "Around that year," writes the continuer of Guillaume de Nangis's chronicle, "men, in particular noblemen and their squires, and a few bourgeois and their servants, took to wearing tunics so short and tight that they revealed what modesty bids us hide" . . . In a way, one could say that fashion began here. For after this, ways of dressing became subject to change in Europe.*

Historians don't agree on why the 1200s and 1300s were an inflection point. One possibility is that trade and travel exposed Europe to more styles, which gave nobles new ideas for outfits. Another theory is that the growth of the textile industry made clothes cheaper. When more Europeans could afford to dress like aristocrats, the aristocrats had to change their outfits more often to stay ahead of the plebes. In any case, Renaissance Europe was a tournament of styles, with Italy's fussy and colorful embroidery going up against the tight black Spanish doublets and capes.

Fashion is governed by a neophilic rule with a neophobic catch: *New is good and old is bad (but very old is good again).* There is a

theoretical benchmark for how fashionable attitudes are shaped by the passage of time called Laver's law, named after its originator, James Laver, a British fashion historian. It goes like this:

Indecent: 10 years before its time
Shameless: 5 years before its time
Outré (Daring): 1 year before its time
Smart: Current fashion
Dowdy: 1 year after its time
Hideous: 10 years after its time
Ridiculous: 20 years after its time
Amusing: 30 years after its time
Quaint: 50 years after its time
Charming: 70 years after its time
Romantic: 100 years after its time
Beautiful: 150 years after its time

One can quibble with the precise language (I'd say "dowdy" is too matronly a term for a look that's only twelve months old). But the larger lesson of Laver's law is that there is no such thing as universal and time-less good taste in clothes, names, music, or perhaps anything. There are only present tastes, past tastes, and slightly ahead-of-the-present tastes. Like financial investing, fashion is a matter of both taste and timing. It doesn't profit, in either profession, to have the correct opinion too late or to be prescient long before the market is ready to agree with you.

How do cool names suddenly become uncool—and then, perhaps, cool again? It's no mystery what happened to Adolf, and few mourn the name's demise. But what did Edna or Bertha ever do to any-body? That is a mystery that Freda Lynn, a sociologist at the University

of Iowa, investigated with Stanley Lieberson. They noticed something interesting about siblings.

Parents tend to pick similarly popular names for their older and younger children. A couple that picks a unique name for its first baby is much more likely to pick a similarly unique name for its next child. Indeed, if you meet a family where the children are named Michael, Emily, and Noah, it's rare for the fourth child to be named something exotic like Xanthippe. But if you meet siblings Xanthippe, Prairie Rose, and Esmerelda, you might be surprised to meet their younger brother Bob. This suggests that parents have a particular "taste for popularity," as Lieberson and Lynn write.[2] Some parents like certain names on the basis of their popularity.

Taste for popularity is a powerful idea in culture. A straightforward example could be seen in music's biggest stars. Some people like Taylor Swift because she's popular. Some people like Taylor Swift and don't really pay attention to her popularity. And some people look for things to dislike about Taylor Swift because her popularity sends the equivalent of a warning that she might be fake, dreck, or both. All three groups can agree on what a Taylor Swift song sounds like. Yet something outside the actual sound of the music—Swift's status as a star—can send a range of signals, from pure appeal to deep skepticism.

Popularity as a taste might apply to many categories—music, food, arts, housing, clothing, hairstyles, and political ideas. Some people are drawn to things because they're hits. Some people shun things because they're hits. You can imagine a spectrum from bandwagoners ("I only tried it because it's popular") to hipsters ("I don't like it anymore now that it's popular"). Although it's possible that one's disposition for

2. There is a second, wonkier defense of the "taste for popularity" theory. As names rise and decline in usage, the new distribution of popular names tends to have a relatively strong correspondence to recent distributions, even though the names are different. That suggests that, year after year, the country has a similar distribution of hipster parents, mainstream couples, and folks in the middle. In other words, America's taste for specific names is constantly changing, but the national taste for popularity evolves much more slowly.

newness or independence holds across items—e.g., that people who like blockbusters also shop at the Gap and eat chocolate ice cream—the more likely scenario is that an individual's taste for popularity differs across categories. For example, I have an innate skepticism toward political ideas that seem too popular but also let photo spreads in mainstream magazines tell me how to dress.[3]

If we imagine that most Americans are in the middle of the taste-for-popularity spectrum for names, it would suggest most parents are looking for Goldilocks names—pretty common, but neither odd nor ubiquitous. But one million families cannot perfectly coordinate their baby naming decisions. It's common for parents to think they've picked a moderately unique name for their girl only to learn, on her first day of school, that several other kindergarteners share the same one.

Samantha was the twenty-sixth most popular name in the 1980s. This level of popularity was pleasing to so many couples that 224,000 parents named their baby girls Samantha in the 1990s, making it the decade's fifth most popular name. At this level of popularity, however, the name appeals mostly to the minority of adults who actively seek out extremely common names. And so a top five name tends to peak and fall for a long period of time. Indeed, the number of Samantha babies has fallen by 80 percent since the 1990s.[4]

This taste-for-popularity spectrum maps onto one of the first ideas in this book: That familiarity underlines popularity, although people have varying tastes for familiar products. Some people like weird names, others prefer common names, and many parents are Goldilocks, choosing from that large swath of names that is neither overex-

3. One difference could be the way experience shapes identity: It's important to me to stand out in political debates, and so I'm inclined to resist ideas that strike me as overly familiar; I don't care about standing out in terms of my fashion, so I let *GQ* tell me what to do.

4. Did Samantha also benefit from the popularization of the American Girl doll Samantha Parkington in the late 1980s? Possibly. But the name had already entered the top twenty-five before the debut of the doll. (It was a top ten name by the time *Sex and the City* introduced its own famous and far less child-friendly Samantha.) Perhaps American Girl dolls helped to popularize baby girl names. But Lynn and Lieberson's thinking would suggest that both American Girl executives and thousands of parents might have had the same idea at the same time—that Samantha was a perfectly popular-but-not-too-popular name.

posed nor proudly weird, but rather a little surprising and yet instantly recognizable.

Individually, these parents are just picking names they like. Collectively, their choices create a fashion.

One of the most important concepts in social psychology is "social influence" or "social proof," which means that other people's tastes often become your tastes. In Dr. Robert Cialdini's classic book on persuasion, *Influence*, he defines the principle of social proof as "the greater the number of people who find any idea correct, the more the idea will be correct."

This theory is widely accepted in media and marketing: *Here is the most popular thing, so you'll like it.* It means that "number one bestseller" is a universally alluring descriptor. It conflates "most read article" with most interesting article. It means you're drawn to videos with more YouTube plays or Facebook likes. The truism even encourages some publishers and authors to artificially inflate book sales to get them on the bestseller lists or pushes game designers to fictitiously inflate download counts to appear in demand.

Manipulating popularity can work. But consumers are not infinitely clueless. There is a limit to how much you can trick people into liking something.

First, as song-testing sites from the first chapter show, you can put lipstick on a dead pig, but that's not the same as creating a market for it. Lady Gaga's third album tested abysmally on the British music-testing site SoundOut. But her label still pushed it down the throats of DJs and marketers and into the ears of radio listeners. Despite this massive marketing effort, the album sold considerably worse than her previous album. Quality might be a tricky thing to define, but people seem to know bad when they hear it. Distribution is a strategy to make a good product popular, but it's not a reliable way to make a bad product seem good.

Second, raising awareness that something is popular might have unintended negative consequences. In the paper "The Paradox of Publicity," researchers Balazs Kovacs and Amanda J. Sharkey compared more than thirty-eight thousand book reviews on Goodreads.com. They found that titles that won prestigious awards got worse reviews than books that were merely nominated for the same awards. In a perfect social-influence world, this would make no sense. If an authority figure tells you a book is good, you ought to internalize the advice and adore the book.

But the real world is more complex than that, and there are several intuitive reasons why a book award might lead to worse ratings. Prizes naturally raise expectations, and heightened expectations often go unmet. What's more, prestigious prizes attract a larger and more diverse audience, and this broad composition will include people who have no taste for the book's genre or style and are reading it only for the award sticker. These readers will dependably leave worse reviews. Meanwhile, a book that's merely nominated for the same prize might not attract the same motley coalition of readers, so its ratings won't suffer so much.

But the researchers' most interesting explanation is that prizewinners attract lower ratings because of a backlash among the book's readers. "Consistent with work in the area of fads and fashion, we found that growth in audience size, or popularity, can itself be seen as distasteful or a reason to give a lower evaluation," the authors concluded. Popularity as a taste has a cousin: It's renown as a taste. Some people are seduced by prestigious books, some people don't care about prestigious books, and others are excited about disliking acclaimed works, because they look forward to forming an counterintuitive opinion about a book that people are talking about.[5]

5. This is close, but not equivalent, to the concept of "hate-reading," which is reading something you expect to hate because you're excited about experiencing and later sharing outrage about it. A hate-read offers something like emotional confirmation bias. You read something inflammatory that is the opposite of what you think in order to feel even more certain about your prior opinion.

In his chapter on social proof in *Influence*, Robert Cialdini begins with the example of the laugh track. TV executives glommed onto fake laughter in the early years of TV comedies because research showed that laugh tracks made people laugh. It initially seemed that hearing other people laugh counted nearly as much as a joke's actual humor.

But the history of the laugh track is not a simple story about social influence. It is a history of an invention that created a trend, a trend that triggered a backlash, and a backlash that created a new mainstream. It is, in other words, a story about fashion.

In the 1960s, the biggest star in American television wasn't Mary Tyler Moore or Andy Griffith. By pure screen time alone, the TV talent most present in American living rooms wasn't an actor at all. It was an electrical engineer who never appeared in front of the camera, but whose work behind the scenes was influential enough that you could hear him almost every minute on about forty shows a week. At one point, he was so powerful, and his work so private, that he was called the "Hollywood Sphinx." His name was Charles Douglass, and he invented the laugh track.

Douglass was born in Guadalajara, Mexico, in 1910 and his family moved to Nevada when he was a child to escape political unrest. He wanted to study electrical engineering like his father, an electrician with a Nevada mining company. But when he found himself in Los Angeles after World War II, the hot new media industry for a technophile like Douglass was television. He took a job as a sound technician with CBS.

Situational comedies in the 1950s tended to be shot in simple sets in front of live audiences. Entertainment often shoehorns past habits into new formats, and indeed 1950s television was basically live radio or theater in front of a camera. But when actors forgot a line or messed up

144

their blocking, the second or third takes of the same jokes wouldn't elicit many laughs. Weak chortling made a show seem stolid when it was broadcast to audiences sitting at home. This led to the practice of "sweetening" laughs by extending or amplifying the sound of merriment in postproduction.

Douglass was interested in a bigger solution to the problem: He wanted to invent a machine to simulate laughter. This way, shows would never be fully defeated by awful writers, worse actors, dead audiences, or the vagaries of a live recording. For several months in the early 1950s, he listened to audio of laughs, gasps, and applause from several theatrical performances and television.[6] He recorded his favorite sounds of mirth on analog tape, which he could play with keys he took right off a typewriter.

The "Laff Box," as his invention came to be known, looked like a gangly bastardized typewriter, but Douglass played it like an organ. The laugh keys could be pressed together like chords to create more than a hundred variations of audience amusement. In his private studio, Douglass knew how to layer laughter for the right moment during postproduction. As a sitcom gag worked its way toward a ridiculous climax, Douglass would play early chuckles, crescendo to hearty guffaws, and finally leave the invisible audience screaming with delight. Layering in the laughs was an art, and Douglass had the only game in town.

Douglass's technology faced considerable antagonism in its early days (and high-minded doubters throughout its existence), but eventually networks realized that canned laughter had several advantages. First, it allowed directors to shoot first and add the audience later. Showrunners began to film television more like movies—inside and

6. There is a rumor, fascinating but unverified, that much of the laughter in 1960s comedy that came from Douglass's machine was recorded during the first American tour of French mime Marcel Marceau in 1955. Laughter at a mime show would be particularly precious to Douglass since the laughs would have been uncontaminated by the voices of actors.

outside, with several takes and multiple camera angles. By 1954 Douglass had so many clients that he quit his job at CBS to work full-time with his Laff Box. He owned a monopoly on mechical mirth, but he was a benevolent monopolist, scoring a single episode for just about $100.

The second reason why laugh tracks eventually caught on requires a deeper understanding of why people laugh in the first place—of what makes something *funny*.

Plato proposed that laughter was an expression of "superiority" over a person or character in a story. Superiority is clearly at work in physical humor and Borscht Belt jokes. "My doctor said I was in terrible shape. I told him I needed a second opinion. 'All right,' he said. 'You're also quite ugly.'"

But the theory of superiority fails to explain puns, which are funny, at least in theory. "Two atoms are walking down the street. One of them turns to the other and says, 'Hold up, I think I lost an electron.' The first atom replies, 'Are you sure?' The second atom shouts, 'Yes, I'm positive!'" This joke has nothing to do with power. The last word of the story arrives as a small yet meaningful surprise. But to explain what makes it funny, a broader theory is needed.

In 2010, two researchers proposed what might be the closest thing that sociology has to a universal theory of humor. It's called "Benign Violation Theory." Peter McGraw, now the director of the Humor Research Lab, and Caleb Warren, now an assistant professor of marketing at the University of Arizona, proposed that nearly all jokes are violations of norms or expectations that don't threaten violence or emotional distress.

- "A priest and a rabbi walk into a bar, and they each order a seltzer": That isn't a joke, because there's no violation of expectations.

- "A priest and a rabbi walk into a bar. They sit down to order a beer. Then they nearly kill each other over irresolvable religious differences": That's too dangerously violent for most people to laugh.

- "A priest and a rabbi walk into a bar. The bartender says, 'What is this, a joke?'": Whether or not you personally find this funny, it's clearly a joke, subverting expectations in a way that isn't purposefully cruel or violent.

"If you look at the most universal forms of laughter shared across species, when rats laugh or when dogs laugh, it's often in response to aggressive forms of play, like chasing or tickling," Warren told me (and, yes, rats can laugh). "Chasing and tickling are both the threat of an attack, but without an actual attack." By this theory, a good comedian chases with impropriety and tickles with wordplay, but does not deeply wound the audience's social mores.

Any mainstream system—social behavior, manner of speaking, identities, even logic—can be threatened or violated. But people laugh mostly when they sense that the violation is benign or safe. And what makes something seem benign or safe? *When lots of other people are laughing with you.* That was the magic of Douglass's box: It was an effective tool of safe public conformity. Hearing people laugh gave audiences license to chuckle, too.

But if the laugh track is such a universally effective tool, why is it disappearing? *Influence* was published in 1984, the year the Emmy for Best Comedy went to *Cheers*, with its riot of audience howls. Every comedy nominated for an Emmy in 1984 had live laughs or laugh tracks, too. So did every show to win the Emmy for Best Comedy going back to the early 1970s, including *All in the Family*, *M*A*S*H*, *The Mary Tyler Moore Show*, *Taxi*, and *Barney Miller*.

But in 2015, none of the comedies nominated for an Emmy had laugh tracks.[7] The last time a show with a laugh track won an Emmy for Best Comedy was *Everybody Loves Raymond* in 2005.

With their three walls and proscenium style, television shows in the 1960s and 1970s looked much more like filmed plays. But by the early twenty-first century, many television shows looked and felt like movies. Since there are no artificial guffaws in film, laugh tracks eventually seemed anachronistic and inappropriate for their genre. A 2009 study called "The Language of Laughter" found that laugh tracks decreased the "mirth behavior"[8] of TV shows that were more intricate, narratively rich, and movielike. For TV that resembles "traditional motion pictures as opposed to simplified theatrical presentations," they wrote, "the laugh track appears to be an impediment to humor and audience enjoyment"—a middlebrow marker, unfit for prestige television. So many comedies signaled their highbrow separateness by dropping canned laughs entirely. By helping television become more like the movies, Douglass created the conditions for his invention's ultimate demise.

This is the life span of the laugh track: It was conceived in controversy, grew up to become a social norm, and is dying a cliché. In other words, the laugh track was a fashion. The sound of other people laughing, which used to make people laugh, now makes many people cringe.

As I write this book in 2016, we are in the midst of several cultural trends—the glut of prestige television, the ubiquity of superhero franchises, the hegemony of hip-hop, the emerging dominance of Facebook—that are so absolute that they feel invincible, even eternal. But for decades, television executives assumed the laugh track, too, was the

7. Several popular comedies, including *The Big Bang Theory*, *2 Broke Girls*, and *Mom*, still have laugh tracks. Indeed, broadcast audiences skew older and the laugh track offers a classic comfort-food familiarity for these audiences. But among younger-skewing channels, practically none of the comedies on most cable networks, premium cable channels like HBO and Showtime, or streaming services like Netflix and Hulu currently have laugh tracks.

8. Either the best or worst term for laughter ever devised.

final free joke, a prosthetic tickle that would never fail. Its magical power was so absolute that it was hailed in one of the most read books about social psychology ever written. But its history suggests something subtler. The laugh track's social power wasn't anything like an iron law. It was more like a summer dress fashion, or a knock-knock joke. It worked once. Then it got old.

Culture doesn't stop surprising us. In fact, culture doesn't stop at all. Anything can be a fashion.

W hat is the next fashion, like names? What is an industry or custom that used to be governed by tradition but where we now see an explosion of choice? Consider one of the most basic human activities in the world: talking.

The *Homo sapiens* species has been around for about two hundred thousand years. But the oldest examples of prehistoric art date to about 50,000 BCE, suggesting that modern humans have spent far more time wandering the earth without written expression as we have spent surrounded by art and writing. After ancient cave paintings and pictograms, it took tens of thousands of years for humans to develop anything approaching an alphabet. Cuneiform in Sumeria and hieroglyphics in ancient Egypt are both dated to about 3000 BCE. In some parts of the world, language slowly evolved from ideograms, where shapes represented ideas, to phonetics, where letters represented sounds. But these early phonetic alphabets were typically all consonants, which forced outsiders to guess at the sounds between the letters. (When I studied Hebrew for my Bar Mitzvah, I was disappointed that I had to memorize the vowel sounds, as the temple's Torah was written exclusively in consonants.) It was the ancient Greeks who finally introduced the concept of a vowel, which unlocked something previously impossible: The ability of anybody to pronounce any series of sounds by deciphering scribbles.

There is a kind of magic in the idea that humans can express quasi-infinite ideas and emotions from a code consisting of twenty-six funny-looking shapes. But this enchantment was slow forming. Thousands of years passed before civilization moved from symbols representing ideas to symbols representing sounds.

Although vowels made language easier, writing remained specialized, and even controversial, for millennia. Plato, who died in the fourth century BCE, disparaged written expression in the *Phaedrus*, as he suspected that writing drained one's memories.[9] Whatever the opposite of "going viral" is, that's what writing did for the majority of its time with humans. It steadfastly refused to catch on. Literacy rates in European countries like France did not cross 50 percent until the 1800s, and half of the world could not read and write as late as 1960.

The true democratization of written language required a technology to cheaply distribute written words. But another 4,500 years passed between the first sign of hieroglyphics and the invention of the printing press by Johannes Gutenberg. The printing press, too, caused a scandal. Monk scribes were aghast about the thing, owing at least partly to the fact that it competed with their monopoly of producing books. In the pamphlet *In Praise of Scribes*, the fifteenth-century abbot Johannes Trithemius wrote, "He who ceases from zeal for writing because of printing is no true lover of the Scriptures." In the final analysis, the apparent blasphemy of the machine did not outweigh its convenience. In a piece of perfect irony, Trithemius's cri de coeur was ultimately printed, making use of the same press he demonized.[10] Thus writing, once slandered and then sacred, gave way to book printing, once slandered and then sacred.

After 1500, inventions, systems, and organizations to facilitate the

9. Which, interestingly, is the exact same fear that people have about Google and mobile apps.

10. I am reminded of this irony every time I see thousands of people "liking" a Facebook post decrying the evils of social media sites like Facebook. I wonder how demonic a medium is if it creates and connects an audience of people who argue for its demonization.

spread of written language came at a breakneck speed, relatively speaking. In 1635, the Royal Mail in Britain was made available to recipients who could pay the postage, marking Europe's first public mail service. Two centuries later, a painter named Samuel Morse received a letter by mail that notified him of his wife's tragic death. He immediately left Washington. But by the time he arrived in New Haven, she had already been buried. This reportedly inspired him to invent a faster mode of communication—the telegraph. Morse sent his first long-distance message in 1844, from Baltimore to Washington. Alexander Graham Bell placed the first phone call thirty-two years later.

Let's pause here to acknowledge that, by 1900, humans had existed for two hundred thousand years and communication was still, in many ways, an ancient custom, just as first names were until the 1800s. People talked. Sometimes they sang. People read books, mostly religious texts. Some families wrote letters, and news might be transmitted by telegraph. But even the telephone seemed like a curious intrusion into the tradition of talking, and Americans appeared to have no idea what to do with it for years. It took less than ten years for cars, radios, color TVs, VCRs, cell phones, or the Internet to go from niche to mainstream— 10 percent to 50 percent penetration—in the United States. It took the telephone almost forty years to make the same journey to the center of the mainstream.

The 1990s saw a Cambrian explosion of communications technology. The first text was sent and received in 1992 ("Merry Christmas," it said); eight years later, half the country owned a cell phone. In 1995, six in ten U.S. adults said they had never heard of the Internet or weren't sure what it was; five years later, half the country was online.

As communication choices abounded, modes of talking became fashionable—and then anachronistic. Corded and cordless phones connected teenagers in the 1990s. By the early 2000s, online chatting was the norm. Then centuries flipped, and the social media revolution erupted, with Friendster in 2002, MySpace in 2003, Facebook in 2004,

Twitter in 2006, Whatsapp in 2009, Instagram in 2010, and Snapchat in 2011. These platforms were joined by other inventions, like Vine and Yik Yak, and modern twists on pre-alphabet pictograms like emojis, GIF keyboards, and stickers. Each of these apps and features are fundamentally pictures and words in boxes. But they all have a distinct patois and cultural context, and each represents a fashionable improvement or purposeful divergence from the previous dominant technology.

Communication, once a simple custom that did not change for millennia, is now so fraught with new choices that it is becoming something more like a fashion, where preferences in how we talk to each other, what technology we use, even what "talking" means, are constantly changing. MySpace and Facebook helped to make it acceptable to post private friend-to-friend messages publicly. Instagram created a massive social network strictly around images. Snapchat Stories allow anybody to create mini-movies about their lives for their friends to watch. None of these protocols are much like talking on the phone, and yet they all feel, to their millions of users, quite naturally like talking, and sometimes even superior.

Communication-as-a-fashion is one reason why today's marketers are so embarrassingly bad in their attempts to glom onto the newest memes and strategies. The fashion changes by the time they get out the message. The 2013 Super Bowl suffered a rare power blackout, and Oreo created a sensation when it filled the dead space with a tweet inviting people to dunk their cookies in the dark. It was a legitimately surprising and clever move for a company to behave like a Twitter-savvy kid. But that was 2013. Within a few years, on-the-nose social media messages were mostly condemned as embarrassing and forced, like a dad misquoting a new teen movie in an attempt to look hip. Advertising firms are still catching up to the fact that the fashion cycle of slang moves faster than their copy desks.

Clothing, once a ritual, is now the definitive fashion. First names,

once a tradition, now follow the hype cycle of fashion lines. Communication, too, is now coming to resemble the hallmarks of a fashion, where choices emerge and preferences change, sometimes with seeming arbitrariness, as people discover new, more convenient, and more fun ways to say hello.

INTERLUDE

A Brief History of Teens

The teenager is one of the more unusual inventions of the twentieth century. Humans have been turning thirteen for tens of thousands of years, but only recently did it occur to anybody that this was a special thing, or that the bridge between childhood and adulthood deserved its own name. The term "teen-ager" dates back to the early 1900s, but the word didn't stick. Even until World War II, there are hardly any instances of "teenagers" in the popular press.

In the last few decades, however, the national media has nurtured a growing obsession with teenagers, in the sort of way that is neither lewd nor, perhaps, fully healthy. The press exhaustively tracks the apps young people use, the music they listen to, and the brands—correct spelling: *#brands*—they follow. In the last few years, the fastest-growing large companies have been software and technology firms whose first adopters are often young people who know their way around a computer, smartphone, or virtual reality app. If most ancient cultures were gerontocratic, ruled by the old, modern culture is fully teenocratic, governed by the tastes of young people, with old fogies forever playing catch-up.

The teenager emerged in the middle of the twentieth century, thanks to the confluence of three trends in education, economics, and

technology. High schools gave young people a place to build a separate culture outside the watchful eye of family. Rapid growth gave them income, either earned or taken from their parents. Cars (and, later, another mobile technology) gave them independence.

1. The rise of compulsory education

As the U.S. economy shifted from a more localized agrarian society to a mass production machine, families relocated closer to cities, and—at least initially—many sent their children to work in the factories. This triggered a countermovement to prevent kids from being forced to toil in mills.

The solution: compulsory public education for kids. Between 1920 and 1936, the share of teenagers in high school more than doubled, from about 30 percent to more than 60 percent. As young people spent more time in school, they developed their own customs in an environment away from work and family, where they could enforce their own social rules. It is impossible to imagine American teenage culture in a world where every sixteen-year-old boy is working weekends jowl-to-jowl with his father on an assembly line.

2. The postwar economic boom

A serious commercial interest in teenagers didn't begin in earnest until after World War II. To entice marketers, teenagers needed money, and that money would come from two principal sources: the labor force and parents. The 1950s saw one of the great periods of economic expansion in American history. With full employment came rising wages for unionized adults and older teenage workers.

Meanwhile, parents gradually had fewer children and spent more per child, as befits any scarce and valuable investment. Birthrates declined across the advanced world in the second half of the twentieth

century due to both the rise of female education and the legalization of the pill. Since the 1970s, the richest 20 percent of U.S. households have more than doubled their spending on childhood "enrichment," such as summer camps, sports, and tutors. As the modern marriage has come to revolve around children, young people emerged as the chief financial officers of family spending.

3. The invention of the car

It might be a horrifying consideration for today's singles, but a first date once meant an introductory chat in the living room with a girl's parents. This might have been followed by a deliciously awkward family dinner.

But cars emancipated romance from the stilted small talk of the family parlor. Just about everything a modern single person considers to be a "date" was made possible, or permissible, by the invention and normalization of car-driven romance. The fear that young men and fast cars were upending romantic norms was widespread. The chorus of the 1909 Irving Berlin song "Keep Away from the Fellow Who Owns an Automobile" is instructive:

> *Keep away from the fellow who owns an automobile*
> *He'll take you far in his motor car*
> *Too darn far from your Pa and Ma*
> *If his forty horsepower goes sixty miles an hour, say*
> *Goodbye forever, goodbye forever*

If you think Tinder and dating apps are destroying romance today, you would have hated cars in the 1900s. Cars didn't just hasten a historical shift from teenage codependence to independence. They fed the growth of a high school subculture. When buses could drive students farther from their homes, one-room schoolhouses gave way to large buildings filled with teeming hordes of adolescents and their hormones.

The fall of the farming economy and the rise of mandatory educa-
tion combined to create a teenage culture that Americans viewed with
deep anxiety. Fears of "juvenile delinquency" were bicoastal, inspiring
Hollywood films, such as *Rebel Without a Cause* and (as we'll see at
length in the next chapter) *Blackboard Jungle*, and galvanizing Wash-
ington subcommittees on the terrible problem of teens.

These forces conspired to unleash an abundance of leisure time, a
temporal vacuum that teenagers filled with experimentation. "The ab-
olition of child labor and the lengthening span of formal education have
given us a huge leisure class of the young, with animal energies never
absorbed by tasks of production," wrote one *New York Times* critic in
1957. Even in the early years of their classification, teenagers were re-
garded as cultural nomads. Rather than settle into the established ritu-
als of American society, they were roving vagabonds seeking out new
frontiers of tastes and behavior.

In 1953, J. Edgar Hoover published an FBI report warning that
"the nation can expect an appalling increase in the number of crimes
that will be committed by teenagers in the years ahead." The message
reverberated in Congress, where President Dwight Eisenhower used
his 1955 State of the Union to call for a federal legislation to "assist the
states in dealing with this nationwide problem." Fredric Wertham's in-
ternational bestseller *Seduction of the Innocent* relied on sketchy fo-
rensics and hysterical prissiness to argue that comics were a cause of
juvenile delinquency.[1] He called comic books "short courses in murder,
mayhem, robbery, rape, cannibalism, carnage, necrophilia, sex, sa-
dism, masochism, and virtually every other form of crime, degeneracy,
bestiality, and horror."

As soon as teenagers were invented, they were feared. Many social
critics made no distinction between the young car-jacking thieves and

1. On the one hand, Wertham's consideration for art's influence on young people is noble in the abstract. But
his specific recommendations were priggish in the extreme; he complained, for example, that Superman was
a fascist and Wonder Woman turned women into lesbians.

the comic readers. To an old worrywart, they were all feral gypsy sprites.

The last sixty years have made teenagers separate. But are they really so different? Or are teens just like adults—but with less money, fewer responsibilities, and no mortgage?

There is some evidence that, as many parents quietly suspect, teenagers are chemically distinct from the rest of humanity. They suffer uniquely from loosely connected frontal lobes, the decision center of the brain, and an enlarged nucleus accumbens, the pleasure center. So where adults tend to see the downsides of risky behavior in high definition, teenagers see the potential rewards as if projected onto an IMAX screen with surround sound. The result is sadly predictable: Teens take more risks and suffer more accidents. Americans between fifteen and nineteen have a mortality rate that's about three times higher than those ages five to fourteen.

For Laurence Steinberg, a career investigating the teenage mind started with a common observation that is self-evident to parents, teachers, or anybody with even the faintest memories of high school: Teenagers often act dumber around other teenagers. Steinberg, a psychologist at Temple University, put people of various ages in a simulated driving game with streets and stoplights. Adults drove the same, whether or not they had an audience. But teenagers took twice as many "chances"—like running a yellow light—when their friends were watching. Teenagers are exquisitely sensitive to the influence of their peers. The precise definition of coolness may change over time, from cigarettes to Snaps, but the deep animal need to possess it does not.

But what is *coolness*, anyway? In sociology, it is sometimes defined as a positive rebellion. It means breaking away from an illegitimate mainstream in a legitimate way. That might sound like a fussy definition. But it has its uses. My high school had a dress code, and when

you're fourteen years old, violating a repressive clothing regime is a beautifully obvious way to signal to other kids that you're noncompliant. But not always. What about sagging your slacks at a school memorial for war heroes? Or proudly untucking your shirt at a funeral for the school's favorite teacher? The same group of people can consider an outfit cool or deeply disrespectful, depending on how legitimate people view the norm that it's violating. For MAYA's sake, "cool" means Most Autonomous Yet Appropriate.

At the end of the twentieth century, many teens gravitated to logos. The long economic expansion from the 1980s and the 1990s gave them the means to spend lavishly on clothing emblems. A fashion hit like Ralph Lauren was based not only on the quality of the garment, but also on the logo's talismanic power in high school hallways. At the same time, the most popular TV shows on network and cable often featured beautiful California teenagers with sand-tousled hair, like *The O.C.* and *Laguna Beach*. Los Angeles culture beamed across the country and elevated surf-and-skate brands, like Hurley, Billabong, and Vans.

Several decades of logo fever came to an abrupt end in the Great Recession. Nearly half of families experienced a job loss, a pay cut, or reduced hours, and youth unemployment soared to almost 19 percent. The richly embroidered logos on Ralph Lauren polo shirts were suddenly unwelcome in a financial downturn, and cheaper "fast-fashion" retailers like H&M, Zara, and Uniqlo grew.

In a new age of cool, the smartphone screen displaced the embroidered logo as the focal point of teen identity. It was once sufficient to look good in a high school hallway, but today Snapchat, Facebook, and Instagram are all high school hallways, where young people perform and see performances, judge and are judged. Many decades after another mobile device, the car, helped to invent the teenager, the iPhone and its ilk offered new nimble instruments of self-expression, symbols of independence, and better ways to hook up.

And so, in half a century, teenagers went from being a newfangled

classification of awkward youth to an existential threat to American security to a valuable consumer demographic and a worthy topic of research. Teenagers are the market's neophiles, the group most likely to accept a new musical sound, a new clothing fashion, or a new technology trend. For adults, especially those with power and money, the rules are what keep you safe. When you're young, every rule is illegitimate until proven otherwise. It is precisely because they have so little to lose from the way things are that young people will continue to be the inexhaustibly neophilic motor of culture.

In the first chapters of this book, I explored how sneaky familiarity creates the aha moments that people crave from art, music, stories, and products. I tried to understand hits and popularity by thinking about individuals.

But that's only half the story. One of the lessons of teenage culture is that people don't decide what they like all by themselves. They determine coolness based on their perception of what is mainstream and what is not; what is radical and what is appropriate; what their community is doing versus what other cliques consider cool. In this way, we are all teenagers. Consumers are constantly learning, changing, and responding to the decisions of the people around them.

This makes popularity a complex system. A person can perfectly understand the formation of rain and still not be able to predict the next thunderstorm. Weather is often described as a chaotic system that makes it challenging to forecast temperature and precipitation too far in advance. The markets for cultural goods—movies, games, art, and apps—can be the same.

Any investigation of the market for hits has to begin with an appreciation of this uncertainty. Culture is chaos.

POPULARITY AND THE MARKET

ROCK AND ROLL
AND RANDOMNESS

Crickets, Chaos, and the Biggest

Hit in Rock-and-Roll History

W e're Gonna) Rock Around the Clock," the 1954 record by Bill Haley and His Comets, was the first rock-and-roll song to reach number one on the Billboard charts. With more than forty million copies sold, it is, by some counts, the second-bestselling song of all time, after Bing Crosby's "White Christmas." Sixty years after its release, the hook seems congenitally catchy, and if you can listen for fifteen seconds without bouncing your head or tapping your foot, you deserve some sort of Mischelian prize for self-control.

But the full history of "Rock Around the Clock" suggests that the song is best thought of not as an obvious world-conquering hit, but as the world's biggest fluke. Its luck nearly strains credulity and suggests that even the biggest hits often need the light touch of fortune's tailwind.

William Haley, Jr., grew up in a poor musical family. His father, William Senior, was a mechanic who played the banjo, and his mother, Maude, gave piano lessons in their home. Blind in his left eye since

childhood, William Junior was shy, and even his most flamboyant attribute from his adult years, the prominent kiss curl in his hair, was reportedly done to divert attention away from his eye.

When Haley was thirteen, his father bought him a used guitar for Christmas, and a love affair began. Despite his poor sight, Haley mastered the instrument and spent his teenage years yodeling in several country bands. Haley's dream, to tour the country singing hillbilly ballads of cowboys, appeared hopeless from the get-go. He moved home in his twenties, dead broke, and settled into a new career as the musical director for a radio station in Pennsylvania. Not quite done writing music, however, Haley used his position to meet new artists and soak up ideas for songs. He started several bands, including a western swing group called the Saddlemen.

Haley loved country-western music, and he gradually learned to blend the influences of his childhood—the hillbilly twang, the cowboy-country swagger, and the new "race music," so called because it was mostly played by black bands, like the Orioles, who pushed the boundaries of rhythm and blues. When a radio music director heard Bill Halley and the Saddlemen, he suggested a cooler name for the band. With a "Haley" leading the group, he suggested, why not something related to the celestial rock of the same name? The band changed their name to Bill Haley and His Comets.

Their first hit came in 1952 with "Crazy Man, Crazy," a largely forgotten and simple-as-pie tune that has the distinction of being the first rock-and-roll song to chart on Billboard. But Haley was eager to push the tempo. In 1953 he brought the song "Rock Around the Clock" to his label, Essex Records. Dave Miller, the label's founder, wouldn't let him record it. In fact, Miller was so confident it was a dud that on numerous occasions he ripped up the music in front of Haley to seal his case.

Haley took the song to a rival label, Decca Records, which agreed to record "Rock Around the Clock" under one condition. The Comets would have to record another song first: "Thirteen Women (And

Only One Man in Town)," a regrettable song about a man who becomes the custodian of a harem of women after a hydrogen bomb destroys the world. Haley agreed to do it. A studio recording date was set for April 12, 1954, in a converted Masonic Temple on Seventieth Street in New York City.

The session was scheduled to begin at eleven a.m. sharp. At eleven thirty, the Comets were nowhere to be seen. In fact, they weren't even in the state of New York.

Several hundred miles north, Haley and his band were on the Chester-Bridgeport ferry, which had breached a sand bar in the Delaware River. After a tugboat nudged the ferry out of the muck, Haley drove like a demon down to New York City and arrived at the temple two hours late, just after one p.m. "The next time we have a recording date," one producer suggested, "take the bridge."

The band unpacked their instruments and set up on the stage. After more than an hour of rehearsal, they played three takes of "Thirteen Women." The producers weren't satisfied. They played the song three more times.

The studio session was scheduled to end at five, and by four twenty, they still hadn't played a second of "Rock Around the Clock." The first take was loud and energetic, a blissful eruption of controlled chaos. The song was so brief that a guitar solo was required to make it at least two minutes long. The guitarist Danny Cedrone didn't have time to devise and master a new riff. So for the first take, he copied, literally note for note, a fifteen-second solo he had played on Bill Haley's 1952 song "Rock the Joint."[1]

When the first take ended, the producers played it back. It was a mess. The Comets' instruments were ear-splitting, pushing the needle deep in the red zone. Haley's voice was almost inaudible. Selling a pop

1. Compare the fifteen-second guitar solo between 0:33 and 0:48 on "Rock the Joint" with the fifteen-second guitar solo between 0:44 and 0:59 on "Rock Around the Clock." It is, essentially note for note, the same passage.

song without a vocalist would be a heavy lift, even for a large music label. But it was almost five p.m. The studio session was practically over. There was no time left to fix the microphones.

The producers offered a solution: The band could play the song one more time, but they would turn off the mikes on the instruments. The record would be all on Haley; he would have one shot to nail the vocals.

The second take ended without any obvious errors. After five p.m., Haley and his band packed up their instruments. The Comets had no idea if the recording was usable. But producers synchronized the two tapes, and the final record was ready to be shipped within a month. It must have felt like a small miracle to Haley; after years of begging labels, his perseverance was rewarded and the song was finally put to wax.

But any relief was short-lived. "Rock Around the Clock" appeared on the B-side to "Thirteen Women," and it was forgotten almost as quickly as it was recorded.

Decca mailed thousands of copies of "Rock Around the Clock" to movie studios and producers around the country and paid for several splashy ads in magazines, like *Billboard* and *Variety*. In May 1954, *Billboard* noted the song with a tepid endorsement: "Big beat and repetitious blues lyric makes this a good attempt at 'cat music' and one which should grab coin in the right locations." The record did not quite flop—it spent exactly one week on the *Billboard* charts—but it was light-years from being any sort of hit. In 1953, "Crazy Man, Crazy" had sold 750,000 copies. In 1954, "Rock Around the Clock" reached exactly one-tenth of that total—just seventy-five thousand records sold.

In a way, we've reached the end of the story. "Rock Around the Clock" was a mediocre B-side of a middling record. It did not fail for lack of exposure. It received major label and magazine marketing, went to thousands of disc jockeys, played on many radio stations in May 1954, and had appeared on the *Billboard* charts for one week. Then, by

July, it was gone, one of so many disks tossed in so many dustbins among the anonymous detritus of pop culture history.

"Rock Around the Clock" had its chance. It failed.

D uncan Watts doesn't believe in stories. He prefers chaos.

A network theory scientist at Microsoft, Watts trusts computer generations over explanations and he discounts anecdotes that sound too interesting. He's one of the worst people to talk to if you're trying to write a cohesive book about success in cultural markets as told through interesting examples. So, out of doubt, self-loathing, or some less discernible masochistic instinct, I decided to meet with him for several hours and devote a chapter to his ideas. [2]

Tall and square-jawed, with blue eyes behind rectangular frames, Watts is a former Australian Defence Force cadet. He went to Cornell to get his PhD in chaos theory in the mid-1990s only to discover, to his disappointment, that people were sort of over chaos. He arrived at his program a few years after author James Gleick had published his popular book on the subject, *Chaos*. "You know all the low-hanging fruit in a subject has been picked if somebody's writing a mass-market book about it," he told me, twisting a knife.

Forced to search outside physics for a satisfyingly chaotic subject in graduate school, Watts became interested in many of the same big questions I'm trying to answer, like why people like what they like, why large groups of people do what they do, and how popularity spreads. Rather than start with designers and songwriters, however, Watts thought about crickets.

"I got interested first in biology, and I started thinking about net-

2. Watts and I spoke multiple times during the writing of this book, and I've tried to be careful in my drafting to select stories that illustrate the most universally established and retested principles—like exposure effect—rather than go about things in the opposite way, by finding stories that are interesting and then hunting for theories to shoehorn inside them.

works of crickets and how they synchronize their chirping," he told me. Watts was fascinated by networks of critters, but the larger question he was seeking was about networks of people, like how something can start small—say, a fashion, like the name Emma—and grow into a mainstream movement, as widespread and synchronized as a field of insects chirping in harmony.

Around the same time, Watts was on the phone with his dad, who asked if he'd ever heard of this idea that everyone in the world is connected to the president of the United States by just six handshakes. It was 1995, and Watts hadn't heard the theory before. He didn't know if it was obviously true or obviously false. But he started to think that crickets and the six degrees of separation were two parts of the same story. He wondered whether social contagions—like cricket sounds, clothing fashions, and pop culture hits—might be governed by the rules of mass behavior. Perhaps the fundamental question of hits isn't "Why do we like what we like?" but rather "How does what *you* like become what *I* like?"

One reason why I like Watts—even though, in our meeting, he relished poking holes in some of my theories—is that he is completely unsentimental about why some products succeed, and he's very good at explaining the pitfalls of sentimental explanations. One of his best attacks on wooly-headed thinking is his take on the *Mona Lisa* as the most popular painting in the world.

Today there is little doubt about the rarefied air of Leonardo da Vinci's portrait. The *Mona Lisa* is the world's most treasured painting, literally: It holds the Guinness World Record for the most expensive insurance policy on any art piece. In 1973, the art critic Kenneth Clark called the *Mona Lisa* the "supreme example of perfection," saying it deserved its title as the most famous painting in the world. But in the nineteenth century, it wasn't even the most famous painting in its museum, the Louvre in Paris. The historian Donald Sassoon reported that, in 1849, the *Mona Lisa* was valued at 90,000 francs. That's a tidy

sum, but not even close to Titian's *Supper at Emmaus* (150,000 francs at the time) or Raphael's *The Holy Family* (600,000 francs), which hung in the same museum.

The *Mona Lisa*'s fame got an assist from a dim-witted thief. On August 11, 1911, a Monday, Vincenzo Peruggia, an unemployed Italian painter, walked into the Louvre and left with the *Mona Lisa*. French newspapers were aghast at the theft and indignantly proclaimed the painting's historic significance. The *Mona Lisa* went missing for several years, until Peruggia—stuck with an expensive artwork whose sale would inevitably lead to his apprehension—tried to hawk the painting in Florence and was duly apprehended. The recovery of the *Mona Lisa* and its return to France was an international sensation.

Several years after the painting's recovery, in 1919, the modernist Marcel Duchamp made a replica of the *Mona Lisa* with a mustache. He called it *L.H.O.O.Q.*, which, if you pronounce the letters in French, is a homophone for something naughty.[3] Defiling the placid smile of the *Mona Lisa* struck a lot of other painters as an inexhaustibly funny idea. So in the last century some of the most famous painters—including Jasper Johns, Robert Rauschenberg, René Magritte, Salvador Dalí, and Andy Warhol—made their own *Mona Lisa* parodies. Her face is everywhere now—on coasters, magazine covers, book covers, movies posters, and trinkets. Critics explaining why the *Mona Lisa* is the most famous painting in history often don't account for the fact that, for most of its history, *it wasn't*. As a result, they end up saying something like: "The *Mona Lisa* is the most famous painting in the world because it has all of the qualities of the *Mona Lisa*."

This is the sort of explanation that drives Watts truly bonkers. He bemoans the many analysts, trend spotters, and journalists who claim to understand exactly why some things succeed, but only after their success is obvious to everybody. He would have us beware those who

3. Read aloud in French, the letters are *"ell-ahsh-oh-oh-koo,"* which sounds quite a lot like *"Elle a chaud au cul,"* or "She is hot in the ass."

claim they can predict the future but offer only retrospective proof of their powers.[4]

Watts is an expert on "information cascades." A cascade is the map of an idea catching on. A global cascade is the map of an idea that's spread far and wide, a massive tree sprouted from a tiny seed. In the real world, global cascades can include both surprise hits, like the tiny stuffed-animal Beanie Babies, and all too predictable hits, like a successful *Star Wars* sequel. Hits and cascades come in all sizes, but they have the same thing in common: Everything starts at zero.

To watch how ideas go from zero to a million, Watts designed a model universe with thousands of people—or *nodes*, as he calls them—connected to other people. Let's call it Watts World. In Watts World, each person, or node, has two variables: vulnerability (how likely each person is to adopt a new behavior) and density (how many people are connected to each other). Watts triggered these networks of varying vulnerability and density over and over, millions of times, to watch trends spread to millions of people or, more often, not spread at all.

The first thing he realized was that there are Goldilocks zones of vulnerability and density. It's worthless to advertise to an older person who literally never changes her habits ("low vulnerability") or to a Siberian hermit ("low density"). But the opposite poles are also problematic. Let's say you're equally susceptible to an ad from Bloomingdale's, the Gap, and every other clothing outlet you see. This makes you a terrible bet for any one brand because you're constantly changing your mind. A consumer who is hypervulnerable to *every* influence is no more reliable than a consumer who is impervious to all influence.

Watts discovered a peculiar point in his network where cascades were incredibly rare but extremely large. Nine hundred and ninety-nine

4. In the 2004 movie *Mean Girls*, the dimwitted Karen Smith, played by Amanda Seyfried, claimed to have "ESPN" (*sic*) because her breasts could always predict when it was going to rain. Pressed for evidence of her gift, she clarified: "Well, they [the breasts] can tell when it's raining." Perhaps scientists like Watts consider many allegedly prescient writers to have similarly dubious talents: They can predict the rain only after their shirts are wet.

times out of one thousand in this particular Watts World, nothing would happen. But in that one-in-one-thousand moment, the entire network would light up—a massive global cascade.

"Huh, that's very interesting," I said.

"It's math," he responded. If a trigger has a 0.1 percent chance of becoming a global cascade, it will create at least a few global cascades if given thousands of chances. That's just how math works.

But imagine what it would be like to live in that 0.1 percent world. Imagine being a journalist, like me, paid to pretend that I understand why everything in that 0.1 percent world happens. I might see a massive out-of-nowhere success—like the indie film *My Big Fat Greek Wedding* or the Korean pop song "Gangnam Style"—and be tempted to explain the improbable event as if it were inevitable.

"When journalists see products succeed, they always want to explain the inevitability of the success," Watts said. "They ask, 'What were the characteristics of the successful thing?' and then they decide that all these characteristics must be very special.[5] Or they try to find patient zero, the person who started the trend, because they decide *he* must be very special." This sort of thinking creates a worthless gospel of success, Watts says. If a dinosaur movie succeeds in May, a thousand articles are written to claim there is something special about the allure of dinosaurs (even if a dinosaur movie just failed in January). If a Belize musician hits it big in 2016, some writers will decide there must be something intrinsically appealing about Belizean music (even if it's the only Belizean hit of the century).

But thinking in probabilities is awfully abstract, and often impossible. Forecasters can say there is a 50 percent chance of rain tonight, or that a movie has a 10 percent chance of making $100 million in its first weekend; and there can be a significant amount of intelligence built

5. What Watts is describing here could fall under various categories, discussed in Daniel Kahneman's *Thinking, Fast and Slow*, in particular hindsight bias: "I knew it all along" or "If it happened, it was the most likely outcome."

into these calculations. But ultimately, it either rains or it does not. The movie makes $100 million, or it doesn't. Probabilities are intuitive for events that happen many times over. You can flip a coin until your fingers are numb, and the share of heads and tails will eventually approach fifty-fifty. But life is one giant roulette wheel that only spins around once for each person.

So most people don't think in percentages. They process the world in stories—actions and reactions; causes and outcomes; *post hoc, ergo propter hoc.* Any story is better than chaos. In fact, one might say that the chaos of life is a chronic condition for which stories are the remedy.

In Watts World, the same product can become a smash hit or a dud in nearly equivalent circumstances. It's just a matter of math, timing, and luck.

For example, sometimes a rock song comes out on the radio in 1954, and tens of thousands of Americans hear it and don't buy the record. Just like "Rock Around the Clock."

Then, in 1955, the song comes out again, for a slightly different audience in a new medium. The context shifts, a chain reaction of improbable events occurs, and the song that a nation once ignored becomes the national anthem of rock and roll. Just like "Rock Around the Clock."

One of the seventy-five thousand people who bought the "Rock Around the Clock" record was a young boy in Beverly Hills named Peter Ford. He came from a family of wide musical talents and kaleidoscopic tastes. His mother, Eleanor Powell, was a celebrated tap dancer who listened to the "King of Swing," Benny Goodman, and jazz; his father, Glenn Ford, was a movie star with a penchant for Hawaiian tunes. But young Peter, seeking his own niche, immersed himself in black bands and "race music."

Peter didn't have many friends visiting him at their five-acre prop-

erty, but music was his refuge. Late at night, he huddled alone listening to Hunter Hancock, the first DJ to play rhythm and blues, on Los Angeles stations KFVD and KFOX. His mother would indulge him with frequent drives to the Beverly Hills music shop, where he would scoop up armfuls of vinyl, most of them by black men, the true originators of R&B and rock and roll: the Kings of Rhythm, Johnny Ace, the Orioles, the Crows, the Flamingos, the Larks . . . "If it had a bird in the name, it was for me," Ford told me.

The Ford family lived in a twenty-room house in Beverly Hills that had previously belonged to Max Steiner, the Hollywood composer who'd scored *Casablanca* and *Gone with the Wind*. The home's jewel was the China Room: a four-hundred-square-foot music room decked out with the latest high-fidelity technology by Steiner. The walls gleamed with gold leaf and wide Chinese murals ran the length of a wall with rivers snaking between skinny green hills. Three-foot-tall speakers anchored two corners of the room, and Peter Ford would sit on a green chintz couch and listen to the bird bands.

In 1954, on one of countless trips to the Beverly Hills music store, a nine-year-old Peter Ford bought a Decca-released 78 record with the A-side song "Thirteen Women (And Only One Man in Town)." He hated it.

"I thought it was terrible," Ford told me, laughing. "I mean, I really, really hated it. But then I turned the record over and found 'Rock Around the Clock.' I thought it was a good song with a great drumbeat. But I can't say that it was one of my favorites. I was more into the Orioles."

A few months later, his father, Glenn Ford, was filming a new movie about inner-city students called *Blackboard Jungle*. One afternoon, near the end of filming, the movie's director, Richard Brooks, visited the house. Glenn made him a drink and they talked about the movie's scoring. Brooks told him he was looking for an upbeat song to kick off the movie, a jump-jive tune that would instinctively evoke a generation

on edge. Glenn told Brooks that his son had gotten into some edgy music and might have some records to share.

"I took Dick Brooks and my parents into the music room, and Dick said, 'Whaddaya got?'" Ford recounted. "I gave him a handful of records: something by Joe Houston, Jake Turner's 'Shake, Rattle and Roll,' and Bill Haley and His Comets' 'Rock Around the Clock.'"

What happened next burns vividly in Ford's memory and in the national consciousness; it is in many ways the birthday of rock and roll as a mainstream American movement. "Three days before my tenth birthday, *Blackboard Jungle* played a sneak preview on February 2, at the Encino Theater," he said. "I was there with my dad." The movie started with a written preface, over the sound of a drum:

> *We, in the United States, are fortunate to have a school system that is a tribute to our communities and to our faith in American youth.*
>
> *Today we are concerned with juvenile delinquency—its causes and its effects. We are especially concerned when this delinquency boils over into our schools.*
>
> *The scenes and incidents depicted here are fictional.*
>
> *However, we believe that public awareness is a first step toward a remedy for any problem.*
>
> *It is in this spirit and with this faith that* Blackboard Jungle *was produced.*

At this very moment, Bill Haley's famous count began: [*ba-dum*] "*One, two, three o'clock, four o'clock, rock!*" On the downbeat, the words *Blackboard Jungle* flashed on the screen. The young boy was electrified: His record had made its way to the opening sequence of a major Hollywood film.

"The breakout success of 'Rock Around the Clock' had everything to do with its placement at the beginning of the film *Blackboard Jungle*," said Jim Dawson, author of *Rock Around the Clock: The Record That Started the Rock Revolution*. The reaction to *Blackboard Jungle* was something like hysteria—not just among teenagers, but also among their parents and politicians. Kids danced in the aisles of movie theaters and blasted the song from their cars. On May 17 1955, the *Philadelphia Inquirer* reported that Princeton University dorms held a competition to play the song as loudly as possible from their rooms. Around midnight, the students emptied into the quads, set fires to trashcans, and chanted up and down the streets. Meanwhile, several major American cities censored the film. The mayor of Memphis forbade teenagers to see it, while Atlanta tried to ban the movie after an alderman's wife said it threatened the "peace, health, morals, and good order of this city."

Just as *l'affaire Caillebotte* consecrated impressionism through scandal in the 1890s, *Blackboard Jungle*'s notoriety promoted its opening track, unleashing the rock-and-roll genre. On July 2, 1955, three months after *Blackboard Jungle* debuted, "Rock Around the Clock" became the top-selling single in the country and the first song called "rock 'n' roll" to reach number one on the Billboard charts, ultimately selling more physical copies than any song by Elvis Presley, the Beatles, Madonna, or Michael Jackson.[6]

One of the laws of chaos is that a microscopic change in the present trajectory can lead to wildly different future outcomes; the Brazilian butterfly shakes her wings, and a Pacific typhoon forms off the coast of

6. In an advertisement in *Weekly Variety*, on September 21, 1955, Decca thanked disc jockeys for getting "Rock Around the Clock" to "over two million in record sales." At the bottom of the page, however, the label also implored DJs to play its new release, "Razzle Dazzle," which it complained "has been smothered by 'Rock Around the Clock.'" As we saw in Chapter 3, twentieth-century music hits often rose and fell off the charts quickly because the music labels were biased toward churn and strongly encouraged DJs to play new music. Here is a perfect example: In September 1955, just months after the release of *Blackboard Jungle*, Decca grumbled—in a full-page ad for Bill Haley, no less!—that his hit was "smothering" their other releases.

Indonesia. The most popular melodies of 1954 and 1955 were dulcet waltzes next to the high-tempo hits of the later 1950s. Billboard's number one songs before and after "Rock Around the Clock" were the schmaltzy "Unchained Melody" and the minstrel ballad "Yellow Rose of Texas," which sounds like it could have been written in the 1850s.

Haley's brief usurpation of the charts foretold a later overthrow of the system. By the end of the decade, rock and roll had conquered pop music, bringing with it several cultural and political shifts. First, the center of gravity in pop music shifted from the songs to the stars themselves. The pop icons of the first half of the twentieth century, like Frank Sinatra or Bing Crosby, were famous for musical renditions of common songs that families could play at home with sheet music. They were expert *interpreters*. But the pop stars of the 1960s were bands and artists, like the Beatles and the Rolling Stones, who wrote, played, and were synonymous with almost all of their own music. The rock revolution meant nothing less than the dawn of the age of modern pop star.

Second, the rise of rock shook American culture in a decade otherwise known for its languid complacency. It's well known that white bands mainstreamed a genre created by black musicians. But the creative exploitation of black artists was even more explicit than that: The most popular songs of the 1950s were often white covers of melodies originally performed by black artists, like "Sincerely" by the McGuire Sisters (originally by the Moonglows) and "Ko Ko Mo" by Perry Como (originally by Gene & Eunice). In 1955, Billboard finally declared "the emergence of the Negro as a pop artist in the disk field"; but, like Billboard's 1991 consecration of hip-hop, this was a rather tardy acknowledgment of something that had been true for a decade or more.

As the rock-and-roll pantheon became crowded with Elvis Presley, Chuck Berry, and Buddy Holly, critics still referred to it as "jungle music." The magazine *True Strange* featured Haley on a 1957 cover with an illustration of several naked African tribesman dancing and beating drums. This was not just adults pooh-poohing loud music and

performative hip gyrations. The music itself was an omen that white America was losing its cultural monopoly, and even suburban families would be forced to confront elements of a black culture that many did not want to acknowledge.

It is hard to imagine a world where *Blackboard Jungle* was never made and rock and roll never had its moment of mass consecration. What does pop music sound like in 1965—or 2015, for that matter? When some products hit, they don't just leave a mark; they sunder the landscape, change the atmosphere, usher in the extinction of an old order. "Rock Around the Clock" was a cultural asteroid. It didn't just make contact with the earth. It killed the dinosaurs.

"Rock Around the Clock" is a story of great songwriting, the broadcast power of film, and the crucible of 1950s teenage culture. But it is also a story of mind-boggling luck. Every person who listens to "Rock Around the Clock" hears the same notes, words, and syncopation. Audiences in 1954 heard a forgettable song. Audiences in 1955 heard the hit of the century. One song, two slightly different broadcasts, two extremely different outcomes. Sounds like a tune that a chaos theorist might sing.

I n 1996, the economists Arthur De Vany and David Walls studied the box office returns of about three hundred movies released in the 1980s to uncover patterns in audience behavior. What they found, however, was something more like the absence of a pattern. "Movies are complex products," they wrote in a follow-up paper, "and the cascade of information among filmgoers during the course of a film's run can evolve along so many paths that it is impossible to attribute the success of a movie to individual causal factors."

In short, Hollywood is chaos.

Success in Hollywood does not follow a normal distribution, with many films earning the box office average. Instead, movies follow a

power law distribution, which means most of the winnings come from a tiny minority of films. The best way to imagine a power law market is to think of a lottery. The vast majority of people win nothing, and a few people win millions of dollars. So it makes little sense to talk about the "average" lottery outcome. It's the same in Hollywood. Hollywood's six major studios released just over one hundred movies in 2015. The five most successful films accounted for 22 percent of the total box office.

What is the best way to understand a market both filled with flops and driven by hits?

Al Greco, a professor of marketing at Fordham University and an expert in book publishing, summarizes the entertainment business this way: "A complex, adaptive, semi-chaotic industry with Bose-Einstein distribution dynamics and Pareto power law characteristics with dual-sided uncertainty." That is quite the disfluent multisyllabic mouthful, but it's worth breaking down word by word:

- **"Complex":** Every year, there are hundreds of movies released to billions of potential viewers, who are watching ads, reading critics, and mimicking each other to decide what movie ticket they will buy next. In the short run, the best indication of next week's movie sales is this week's movie sales. But since everybody is constantly influencing everybody else, predicting the distant-future box office of a movie is like predicting the final resting place of sixteen billiard balls crisscrossing a table and smacking into each other.

- **"Adaptive":** When a book in one genre succeeds—e.g., porny romance, dystopian young adult fiction, or nonfiction pop psychology books—the rest of the industry will adapt to copy it. But aggressive mimicking will eventually chase away the trend, rendering it obsolete by the time some adaptive prod-

ucts hit the market. Paying through the nose for A-list stars seemed like the best bet in 1980s and 1990s Hollywood, and superstar salaries entered a period of hyperinflation, until a few flops, like 1993's *Last Action Hero*, starring Arnold Schwarzenegger, shattered the Hollywood religion that superstars could carry any film. On television, viewers recently witnessed this sort of clustering effect in the dark-and-disturbed male antihero genre. At the moment, comic book heroes seem rather immortal, but there is no way that comics are the final evolution of film. In this way, all hits can ironically sow the seeds of their own demise, as over-imitation ultimately renders the trend obsolete.

- **"Semi-chaotic industry with Bose-Einstein distribution dynamics":** One hundred years ago, scientists Satyendra Nath Bose and Albert Einstein concluded that gas molecules in sealed containers would aggressively cluster at a time and place that was impossible to predict with certainty. Consider it a metaphor for pop culture, with consumers playing the role of gas molecules. At some point in time, they will cluster around an unforeseeable cultural product by buying the same book or attending the same movie. Recall Duncan Watts's big idea: Like a massive earthquake, some "global cascades" are mathematically inevitable, but they are also impossible to predict too far ahead of time.

- **"Pareto's power law characteristics":** Vilfredo Pareto, an Italian economist, is credited with discovering that income within a country follows a "power law," such that 80 percent of wealth is held by 20 percent of the population. This Pareto principle has been extended to mean that 80 percent of sales often comes from 20 percent of products. In the movie sample De

Vany studied, one fifth of the movies took four fifths of the box office. In book publishing, more like 90 percent of revenues come from about 10 percent of books. In digital markets, it's even worse: 60 percent of all app store revenue comes from just 0.005 percent of companies. For hit makers, the vast majority of bets are failures. The difference between a great year and a terrible year in publishing might come down to a tiny minority of deals.

- **"Dual-sided uncertainty":** Screenwriters and producers don't know what viewers want to watch in two years. Viewers don't know what movies are coming out in two years, nor do they have perfect information about what they want to see. And yet Hollywood is in the business of predicting what audiences want many years in the future, even though most people couldn't even say for sure, even if you asked them.

If this makes the business of hits seem hopeless, then good. Making complex products for people who don't know what they want—and who aggressively cluster around bizarrely popular products if a couple of their friends do the same—is unbelievably difficult work. It's important to appreciate the stress inherent to being a creator, an entrepreneur, a music label, a movie studio, a media company. People are mysterious and markets are chaos. Is it any surprise that most creativity is failure?

One solution for taming the chaos is to own the channels of distribution. Making music is less risky when you can bribe radio stations to play your songs. So the music labels tried exactly that for decades, until the federal government deemed the practice unlawful with the FCC "payola rules." Making movies is less risky when you own the

theaters that play the films. So the film studios in fact owned many of the cinemas for decades, until the Supreme Court decided, in 1948, that this constituted an anticompetitive oligopoly, bringing an end to the Hollywood studio system. The problem with owning too much distribution isn't that it doesn't work. Rather, it works so well that it's illegal.

The next best solution is to surround audiences with advertising to ensure that every consumer who might be interested in a new product is aware of it. Americans bought almost thirty movie tickets a year in the 1940s. These days they buy about four. How could studios wrangle this newly fickle crowd into movie theaters? It would have to turn movies into national blockbuster events—lavish productions buoyed by monstrous marketing budgets with nonstop commercial and posters plastered on every square inch of the country. In a 1997 economic paper, De Vany said movie studios could reduce the risk of failure through "unprecedented promotional expenses." And that's exactly what they did. The number of major-studio films has fallen in the last two decades while marketing costs have soared. In 1980, the major studios spent less than 20 cents on advertising for every $1 they earned at the box office. Now they spend 60 cents to get that buck.

Finally, Hollywood has taken a lesson from the second chapter of this book and created original products rooted in familiarity—sequels, adaptations, and reboots of well-known properties. In the last twenty years, Hollywood's core strategy has shifted toward multi-sequel franchises, particularly with superheroes at the center. In 1996, none of the ten biggest films were sequels or superhero movies (e.g., *Independence Day*, *Twister*, and *The First Wives Club*), and films based on comics accounted for just 0.69 percent of the box office. In each year so far this decade, most of the ten top-grossing films were sequels, prequels, or reboots. Of the first 371 movies released in 2016, just four superhero

films—*Captain America: Civil War, Deadpool, Batman v. Superman,* and *X-Men: Apocalypse*—accounted for 29 percent of the total box office. In a way, Hollywood has taken a lesson from old-fashioned serials (or modern television): If you find a story that clicks, keep churning out new episodes.

The franchise strategy, which prizes familiarity and "preawareness" of characters and stories, is a commercial solution to the chaotic nature of art. But it's also a direct response to the globalization of movies. Americans are on pace to buy fewer tickets per person this decade than at any time since the invention of film. Meanwhile, almost the entire growth in global box office is happening in eastern Asia and Latin America. The rise of a global crowd encourages studios to produce visual Rosetta Stones, single stories interpretable for many tongues. There is no language in the world more universal than heroes destroying bad guys, with the help of explosions.

The franchise strategy might be a prudent way to mitigate the uncertainty of the moviemaking process. But it carries specific negative consequences, both creative and financial. Writers who observe Hollywood's abandoning of smart, complex dramas for superhero franchises have moved on to television. It's not a coincidence that the "golden age of TV" coincided with the "franchise age of movies." The number of scripted dramas on television (including streaming sites like Netflix and Hulu) increased from about one hundred in the late 1990s to more than four hundred in 2015. By teaching audiences to see only the movies with the biggest marketing campaigns, studios risk impoverishing smaller films and pushing their future auteurs into the welcoming arms of TV executives. What's more, the blockbuster strategy guarantees that the flops will be spectacular—and, for film executives, devastating. All but three of the thirty biggest box office bombs in Hollywood history were released since 2005.

As they say in baseball: *Live by the long ball, die by the long ball.* Sooner or later, chaos wins.

Blackboard Jungle was a notorious film with an impressive box office. But it wasn't quite a blockbuster.

The movie's 1955 box office gross made it the thirteenth most popular film of the year behind *Cinerama Holiday, Mister Roberts, Battle Cry, Oklahoma!, Guys and Dolls, Lady and the Tramp, Strategic Air Command, Not as a Stranger, To Hell and Back, The Sea Chase, The Seven Year Itch,* and *The Tall Men.* If you've heard of five of those twelve movies, you have me beat. And yet they were all more popular than the film that launched the bestselling rock song of all time.

There is no statistical model in the world to forecast that the forgotten B-side of a middling record played over the credits of the thirteenth most popular movie of any year will automatically become the most popular rock-and-roll song of all time.

The business of creativity is a game of chance—a complex, adaptive, semi-chaotic game with Bose-Einstein distribution dynamics and Pareto's power law characteristics with dual-sided uncertainty. You, the creator, are making something that doesn't exist for an audience that cannot say if they will like it beforehand.

Dealing with this sort of uncertainty requires more than good ideas, brilliant execution, and powerful marketing (although it often requires those things, too). It also begs for a gospel of perseverance through inevitable failure. It's like Duncan Watts said: If a trigger has a 1 percent chance of becoming a global cascade, it should create at least a few hits—*if* given hundreds of chances. There is no antidote to the chaos of creative markets, only the brute doggedness to endure it.

Bill Haley was that kind of brute. By all accounts, he should have never been in that recording studio. He was a cowboy yodeler with a fat-boned jaw unsuited to the burgeoning age of television. His label had refused the song. His ferry got stuck in a mud bank. His recording session was a disaster. A reasonable man might have given up.

But Haley was unreasonable. He left his label, negotiated for precious studio minutes with another company, raced to a New York City studio, and spent hours recording a song he didn't like just to have one hundred and thirty seconds to nail the song he loved.

So when you think about Haley, you should consider his surpassingly lucky break. But if you can hold it in your head next to Einstein, Pareto, and probabilities, think of this, too: a half-blind kid who taught himself guitar, followed his cowboy-western dreams through a thousand failed experiments just to get his turn inside a Masonic temple on April 12, 1954. And there, with just one shot to sing the melody that sold forty million records, he summoned his tired voice and counted up from "one."

THE VIRAL MYTH

Fifty Shades of Grey *and the Truth*

About Why Some Hits Get So Big

The world's most popular erotic website for women is not what most people would consider an erotic site at all. It's FanFiction.net, a massive online campfire where amateur writers swap adaptations of popular stories, sometimes with a bit of sexual fantasy mixed into the plot. The most popular inspiration for the site's fan fiction includes the Harry Potter books, *Naruto,* a Japanese comic series about a young ninja, and the television shows *Glee* and *Doctor Who.* But perhaps the site's most famous contribution to pop culture started with the *Twilight* series.

For many years, FanFiction writers played with *Twilight*'s romance between Bella Swan, a sullen teenage girl, and Edward Cullen, a beautiful love-struck vampire, remixing it with several genres and gradually introducing graphic sex as a key plot element. The online fanfic universe was a hallmark of this new age of hits. It was both massive, with hundreds of thousands of writers and readers, and mostly invisible to much of the outside world. It wouldn't stay invisible forever.

One of the most popular fanfic writers in the *Twilight* genre was Erika Leonard, a working mother of two near Ealing, a northwest suburb of London. In November 2008, Leonard watched the movie adaptation of *Twilight* and was utterly entranced. She bought all four books in the series and read them in a five-day binge over the Christmas holidays. "It was one of the best vacations I ever had," she told me.

In her early thirties, Leonard was an avid, if slightly embarrassed, devotee of romance novels. On the train to central London, she read "hundreds" of them, demurely folding back the jackets to hide the image on the cover—often a young woman, dressed in something less than Tube-appropriate attire, fainting into the arms of a comically sinewy man. More recently, she had been drawn to erotic fiction, like *Macho Sluts*, a 1988 collection of short stories by Pat Califa, which often featured sadomasochistic lesbian sex.

In 2009, Leonard signed up for FanFiction.net, which prompted her to select a pen name. When her first choices were unavailable, she thought of her favorite British cartoon from childhood, *Noggin the Nog*, and the stories' friendly ice dragon Grolliffe. She typed in the name Snowqueens Icedragon, and it took.

The world of *Twilight* fanfic was a menagerie of styles and genres, recasting the protagonist Edward as a quiet dork, lame dad, dominant sex god, submissive artist, tattoo-covered ruffian, or refined Oxbridge executive. Leonard was drawn to the BDSM interpretations, particularly those with an office setting. Within a few months, it became clear that the writer FanFiction readers often called "Icy" had a golden ear for the most tantalizing and raunchy motifs. Her work, originally titled *Master of the Universe*, cast Edward as a CEO with a flair for bondage.

As George Lucas showed in the 1970s, the most successful storytellers are often collage artists, bringing together never-before-assembled allusions to create a story that is both surprising and familiar. Leonard's

stories were certifiable blockbusters, fetching more than fifty thousand comments on FanFiction.net and more than five million readers.

One of her biggest fans on the site was an Australian writer named Amanda Hayward. They met over Twitter in early 2010 and exchanged messages. In October of that year, Hayward launched the Writer's Coffee Shop, a small digital publishing house based out of New South Wales, Australia, and offered to publish Leonard's work. At first, Leonard resisted. But as *Master of the Universe* grew to become one of the most popular stories in the entire FanFiction network, Leonard grew anxious that somebody might steal her work and publish it as a book. She decided it would be best to publish the stories herself.

On May 22, 2011, she left FanFiction. Three days later, her work was published as an e-book and paperback with the Writers Coffee Shop under a new title and an updated pseudonym—*Fifty Shades of Grey*, by E. L. James.

Hayward's Australian imprint was tiny. Few outside the fanfic community could have heard of it. But thousands of people followed Hayward and "Icy" and bought James's first book when it was published in May 2011. James's longtime engagement with her fellow fanfic writers, cultivated over hours and hours of reading and responding to her fans and fellow adapters in online comment threads, had created something extraordinarily rare for a first-time author: a massive audience of readers, commenters, and fellow co-creators.

But at the end of 2011, scarcely anybody at the large publishing houses of London and New York had heard of the book or its enigmatically pseudonymous author. Few would have guessed that within six months, James's stories would become not only one of the great publishing coups in history but also a global cultural phenomenon. By the summer of 2012, several American news organizations, including the *New York Times*, the *Huffington Post*, CNN, and CBS, all made the same claim. The book was not just a success. It had gone "viral."

I t's become fashionable to talk about ideas as if they were diseases. Some pop songs are *infectious*, and some products are *contagious*. Advertisers and producers have developed a theory of "viral" marketing, which assumes that simple word of mouth can easily take a small idea and turn it into a phenomenon. This has fed a popular conception of buzz that says that companies don't need sophisticated distribution strategies for their product to go big. If they make something that is inherently infectious, they can sit back and wait for it to explode like a virus:

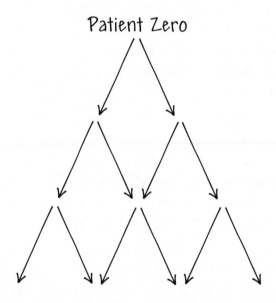

In epidemiology, "viral" has a specific meaning. It refers to a disease that infects more than one person before it dies or the host does. Such a disease has the potential to spread exponentially. One person infects two. Two infect four. Four infect eight. And before long, it's a pandemic.

Do ideas ever go viral in that way? For a long time, nobody could be sure. It's difficult to precisely track word-of-mouth buzz or the spread

of a fashion (like skinny jeans) or an idea (like universal suffrage) from person to person. So, by degrees, "That thing went viral" has became a fancy way of saying, "That thing got big really quickly, and we're not sure how."

But there is a place where ideas leave an information trail: on the Internet. When I post an article on Twitter, it is shared and reshared, and each step of this cascade is traceable. Scientists can follow the trail of e-mails or Facebook posts as they move around the world. In the digital world, they can finally answer the question: *Do ideas really go viral?*

The answer appears to be a simple no. In 2012, several researchers from Yahoo studied the spread of millions of online messages on Twitter. More than 90 percent of the messages didn't diffuse at all. A tiny percentage, about 1 percent, was shared more than seven times. But nothing really went fully viral—not even the most popular shared messages. The vast majority of the news that people see on Twitter—around 95 percent—comes directly from its original source or from one degree of separation.

If ideas and articles on the Internet essentially never go viral, then how do some things still achieve such massive popularity so quickly? Viral spread isn't the only way that a piece of content can reach a large population, the researchers said. There is another mechanism, called "broadcast diffusion"—many people getting information from one source. They wrote:

> *Broadcasts can be extremely large—the Super Bowl attracts over 100 million viewers, while the front pages of the most popular news websites attract a similar number of daily visitors—and hence the mere observation that something is popular, or even that it became so rapidly, is not sufficient to establish that it spread in a manner that resembles [a virus].*

On the Internet, where it seems like everything is going viral, perhaps very little or even nothing is. They concluded that popularity on the Internet is "driven by the size of the largest broadcast." Digital blockbusters are not about a million one-to-one moments as much as they are about a few one-to-one-million moments.

Extended to the full world of hits, this new finding suggests that articles, songs, and products don't spread like in the first picture we saw. Instead, almost all popular products and ideas have blockbuster moments where they spread from one source to many, many individuals at the same time—not like a virus, but something like this:

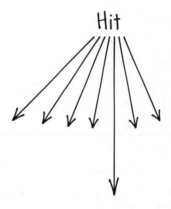

Imagine you go to work on a Monday and a coworker tells you about a new guacamole recipe she read in the *New York Times*. Several hours later, you go to lunch with another coworker, who asks if you've heard about the new guacamole recipe he read about in the *New York Times*. After work, you go home to your spouse, whose coworker evangelized a new guacamole recipe she found in the *New York Times*. The common observation is: "The *Times* article about guacamole went absolutely viral." But the truer observation is that the article didn't go viral in any meaningful sense of the word. It reached a lot of people who read the recipe section of a large international newspaper, and a few of them talked about it.

Disease is an infectious metaphor. We need a revised epidemiological analogy to rival the viral myth—one that explains how ideas can spread to many people at once, like a thousand people getting the flu from one source.

In fact, there is a perfect story for this purpose. It is one of the most celebrated episodes in the history of disease research, taught in several medical schools and investigated in popular nonfiction books, like Steven Johnson's *The Ghost Map*. It begins in the Soho district of 1850s London.

Two hundred years ago, the popular theory of disease held that people got sick because of a spectral force called "miasma"—invisible poisons lofted by the winds. Miasma theory persisted because, like vampires and virality, it was a great story with inconspicuous flaws. The spread of disease was once as difficult to track as word-of-mouth buzz, and there was little understanding of germs, bacteria, and viruses.

In the middle of the nineteenth century, London was both the greatest city in the world and a massive stinking cesspool of disease. In 1854 a cholera outbreak struck the city, killing 127 people in three days and causing 75 percent of residents to flee the working-class Soho neighborhood within a week. The city government still assumed that the disease was carried through smells and inhaled by residents.

The scientist John Snow disagreed. A doctor with the instincts of a journalist, Snow interviewed hundreds of sick and healthy families from the neighborhood. He plotted their cases on a map, where dark bars signified households with cholera.

Snow's investigation uncovered several critical clues:

1. The infected houses clustered within a few blocks.
2. Outside of that cluster, there were practically no incidents of cholera.
3. In the heart of the cluster was a brewery whose workers were remarkably healthy.

Imagine yourself as a detective with these clues and this map. Given the pattern of the disease, you might rule out the miasma theory. But you'd still wonder if this disease was spreading *between* houses—like a virus—or spreading from one source to many houses. And why would beer offer immunity to workers in the midst of an urban epidemic?

Snow added more details to the map—restaurants, parks, water pumps—and he noticed something. On blocks where the Broad Street water pump was the nearest source of water, cholera cases were numerous. On blocks where the residents were more likely to retrieve water from another pump, cholera was rare. The families with cholera had one thing in common: They were drawing water from the same source.

"There were only ten deaths in houses situated decidedly nearer to another street-pump," Snow wrote in a letter to the editor of the *Medical Times and Gazette*. "In five of these cases the families of the deceased persons informed me that they always sent to the pump in Broad Street, as they preferred the water to that of the pumps which were nearer. In three other cases, the deceased were children who went to school near the pump in Broad Street." And what about the healthy brewers in the heart of the hot zone? They were lucky lushes. For their labor, the brewers received malt liquor, whose fermentation process required boiling the water and removing the toxic particulates.

The disease wasn't spreading through the air. It wasn't spreading between households. Many infections were coming from a single source: an infectious water pump. The disease was a broadcast.

People are social creatures—they talk, they share, they pass things along. But unlike with an actual virus, a person chooses to be infected by an idea, and most people who confront any given thing don't pass it along. Viral diseases tend to spread slowly, steadily, across many generations of infection. But information cascades are the opposite: They tend to spread in short bursts and die quickly. The gospel of virality has convinced some marketers that the only way that things become popular these days is by buzz and viral spread. But these marketers vastly overestimate the reliable power of word of mouth.

Much of what outsiders call virality is really a function of what one

might call "dark broadcasters"—people or companies distributing information to many viewers at once, but whose influence isn't always visible to people outside of the network. For example, somebody looking at cholera statistics in 1854 London might have thought that a virus was spreading from house to house. Only by studying the scene would he or she see how the disease was really spreading—that it was mostly coming from a single source.

Mistaking dark broadcasts for viral spread is common. In 2012, a thirty-minute documentary about the Ugandan rebel leader Joseph Kony became the "most viral video in history," with one hundred million views on YouTube in just six days. It is unquestionably an amazing feat for a documentary to reach all-time Hollywood blockbuster distribution in less than a week. But was this really a case of pure viral spread, powered by millions of ordinary individuals sharing it with one or two people? Not really. The video was shared by pop stars like Rihanna and Taylor Swift, television stars like Oprah Winfrey and Ryan Seacrest, and some of Twitter's largest broadcasters, including Kim Kardashian, with thirteen million followers at the time, and Justin Bieber, with eighteen million followers. These weren't ordinary individuals passing the information to two or three other people like a virus. They were dark broadcasters sending the video to millions of people instantly within a densely connected network, even though many people who ultimately saw the video never knew that these celebrities were responsible for its distribution.

Here's another example: On April 24, 2012, on World Malaria Day, Tracy Zamot, a media-relations executive for a music label, published a tweet with an embedded video about the disease. The background music was provided by the Kin, a rock band. The video exploded online, tallying up more than fifteen thousand total retweets. But Tracy Zamot's original message was shared exactly once—by the Twitter account for the band. So, how did the video become a phenomenon? The

brief answer is that several celebrities, each with followings as large as a national newspaper's subscriber base, shared the video.

Getting the full story requires a bit of Internet spelunking. The comment section of YouTube is best known for hosting some of the grossest opinions and worst spelling on the Internet. But in this case, reading the comments under the malaria video offers a rare glimpse inside the information cascade. Of the ninety-six comments, more than half make reference to how users found the video: forty-one thank or mention the pop star Justin Bieber, thirteen reference the country singer Greyson Chance, and five mention the actor Ashton Kutcher. All three celebrities tweeted the video to more than a million followers. "Thumbs up if Ashton Kutcher, Justin Bieber, Greyson Chance or anyl else sent you here!! lol" posted the user Riham RT.

Microsoft Research scientists who studied the phenomenon saw the same thing. The video's popularity did not bloom like a virus, spreading far and wide across many generations. The information cascade looks more like a bomb fuse—a quiet string of solitary shares followed by several explosions, in the form of celebrity tweets. Did the malaria video go "viral"? You might say that. But it became a hit not because of fifteen thousand one-to-one shares, but in large part because three celebrities had the power to share the video with a million people at once. The hit was a dark broadcast—and the darkness was illuminated, in this rare instance, by YouTube comments.

As we saw in the book's first chapter, an individual broadcast is more powerful in an age with fewer channels of exposure. When there were only three television channels, for example, it was easier to get high ratings. But the future looks to be an age of abundance, with hundreds of channels, national media sites, podcasts, newsletters, Twitter profiles, Facebook pages, and media apps. Each of these media sources can reach thousands or millions of people a day. These publishers are broadcasters. Their work isn't viral at all. To say that an idea "went

viral" after it appeared on the *New York Times* front page is nearly as silly as saying a commercial "went viral" after appearing in the Super Bowl, or saying *E. coli* "goes viral" when many people get sick eating at the same restaurant. Words have meanings, and even the most elastic definition of virality has nothing to do with such one-to-one-thousand (or one-to-one-hundred-million) events.

The spread of a viral video is not mostly viral, but neither is it all broadcast. Rather, the studies of social networks suggest that the majority of viral hits involves one or several mass contamination events that look like this . . .

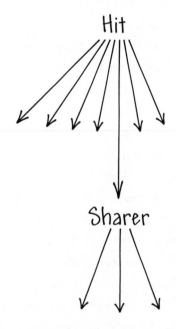

. . . where one Facebook post, one favorable spot on the *Drudge Report*, or one well-watched segment on Fox News reaches thousands and thousands of people *instantaneously*, and then a small fraction of that infected group passes it along again.

Almost nothing really goes viral, but some ideas and products really are more infectious than others. They are shared and discussed at

higher-than-average rates. But to go big, they need that broadcast—the Walmart book stand, the Kardashian tweet, the proverbial water pump—to push them into the mainstream, where people will find them and share them.

That was *Fifty Shades of Grey* at the end of 2011. It was a dark hit, a product whose large audience was invisible to the most prominent measures of popularity. It wasn't on any bestseller list. Nobody read about it in the newspaper. But *Fifty Shades* was already infectious. It just needed a bigger pump.

On January 6, 2012, Anne Messitte, then the publisher of the Vintage Books imprint at Random House, received an on-demand paperback copy of *Fifty Shades of Grey* that had been passing around the publicity and editorial departments of another imprint at her company. It was a Friday. On Saturday, she read the book in a single sitting.

Messitte knew little about the novel beyond the fact that *Fifty Shades* was generating buzz among mothers of the Upper East Side and Westchester, a solidly upper-middle-class county just north of New York City. "I went to dinner with some friends that night, and they asked what I did all day," she told me. "I told them that I read the first *Fifty Shades* book. Immediately, somebody at dinner said her friend in Westchester had read it and loved it." The following week, Messitte read the second installment, *Fifty Shades Darker,* and felt determined to meet with James. There was just one problem: "E. L. James" was a pseudonym and first-time writer. Messitte didn't know how to find her.

Meanwhile, another influential New York City mother was making a simultaneous discovery. Lyss Stern, the founder of Diva Moms, a social group for well-heeled mothers with an Upper East Side élan, visited the large Barnes and Noble in Union Square to find *Fifty Shades,* at a friend's suggestion. But the author name "E. L. James" wasn't even in

the Barnes and Noble system in January 2012. "The woman at the counter looked at me like I was crazy," Stern told me.

So Stern went online and bought the e-book. Like Messitte, she finished it in a day. Suddenly obsessed, she evangelized *Fifty Shades* in her DivaMoms newsletters and invited E. L. James to New York to attend a book party in her honor at a large Chelsea penthouse apartment.

One of the subscribers to the Diva Moms newsletters was Messitte. She e-mailed Stern to attend the event, identifying herself as both a reader and a publisher. Stern responded by e-mail that the event had sold out and forwarded Messitte's inquiry to Valerie Hoskins, a film agent who was helping James navigate her growing fame.

On January 24, 2012, the three women—Messitte, Hoskins, and E. L. James—met at the Vintage offices in Manhattan to discuss the possibility of relaunching *Fifty Shades* with a paperback publication. James was hearing directly from readers, booksellers, and librarians about their difficulty sourcing the book, and she was eager to make it more available.

James had strong and specific opinions about how she wanted her book to be presented—in ways, such as packaging, that were unexpected for the romance genre. She had designed her own covers—the now iconic silver necktie, a winking allusion to both the corporate setting and the bondage theme. "I thought it was brilliant," Messitte said. "People thinking conventionally had told Erika that it should look more like a romance. Erika wanted it to be different. I think the covers' distinction opened the books up to a much broader audience."

At the time, Messitte was a publisher of neither romance nor erotica, free from preconditioned notions of the genre's conventions. The three women spoke about publishing the book not as a category romance novel, but as a front-of-store bestseller—hoping there might be a chance to launch a book that would transcend genre, trying to position it as a cultural phenomenon.

I met Messitte at her office in 2016. I wanted to learn more about the story of the *Fifty Shades* blockbuster, but I also wanted to know more about its publisher. In January 2012, the book was a blip on the publishing radar. In a few months, it would be the pop culture sensation of the world. What did Messitte see in the book before the world did?

She certainly didn't see hard evidence of sales. According to the best available public data, *Fifty Shades* hadn't sold more than a few thousand paperback copies in the entire United States in early 2012.

But Messitte was closely monitoring the conversation building on-line. She knew that uncommon excitement precedes uncommon sales, and the reaction to *Fifty Shades* was deeply uncommon. Across New York City and its suburbs, a certain demographic of women—smart and well-read women with broad social connections—were clamoring for the book. "So much of this business comes down to gut and informed risk, and we could see that something was happening," she said. Google searches for the book spiked first in states with large urban populations, like New York, New Jersey, and Florida.

On February 10, after two weeks of e-mails and calls, Messitte sent Hoskins an offer for Vintage to publish the Fifty Shades trilogy, and after a month of negotiation between the author, the Knopf Doubleday Publishing Group, and the Writer's Coffee Shop, a deal was signed on March 7, 2012, to move the publishing rights to Vintage. Two weeks later, on March 18, *Fifty Shades of Grey* debuted at the number one spot on the *New York Times* combined print and e-book fiction best-seller list. On March 25, *Fifty Shades Darker* joined, taking the number two spot. The following day, Universal Pictures and Focus Features announced that the companies would partner in the development of a film based on the first installment of the Fifty Shades trilogy. On April 1, *Fifty Shades Freed* appeared on the bestseller list in the third-place spot.

If a book sells one million copies total, it is a historic bestseller. In the spring and summer of 2012, Random House was printing one million copies of the Fifty Shades trilogy every week. Now with more than 150 million sold copies, *Fifty Shades of Grey* is the bestselling book in the history of Random House.

The *Fifty Shades* story is a paradox. How could a book go viral in a world where "nothing really goes viral"?

Imagine for a moment that we are sitting in lab, watching the information cascade of *Fifty Shades* blooming from a single point in 2011. Does that picture look like this, a series of one-to-one and one-to-two shares over thousands of generations, like a cold virus?

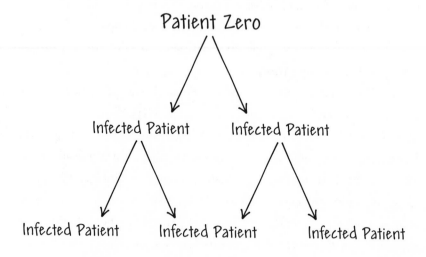

Or does it look like this, a traditional broadcast with social sharing tendrils, as several recipients pass the information along to their friends?

The nondigital world does not provide researchers or journalists with a clear map of influence and social spread. We have to make some inferences. But after corresponding with Anne Messitte, Lyss Stern, Amanda Hayward, and E. L. James herself, I've come to think that although *Fifty Shades* has become a poster child of virality, it was really the beneficiary of three distinct one-to-one-million broadcasts.

First, it benefited from a prototypical dark broadcast, which practically nobody reporting on the *Fifty Shades* phenomenon seems to have paid much attention to—except for James, herself. "When I published the books with the Writer's Coffee Shop, several fans of the story gave the book five stars on [the reader review site] Goodreads," she told me. Goodreads has readers choice awards every year, and because *Fifty*

Shades of Grey had so many five star reviews, it was nominated in the Best Romance category in November 2011.

In the final tally, *Fifty Shades of Grey* received 3,815 votes—more than any other romance novel except for *Lover Unleashed*, by the best-selling author J. R. Ward. This second-place finish brought the novel to the attention of not just other romance readers, but also Hollywood executives. By December, James recalled, she was fetching inquiries from movie studios seeking rights to the novel. "Goodreads had a great deal to do with bringing [*Fifty Shades*] to readers' attention," she said. Like a celebrity tweeting a video to other celebrities, the Goodreads awards vote broadcast the novel to thousands of readers and entertainment executives.

This is a small but critical detail in the mystery of how *Fifty Shades* got so big so quickly. Several months before almost any casual, non-fanfic readers in the United States or Europe had heard of the book or its author, it had already attracted so many readers that it received the second-most online votes of any romance novel published that year.

If *Fifty Shades* hadn't gone viral by November 2011, how did so many people already know about it?

This brings us to the second subtle broadcast—the world of Fan Fiction.net itself. James was already a fanfic celebrity with more than five million readers before Random House found her. Long before she was "E. L. James," Erika Leonard was Snowqueens Icedragon, a dark broadcaster writing for an absurdly large audience of readers that traditional New York publishers could not see or measure. They bought her e-book, gave it five stars on Goodreads, and voted for it as the romance novel of the year, all before the publishing world picked up on the budding phenomenon. When James published her book in 2011, she didn't need a viral cascade to reach hundreds of thousands of devoted readers. *She already had them.*

Third, to reach a truly global audience and become one of the best-selling authors of all time, James needed the distribution and marketing

power of a large publisher like Random House. The vast majority of the book's publicity and success happened after Messitte and James agreed to the deal on March 2, 2012. One week later, on March 9, the *New York Times* trumpeted the Random House acquisition in a page-one story that went out to millions of people in print and online. In early April, an interview with James was the splashy cover story of the magazine *Entertainment Weekly*, with a circulation of around two million. On April 17, she appeared in interviews on both ABC's *Good Morning America* and NBC's *Today* show,ø two morning programs with a combined audience of about ten million viewers. The following day, *Time* magazine, the most read newsweekly in the country, with more than ten million combined print and digital readers, named her one of the world's one hundred most influential people in its cover story package.

There is no question that a good deal of the success of *Fifty Shades* was due to ordinary word of mouth. Indeed, Messitte was initially drawn to James's work in part because so many people had seemed desperate to talk about it.

But there is also no question that *Fifty Shades* reached historic levels of success because of several one-to-one-million moments. The initial publication of the e-book reached many fanfic readers with a single strike, like a bowling ball knocking over a group of prearranged pins. The book's popularity was distributed via many traditional media outlets, who evangelized the books to tens of millions of newspaper readers and television viewers; then other media outlets, like the *New York Times* and *Wall Street Journal*, further evangelized the book by praising its success to an audience of millions more.

That is the difference between virality in epidemiology and culture. A real virus spreads only between people. But a "viral" idea can spread *between broadcasts*. For most so-called viral ideas or products to become massive hits, they almost always depend on several moments where they spread to many, many people from one source. Not like a flu, but rather like a Broad Street water pump.

———

The fan fiction petri dish that spawned *Fifty Shades* is, like so much of modern culture, a new technology serving an old purpose. Broadly defined, fan fiction might be as ancient as literature and the basis of some of the most famous stories ever written. Shakespeare's most popular plays, including *Romeo and Juliet* and *Twelfth Night*, used old tales as scaffolding for new poetry. *The Divine Comedy* by Dante is fathoms deep in allusions to the Bible and ancient classics. Dante was such a fanboy that he meets his idols Virgil and Homer in the text and blushingly describes how they and other poets "made me of their tribe."

Although they have not always called themselves "fans" or their work "fic," novelists are never free of influence. *Fifty Shades'* source material, *Twilight,* was an adaptation, too, loosely based on the plot of Jane Austen's *Pride and Prejudice,* but with Mr. Darcy's sangfroid updated to make him literally coldblooded. Jane Austen's classic is both an original species and a classic of its genus—the power-inversion metamyth. Many romances follow the same dramatic arc: A powerful man desires the less powerful woman and, by falling in love, loses his dominion, making their union possible. It's *Beauty and the Beast,* where the small woman tames the great monster. It's *Jane Eyre,* where the rich aloof nobleman melts for the working-class nanny. "Everything in the world is about sex, except sex," Oscar Wilde said. "Sex is about power." *Fifty Shades* is a power struggle, too, one in which sex is the setting for the central inversion of power.

Classic literature is despotic, in a way; there is one author of the text, and millions of readers whose only choice is to dutifully follow along. Those authors could seem like distant deities and, as John Updike wrote, "gods do not answer letters." But in the direct democracy of fan fiction, the readers are writers, the writers are also readers, and they all answer letters. In this peaceful revolution against the sovereignty of

authorship, an audience of readers comes together to become each other's audience—and, once in a while, produces a piece of art that eclipses its influence.

Above all, a popular fan fiction writer is a talented reader—of the source material, of her peers' interpretations, and of her audience's reception. It's clear that, even if nobody outside of FanFiction.net ever bought a copy of her books, James was a keen reader of all three groups. On the site, she would spend hours in the comment threads on her stories, absorbing praise, noting suggestions, and welcoming feedback. By her own account, James was exhaustively devoted to staying in touch with her fans.

From the beginning, *Fifty Shades* was a conversation—between Erika Leonard and other fanfic authors, between Snowqueens Icedragon and her tens of thousands of devoted online readers, between E. L. James and her global legion of fans, and finally between the fans themselves. "Conversation is the most powerful thing for selling books, and this book touched off a conversation that women wanted to have with other women," Messitte said. "Mothers and daughters discussed it. People who hadn't read a book in fifteen years discussed it."

Many people wanted to read *Fifty Shades* because it was already popular. For all of Random House's carefully planned marketing strategy, the book's best advertisement was its own notoriety. Many readers with little former interest in bondage, romance novels, or even books in general bought copies of the Fifty Shades trilogy because they were curious about participating in a cultural phenomenon. They wanted entry into a crowded club simply because it was crowded.

How does popularity beget more popularity? Several years after his work with global cascades, Duncan Watts and two researchers at Columbia University, Matthew Salganik and Peter Dodds, designed a study to research the phenomenon of hits in music.

They created several music sites, or "worlds," with the same forty-eight songs and asked visitors to download their favorites. This way, the researchers could watch the same songs' popularity evolve, as if in parallel universes.

There was a clever wrinkle. Some websites showed viewers a ranking of the most popular tracks, but other sites had no such rankings. Although each world started with zero downloads, they evolved to be quite different. In Music World 1, the top song was "She Said" by the band Parker Theory. In Music World 4, however, that song was in tenth place.

Most important, the rankings were like steroids for hits: People who could see them were more likely to download songs that were already popular. The mere existence of rankings—the simple signal of popularity—made the biggest hits even bigger.

In a follow-up experiment, Watts and his fellow scientists got a little cheeky: They inverted the rankings. Some visitors went to music sites where the least popular song was falsely listed as number one. You can probably guess what happened. Previously ignored songs initially soared in popularity. Previously popular songs were ignored. Simply believing, even wrongly, that a song was popular made many participants more likely to download it. Rankings created superstars, even when they lied.

Some consumers buy products not because they are " better" in any way, but simply because they are popular. What they're buying is not just a product, but also a piece of popularity itself.

Today's cultural marketplace is a pop-culture Panopticon, where everybody can see what the world is watching, playing, and reading. In such a world, historically large audiences will inevitably cluster around a handful of mega-blockbusters, such as *Fifty Shades*, or, more recently, the augmented-reality game Pokémon GO. That is the lesson of Salganik, Dodds, and Watts: Cultural products will spread faster and wider when everybody can see what everybody else is doing. It suggests

that the future of many hit-making markets will be fully open, radically transparent, and very, very unequal.

In the final analysis, this was perhaps the key mechanism in the *Fifty Shades* phenomenon. Like a viral video, it was propelled by a combination of traditional broadcasters (the *Today* show and the *New York Times*), dark broadcasters (the massive fanfic cluster and Facebook groups), and ordinary sharing (readers talking to readers). Millions of people were exhilarated, maddened, and puzzled by the book, but there are thousands of books that exhilarate, madden, and puzzle. None of them sell one hundred million copies. What separated *Fifty Shades* is that its notoriety became a distinct product; people who didn't even enjoy reading still wanted to avoid being the last person to have read it.

In this way, E. L. James's saga is both extraordinary and typical. For many cultural achievements, the art itself is not the only thing worth consuming; the experience of having seen, read, or heard the art for the purpose of being able to talk about it is its own reward. Such consumers are not just buying a product; what they're really buying is entry into a popular conversation. *Popularity is the product.*

Since *Fifty Shades* has conquered the world, there have been several pop sociological attempts to explain its success. Some have pointed out that romance sales always rise during economic downturns, as women seek the comfort of a bodice ripper. Others argued that the advent of e-books meant that even urbane women could read erotica without feeling judged in public.

It would be satisfying if *Fifty Shades* offered an easy lesson for how to create the most popular product in the history of the world. Unfortunately, its very outlier status makes it both a target for theorizing and an extraordinary exception. There is no doubt that the book benefited from traditional media broadcasts. But if the broadcast power

of a publisher were enough to ensure a global sensation, then thousands of books would sell more than one hundred million copies every year. Instead, *Fifty Shades* calls for a sample of humility—from publishers, from writers, and, yes, from people like me trying to explain its success.

To understand why some hits get so big, one cannot look exclusively at characteristics like familiarity or at marketing strategies like one-to-one-million moments. The broadcasts come first, but they are not enough. A handful of products will inevitably become massively popular each year for the simple reason that, once they are pushed into the national consciousness, people just can't stop talking about them.

So how do you get people to talk?

THE AUDIENCE OF
MY AUDIENCE

Clusters, Cliques, and Cults

Vincent Forrest was working his way through college in the inauspicious year of 2008 and, like so many young people from his recession-bitten generation, found himself at an uninspiring job in an independent gift shop in his hometown of Grand Rapids, Michigan. Business was slow, and Forrest, an amateur cartoonist, passed his time by flipping through the pages of greeting card catalogs. He would rewrite the cards' punch lines with his sense of humor—weird, detached, and pithy—and pass them around the office.

This was basically a game for bored clerks, not a bid for stardom. But occasionally boredom is a cavity where creativity breeds. Forrest's colleagues were delighted by his hobby and insisted he had an uncommon talent. So in May 2009 he opened a shop on Etsy, an online marketplace for independent artists, to sell pin buttons with his jokes. His first eighteen designs found a small audience. He kept writing. He shared jokes with his close friends to get feedback and printed their favorites. He experimented with political jokes (which buyers often

ignored), pop culture jokes (which they liked), and goofy grammar jokes (which they loved). He kept learning, tweaking, printing.

Forrest's pinback button shop currently has more than five hundred designs and more than one hundred thousand sales. Between 2011 and 2014, he held the site record for the most items sold in Etsy's Handmade department, and his store remains among the the most popular in the site's history.

The success of somebody like Vincent Forrest interested me for two reasons. First, he's a little voice without a megaphone. In the previous chapter, we saw that when researchers studied the evolution of massive hits online, the most dependable path to success relied on one-to-one-million blasts rather than what you'd typically call a "viral" hit. But people like Forrest don't have access to the marketing muscle of a company like Random House. They might never achieve literal virality, but to get started they need to build their own broadcast. That typically means they have to make something worth sharing.

Starting from such a small base of exposure, Forrest's early success relied on networks of people he didn't know and whom he would never meet. He needed these strangers to adore his jokes and to pass them along. That's the second reason why Forrest's story interests me: It's not a story about buttons. It's a story about why people like to share private things like inside jokes.

"The nature of the in-joke is that it creates an opportunity for people to get to know each other," Forrest told me. "If a button says, 'I like reading,' there's no conversation there. Plenty of people like reading. But a specific *Jane Eyre* joke is only going to go noticed by a smaller number of people who love *Jane Eyre* and can genuinely connect over something." The smaller, densely connected audience beats the larger, diffuse group.

The first half of this book focused on a simple question: *Why do individuals like what they like?* But the last few chapters have shown that this question alone is insufficient. People don't make decisions in-

dividually. They aren't just creatures of influence ("I bought it because it's popular"). They're also creatures of self-expression ("I bought it because it's me"). People purchase and share all sorts of things because *they want people to see that they have them.* Vincent Forrest sells buttons to be worn in public. He sells 1.25-inch baubles of identity.

When somebody posts an article online, people often say the article is "shared." *Shared* is an interesting usage, because in the physical world you tend to share things that are excludable. When you share a blanket, there is less to keep you warm. When you share a dozen cookies, you eat fewer than twelve. But information is different. Information is a nonexcludable resource. When you share something online, you are giving up nothing. In fact, you are gaining something quite valuable: an audience. Sharing, in the context of information, isn't really sharing. It's much more like talking.

So when somebody shares information—like an article, a joke, or a button—are they doing something for other people, or are they just talking about themselves?

Vincent Forrest was born, raised, and educated in Grand Rapids. In high school, he was a jokester with a sketchbook and a fondness for testing the limits of humorous propriety. "I've always liked to try out jokes, and I've found that I'm as weird as other people let me be," he said. "If you laugh, my feeling is, that's the new zero, and I'll keep moving forward. If you don't laugh, I'll see that's the edge and I'll pull back."

When he graduated from high school, Forrest spent several years at community college before enrolling in Grand Valley State, just down Lake Michigan Drive, to study art. After moving out of his parents' house, he worked at the boutique gift shop to make rent, but the combination of a forty-hour week and intensive studio classes were punishing. "I developed terrible insomnia," he said. "I'd have anxiety

nightmares, but those were okay because at least the nightmares told me I had fallen asleep." Forrest switched majors after one semester, to English.

At the gift shop, Forrest rewrote the jokes in card catalogs as a way to daydream through the drudgery of a cashier's job. But in 2009 a confluence of unconnected events gave him the confidence to sell his jokes for money. A tax rebate from the federal government was just enough to spend on a button-making machine. He opened an Etsy shop and used the pen name Beanforest. "At first, it was just throwing weird stuff into the void," he said. "Some of the jokes didn't work. But the ones that did were selling. People were sharing the jokes on Facebook and tagging their friends." Just as sales were growing, he and his girl-friend broke up, and Forrest seized the moment to take a big risk. In July 2009, he quit his job to go full-time with buttons.

Many of Forrest's jokes aim for a peculiar niche: introverts with a nerdy streak, who are as likely to quote a new Internet meme as Shake-speare's *Othello* or Strunk and White's *The Elements of Style*. Within two years, Forrest's site became the top-selling handmade shop on Etsy. Some of his all-time most popular buttons include:

- ". . . and *this* little piggy stayed home eating bacon, not realizing the horror of his actions."
- "I'm not to be trusted in a bookstore with a credit card."
- "When I wake up in the morning and stretch, I make baby dinosaur noises."
- "Wouldn't it be awesome if life were a giant musical?"
- "It's worth mentioning that I'm *really* good at misinter-preting social cues."
- "Spell check yourself before you wreck yourself."
- "If I fall asleep in direct sunlight, let me be. I am photo-synthesizing."
- "I am gone forever. [*Exit, pursued by a bear*]" (a line from

from *The Winter's Tale*, and his most popular Shakespeare pin)

"I've never been of the opinion that I should write for as big a crowd as possible," Forrest said. "I want to write for people with narrow interests that they're passionate about. I'm essentially writing inside jokes that create a magnet of understanding."

I asked Forrest whether he had a personal philosophy of why some jokes just work. He told me he might, but he'd have to put the answer in writing. Several days later, at 8:34 in the morning, I got an e-mail from him that began: "The sun is up and I've spent the last 5.5 hours working on these questions."

The e-mail was more than one thousand words long, and he assured me that many paragraphs of half-finished thoughts had been culled in the process. It was either ironic or perfectly fitting that somebody who wrote 1.25-inch sentiments for a living struggled to explain what he had learned from several years of those sentiments and their accumulating yards.

I read the e-mail several times over. It was perfect, a Cracker Jack box of insights into ideas that I turned around in my head in the first chapters of this book, like the dance between surprise and familiarity and the power of poetic concision.

Here is Forrest on how to be interesting in 1.25 inches. It beautifully summarizes the aesthetic aha, the tension between uniqueness and relatability, which is ultimately about creating a new kernel of meaning for people.

> *The size of a pinback button limits how much can be said while still being readable . . . When I'm doing my job well, I'm saying something precise about topics that are personal to me or those I'm close to (whether that's education, existential panic, or my pets, etc.) in a way that is specific enough that it feels personal*

and relatable to others with the same interests . . . Success is in making a meaningful connection with my audience.

On where meaning comes from:

Specificity and familiarity matter. Detail can make the difference between something that feels like it comes from experience (and meaningful) versus something general and passive. I want to be educated enough on a subject to feel like I have something real or new to say. Customers have requested designs for a wide range of subjects, but even if I like the topic, there are a lot of clever people out there and most of the low-hanging fruit has been picked. Chances are decent that even if a joke feels new to me, it's played out to the audience most likely to buy it. Knowledge and personal interest don't guarantee that everything I do is new, but it significantly reduces the risk of retreading old material.

On the chaos of hits:

It feels almost impossible to tell what people will respond to. I've written a fair amount of hits and at least as many misses, and in most cases it'd be difficult for me to explain why one goes on to be a bestseller and the other a complete failure.

But Forrest's most interesting observation to me was about why he thought people bought his buttons. "The best jokes are so specific that they feel private," he told me. "It's that surprise, I think, that people like—that I shared something that felt almost too small and personal for anybody else to know." Later in his e-mail Forrest said that his jokes served as "a small way to communicate kinship."

Forrest says that people buy his buttons because his jokes are so

specific that they feel private. Then he says that people buy his buttons to communicate with their friends. These interpretations initially seem contradictory. Why would you buy something private for the purpose of sharing it?

But perhaps that's just it: An inside joke *is* a private network of understanding. It crystallizes an in-group, a kind of soft cult, where unique individuals feel like they belong. Vincent Forrest's physical products are buttons and magnets. But what he's really selling is something else: a sentiment that feels so personal that you simply have to talk about it.

Every time you pass along a piece of information in a social network—online or offline—its ultimate popularity depends on whether your audience decides to tell other people, *their* audience, about it. You face a simple question: "Is this news right for my audience?" Then your audience applies the same calculation to determine if they should pass it along to their friends: "Is this right for my audience?" And their audience, the audience of your audience, makes the same judgment before telling an entirely separate group of people: "Is this right for my audience?" With each step, the news travels further from its original source.

"To make popular content, it's not enough to know your friends or your followers," said Jure Leskovec, a computer scientist who studies online behavior at Stanford University. "It's about knowing the friends of your friends and the followers of your followers. For something to go big, it has to be interesting to those beyond your immediate audience— the audience of your audience."

If we share information with the people we're connected to, another way to ask the question, *Why do people share what they share?* is to ask, *What connects people?*

Among the most established and consistent principles in the

organization of humans is an idea called "homophily." It's a funny-looking word that communicates a simple idea: You are like the people around you—your friends, your spouse, your online networks, and your office relationships. There is a related idea, "propinquity," which says you are fond of, and become similar to, the people you see many times, often because they live or work nearby. Together, they are like the social dimensions of fluency and the mere exposure effect. We've seen how individuals gravitate toward the familiar and become products of their environment. Groups of people are the same way. It's exhausting to have to constantly explain oneself and face confrontation. It is deep and lovely to be near people who seem to understand us.

On the surface, homophily seems so self-evident as to be mundane. It's only natural that San Francisco engineers like the company of other San Francisco engineers, or that young Catholic moms feel a kinship with other young Catholic moms. Much of the research on homophily seems to uncover pure common sense. For example, a 2011 survey of seven thousand English teenagers between fifteen and seventeen found that "academic achievement" formed a key bond in many high school friendships. Well, naturally: You don't need a sociologist to tell you that nerds hang out with nerds.

But the implications of homophily are not simple or harmless. It can be a force behind racial segregation or bigotry. Kids who grow up in more ethnically diverse neighborhoods and schools may have more ethnic diversity in their friendships. But broadly speaking, the racial homogeneity of social groups is shocking. The average white American has ninety-one white friends for every black, Asian, or Hispanic friend. The average black American has ten black friends for each white friend. Perhaps the most stunning statistic of interracial friendships is this: In the United States, where the majority of three-year-olds are not white, up to 75 percent of white people cannot name a single "minority" friend.

A child's first social group is profoundly shaped by his or her first neighborhood—something an infant cannot possibly control. The

power of geography returns with a vengeance in parenthood. The parents of students often become close friends with each other, and these social groups can be deeply homophilic as well. Many elementary schools are heavily sorted by geography (which reflects similar income and demography) and the children's abilities (which reflect, to a certain extent, the parents' genes, values, and socioeconomic status). Geography and schools shape parents' social networks, three or four decades after geography and schools shaped their first social network as children themselves.

The fact that people want to belong to like-minded flocks can be scary when the group is a few standard deviations from the cultural median. In 1984, the British sociologist Eileen Barker published *The Making of a Moonie*, a seven-year investigation of the Unification Church based on interviews with members of one of America's most popular cults. While many cults are seen as preying on poor and uneducated people from broken homes, Barker discovered that Moonies tended to be middle class with college degrees and stable families. Outsiders were sure that Moonies were victims of sleep deprivation, trances, and other trickery. Perhaps they wanted to believe that only advanced brainwashing could transform somebody into a Moonie. Instead the cult inculcated new members through more innocent techniques: weekend retreats, long conversations, shared meals, and an environment of love and support. Outsiders did not want to contemplate the idea that ordinary people like them might enjoy the comfort of a cult.[1] The truth was perhaps more frightening: Moonie participants were free to leave (many left within a week) and those who stayed simply felt at home.

One of the hallmarks of a cult is that members unite to oppose what they see as an oppressive or illegitimate mainstream culture. But if

1. The idea that the Moonies, named for the Korean religious leader Sun Myung Moon, were "brainwashing" recruits may have had a racial element to it, too. The word "brainwashing" is a neologism from the Cold War, a translation of a Chinese term. The word entered the English lexicon during the Korean War amid fears that American POWs would return as zombies, à la *The Manchurian Candidate*.

you recall from an earlier chapter, rejecting an illegitimate norm is precisely the sociological definition of being "cool." So what's the difference between what people consider "cultish" versus "cool"? Both groups self-organize around the idea that the world doesn't get them. Both develop customs that belong to them exclusively. Perhaps a cult is an extreme version of homophily. But in a way, every social network is a soft cult—a place where people can, ironically, feel like individuals by belonging to a group.

There are hundreds of BuzzFeed articles about introverts, including but not limited to: "31 Unmistakable Signs That You're an Introvert," "23 Things All Introverts Are Guilty of Doing," "21 Insanely Useful Skills Every Introvert Has Mastered," "15 Things Introverts Should Know About Planning a Wedding," and "11 Talents Introverts Don't Realize They Have." Why would a media company exquisitely attuned to publishing "shareable" content want to write so much about people who theoretically keep to themselves? It's not just that introverts, like all people, love reading about themselves on the Internet. It's also the case that introverts, like all people, love sharing within their clique evidence that they are distinct from the mainstream. The truth is that everybody is a little bit introverted. But "14 Ways That You Are Probably Just As Introverted As the Median Person" doesn't make anybody feel special or different.

Stanford's Leskovec says there are two basic feedback loops in every social circle. First, people seek out others who are like them. Sociologists call this "sorting." Second, individuals change to become more like the group around them. This is called "socializing." These sorting and socializing effects are most commonly studied in cities. But the Internet, too, is a universal metropolis, a mosaic of neighborhoods, many of which are deeply segregated or, at least, trafficked by like-minded users. There are corners of the Internet visited almost entirely by white people or black people, white nationalists or feminists, bicoastal media gabbers or Wisconsin Packers fans.

Here's a brief explanation of how sorting and socializing might work on the social network Twitter. Let's say I post an article on Twitter about Chinese history. Thousands of people see it. Some of them aren't interested in Chinese history, and they might leave my network by "unfollowing" me. But some of them enjoy Chinese history and pass the article through their networks by "retweeting" it. Occasionally, people who see this retweet—the audience of my audience—might join my network.

This is a very simple model of information traveling around the Internet, but it has two important implications. First, social networks often sort themselves by bringing like-minded people together. They evolve toward homophily. Second, growing my popularity on a social network like Twitter, Facebook, or Instagram is about appealing not only to my audience, but also to the audience of my audience.

Another interesting thing happens on these digital social networks. Over time, I learn which kinds of messages get the most attention. I adopt the ideas and writing styles that are most successful for getting positive feedback, such as retweets or followers. I learn that posting dramatic charts or funny pictures is good and giving people smart reasons to believe what they already think is great. I learn that too much cynicism about certain celebrities is unwelcome, and my personal feelings about Coldplay are unpopular, and using ALL CAPS TO MAKE A SINCERE POLITICAL POINT is awkwardly effortful. As if by osmosis, the patois of the network becomes my own.

In short, similarity in social networks goes both ways. My network looks more like me and I look more like my network.

Vincent Forrest intuitively understands both sides of this convergence. His best buttons are, by his own admission, the ones that draw the tightest circle. People want to share the messages that strike them as the most personal. But he's also learned from his audience. He discovered that Etsy buyers like arch pop culture references and unabashedly nerdy grammar jokes. So over time, he made more buttons blending pop culture with jokes about reading and syntax. He built his

own social network with tens of thousands of buyers, but, ironically, he did it not by writing jokes for all ten thousand people at once, but by writing jokes for just a few of them at a time.

The most popular mobile apps in the world are various shades of self-expression. The most downloaded nongaming apps in iPhone history are Facebook, Facebook Messenger, YouTube, Instagram, Skype, WhatsApp, Find My iPhone, Google Maps, Twitter, and iTunes U. In other words: maps, videos, and a whole lot of talking. If you think the download counts are skewed, try the independent surveys. According to a 2014 Niche study, the most common mobile uses for teenagers are texting, Facebook, YouTube, Instagram, Snapchat, Pandora, Twitter, and phone calls. Six of the eight (texting, Facebook, Instagram, Snapchat, Twitter, and the old-fashioned telephone) are just different tools for self-expression—visual, textual, and voice.

These social networks really work only when they're big.[2] There is an idea called Metcalfe's law, which says that the value of a network is proportional to the number of its users squared. Consider, for example, a dating app. With five users, it's worthless. Even with a hundred users, it's not quite alluring. But with 10,000 users within a one-mile radius, it's pretty easy to persuade user 10,001 to join the app. Getting one marginal user is easier when the social network has already reached this critical mass. But if you need thousands of people to sign up for a product before it's useful to any one participant, how do you lure User Number One?

When Tinder, the popular dating app, was just taking off, Whitney Wolfe, the company's de facto head of outreach and marketing, faced

2. Not every mobile app benefits so much from network effects, which apply specifically when a product's popularity makes it much more useful. Being the only person on Facebook, for example, isn't much fun. But a news or music app might be perfectly useful for millions of people to use alone.

just this problem.[3] She needed many, many single people to join the dating app all at once in each city. (After all, even if she'd signed up a hundred thousand singles in California, the app would be useless for anybody in Baltimore.)

At first Wolfe's problem seems to have nothing at all to do with Vincent Forrest's challenge to sell inside jokes. But her solution returns us to homophily. Remember Watts's and Leskovec's rules for popularity: Ideas spread most reliably when they piggyback off an *existing network of closely connected and interested people.* In other words, if you're trying to attract groups, find common points of origin. To build an early user base, Wolfe had to go somewhere hundreds, hopefully even thousands, of single people were already connected. So she went back to school.

Wolfe had graduated from Southern Methodist University in Dallas, which is well known for its culture of bacchanalia. She understood what she called "the Southern college experience." To find users, she first went to the sororities. "I'd walk into the house and I'd ask them to download Tinder as a favor to me," she said. "I would tell them I was a young working woman who needed their support, and also, by the way, every cute guy on campus was going to join this thing in the next twenty minutes, because I was walking straight to the frat houses after I left."

After persuading the sororities to get on the app, she would go to the fraternities. She would tell the men that she personally watched every girl in the house down the road download the app. "Do not disappoint the girls, because they're waiting for you!" she'd say. And would you guess what the guys did? "They would immediately download the app."

Wolfe didn't seed the app by seeking out magically influential individuals. She did it by lassoing entire groups at once. She piggybacked on networks that already existed, popular fraternities and popular so-

3. Although I don't think it's relevant to network theory or homophily, it's quite relevant to the story of Tinder to note that Wolfe sued the company for sexual harassment, settled out of court, and used some of the money to start Bumble, a rival.

rorities that were themselves connected to other fraternities and sororities in a metacluster of Greek life at SMU.

Tinder sent Wolfe to prominent colleges around the country with the same playbook, according to Joe Munoz, who helped to build Tinder's back-end code. "Her pitch was pretty genius," he told *Bloomberg*. "She would go to chapters of her sorority, do her presentation, and have all the girls at the meetings install the app. Then she'd go to the corresponding brother fraternity—they'd open the app and see all these cute girls they knew." There were fewer than five thousand users on Tinder before Wolfe's cross-country jaunt. By the time she returned, there were some fifteen thousand. "The avalanche had started," Munoz said.

Facebook's early success followed a similar pattern. The company started in 2004 as a directory for college students at Harvard University and other selective colleges. It spread rapidly between young people who were already connected to each other by classes, dorms, and extracurricular activities. Like Tinder, its growth relied on a "bowling pin strategy," where a product is adopted by a small niche, a densely connected network that already exists, like a bowling ball smashing into a tidy arrangement of pins. The social network wouldn't have been useful if it found one thousand people randomly distributed around the world. But Facebook wasn't trying to create new connections so much as it wanted to digitize—and, perhaps, deepen—the millions of student relationships that already existed.

Wolfe used the same strategy to grow Bumble, her next dating app, which had the key distinction that only women could initiate conversations. "I went back to SMU, stood on the sorority tables, and begged people to download my app," she said. This time, she brought merchandised reinforcements—lots and lots of prizes emblazoned with the yellow Bumble logo—and she promised golden goodies for the girls who texted the most friends.

Bumble slingshot itself to growth, too, soaring to more than three million users after the first fifteen months. When I spoke with Wolfe

in 2015, Bumble was still spreading through college campuses, but by her own admission, Wolfe's shtick was already wearing thin. Sororities had become so aware that they were the gateway to college networks that they were tired of start-up founders begging them to seed a new app. "I'm a firm believer that a person can only be advertised so many times in the same format before they become cynical," Wolfe said. "My brain is constantly looking for where you are trying to advertise to me. Visiting the sororities worked for a long time, but now I think it's about finding the right person inside of each network who can act as my proxy."

The most important element in a global cascade isn't magically viral elements or mystical influencers. Rather it is about finding a group of people who are easily influenced. It turns the influencer question on its head. Don't ask, "Who is powerful?" Instead ask, "Who is vulnerable?" In Duncan Watts's computer models, global cascades happen when a trigger hits a densely connected audience clustered around a commonality, a soft cult. Whitney Wolfe discovered the same. "I often ask my team if they'd rather advertise on a New York City taxi or with a sticker on a backpack," she said. "The NYC taxi cab will be seen by thousands of people, and the backpack sticker might only create curiosity among a handful." But Wolfe, like Vincent Forrest, prefers the smaller emblem of identity, a jumping-off point for a conversation between friends. "When I'm doing my job well," Forrest told me, "I'm saying something precise that is specific enough that it feels personal and relatable to others with the same interests."

The world isn't a uniformly connected glob of people. It's still a billion clusters, cliques, and cults. What Watts sees in his models, what Wolfe sees in her apps, and what Forrest sees in his customers, is that successful creations grow most predictably when they tap into a small network of people who do not see themselves as mainstream, but rather bound by an idea or commonality that they consider special. People have all day to talk about what makes them ordinary. It turns out that they want to share what makes them weird.

INTERLUDE

Le Panache

I majored in journalism and political science in college, but I acted, too, and generally preferred the stage to the newsroom. In fact, I think I always loved writing because it felt like acting. Both jobs require workers to develop an intuitive sense of the within and the without, feelings versus gestures, thoughts versus words. As a freshman, I saw a student production of *Cyrano de Bergerac*, an 1897 romance that my peers mounted in a black-box theater on campus that infamously resembled a condemned hovel from the outside. It was no regal setting, with harsh lights, cheap chairs, and a makeshift stage befitting a student production. But I was rapt. I had loved Shakespeare, Stoppard, and Kushner, but I felt strongly, at eighteen, that this was the cleverest play I had ever seen.

Cyrano is the story of a nobleman by that name whose felicity with swordplay and wordplay is so singular that the character is credited with inventing the word "panache," which translates directly to "plumage" but means something more like "swagger." Cyrano, infamously long in the nose, loves the beautiful Roxane and assumes that a woman so fetching could never return the affections of a man so grotesque. When Christian, a handsome dullard, asks Cyrano to ghostwrite notes

on his behalf to woo Roxane, Cyrano obliges. At the end of the play, how-
ever, Roxane realizes that she has fallen for the words themselves. The
one she truly loves is the author of the letters—the ugly Cyrano, not the
handsome Christian.

The play sprang to mind one evening during the research for this
book. I was writing the next chapter, which is, in large part, about
Cyrano's singular gift—pleasing an audience.

"The medium is the message," as Marshall McLuhan said once and
everybody else repeated a million times. The Internet and its social
network inhabitants are forces of amplification, extending our mes-
sages to more ears and eyes. What I wanted to know was whether people
change what they talk about when they think they're addressing a large
group of people, as they often do on Facebook, Reddit, and Twitter. If
the medium dictates the message, might the *size* of the audience shape
the subject of the message?

I cannot say for sure what people talk about over dinner. But I
know what they talk about online, because the Internet leaves a data
trail. Every year, the social content analytics firm NewsWhip unveils
the most popular stories on Facebook. Here are the top ten stories
from 2014.

1. He Saved 669 Children During the Holocaust . . . And He
 Doesn't Know They're Sitting Next to Him—LifeBuzz
2. What Animal Are You?—Quizony
3. How Observant Are You?—Playbuzz
4. Can We Guess Your Real Age?—Bitecharge
5. What State Do You Actually Belong In?—BuzzFeed
6. What Color Is Your Aura?—Quiz Social
7. How Old Are You at Heart?—Bitecharge
8. How Old Do You Act?—Bitecharge
9. What Kind of Woman Are You?—Survley
10. How Did You Die in Your Past Life?—Playbuzz

The common observation about stories like these is that they are *relatable*, mapping themselves onto readers' ordinary anxieties and curiosities, each one a little itch that begs for a quick scratch. But looking again at the list, I couldn't help but think: Nobody actually talks about these things!

Here are three sentences that have never been uttered in human history:

- "Before we go to bed, honey, what American state do you actually belong in?"
- "Hey, Mom, I was just wondering, what color is your aura?"
- "Grandma, what kind of woman are you?"

These are, at best, the sorts of questions you might ask a first date after discovering that you share nothing in common. If they are relatable questions, they are relatable to unspoken curiosities that bear no resemblance to face-to-face conversations, which are typically particular and quotidian. *How was your day? Hon, we need a new mop. Are you taking her to soccer practice or am I? How did the talk with Janine go?*

A 2012 Harvard study found that people use about one third of personal conversations to talk about themselves. Online, that number jumps to 80 percent. A person's egoism quotient more than doubles when she opens a computer or lock screen. Look back at the Facebook article list: Nine of the ten stories have the words "you" or "your," which, to each reader, mean "me" and "mine." Offline, one on one, I talk to other people. Online, one to one thousand, I talk (and read) about myself.

All communication involves an audience, but the size of the audience can shape the communication. A 2014 study by Alixandra Barasch, then a doctoral candidate at the Wharton School at the University

of Pennsylvania, and Jonah Berger, an associate professor of marketing at the school, tested this effect by giving subjects a simple task: Describe your day to one person or to a group of people.

The researchers provided each participant with details from an imaginary day, with several happy events (like joining a friend to see a great new movie) and some bummers (having an unappetizing dessert at a local bakery). They asked participants to document the day in a note, which was meant for one friend or a larger group. People were more forthright about the bad stuff in their lives when they thought they were addressing one person. When they thought they were addressing a larger group, they airbrushed their stories for dazzling happiness.

Here is a selection from a note in the study intended for just one friend:

> *My day had a rocky start. After a brief meeting with my mentor, which I was late for by the way, I met up with Charlize to go see a movie . . . After the movies I took her to the Cheesecake Factory for some dessert but they were closed and we had to settle for a Hot n Crusty around the corner. Womp Womp!*

And here is a selection from a note intended for a larger group:

> *Hey guys! I had a great weekend! I went with a couple of friends to see Iron Man 3. It was PHENOMENAL. I really really enjoyed it! I thought it was way better than the second movie.*

It is the vanity of crowds: Simply knowing that we're talking to a large audience shapes the information we share and how we describe what we know. In the last few years, several social critics have wondered why social media profiles are galleries of self-love. Perhaps it's

not so much that Facebook is turning us into narcissists, but rather that Facebook is tapping into the natural narcissism of all broadcasts. One to many, we sculpt, smooth, and sand our life stories; mammal to mammal, we're more likely to relate.

In the play *Cyrano de Bergerac*, Cyrano and Christian are foils. But in the real world, many people are both the silver-tongued Cyrano and leaden Christian in one body. They sparkle with wit and panache in front of a keyboard or a piece of paper. But dumped before a friend, a date, or a boss without a script, they'll talk about their marriage woes or the awful commute.

One source of the online-offline communication gap is, simply, time. Speaking is hand-to-hand combat. Like sword fighting, it requires repartee, quippy thrusts, instinctive parries, and little opportunity to rest your weapon and simply *think*. Speakers are so attuned to their talking partners that conversations have a kind of universal time signature, a standard cadence of chitchat. Psycholinguists have observed that speakers across many languages and cultures pause for an average of two milliseconds before the "right" to talk is passed between them. Linguists have found this global recognition of ideal pauses in Italian, Dutch, Danish, Japanese, Korean, Lao, Ākhoe Haillom (from Namibia), Yélî-Dnye (from Papua New Guinea), and Tzeltal (a Mayan language from Mexico).

Written communications isn't like fencing. It's more like programming a long-range missile. You have time to choose a target and refine it, and if you find yourself going astray, there is always a delete key. The difference in time leads to a difference in focus. Speaking to one person, my attention falls naturally on my fellow conversationalist. Speaking to one thousand people online—for example, in a post on Facebook or Twitter—it's impossible to look anybody in the face or be attuned to their collective needs. The spotlight turns inward. A one-to-one-thousand conversation is not a conversation. It is a presentation.

Perhaps you know the feeling—I certainly do. Twitter is, for me, a

home page of news, a chat room for journalists, and a resource I can scarcely imagine living without. But when I look back over several months of posts on Twitter, it's striking to me how specific my online persona is and how unlike the way I talk to people I can see at a dinner table. I absorb the slang of the medium—detached, arch, painstakingly aware of the slightest turn in the news media carousel—and so rarely reveal the small failures of understanding that characterize so many one-on-one conversations: *Huh? . . . Tell me more about this . . . I had no idea . . .*

Publicly, people often talk about issues. Privately, they talk about schedules. Publicly, they deploy strategic emotions. Privately, they tend to share small troubles. Publicly, they want to be interesting. Privately, they want to be understood.

The science of network effects says that, as a network grows, it becomes exponentially more valuable to each user. But if larger networks reward preening messages, this might turn off audiences seeking the intimate authenticity that tends to come from less crowded conversations—one to five, or even one to one. For those who want to avoid a deluge of self-congratulation, there is something like an "anti–network effect" in which large social networks become cloyingly self-congratulatory. One common criticism of Facebook and Instagram is that users make their lives look so fantastic that our own appears bleak by comparison. Criticism of our friends' behavior on social media—"I hate my friends on Facebook"—is often given the shorthand "I hate Facebook."

This online-offline gap has very real implications for companies trying to generate word-of-mouth "buzz" for their products. In reporting the previous chapter, I spoke with several companies that have started online dating apps. Each of them expressed the difficulty of getting an online dating app to go "viral." Some dating app executives suggested it's because, until quite recently, most people were loathe to discuss their romantic emptiness online. Instagram, for example, is a

place to post pictures of you dangling a beer in your fingers on a calm beach before an impressionist sunset; it's no place to announce to the world that you're desperate for a date. Social media is a kingdom of self-regard. "I'm single and looking" is the sort of self-deprecating thing most people save for a call with a close friend.

Internet culture still values authenticity, and there have been several developments in media that seek to inject one-to-one intimacy into one-to-one-thousand communications. The style of Internet writing has absorbed many of the tics from texting and e-mail. Even in serious online essays, there are gifs, emojis, breezy abbreviations, and the cultivation of a casual patois that is indistinguishable from a friend's e-mail. With personal podcasts in full bloom, a radio broadcast now often sounds like an intimate chat. YouTube stars address millions of viewers from their bedrooms, like an ordinary teenager welcoming an old friend. Predicting the future of media is a game for fools, but, to dip briefly into such foolishness, I expect that new media formats will continue to balance the conversational tone of one-to-one interactions with the reach of global platforms. The broadcasts will get bigger, but they'll feel smaller.[1]

Cyrano de Bergerac dies at the end of the play, in the arms of Roxane. The final scene is at a Paris convent in autumn, many years later, where the script describes leaves burning red and yellow against the green of the boxwood and the yews. Roxane cradles the dying champion, kisses his forehead, and says she loves him. As Cyrano passes into silence, he takes the play's last two words to fit a capstone on the life of a man of letters. Those final words are not "my love," "my truth," or "my virtue." They are "my panache." On the verge of death, in the arms of his love, Cyrano can't help himself. He's a performer to the end, reaching for a laugh, angling for an audience.

1. I've also felt the converse happening: As I spend more time talking to large groups of people on social networks like Twitter, my one-to-one texts have absorbed their vernacular.

WHAT THE PEOPLE WANT I: THE ECONOMICS OF PROPHECY

The Business of Being
Mostly Wrong

Steve Jobs promised "three revolutionary products." He lied.

Dressed in his ritualistic black turtleneck at the Moscone Center in San Francisco in January 2007, he introduced a technological triptych to the five thousand attendees of the Macworld trade show. "The first one is a wide-screen iPod with touch controls," he began, inviting an eager round of hooting and clapping. "The second is a revolutionary mobile phone," he continued, to more bellowing cheer. "And the third is a breakthrough Internet communications device," he said, to perfunctory applause and a lonely, halfhearted "whoop."

The catch, naturally, was that these three revolutionary new products were in fact one product, combining a touch screen, a music player, a phone, and Internet access. "And we are calling it: iPhone," Jobs

concluded. The audience laughed and hollered and threw claps over their heads.

But outside the Moscone Center, skepticism was en vogue. Former Microsoft CEO Steve Ballmer considered the prospect of a $500 cell phone to be beyond ludicrous. ("There's no chance that the iPhone is going to get any significant market share," he said. "No chance.") In June 2007, a few days before the iPhone appeared in stores, the media and advertising company Universal McCann issued a blockbuster report on Apple's new product. They said it would flop.

"The simple truth," said lead author Tom Smith, is that "*convergence* [an all-in-one device] is a compromise driven by financial limitations, not aspiration. In the markets where multiple devices are affordable, the vast majority would prefer that to one device fits all."

The Universal McCann survey was massive, with ten thousand participants. They predicted that the iPhone would struggle in the richest markets, like the United States, Europe, and Japan, because few consumers wanted to trade in their nice cell phones, cameras, and MP3 players for a jack-of-all-trades product that would be a master of none. Although more than 70 percent of respondents in Mexico, Malaysia, and India said they "like the idea of having one portable device to fulfill all my needs," only about 30 percent of Germans, Japanese, or Americans said the same.

Humans are *prostalgic*, enamored by little predictions. But the future is an anarchy that refuses to be governed by even the soundest forecasts. A decade later, the iPhone was not a flop. It was the most profitable hardware invention of the last fifty years. This outcome was especially awkward for Ballmer, since Apple's iPhone business was, within less than a decade, worth more than Microsoft.

It's easy to say that Universal McCann made an embarrassing mistake. The stranger truth, however, is that Universal McCann was right. People in advanced democracies honestly thought they didn't want the iPhone. The firm precisely measured Germany's, Japan's, and Ameri-

ca's indifference to a product they had never seen and did not understand. Apple had spent billions of dollars and five years designing a product that Americans truly did not want. Until they really, really did.

Each industry has its own fairy tales of toadish rejects metamorphosing into princely hits. Several publishers passed on the first Harry Potter volume. Nigel Newton, the chief executive at Bloomsbury, bought the manuscript for a few thousand pounds only when his eight-year-old daughter insisted, with some prescience, that it was "so much better than anything else." Now with more than $450 million in global sales, Harry Potter is the bestselling book series by such a wide margin that it's outsold The Chronicles of Narnia and The Lord of the Rings combined. When members of the Who allegedly told guitarist Jimmy Page that his band would go down like a "lead balloon," he embraced the prediction and renamed his band Led Zeppelin. After the Beatles, Page and his mates are the second bestselling band in history, with more certified album sales than the Who and the Rolling Stones combined. One night in 2001, Rupert Murdoch, the founder of News Corp and 21st Century Fox, received a call from his daughter Liz urging him to adapt a British TV show called *Pop Idol*. Executives at Fox were skeptical of the project. But Murdoch, trusting his daughter, ordered them to buy the rights anyway. For ten consecutive years, the program it inspired, *American Idol*, was the top-ranked show in the United States.

These stories are retold often not only because they highlight that thin line between success and failure, but also because they allow hit makers to remind themselves of their industry's fickleness. "Nobody knows anything," said screenwriter William Goldman, and his quote has become a motto for many companies. When it comes to predicting the future, ignorance is a club and everybody is a member.

Picking a few hits requires a tolerance for many bad ideas, mediocre ideas, and even good ideas cursed with bad timing. Above all, it requires a business model that supports the inevitability that most new

things fail; the most promising ideas often attract a chorus of skeptics; and one big hit can pay for a thousand flops.

In Greek legend, Cassandra is a daughter of the king and queen of Troy. She is blessed with the ability to see the future with perfect accuracy and cursed by the inevitability that nobody will believe her. Before the Trojan War, Cassandra foresees that the Greeks will invade through a wooden horse and sack the city. But the city's guardians ignore her warnings, and Troy is destroyed. The cruelty of her gift eventually drives her to madness.

Today, when an individual's baleful predictions fall on deaf ears, that person is called a Cassandra. It is a title of scorn or pity. To be a Cassandra in the modern world means to lack a certain authority. Modern Cassandras are seen as semitragic oracles, those who howl ineffectually about a calamity, only to be brushed aside.

But I think Cassandra's legacy deserves a modern renovation. To be a Cassandra in any hit-making market is not only a compliment; it is a title to which everyone should aspire. If the original oracular Cassandra were alive today, with modern betting markets, she would be the richest woman in the world. While other traders sell their positions as the stock market crashes, only a Cassandra sees the bottom. While other late 1980s music studios sign up hair bands, only a Cassandra sees the forthcoming reign of hip-hop. It's always nice to be on the right side of history. But it is an economic fact that predicting the future is most valuable when *everybody thinks you're wrong.*

Unique and unrivaled access to perfect information about the future is the holy grail of profitable forecasting. Predicting the most valuable hits is essentially about finding Cassandran resources—people, reports, or insights that are both predictive and mostly ignored. The most famous investments in Wall Street history—like Warren Buffett's 1990 bet on Wells Fargo during the savings-and-loan crisis, or the infamous bet against the U.S. housing market in *The Big Short*—were

absurdly profitable precisely because those investors discovered information that most people discounted at the time.

Buffett and the men who foresaw the housing crash were both once considered crazy. They were Cassandras. They predicted the future *and* people thought they were nuts, and it was only because both things were true that their bets were so historically successful.

In a world of abundant and transparent information, it's difficult to find a resource or strategy that is both prophetic and secretive. If every investor realizes that today's marriage rate predicts tomorrow's economic growth, then nobody gets much advantage from tracking the marriage rate. When comic books seem to be excellent source material for movie franchises, all of the major studios compete for the rights to the most popular comic books, which drives up the price and makes them a poor investment. When Candy Crush becomes a top-rated mobile game, other developers flood the App Store with similar games. You get it: It's difficult to make much money from prophecy if everybody else has the exact same forecast.

Imitating recent successes is a game that everybody knows how to play. But seeing the next big thing before anybody else sees it is far more valuable. It's Buffett in 1990. It's Murdoch in 2001. It's Apple in 2007. It means being a little bit wrong at just the right time.

In 2000, a group of business school graduates and a Stanford PhD named Avery Wang cofounded a cell phone app called Shazam. Their idea was something like magic: Build a technology that can identify any song in the world with a press of a button and send a text back to the user with the title and artist. At first, Wang thought the goal was impossible. Most music in public spaces competes with shouting, forks scraping plates, and other sonic garble. So he built a tool that turned millions of songs into unique audio maps called spectrograms. It was a

bit like creating a digital fingerprint for every song in the world. Any live recording could be matched to these digital fingerprints within seconds—even in a busy restaurant.

Shazam is now one of the most popular apps in the world. It has been downloaded more than five hundred million times and used to identify thirty million songs. Shazam's engineers even built a world map overlaid with its millions of song searches so that users can zoom in to see what songs are most searched in New York, Shanghai, or Tokyo. "We know where a song's popularity starts, and we can watch it spread," Jason Titus, Shazam's former chief technologist, told me. Lorde, a New Zealand singer, was the surprise music sensation of 2013, one of those artists who seemed to come out of nowhere. But Shazam knew exactly where she came from: It traced the global spread of her hit single "Royals" to watch searches sprouting all over the world, like toadstools in a meadow, in New Zealand, in Nashville, blooming outward to the American coasts and in hundreds of U.S. cities.

Shazam turned the world of music fandom into a searchable map of popular music. For a scout at a major label, that's more than a neat tool: It's an early detection system for hits.

In February 2014, I visited 1755 Broadway, the Manhattan headquarters of Republic Records, to talk about the technology behind predicting music hits. At the time, Patch Culbertson was merely one of Republic's most successful young scouts. Now he's the director of its entire scouting division. Culbertson was a warm and helpful explainer of the various ways scouts use radio and download data to watch songs go from tiny specks to global cascades. But by far the most interesting thing he showed me was the way scouts use Shazam.

Culbertson took out his iPhone. He opened the Shazam map. The New York City area came into view, with tiny song icons sprouting in Queens and New Jersey, each showing the most searched track in that area. He zoomed out and panned south, through Virginia and past Arkansas. His finger paused near the Gulf of Mexico. He zoomed in on

Victoria, Texas, a small city between Corpus Christi and Houston. A radio station there had recently started playing "Ride," a new single by the R&B artist SoMo, whom Culbertson had signed.

"'Ride' is the number one tagged song in Victoria!" he said proudly. "That's great," I said out loud. But quietly I wondered what the fuss was about. I had never heard of Victoria, Texas. Why would one of the most sophisticated scouts at the most sophisticated music label care about winning a market nobody outside of Texas had ever heard of?

Victoria is a small city near the Gulf coast with fewer than a hundred thousand people. By itself, it is utterly incapable of launching a hit song. Even if every household in Victoria bought ten copies of a new album, it still wouldn't go platinum. But Victoria's size and location make it perfectly Cassandran. As a two-hour drive from Houston, San Antonio, and Austin, Victoria is a Texas augury, a prescient indicator of the music listening habits of the largest cities in the state.

It's hard to persuade an influential DJ at a popular radio station to play a song like "Ride," which nobody has ever heard before. After all, most people listen to Top 40 radio for fluency: They want to hear songs they already know. But Culbertson had a clever idea. He could play "Ride" in a smaller market with less noise and determine if the song had potential in a larger city. When users looked up "Ride" more than any other song in the area, Culbertson had the proof he needed to bring the song to more popular stations in Houston and the rest of the United States.

In short, Culbertson was using Victoria not only as an early detection system for hits, but also as proof of popularity that he could sell up to larger markets.

The best hit makers are often those who know the dark corners to find ideas to pull into the light. Hollywood studios study bestseller lists to find their next great stories. But a *New York Times* bestselling book already has the world's attention, and the most precious gems are more obscure. Several years ago, the film producer Aditya Sood got an e-mail

from an agent suggesting he check out a self-published book about a stranded astronaut fighting to survive on Mars. The book was a Kindle bestseller, but it didn't have much mainstream attention. Like *Fifty Shades of Grey* in early 2012, it was still a dark hit. Sood got the book on a Friday and read it on Saturday. He was immediately struck by the confident tone, the cinematic scope, and even the nerdy details about how one might go about growing food on a desert planet. On Monday, Sood called back the agent and said he planned to acquire the rights to turn the book into a movie. The book was *The Martian*. The film eventually earned more than $600 million worldwide and received seven Academy Award nominations, including for Best Picture.

In February 2014, when I visited Culbertson, few people outside of Texas and Republic's Broadway headquarters had heard of SoMo. For Culbertson to suggest then that his artist was having a significant year would have been sketchy at best. One month later, "Ride" was tracking on the Billboard Hot 100. Nine months after I visited Republic, the song had gone platinum, selling more than a million copies.

"Does everybody think like this?" I asked Culbertson.

"At Republic, they do," he said.

Many good seeds fail to flower in bad weather, and many would-be hits fail through no fault of their own. Catchy songs miss the radio, brilliant books miss their core readership. Success in an attention-seeking industry requires a business model that acknowledges that attention, like the weather, is inherently unpredictable.

People talk about television as if it's one large industry. But it's better understood as three business models: broadcast, cable, and premium.[1] The first has historically relied mostly on commercials. The

1. . . . for now. In the near future, I expect broadcast networks like CBS to sell more products direct to consumers, like Netflix, and subscription companies like Netflix to experiment with advertising, like CBS. The merging of business models is already happening. In the last few years, broadcast networks like CBS have made billions from retransmission fees, which are like cable affiliate fees for broadcast.

second relies on payments through cable, which are supplemented by commercials. The third relies exclusively on direct subscribers. These business models are the subterranean roots pushing art to the surface. On television, the hits we watch sprout from business models most people don't see.

Broadcast networks, like NBC, ABC, and CBS, have historically made most of their revenue from advertising. Broadcast aims, well, broadly, to assemble many live viewers who will be watching when the commercials roll.

The economics shape the entertainment. Popular procedural dramas like *CSI*, *Law & Order*, and *NCIS* are like regulated shipping containers, with each episode meeting the exact measurements of the one-hour block. These shows use a similar narrative formula: a steady slate of characters, weekly challenges with clean resolutions, and a new cliffhanger every ten minutes to keep viewers from changing the channel during the commercials. More recently, broadcast television has poured money into entertainment that benefits from live viewing—like awards shows (e.g., *The Voice* and *Dancing with the Stars*) and live sports, particularly football and basketball. Sports is perfectly ephemeral for broadcast's purpose in an age of time-delayed viewing, because fans have to watch live. According to one analysis in 2012, sports rights account for half of all of television's programming costs.

Since broadcast relies heavily on advertising, its job is to find the shows that attract the largest (and richest) audiences. To know if a show will be a hit, NBC administers a series of national surveys. If 40 percent of respondents say they are aware of a new show, and 40 percent of that 40 percent say they want to watch it, and 20 percent of that 16 percent say they are passionate about the new show, NBC can confidently predict that the program will be a hit. This is the 40-40-20 test, and it works. One of the last shows to pass this threshold, *The Blacklist*, debuted on NBC as one of the ten most popular shows on television.

The intense pressure to immediately discover popular shows hurts

broadcast in the long run, because great characters and rich relation-ships take time to develop. NBC and the other broadcast networks test their pilots in screening rooms with live audiences armed with dials they turn to the left to signal their displeasure or to the right if they're entertained. These famous dial tests might be accurate measurements of a show's pilot, but they aren't always great measurements of a show's potential. "*Seinfeld* was not a great test," said Sumi Barry, senior vice president of consumer and market intelligence at NBC. "Neither was *Friends*. *The Office* had an awkward first screen test, but then we put it behind *My Name Is Earl*, and it took off."

Some of the most famous shows in broadcast history did not debut fully formed, like Athena springing from the head of Zeus. They were more like ordinary children, born helpless and slowly reaching matu-rity. When *Cheers* debuted on NBC on September 30, 1982, at nine p.m., it finished last in its time slot. Out of seventy-seven shows that premiered in the 1982–1983 season, its dismal ratings placed it in the seventies. But the show was critically acclaimed, and if NBC had can-celed it, there wouldn't have been many suitable replacements.

Cheers survived to year two, but it still wasn't a hit. But NBC showed patience. Executives knew they had an awards show darling and thought perhaps it would slowly build an audience to match its critical reception. Finally, in its third season, the show's average ratings perked up. In 1985, *Cheers* began an eight-year run as one of the top ten shows on TV.

Hits have what economists call "multiplier effects." If you intro-duce one dollar into an economy, it can produce more than one dollar of GDP growth. The same is true of hits: Growth begets growth, popular-ity begets popularity. The value of a hit television show is greater than its ratings or its ad rates alone, because those don't account for an even more important feature: their ability to support other shows.

The spillover effects of NBC's patience in the mid-1980s were mas-

sive. The obvious dividend was that *Cheers* launched a spin-off, *Frasier*, based on the character of Frasier Crane, a sonorous psychiatrist. *Frasier* debuted as a top ten show in 1993 and went on to be perhaps the most successful TV spin-off, commercially and critically, of all time.

But *Cheers*'s subtler beneficiary was the immortal, loquacious sitcom *Seinfeld*. In the late 1980s, when NBC tested the show's pilot with four hundred households, the response was worse than lukewarm. "No segment of the audience was eager to watch the show again," the NBC pilot tester reported. But several executives loved its conversational pitter-patter.

The network opted to air a one-episode special called *The Seinfeld Chronicles* in the summer dead-zone of 1989. It was a critical curiosity with mediocre ratings. For the next year, nothing much happened. Then the cancellation of a Bob Hope special freed up money for a four-episode run the following summer. The episodes did surprisingly well. No surprise: They aired behind reruns of *Cheers*.

The typical sitcom is a predictable hopscotch between small domestic problems followed by much hugging and learning. *Seinfeld*'s writers, however, would have none of this. They wore jackets embroidered with the show's one and only rule: "No hugging, no learning."

But this pure and unsentimental vision took time to pay off. Even in its third season, the show got walloped by its competition, like ABC's *Home Improvement*, and finished a dismal fortieth among prime-time shows. But in the fall of 1993, NBC moved *Seinfeld* behind its thoroughbred comedy *Cheers* on Thursday nights. It was only then that everybody started watching the show about nothing. Buoyed by the audience of *Cheers*, *Seinfeld* soared in the ratings, from the fortieth to the fifth most-watched show on television.

The rest of the story is lore: In its last five years, *Seinfeld* was one of the most popular shows on television, and *TV Guide* named it the greatest show of all time. Some might argue that *Seinfeld*'s genius is

platonic, an objective example of the presence of godly perfection on earth (I would). But without *Cheers* to help launch it into the cultural pantheon, would anybody have tuned in to find out?

One could draw a sentimental conclusion from this story—for example, that businesspeople are always rewarded for following their hearts. But this isn't that kind of book—"No hugging"—and this isn't that kind of story. *Cheers* was, above all, a beneficiary of its time, when critically acclaimed comedies were scarce and networks rarely canceled original shows after a year. Even in the early 2000s, more than 90 percent of original series on broadcast and cable were renewed the following season. In 2015, however, the number of original shows has exploded, and now only 40 percent of them survive to see another year. There is practically no chance that NBC would renew the four hundredth most popular show in today's era of television abundance.

But perhaps another lesson is about the rewards of betting on talent over outcomes, or "people over products." The truth is that extending *Cheers* in 1983 and 1984 when it was one of the least popular shows on television was a commercially dubious decision, and a broadcast television network might not make the same one today. But NBC didn't rush its writers. It believed in its showrunners as individuals. The network gave them time to develop characters and relationships. Because NBC made the decision in 1983 to extend a show that nobody was watching, the channel spent two decades with some of the most popular and critically celebrated comedies ever. The last episodes of *Cheers*, *Seinfeld*, and *Frasier* are among the fifteen most watched finales in television history.

The definition of *broad* in "broadcast" has narrowed in the last few decades as the number of cable channels and original shows has bloomed. The 40-40-20 rule for hits has depreciated to something more like a 30-30-20 rule. A network can have a "broad" hit on its hands with just 2 percent of the country feeling passionate about its debut.

In 2000, there were 125 original scripted series and fewer than three hundred unscripted cable series, or "reality shows." By 2015, there were four hundred original scripted series and nearly one thousand original reality series—an across-the-board tripling. One can see the effect in Nielsen ratings, which estimate the percent of TV-owning households that watch a given program. For a show to have a Nielsen rating of 20 means that one fifth of homes with a television are watching it. In 1979, twenty-six shows surpassed that lofty threshold. In 1999, only two shows hit the mark: *ER* and *Friends*. In 2015, none did. As television watching options expanded, the threshold for hits lowered.

Cable networks invaded the television landscape with a different business model. They don't make most of their revenue from advertising. Instead, a cable network makes most of its money from fees paid out of each household's monthly cable bill for the legal rights to distribute their channel.[2] If a family pays about $100 for cable each month, approximately $40 of it is divided among hundreds of channels. ESPN gets more than $7 per month, the most of any network. A news channel like CNN gets about 60 cents. This small fee multiplied across the entire country adds up to an enormous sum of money—tens of billions of dollars to support more entertainment than anybody can reasonably consume in several lifetimes. Cable has been the closest thing that the United States has had to a private sector tax. Just as 150 million taxpaying households fund a bundle of services called the U.S. government, 100 million cable-owning households have funded this bundle of entertainment, even if many of the programs don't serve their particular demographic. Young urban workers subsidize Medicare and farm subsidies; young cable households subsidize Fox News and Green Bay Packers games.

2. Although the networks are called "cable" channels, they can also be accessed through satellite television companies like DirecTV and telco companies like Verizon, not just cable companies like Time Warner Cable. But I'll continue to use the catch-all "cable."

In 2005, Rob Sorcher was the executive vice president of programming at a cable channel that most people knew as American Movie Classics. The network had recently changed its name to AMC, but like the surviving actresses in its black-and-white films, this facelift alone was insufficiently rejuvenating. The channel was struggling mightily and in danger of being dropped by cable operators like Comcast and Time Warner Cable. This would have been ruinous, since the first business of a cable network is to stay on the bundle. Sorcher wasn't looking for a broad show with mass appeal, like a raunchy family comedy for Fox. He wanted something that couldn't be copied. As he said: "Your strategy becomes: Let's go for quality."

Sorcher came across an intriguing script by a writer for the HBO mafia family drama *The Sopranos*. The writer's name was Matthew Weiner. Both sides had every reason not to work together. Weiner knew that AMC was a channel without renown or money and might give his show the worst possible exposure. For AMC, this was a slow show about sad and unlikable people in the 1960s world of advertising by someone with no record as a successful showrunner. But they made a deal anyway, because AMC was devoted to making a distinctive show that would ensure its place in the cable bundle. The show was *Mad Men*.

Mad Men was precisely the sort of television that Sorcher wanted— beautiful and strange, a shadowy, intimate drama with cinematic touches and methodical pacing. It was not a blockbuster hit by audience size; the show averaged fewer than one million viewers in its first season, less than a show that might be abruptly canceled on a broadcast network, like NBC.

But AMC didn't need a blockbuster hit. It needed a unique show appealing to a critical mass of valuable viewers so that no major cable company would think of leaving AMC off the bundle. Ultimately, it's almost wrong to say that AMC made money from the few million people who watched *Mad Men*. The channel really made money from the

tens of millions of households who never watched *Mad Men* but none-theless paid a few dollars every year for AMC through their cable bills. One little hit had a massive multiplier effect: *Mad Men* helped to rescue an entire network.

The difference between broadcast and cable speaks to a critical lesson for picking hits: Artistic judgment can go hand in hand with economic savvy. *Mad Men*'s ratings were so low that it might have been canceled after one year on NBC. But on AMC it was a hit, not strictly because of the size of its audience, but because of the business model that it clicked into.

In the last decade, the cable channel FX has arguably produced the deepest lineup of prestige drama and critically acclaimed comedy on cable, including *The Shield, Nip/Tuck, Damages, American Horror Story, Archer, Fargo, Louie, The League, Justified, It's Always Sunny in Philadelphia, The Americans,* and *Sons of Anarchy.* Their genres span surrealist horror, dark biker drama, and verbose spy comedy. "I'm looking for a ninety-hour movie, a novelistic character journey," said Nicole Clemens, executive vice president for series development at FX. "Genre is irrelevant. It is just a Trojan horse carrying the deeper emotional question: Who is the main character becoming? What is he or she going to do next?"

Clemens describes herself as a former latchkey child, raised in the glow of television in the 1970s, with shows like *Happy Days* and *Laverne & Shirley.* She can remember the day she was deemed old enough to stay up and watch *The Love Boat.* Clemens first went to work in film, but she found that the middle class of movies was being hollowed out. Some moviemakers went to work on franchise films that cost hundreds of millions of dollars, while others toiled on small indie films. But the middle left for cable, and in 2012, Clemens followed them for television.

"The key to success for us is to find an authentic original voice and

characters so compelling that the audience wants to wear their skin," she said. That is, FX is looking for superheroes and antiheroes, but they don't have to wear a cape, or even a $5,000 suit. "I define a hero as somebody who can do what we can't do," she said. "That would include a brave fireman, but also a sociopath. Aaron Sorkin's characters are all superheroes. They can't leap tall buildings in a single bound, but they can talk and think better than ordinary humans."

The second principle at FX is what Clemens calls the "hide the vegetables and potatoes" approach to storytelling. Like George Lucas festooning his evergreen myths with glittery technology, Clemens sees the value of old stories wearing new costumes. In *Sons of Anarchy*, its popular drama about an outlawed motorcycle club, "You think it's this super-uber-macho motorcycle show, but it's also a soap with handsome guys. And the plot is basically *Hamlet*." In *The Americans*, the critically acclaimed spy drama about Soviet agents posing as a married couple in the United States, "You crash in, in the middle of the Cold War, and meet this spy couple who has been in an arranged marriage for ten years. They've just started to fall in love, but they have to kill people and sleep with other people. So the spy genre has been subverted to tell a classic story about marriage."

A third business category within television is subscription-only channels, like Netflix and premium networks like HBO and Showtime. It sounds risky to forgo advertising. But this business model is an artistic luxury. If somebody pays for HBO, it doesn't matter if she watches fifty hours a week or never watches at all: HBO makes the same amount of money. The company doesn't have to worry about maximizing ratings each hour to lure advertisers.

NBC studies audience data with Talmudic exegesis because its business model encourages a devotion to delighting the largest possible

audience. HBO does not rely on dial testing, focus groups, or surveys, its executives told me, because its business model requires something subtler. Its economic imperative is to build a television product that viewers feel like they have to pay for—*even when they don't watch it.*

"HBO is in a different business than broadcast," said Michael Lombardo, HBO's former president of programming. "The broadcast channels are selling eyeballs and advertising. HBO is not in the business of selling tickets. HBO is selling a brand." No audience would tell a television network to make a show about neurotic, narcissistic young women flailing in their early twenties, he told me. But when HBO made that very show, Lena Dunham's *Girls*, it debuted as a critical darling and might have been the most written-about show on television. "To what end would I focus-group that show?" Lombardo said. "So that Hannah would be nicer to her friends?"

HBO's first two hit original drama series, *The Sopranos* and *Six Feet Under*, were dark, strange, and too explicit for broadcast television or cable. Several broadcast networks turned down David Chase, the creator of *The Sopranos*, before he accepted HBO's promise of creative latitude. That is HBO's long game: to build a reputation as a place where creative geniuses have artistic freedom. That strategy might not produce a hit each year, but over time serious television viewers will feel obligated to pay HBO for the expectation of forthcoming genius (even if it doesn't always materialize). In this way, a company like HBO is more like a talent management agency than a typical television channel. The network's thesis is: Find the best artists, give them time and space to create, and distribute their creation.

When Lombardo first read the script for *Game of Thrones* in 2006, he worried it would be an impossible haul for his company. The series would be based on George R. R. Martin's bestselling doorstop books about several families battling for power in a fantasy universe similar to J. R. R. Tolkien's Middle Earth. But the price could be prohibitive. The

ten-hour filmed trilogy of The Lord of the Rings, directed by Peter Jackson, had cost about $300 million to make; HBO would have to produce ten hours of similar entertainment year after year. "A part of me thought we shouldn't be doing a show with dragons and White Walkers," Lombardo told me. "I was concerned that we couldn't afford a production that would have to rival those feature films, and HBO had no record of successfully doing this genre."

One afternoon, as Lombardo was undecided on the script, he stopped by the Santa Monica Equinox gym, a few blocks from the beach. He was walking through the cardio section when he saw Dan "D. B." Weiss, one of the two lead writers on the *Game of Thrones* pilot, hunched over an incline bike, reading a copy of the original George R. R. Martin book with copious annotations.

Lombardo approached Weiss to say hello. They chatted for a few minutes. "He was holding a highlighter in his hands," Lombardo told me, "and the book was absolutely covered in notes and dog-ears. That's what HBO wants, to bet on that sort of commitment and passion"—the sort that inspires an obsessive-compulsive approach to adapting a fantasy epic for a network that doesn't do fantasy. "Whatever reservations I had, they were gone. I thought, 'These guys aren't swinging for the easy hit. They're doing this because they love these stories.'" In January 2007, Lombardo and HBO optioned the series. Eight years later, *Game of Thrones* knocked off *The Sopranos* to become HBO's most watched show of all time. Perhaps even more impressively, it holds another superlative that speaks to its global popularity: It is the most illegally downloaded show in the world.

People often compare business to baseball. In both activities, one can mostly fail 70 percent of the time and still be an all-time great. But the difference between baseball and business is that baseball has what Amazon founder and CEO Jeff Bezos cleverly called "a truncated outcome distribution." Home runs can only be so big. In a letter to shareholders, he wrote:

When you swing, no matter how well you connect with the ball, the most runs you can get is four. In business, every once in a while, when you step up to the plate, you can score 1,000 runs. This long-tailed distribution of returns is why it's important to be bold. Big winners pay for so many experiments.

The Sopranos was no ordinary home run. It wasn't just the most watched show in the history of HBO for its time. It also increased subscriptions to the premium cable channel by 50 percent. *Mad Men* wasn't just a critical gem. It also led to AMC picking up *Breaking Bad*, one of the most acclaimed shows in TV history, and the network's cable fee revenue rose 50 percent between 2007 and 2013. This growth in fees helped the network produce *The Walking Dead*, which became the most popular drama on cable.

The risky bets on *The Sopranos* and *Mad Men* didn't just earn their parent companies a ton of money; they also sparked a commercial and artistic revolution on television. The genre of prestige television, which was once a monarchy overseen by HBO, is now a raucous parliament. Netflix, Amazon, Hulu, Showtime, Cinemax, Starz, FX, AMC, USA, and more compete for television shows that will be the next *Sopranos* or *Mad Men*—a critical juggernaut with cinematic panache and the expansiveness of an old-fashioned doorstop novel. Some hits save their company. A special few revolutionize their business. They score a thousand runs.

One of the hard things about writing a representative book about successful cultural products is that hits are not representative. They are intrinsic freaks, outliers, and exceptions. There is no complete and perfect formula for building a popular product. If there were, everybody would know and follow it, and the world would be awash in similarly successful cultural products, which technically means noth-

ing would be very successful. Instead, the entertainment landscape is awash in imitation—comic book sequels chasing comic book sequels, young adult fantasy novels piled upon young adult fantasy novels. Imitation is not a sign that people know the secret of popularity. It is a sign that there is no secret, and the only thing people know is the last thing that succeeded.

"Hit" is a relative term, not only within the television business, but also across entertainment. Bestselling books, blockbuster films, and online videos can all claim the title of "hit," but their commercial popularity can differ by orders of magnitude. If a book sells a hundred thousand copies, it might be a national bestseller, but if a major studio film sells a hundred thousand tickets, yielding a domestic box office of around $1 million, it's a disgraceful flop. Meanwhile, if a studio film sells a hundred million tickets worldwide, it might be one of the highest-grossing movies ever, but a YouTube video with a hundred million views isn't historic at all. The most popular music videos on the platform can amass more than one billion views each year.

An e-book might cost ten dollars and a movie ticket might cost ten dollars, but underneath the price tag the economics of books and movies couldn't be more different. A major movie studio, like 20th Century Fox, might churn out about twenty films a year and spend about $100 million on production and marketing for each one. A major publisher like HarperCollins might publish ten thousand books a year—almost more titles each week than 20th Century Fox will release in this decade.

Both companies are in the business of selling stories, feelings, inspiration, and information. But they *stay* in the business by aligning costs with demand. 20th Century Fox survives in an industry where a handful of products require ten million customers, and HarperCollins survives in an industry where almost nothing sells more than one million copies.

HBO, AMC, FX, Republic Records, 20th Century Fox, HarperCollins, and other hit-making companies are all venture capitalists.

They evaluate an enormous pool of products. They bet on a diverse set of potential hits. But success is semichaotic. Most ideas fail, and ideally the few successes pay off enough to compensate for the failure.

Michael Lombardo and Nicole Clemens have had their share of Cassandra moments, but they are not Greek oracles. Their success begins with a business model that provides a steady stream of revenue to their companies, even in the case where they produce a season of entertainment that almost nobody watches. "We are in the brand play," Lombardo told me. "AMC is a brand. FX is a brand. NBC is still about selling a half-hour slot."

Cable television might have been one of the best business models in modern media—a multibillion-dollar entertainment subsidy from a hundred million households for hundreds of channels, despite the fact that most families never watched most channels. But many signs suggest that the near future will be different. Cable is in structural decline, with young audiences cutting the cord or never even plugging in. The future won't be one bundle for all, but rather many bundles for many— HBO, Netflix, Amazon Video, Hulu, and soon maybe a Disney bundle, a CBS bundle, and a sports bundle. There will be so much high-quality television and digital video series in the near future that audiences will clamor for a product that finds and organizes the best stuff across all of these discrete services. In other words, it will be time for a new bundle. This seems to me the likely future of video: the rebundling of unbundled bundles (which will inevitably be unbundled themselves).

As the monolithic cable bundle disintegrates, it will fall to younger companies to learn what audiences are willing to pay for. Workers in some industries, like journalism and art, occasionally shudder at the pressure to monetize their work. It's always nice to think of creators working in a separate universe from the oleaginous world of commerce. But everybody has to eat. Claude Monet painted for about sixty years—that's twenty-two thousand dinners—with many thanks to his heroic art dealer Paul Durand-Ruel and his friend and benefactor Gustave Caillebotte. Monet

had the freedom to be a dedicated artist because somebody else was his dedicated merchant. David Chase and Matthew Weiner relished artistic freedom because HBO and AMC had an economic model that allowed them—even encouraged them—to take risks.

Art may be invaluable, but it's not free. One way or another, someone has to pay.

WHAT THE PEOPLE WANT II: A HISTORY OF PIXELS AND INK

What People Want from the News

(. . . Is Often Not the News)

Writing in the twenty-first century might be the most competitive industry in human history. The barriers are low, the supply is massive, and the competition is global, with countless publishers producing content for a global audience. Every day, writers compose several million news articles and blog posts, along with hundreds of millions of messages on Twitter and Facebook. But how many of these trillions of gigabytes are something anybody actually wants to read?

To seek the unvarnished truth is the first, and perhaps only, objective of journalism. But news is a business, and a wise publisher seeks a (hopefully) complementary metric: the pleasure of its readers.

Figuring out how to delight readers and audiences might seem like a simple investigation. But understanding what people actually *want* in

the world of art and ideas is anything but straightforward. In fact, audiences are so curious and complicated that the most successful methods of studying their behavior are often indistinguishable from anthropology. So let's go back to the first anthropological study of readers, almost one hundred years ago, in yet another age when it seemed like the world was hopelessly awash in words.

The 1920s were a golden age of reading, and the spine of American bibliophilia ran down Fourth Avenue, south of Union Square, in Manhattan. This was "Book Row," a cluster of forty-eight independent bookstores along six slender blocks. (Today, the storefronts are all gone, except for one of the most famous independent bookstores in America; appropriately for a solitary survivor, it's called the Strand.)

It was a fine decade for the budding of bookstores. The number of books published each year doubled between the 1910s and 1920s, to ten thousand unique titles. But the volume of pulp wasn't the most impressive thing about the decade's literature. The 1920s gave us F. Scott Fitzgerald's *The Great Gatsby*, Ernest Hemingway's *The Sun Also Rises*, and William Faulkner's *The Sound and the Fury*. The European imports included James Joyce's *Ulysses*, Franz Kafka's *The Trial*, and Virginia Woolf's *Mrs. Dalloway*. It was a time for drearily faithless poetry, with T. S. Eliot's *The Waste Land*, and for inspirationally faithful fiction, with the publication of *Siddhartha* and *The Prophet*. One of history's great mystery writers handed off the baton to another. Agatha Christie's first book, *The Mysterious Affair at Styles*, arrived in 1920, and Sir Arthur Conan Doyle's final volume of new Sherlock Holmes stories was published seven years later.

With thousands of titles flowing through the book rows of 1920s America, discovery became a fashionable problem, and new organizations rose to solve it. The Book of the Month Club, born in 1926, promised to handpick only the best works for its select members. The very

next year it got competition in the book subscription business from the Literary Guild of America. Neither organization is praised as an innovator today, but their business model anticipated a century of selling bundled content. Paying a greatly discounted per-unit price to get more stuff than you can reasonably consume is cable TV, Spotify, Netflix, and the modern subscription box business.

What made the twenties such rollicking years for the printed word? A plausible explanation must include education, technology, and politico-economic fortuity. The share of men and women with a high school degree surged from about 30 percent in 1900 to about 70 percent in 1930, and the demand for news and entertainment for this educated workforce soared. Over the next century, the center of gravity in American news would shift to radio, television, computers, and mobile phones. But for a while, ink and paper enjoyed a brief media monopoly. Finally, the 1920s were a peaceful and prosperous period, compared with the war and recession that bookended the decade.

Depending on your perspective, journalism either benefited or outright bloated in this golden age of paper. A litter of iconic magazines was born, which included *Time* in 1923 and *The New Yorker* in 1925, and magazine advertising revenue rose by 500 percent in the decade. Yet the arrival of new periodicals and extraordinary works of literature hardly seemed to quench readers' thirst for daily publications. Newspaper sales also rose by 20 percent in the 1920s, to thirty-six million copies a day. That worked out to 1.4 newspapers for every home. At one point, New York City had twelve daily papers all to herself.

The first decades of the twentieth century also witnessed the aggressive spawning of a new product: the tabloid.

Like so many things in the history of American letters, the tabloid was a British import. Originating in late 1800s medicine, the word "tabloid" first referred to a small tablet of drugs. It soon became a catchall for a smaller, compressed form of anything, including journalism and newspapers. The godfather of tabloid news was the great Brit-

255

ish media mogul Alfred Harmsworth,[1] the founder and owner of the *Daily Mail* in London, which debuted in 1896. With shorter articles, populist pluck, and a halfpenny price (one halfpenny cheaper than its rivals), the *Daily Mail* was a sensation in Great Britain. By 1900, it was the first newspaper in the world to claim a circulation of more than one million.

Unexpectedly, for a pioneer in pithy vulgarity, Harmsworth was grandiose, placing his growing media empire in the sweep of history. "We are entering the century of combination and centralization," he wrote. "The world enters today upon the Twentieth or Time-Saving Century. I claim that by my system of condensed or *tabloid* journalism, hundreds of working hours can be saved each year." Thus the tabloid was conceived not merely as a digest of smut, but also as a time-saving technology.

Tabloids focused on sports, gossip, and, above all, crime. A 1927 study showed that they devoted nearly one third of their inches to crime stories, ten times more than traditional papers. The first U.S. tabloid, inspired by Harmsworth's *Daily Mirror*, was the *Illustrated Daily News*, which launched in New York in June 1919. By the 1940s, it was the bestselling newspaper in the United States. By degrees, the tabloid ethos colonized even the most venerable papers, like the *Washington Post* and the *New York Times*, which beefed up on ballgames and blood to keep up with readers' evolving (or, some might have argued, devolving) tastes.

It was an era of growing pains for America's largest newspapers. The late 1800s had seen an explosion of smaller papers, tailored for specific classes, languages, and ethnicities. New York and New Jersey alone were home to *L'Eco d'Italia*, *L'Observateur Impartial*, *Armenia Times*, *Norway Tidings*, and *Der Idisher Zschurnal* (*The Jewish Journal*), among other ethnic papers. *The Canajoharie Radii*, founded by

1. Harmsworth: an exquisitely Dickensian name for a man who got filthy rich while standing accused of harming the institution of journalism.

a deaf-mute teacher named Levi Backus, initially focused on news for the deaf. This level of specialization meant that, say, Italian American reporters were writing for Italian American readers, who were sometimes their own Italian American neighbors. Journalists were members of their own audiences, and editors did not have to agonize over what to put in the paper, since writing for one's readers often meant writing for oneself.

But the papers of the early twentieth century were a different beast altogether—national rather than local, pluralistic rather than purely ethnic. Urbanization encouraged smaller papers to consolidate. The invention of the telegraph and the syndication of news brought far-flung stories to local readers. The business of newspapers was changing, but so was the basic charge of journalism. As newspapers got bigger, editors were responsible for reaching a massive and diverse group of readers they didn't know at all. Writing for one's audience no longer meant writing for one's neighbors. It meant writing for hundreds of thousands of strangers.

These technological and cultural changes forced editors and publishers to come up with a new approach to an old question: *What do readers want?*

Newspapers had all sorts of ways to measure the demands of their readership in the early 1900s, but each was flawed and some were preciously primitive. Circulation records could tell publishers the size of their audience, but not where readers looked when they opened the bundle. Complaints and responses—e.g., letters to the editors—were an honest source of feedback, but a vocal minority of readers offered a caricature of a paper's true readership.

Publishers stooped to absurd tactics to find out what people were reading. To learn what features were most popular, some papers hired private investigators to sneak up behind readers to mark the articles they were looking at. Other publishers sent spies onto trains and trolleys to record the exact page that discarded papers were left open on the

floor. This was a horrid way to measure readership, since it didn't say whether people enjoyed the page before exiting the train in a hurry or hated the story so much they flung it to the ground in disgust. But desperate times called for trolley trawling.

The golden age of reading was still in the stone age of understanding readers. Then along came a man whose name is now synonymous with public opinion. He offered a beguilingly simple plan to figure out what people want. Go into their living rooms, he said, and just watch them.

George Gallup dreamed of being a professional newspaper editor. But when he graduated from the University of Iowa in 1923, he joined the school's PhD program in applied psychology. Five years later, he published a dissertation that united his dream and his degree, by studying readers as if they were research subjects.

Gallup was no sentimentalist when it came to the Fourth Estate. He saw newspapers principally as gladiators in the arena of attention. "The problem of the modern newspaper is to fit itself as nearly as it can to the needs of the reading public," he wrote. "Specifically, its problem is to get itself read." This was not a rousing avowal of journalism's civic duty, and yet it had merit. A paper without readers is destined to be bankrupt, and a well-reported story is of little use if nobody reads it. Gallup was ahead of his time in understanding that newspapers' competition didn't just come from the pulpy inventions of his era, like tabloids and weekly magazines. It came from *anything* that required the attention of potential readers. Among the newspaper's rivals, he included radio, the burgeoning film industry, and even time spent driving in a car.

His 1928 dissertation was titled "An Objective Method for Determining Reader Interest in the Content of a Newspaper." Gallup's em-

phasis was squarely on the adjective "objective." He was dismissive of circulation and publishers' pathetic efforts to dispatch secret agents to spy on readers. He was even skeptical of questionnaires.

Instead, he proposed an ethnographical approach that he called the "Iowa Method." Intent on observing families in their own living rooms and kitchens, he sent interviewers into Iowans' homes to sit across a table from subscribers. Researcher and reader would flip through the Iowa papers together, from the top story on the front page to the cartoons, marking each headline, paragraph, and image as read or unread.

Gallup suspected that readers often lied in surveys, so he instructed his team to ignore statements like, "I read the whole front page" or "I read nothing but the comics," because, he wrote, "almost without exception later questioning proved these preliminary statements false. The person who believes he has read all of the front page may not have read a fourth part of it."[2]

Gallup meticulously recorded his interview data across dozens of pages. He considered how working male readers differed from women and how farmers treated the newspaper differently from urban families.

He determined that hard news on the front page was no more popular than some soft features buried in the back of the paper. The most read item wasn't news at all. It was the front-page cartoon by J. H. Darling, read by 90 percent of men, compared with just 12 percent reading the day's local government news. For women, the most read parts of the newspaper were "style and beauty pictures." Today's media critics offer trendy warnings about journalism drowning under Facebook, cable news, and the deluge of social media. But the typical news readers of the 1920s didn't crave long-form coverage of arcane yet politically con-

2. Since the name Gallup now brings to mind surveys and market research, it's more than a little ironic that the thesis that made him famous highlighted the problems with relying on people's knee-jerk reactions to questions about their behavior.

sequential international reportage. Men in the 1920s liked funny pic-
tures and the women liked pretty photos.

The idea of doing product research by watching people in their
kitchens might not seem jaw-dropping. But it was subtly revolutionary.
Gallup was a pioneer in what some now call "applied anthropology,"[3]
the use of anthropology to solve a practical human problem. In the
1930s, the U.S. government hired its first applied anthropologists to
study Indian reservations to implement the Indian Reorganization Act
of the New Deal. In the 1980s, Xerox PARC, Palo Alto's idea factory,
employed anthropologists to design prototypes for the modern com-
puter. Today, consulting firms like IDEO and McKinsey often begin
projects by dispatching young employees to observe clients and con-
sumers in their natural environments—their offices, kitchens, cars,
and living rooms. After the U.S. government, the second-largest em-
ployer of anthropologists today in the United States isn't Harvard Uni-
versity or UCLA. It's Microsoft.

Gallup's methods made him a marketing celebrity in the 1930s. He
joined the ad agency Young & Rubicam and applied his approach to
print advertising in the depths of the Great Depression. Gallup changed
the way publishers thought about white space, surprising fonts, and
large images. For example, based on close interviews with readers, Gal-
lup concluded that ads placed "beneath the fold," in the bottom half of
a newspaper page, were often ignored. He also found that readers pay
more attention to photos than words.

Gallup eventually applied his methods to politics, where his sur-
name became a widely known brand in the arena of public opinion.
Today journalists and researchers often refer to Gallup surveys and
polls on everything from worker engagement to racial attitudes and
presidential elections. But there is an important distinction between

3. Gallup's method is best described as ethnography, and yet the field is often called "applied anthropology."
What's the difference? Anthropology is the study of people and their environment. Ethnography is a method
of studying people in their environment *by observing them firsthand*. Anthropology is a broad discipline,
and ethnography is a specific method.

these two services. Surveys measure *present* feelings and behavior (Are you a registered Republican?). Polls forecast *future* election results (Will you vote for the Republican in next year's election?).

The distinction between surveys, a measure of the present, and polls, a measure of the future, points to the second lesson of Gallup's Iowa Method. People are good at telling you their feelings. But they're less dependable at reporting their habits (particularly their bad habits) or projecting their future wants and needs.

Iowa readers were untrustworthy reporters of their own behavior. But so are most people. Ask somebody about his shortcomings and he'll often cover up the filthy truth by encasing it in a Loewyesque shell of aspirational thinking. In psychological studies this is sometimes attributed to "social desirability bias." People tell researchers (not to mention friends and family) that they're better than they really are because they want people to like them. Or, more subtly, they want to tell *themselves* that they are the kind of person that people like. A 2008 review of the effect found that research subjects fib about almost every element of their identities: their competence at various tasks, their psychiatric condition, their exercise regimen, their emotions, their behavior toward partners, and their diet.[4] Given time to reflect, people prefer to talk about the person they want to be, not the person they are.

People mischaracterize their bad habits because they can. They fail to forecast their future behavior because they can't. Predicting *anybody's* future is difficult, even your own. It was especially difficult for avid newspaper readers in the 1920s and 1930s to foresee the whiz-bang technology just around the bend. It was a small box powered by cathode-ray tubes that would supplant newspapers and radio on its way to becoming the most popular media product in American history.

4. Equally interesting, perhaps, are the areas where researchers found no evidence of social desirability bias—religion, for example. Belief in God is perhaps one of the few traits stronger than a person's desire to be well liked.

B y the middle of the twentieth century, large newspapers continued to grow in both page count and readers, having absorbed many small and specialized dailies. But they faced a new test, which proved more daunting to the future of reading than tabloids, radio, film, or even cars.

In the 1950s, the television went from living room curiosity to household ubiquity. Less than 1 percent of homes owned a television set in 1948. One decade later, 83 percent did, and they sat in front of it for more than five hours a day. No personal technology—not the radio, the telephone, the car, the refrigerator, or indoor plumbing—had ever spread so quickly from household to household.

Newspapers initially ignored the threat from television. Print journalism was "far more fascinating, far more varied, and offers far greater possibility of financial reward," *New York Daily News* executive editor Richard W. Clarke said in 1947. *New York Times* executive editor Turner Catledge, writing in 1951, claimed he did not "regard TV as a direct competitor of the type of newspaper we publish." Meanwhile, publishers hedged against the possibility that there might be something to TV after all, by owning six of its first fifteen stations.

Although it's easy to judge the publishers' misplaced confidence several decades later, they were comparing themselves to a television news product that was just plain awful. There was little original reporting on television, and the first generation of producers didn't understand how to make a good TV show. Rather, they knew how to put a good radio show on TV. But bad television didn't stop people from building channels—which quintupled in the 1950s—or from watching television. Between 1948 and 1955, a household's average time spent listening to the radio fell from 4.4 hours to 2.4 hours.

It would be satisfyingly dramatic to report that a single news story marked the inflection point in television's transition from fringe to

mainstream. No such event exists, but the story of a young California girl named Kathy Fiscus comes quite close. On a Friday afternoon in San Marino in April 1949, the young girl, with light curly hair and a giggly smile, fell into the narrow shaft of an abandoned water well. The city commandeered an arsenal of digging tools at the scene to rescue Kathy—drills, bulldozers, cranes, and dozens of floodlights from Hollywood studios. Reporters from the Los Angeles station KTLA covered the rescue attempt for twenty-eight consecutive hours, and ten thousand people assembled to learn, sadly, that Kathy had died at the bottom of the well. The rescue effort was front-page news for the *Los Angeles Times*, but the tragedy highlighted the ability of television to transport people to breaking news in a way that the printed word could never do. "This was the first time that the cathode-ray tube had out-and-out scooped the newspapers," recalled Will Fowler, a famous longtime Los Angeles reporter. (Seven decades later, cable news remembers the lesson. Nothing on television captures the national attention like a relatable mystery that holds out the promise of a pat resolution: *Who won the election? Who planned the attack? Where did the plane go?*)

In the 1950s, several political events demonstrated the power of this curious little box. The 1951 Senate committee to investigate organized crime and General Douglas MacArthur's return to the United States were both transmitted to tens of millions of viewers. The 1952 Republican National Convention created the largest audience for a live television event ever to date, with sixty million viewers. *Newsweek* called it "the television convention." In 1956, Dwight Eisenhower was so keen on the power of television as an empathetic medium that he hired a young television marketer—from Gallup's old firm Young & Rubicam, in fact—to orchestrate the Republican National Convention and inject it with "informality, feeling, and emotion."[5] The 1960 presi-

5. I cannot resist pointing out that the values ascribed to television in the mid-1950s—informality and feeling—are precisely the words that Internet publishers use to describe the uniqueness of digital content. One possibility is that each new medium feels more intimate and emotional when it debuts. Another is that the long arc of news and entertainment media innovation bends toward ever greater informality and feeling.

dential election featured the first televised debate, fatefully juxtaposing the regal air of John F. Kennedy with the moist mug of Richard Nixon. Today, the 1960 contest is widely considered "the television election," but it would be a mistake to think that it was the first election inflected by television.[6]

By degrees, the country's leading media critics changed their tune about television news. It wasn't all terrible, merely *often* terrible, and occasionally exquisite. In 1961, Newton Minow, chairman of the Federal Communications Commission, delivered his famous address calling television a "vast wasteland." But his speech was not as dire as its most well-known quote would suggest. In fact, the address included another line that ought to be similarly immortal. "When television is good, nothing is better," he said.

*W*hat do people want to read? is the question that kicks off this chapter. It's the question that motivated newspaper publishers to hire spies and made George Gallup a star.

But the success of television suggests that the query is too narrow. The correct question would be: "How do people want to experience news, entertainment, and storytelling, whether the medium is words, images, or sounds?"

Sometimes, an upstart company will topple a legacy industry not with a superior product in the old market, but with an inferior product in a new market. Indeed, it turned out that the greatest threat to newspapers wasn't better newspapers. It was bad television. Television supplanted paper as the main source of news almost everywhere it was introduced. In the United States, the UK, Australia, and across conti-

6. This would not be the last time a news outlet used this construction for a newfangled technology and an election. The *Huffington Post* announced the "Snapchat election" in 2015. BuzzFeed named the "Facebook election" in 2014. *The Hill* called 2012 the "Twitter election," and in 2006 the *New York Times* forecast the "YouTube election."

nental Europe, newspapers sold per person plummeted in the second half of the twentieth century.[7]

If television sapped newspapers' readership, the Internet finally felled the dead-tree business model. Like their physical delivery, newspapers are an economic bundle. The business section pays for the political reporting; the auto and real estate sections cross-subsidize the international investigations. But the Internet uncrossed the subsidies. Sites like Craigslist, eBay, and Zillow offered more direct and accessible versions of the classified sections and real estate pages, and advertising fled print for other websites. If that wasn't enough, digital news has surreptitiously undermined paid news in a broader sense by creating an expectation that news should be free. There are now dozens of excellent advertising-only websites that have taken the place of legacy newspapers and magazines. But together, they have committed a kind of unintentional manslaughter of paid news by instructing a generation of readers that attention time alone can fund journalism.

Internet news is evolving, too. In the first stage, newspapers and magazines put their articles on the Web, shoehorning the previous decades' content into the new medium, much like early television shows were essentially radio programs plopped in front of a camera. In the second stage, aggregators took over. Readers learned they didn't have to go to a website to learn about the morning's news. They could type keywords into the Google search bar and the news would blink into view. They could visit portals like Digg and Reddit, which ranked and contextualized links from several publishers. Or they could log on to social media, like Facebook and Twitter, to read articles posted by their friends and peers. The rise of the aggregators diluted the power of websites and home pages, as readers learned to go to Google or Red-

7. There are exceptions to this rule, but they are mostly countries that got rich after the 1950s. The country with the highest growth in newspapers-per-person in the second half of the twentieth century was South Korea, and no OECD country added more total dailies than Mexico.

dit for questions previously reserved for their local newspaper. The center of power in publishing was shifting from news brands to discovery platforms, quite like it did in another age of abundant words, when the Book of the Month Club helped readers strategically sample from the surfeit of new titles.

Today social media has replaced the morning paper as the first stop for many young people seeking news about the world. Young people between eighteen and thirty-four—alternatively called Millennials, Gen-Y, and several other things—tend not to follow news "by going directly to news providers," the American Press Institute found in a 2015 survey. Instead, nearly 90 percent of young people get news from social media.

The twenty-first century marks a high-tech reversion to the values of nineteenth-century news, with the niche reconquering the mainstream—with a twist. When mass media was splintered into hundreds of ethnic papers, editors still served readers in a strictly unidirectional relationship. Today, however, readers are their own editors. Facebook and Twitter users don't have to follow news brands at all. They follow individuals, who share whatever article or image they happen to find interesting or outrageous. The basic unit of news used to be a paper bundle, organized by strangers and distributed via delivery route. Today the atomic unit is an article, delivery is free, and everybody serves as editor, reader, and broadcaster at the same time. *The news* is an anachronism. It's *my news* now.[8]

There are three themes here worth unpacking specifically: the twentieth-century shift of news from text alone to text, sound, and video; the evolution of news discovery from individual publishers to

8. The door swings both ways. News readers serve as their own editor, reader, and broadcaster, but so do newsmakers. When newspapers (and TV, radio, etc.) owned the distribution of news, celebrities, CEOs, and politicians had to go through reporters to get their word in. Now those same celebrities, CEOs, and politicians can post things in their own words, on their own time, on Facebook, Twitter, Instagram, Medium, and so on. So the Internet has flattened the news-reading process and the newsmaking process by giving news subjects their very own outlets.

platforms aggregating many publishers; and the rise of personal networks replacing the news curation once performed by editors and journalists. There is really one company that sits at the center of all these trends and is, today, the most important source of news and information in the world. That company is Facebook.

When George Gallup said the problem of the modern newspaper was "to get itself read," he could not have possibly imagined the scale at which a company might succeed along this metric. More than one billion people around the world log on to Facebook on any given day, and about 170 million of them come from the United States and Canada alone. In July 2014, the company reported that the average U.S. consumer spends fifty minutes daily on the social network. That is more time than the typical American spends reading and playing sports combined, according to the Bureau of Labor Statistics.

Facebook's home page is called the News Feed, a stack of life notes, videos, photographs, and articles, organized by a master algorithm to display the most interesting stuff at the top. Like any algorithm designed to engage people, the News Feed is a mirror of user behavior. People who like liberal articles and baby pictures tend to see more liberal articles and babies. But it's also a reflection of Facebook's own values. As an ad-supported business, Facebook's commercial interest is not merely to help you find something interesting and fly away to some other corner of the Internet, but rather to build an environment where people come, stay, and scroll through advertisements.

In the twentieth century, one could roughly divide each communications technology into two categories: social (one-to-few) and broadcast (one-to-many). Talking was social; radio was broadcast. Telephones were social; television was broadcast. Facebook is a departure from twentieth-century technologies because it is both social media (a place to see friends' photos) and a broadcast platform, as the single most im-

267

portant source of Internet traffic. This is what makes Facebook power-
ful: It is both a global mail system and a global newspaper, part
telephone network and part television broadcast.

The News Feed's algorithmic formula is like the Coca-Cola recipe.
It serves billions of people and nothing close to its full explication has
ever been published. Recently, I visited Facebook's headquarters in
Menlo Park to meet with its head of product management, Adam Mos-
seri, a former designer who once ran a consultancy that specialized in,
among other things, museum exhibitions. I didn't expect Mosseri to
reveal the darkest secrets of his lab, as if I were Charlie Bucket staying
late at the Chocolate Factory. Instead, I wanted Mosseri to explain the
News Feed's philosophy of engagement and how Facebook thinks about
Gallup's central question: *What do people want to read, and how do
you give it to them?*

Facebook has an advantage over the Iowa Method and basically
every other company in the world when it comes to understanding peo-
ple. In psychological studies, "reactivity" is the notion that when people
are aware that they're being watched, they change their behavior. On
Facebook, however, it's unlikely that most people are in a constant state
of nervous self-monitoring, lest Facebook's data scientists know that
they like videos of red pandas. Facebook can watch readers with-
out readers' explicit awareness that they are under surveillance. This
ought to afford a fairly accurate understanding of what people really
want to read.

The most obvious thing that Facebook can tell is that reader prefer-
ences are a mosaic within countries and around the world. South Kore-
ans watch more videos on Facebook, many Middle Eastern countries
have longer comment discussions, Thailand and Italy use more illus-
trated faces called "stickers." But there are universalities, too. "If you
ask people worldwide why they come to Facebook, they primarily talk
about connecting with friends, family, or people they care about who
are far away, like a sister in college across the country," Mosseri said.

Given the chance to look at anything in the world, most people don't gravitate to hard news. They are rather like the Iowan readers from Gallup's dissertation, preferring to look at things that are personal, funny, or beautiful.

The strongest signal that somebody enjoys a post on Facebook is liking it, sharing it, and leaving a comment. These likes, shares, and comments pour into an algorithm that is constantly reordering the feed to surface the most relevant stuff at the top. It's a bit like opening each morning's newspaper to find the front page is a reflection of the stories you read in previous weeks. In 2013 Mark Zuckerberg made the analogy himself, saying, "The goal is to build the perfect personalized newspaper for [more than a] billion people."

Facebook's ability to watch its readers as they read is the dream of any publisher, going back to George Gallup.[9] But it turns out that when a personalized newspaper holds up a perfect mirror before its audience, the reflection can be kind of gross. When the News Feed relies exclusively on user behavior, it can become pure sludge, an endless stream of nutrition-free diversions.

The journalist Steven Levy has called this the "dozen doughnuts" problem. People know they shouldn't eat doughnuts all day, but if a coworker puts a dozen doughnuts by your desk each afternoon, you might eat until your mouth is caked in sugar. The News Feed, too, can be a daily tabloid—a hyperminiaturized serving of celebrities, quizzes, and other forms of empty calories that people click on, telling Facebook's algorithms to serve more doughnuts. But Facebook realized that if people think the News Feed is just a sugar bomb without any deeper meaning, readers might shutter their accounts.

9. The company's ability to run thousands of tests simultaneously on its users has created controversy, as when Facebook revealed that it had manipulated the News Feeds of more than 689,000 people to make them see more positive or negative news. The results of the study were interesting: People who saw more positive posts contributed happier content, while people who saw more negative stories adopted that negative tone in their posts. Online critics responded that if moods are indeed contagious, Facebook shouldn't be so cavalier about infecting readers with depression.

So Facebook, having taken Gallup's ethnographical method to its extreme, has decided there *is* value in asking people what they want. This is why Facebook offers in-line questions on the News Feed ("Do you like what you just read?"), readers surveys ("What sort of thing would you like to see?"), and expanded questionnaires where paid "raters" around the country answer several questions about every item in their News Feed and write a paragraph about each story. Did they talk about it later with their family and friends? Did they have an emotional response? Did they find it insightful?

There is what people *want* to read. And then, there is what people *actually* read. Mosseri told me that one of the most important things Facebook studies is this gap—and how to close it. The News Feed must appeal to the behavioral self, by displaying stories that readers reliably click, like, and share. But it should also appeal to the aspirational self, by showing stories that readers want to see even if they don't interact with them.

"If I asked if you want to exercise, you would probably say, 'Yeah, maybe twice a week,'" Mosseri said. "But if I ask you at six thirty in the morning tomorrow, 'Do you want to exercise?' you'd say, 'No, I want to sleep for another hour.'" Mosseri is interested in where these two selves—the aspirational self and the behavioral self—can be served by one product. "What could we show you that you would say you want and you would interact with? We are always looking for those aligned interests," he said.

The best example of the gap between the behavioral self and the aspirational self from recent media history is the story of "clickbait." An article is considered clickbait if the headline gets the reader to click on a story that doesn't live up to its promise. Several years ago, the Internet was awash with headlines that tantalized with some delicious detail and ended with a cliffhanger. "A Bear Walked Into a Grocery Store. You Won't Believe What Happened Next." "Why Do Babies Cry So Much? The Answer Might Surprise You." "If You Think Exercise

Will Help You Lose Weight, This Will Blow Your Mind." These stories lured readers into terrible, saccharine, nutritionless stories. Clickbait was that daily box of doughnuts—irresistible, yet unhealthy.

If Facebook had relied exclusively on clicks, then clickbait might well have taken over the entire Internet. Instead, the company had several feedback metrics, like in-line surveys and questionnaires, which showed many readers hated clickbait stories, *even though they often clicked on them.* In the last few years, Facebook has announced several initiatives to delouse the News Feed of bad curiosity-gap headlines.

My favorite example of this gap between the behavioral self and the aspirational self has nothing to do with reading, but usefully extends the foodie metaphor beyond doughnuts. In the early to mid-2000s, McDonald's got more aggressive about promoting healthy options like salad and fruit on its menus. But its revenue growth in those years was due entirely to people eating more greasy fare, like cheeseburgers and fried chicken. New healthy options seemed to lure wannabe dieters into the restaurant, where they would order fast-food basics. In 2010, a group of wordsmithing Duke University researchers called this phenomenon "vicarious goal fulfillment." Merely considering something that's "good for you" satisfies a goal and grants license to indulge. People say they want hard news in their social media feeds, but mostly click on funny photos. People say they want to eat greens, but mostly order greasy sandwiches at salad-serving restaurants. People aren't lying—they *do* want to be the sort of person who reads news! They *do* want to see salad options!—but mere proximity to good behavior satisfies their interest in behaving well.

The economics of highbrow media, or any "good for you" business, often requires monetizing aspiration rather than actual behavior. Most gyms don't make money by letting infrequent visitors pay by the minute. Instead, they get suckers to sign up and pay in early January for hours of exercise that will never materialize in June (or even late January). The subscriptions of the flabby-bellied are subsidizing the sweat

of the gym rats. But there's another way to conceptualize this scheme: Gyms are monetizing the gap between aspiration and behavior.

Prestigious magazines do it, too. It is a common observation among *New Yorker* readers (at least the ones I know in New York) that the magazine can be a source of guilt, since it publishes more excellent stories than its subscribers can realistically consume. I have been in many apartments and homes where the living room or bathroom includes a collapsed tower of untouched *New Yorker* issues on a table or in a wicker basket.[10] Digital pages are typically monetized by each click and impression. If *The New Yorker*, *The Atlantic*, or the *New York Review of Books* made money only from the individual print pages that their subscribers read, they might be in trouble. Instead, those magazines each have hundreds of thousands of subscribers who pay the same annual amount whether they read a thousand pages or zero. Subscriptions insulate a business like HBO, Netflix, or *The New Yorker* from the need to maximize attention or use on a per-unit basis. That gives companies a dependable revenue stream and offers creators a bit of slack.

There is a third dimension to giving people what they want beyond stated preferences (what I say I want) and revealed preferences (what I do). Those are latent preferences: what I don't even know I want.

Facebook observes several network effects that are too complicated to ask someone in a survey. For example, users never ask to see notifications of other people making new friends on Facebook. But "friending stories"—notifications that two people have become friends—have a contagious effect. When people see friendships forming, they're more likely to add friends themselves, which creates more connections, which means more content, which makes News Feed a better experience for people.

Several years ago, Facebook tried showing more comments under

10. There is a Japanese word related to this: "Tsundoku," which means the piling up of unread books. In a culture of abundant media, everybody is practicing a form of multimedia tsundoku—buying books they don't read, subscribing to magazines they don't open, and queuing up shows they don't finish.

articles. This wasn't necessarily something that most Facebook users knew they wanted. But Facebook found that people who saw more comments eventually posted more comments. That led to more overall content, more notifications, and more time spent on Facebook.

So the answer to the question "What do people want to read?" has three dimensions. The first dimension is the simplest to observe: It's clicks, likes, and shares. It's everything you can learn from just watching people, like George Gallup in an Iowan's living room. The second dimension is closer to vicarious goal fulfillment. It's what people ask for in surveys—hard news on the News Feed, salad on the menu—but doesn't always show up in their observed behavior. The third dimension is the most complex and, perhaps, the most valuable. It's what people don't know they want, but if you give it to them, it will make their lives better, sometimes through sheer surprise, like the iPhone, and sometimes through unexpected network effects, like friending stories on Facebook.

I n the second half of the twentieth century, television slowly eroded the influence of newspapers as it became clear that most people preferred moving images to static text. On Facebook, this half-century shift from text to video might be complete in a few years. Facebook "will be probably all video" in five years, said Nicola Mendelsohn, the head of Facebook operations in Europe, the Middle East, and Africa.

Facebook is not predominantly a news site, but young people spend so much time on it that it's become the dominant source of news traffic for digital publishers. Forty-four percent of the entire U.S. population—and 88 percent of people under thirty-five—get their news from Facebook. That makes it a larger news destination than Twitter, Instagram, Snapchat, Reddit, LinkedIn, and YouTube combined. Facebook has, for the moment, achieved a sort of dominance that was unheard of with previous technologies. The *New York Times* was never the equivalent of

"newspapers." Fox News was never the entirety of "cable television." But when it comes to news, Facebook is quite nearly "the Internet."

But Facebook may find that widespread scrutiny is an inherent cost of growth. In 2016, the company faced a broad public backlash when ex-employees went public with the explosive accusation that the company was suppressing politically conservative publishers. If Facebook was just another media channel, this wouldn't matter. Liberal news channels like MSNBC harshly criticize Republicans all the time and it's not a national news story. But Facebook is not like a television channel. It is like something we've never really seen before: a superpowered cable operator for the mobile future. Facebook is a media company, but more than that it is a social utility, an integral piece of information infrastructure upon which hundreds of publishers and media companies rely to reach their audience.

The company's swift rise to media juggernaut has attracted skepticism, particularly from journalists who think Facebook has an obligation to be more forthcoming about how the News Feed works if it's going to be the central distribution channel of news. Facebook has stressed that it is a neutral platform to facilitate the transmission of any communication. But this seems insufficient, since the very idea of a neutral platform governed by a human-designed algorithm is fundamentally flawed and possibly paradoxical. The Facebook algorithm is not a divine expression of audience preferences. It is, like so many artworks and products, a hypothesis, a best attempt to engage an audience. This algorithmic hypothesis was written by humans, and those humans have human bosses, and the human bosses have human motivations, flaws, and investors, and this weight of humanity leaves its imprint on every algorithm, including Facebook's.

The truth is that nobody wants Facebook to be entirely neutral, least of all Facebook. The company does not want to become a petri dish for clickbait or emotional abuse, and it has taken measures to suppress specific headline styles and fight trolls. But the News Feed can

also fill up with conspiracy theories and outright lies designed to amass an audience through gullibility and outrage. As Facebook continues to grow, the company may have to reckon with new obligations that go beyond any previous newspaper, news organization, or public utility. But it is not sufficient to build an open road for online communications and then neglect to police the worst drivers.

Facebook is a modern newspaper, by virtue of its readership and the fact that it has become a major portal for news. But Facebook is an expert in networks, not news. There is no equivalent editor-reporter relationship or civic duty to focus on issues of local significance. Rather, Facebook is principally in the business of encouraging people it does not employ to post content it did not commission that is meaningful to an audience it does not know. In other words, the News Feed's raison d'être is to *induce interestingness*.

That is a far cry from the *Des Moines Register* or the *New York Daily News* of the 1920s. But it is the apotheosis of George Gallup's 1928 edict for the modern publisher: "To get itself read."

INTERLUDE

828 Broadway

One of the most frustrating things about writing this book is that I cannot see you. An actor can feel the chill of a dead audience. Or if the house is full and loud, he can feel the imminence of a standing ovation the way an animal can sense a storm. But writing is relative solitude. Writing a book for people I don't know feels like putting on a play in blindfold behind a soundproof wall. The work itself offers few hints of the reception.

So it's always been, you might say. But the feedback loop for digital writers today couldn't be clearer. Several years ago, when I was an economics writer for the website of *The Atlantic*, the newsroom received a tool called Chartbeat that offered a kind of total reader surveillance. Chartbeat provided a one-page live gauge of our global audience. In a glance, writers could see the exact number of people around the world currently reading the most popular articles, where they were coming from, how many minutes they spent reading, and how far down the page they went.

Like any number of Internet tools, Chartbeat was a utility wrapped in a distraction inside an addiction. It answered an important question that had haunted publishers for decades: *What do readers actually*

read? But its lessons were not always positive. The most shared articles on Facebook, as you might recall, aren't typically investigative reports from Syria, but rather frivolous quizzes. I spent many hours once reserved for writing just staring at Chartbeat and trying to glean its secrets: Should I write more headlines that are questions? Should I write more about the business model of television, or about the consumption habits of teenagers? Neither all good nor all bad, Chartbeat was rather like a nesting doll set of Trojan horses where you're not sure if the thing at the heart of it all is a gift or a mortal enemy.

I wanted to know more about this attention meter that had ironically soaked up all my attention. I wrote to the company's founder, Tony Haile, and asked if I could interview him for an article or, perhaps, a book. He invited me to come by Chartbeat's headquarters, near Union Square in Manhattan.

Approaching his block, I saw a large maroon banner unfurling the words "Strand Books." As I got closer, I realized that Chartbeat wasn't just on the same block as the legendary bookstore the Strand; it was in the same building, at 828 Broadway.

I got in the elevator and rode up several floors. Inside, the office looked like so many small technology companies: open floor plan, rows of twenty- and thirtysomethings wearing headphones in front of Apple computers. Tony met me there. Tall, with short blond hair, he wore a twice-unbuttoned white oxford shirt revealing a polar bear's tooth, which dangled on his chest from a thin leather strap around his neck.

Before he invented Chartbeat, Haile saw much of the world that he eventually monitored. He lived in a Palestinian basement, served as the bowman on an around-the-world yacht race, led expeditions to the North Pole—hence the polar bear tooth—and ran a social network start-up that quickly fired him. When he moved to New York, he slept on the floor in a girl's apartment. "She is now my wife," he said.

I went to Chartbeat to talk about attention. Instead, we talked about feedback. In the second half of the twentieth century, an air

force pilot and military strategist named John Boyd devised a decision-making model that he called OODA. The acronym stood for Observation, Orientation, Decision, and Action. It described a strategic approach in which information was constantly funneled back to the decision maker to construct a new theory of attack.

Every fighter pilot decision—like every book, article, song, or film—is a hypothesis, a theory about how the other side, or audience, will respond. When the response comes, it is almost always a surprise. So, what do you do next?

According to Boyd, the key to a successful fighting force wasn't just a brilliant plan of attack. It was a facility for learning and changing strategy quickly, when the enemy inevitably adapted to counter the initial strategy. "The speed of adaptation was the key factor in whether you could win or lose in a dogfight," Haile said.

OODA has since been applied to several disciplines, with the takeaway being that the most successful warriors—or publishers, politicians, or sports coaches—aren't necessarily the biggest and the strongest. Rather, a special few have the gift of perception and keen reactivity. They can size up an opponent, attack, absorb the meaning of the response, and gradually learn to anticipate the next move. On this point, Hamlet was brief, for once: "The readiness is all."

"There are no mysteries anymore about what articles people are reading," Haile told me. "Instead, the mystery is, what do you do with all that information?" The most successful publishers of the future, he said, would be those who didn't just have the raw reporting and analysis talent to produce great journalism, but who also understood how to adapt, how to maneuver in midair, how to move with their audiences, like Colonel Boyd's fighter pilots. The conversation made me want to write a whole new book. A book about dogfights and start-ups, customer development cycles and OODA loops. A book about feedback, and what happens after your hypothesis blows up in your face.

Haile and I shook hands, and I descended in the elevator. The Strand's maroon banner snapped loudly above my head. I felt the pull of a bookstore on an empty backpack and walked in, remembering how every room with books feels subtly subterranean to me. I browsed the mole mounds of new arrivals, "Staff Picks," and old classics. The space gave off a family basement feel, warm and soft. I bought some books I planned on reading, along with several conspicuous classics that I didn't. It always seemed to me that owning a canonical book technically counts as participating vicariously in its consumption. "No, I haven't read it, but it's on my shelf . . . "

Culture isn't just what people do. It's also what people say they do. If many people read *Us Weekly* at home (but never talk about it at parties) and talk about Thomas Piketty at parties (but never read past page 5 of *Capital*), then who has the bigger influence on culture: *Us Weekly* or Piketty? In his famous 1980 sociological study *Distinction*, Pierre Bourdieu argued that taste is partly a performance, a show of "cultural capital." The elite do not just like opera because they have been exposed to it; they are exposed to opera because they think it makes them elite.

But a lot has changed since 1980. Cultural markets have become more transparent, blurring the line between stated and revealed preferences. *Billboard* has become an honest reflection of music, and Chartbeat a more transparent view of reader interest. In a culture like this, where status is a performance but tastes are transparent, the socially correct posture is not to like any one thing too much, but rather to be exquisitely and unblinkingly aware of it all. There is something more prized than "cultural capital" in an age of media abundance, and that is what you might call "cultural cognizance," a global awareness of the news and opinions that make up the cultural landscape. So you saw *Hamilton*? That's fine. You can cite its rap references, *and* suggest why its universal praise might be overrated, *and* contextualize its signifi-

cance in twenty-first century race relations? Now we're talking. Super-awareness is the new cultural capital.

I 've been back to the Strand several times while writing the book you're holding—whether the flat plane displaying these words is made of pulp or glass. But even more often, I've returned to the idea of 828 Broadway. It seems to me like a living museum of words. *Upstairs*: a Borgesian map of the world's online readers who cannot hide from Chartbeat's omnipresent Sauronic eye. *Downstairs*: "eighteen miles" of paper books, which never give up their readers' secrets. The floors of 828 Broadway posed an irresistible question: Does great art begin with feedback, or does it start with the opposite—a quiet space, devoid of distractions, where creators can turn the spotlight inward and make something mostly for themselves?

At Chartbeat, there is the perfect OODA loop. The readers read the website and the website reads the readers. It is journalism as laboratory, or writing as dogfighting: experimentation, learning, lightning-speed adaptation. At the Strand there is the perfect sanctuary. The most visible feedback loop for a book writer is internal, between the gut, mind, and fingers. Imagine the horrifying paralysis of trying to write a novel on a platform where the whole world has real-time access to each page. Critics brutalized the most famous novels of the twentieth century. *The Great Gatsby* came out to awful reviews— "unimportant," "painfully forced," "a dud"—and weak sales. Virginia Woolf called James Joyce's *Ulysses* "a memorable catastrophe— immense in daring, terrific in disaster." If novelists had perfect foresight of how the public would greet their work, they might never lift a quill or tap a keyboard.

I've come to see that I need the feedback loop, the standing ovations and devastating silences that can greet an online article. But when

I circle a pile of books at the Strand, it's hard to avoid the conclusion that perhaps the best writers also knew to just do the work and forget, for a moment, that anyone would ever read their reverie. They mounted a stage production in their minds, but just for them, something palatial and private, like a daydream.

THE FUTURES OF HITS: EMPIRE AND CITY-STATE

Familiar Surprises, Networks, and

Magic Sprinkle Dust

We are living through an industrial revolution in attention.

In the century between the 1870s and 1970s, the United States underwent an industrial revolution in food (the invention of the refrigerator), light (the mainstreaming of electricity), travel (the triumph of the automobile and the airplane), and even in the anatomy of homes, with the modernization of gas, sewers, and running water. As the economic historian Robert Gordon has argued cleverly, a time traveler visiting a 1970s house would feel quite at home in its kitchen, bathroom, living room, or bedroom.

But if this decade-hopper wanted to watch cable on a giant flat-screen television, or stream music from a million-song library, or look up something on the Internet, he would feel lost. In the 1970s, there were no phones capturing their owners' gaze like Narcissus at the

water, no headphone cords snaking up from every person's pocket, no libraries of information stored in tiny plates of glass. In the last forty years, the most visible technology changes have been in the realm of attention and its sub-kingdoms of entertainment, communications, and information.

This book is about that revolution, and it offers several lessons to readers who seek something more from culture than an afternoon's diversion—meaning, emotion, a deeper truth about life, and, perhaps, even a sense of genius.

1. The dark side of music and story

Several tactics behind pop culture hits can be dangerously seductive outside the arena of entertainment. For example, repetition is the God particle of music. Without it, the world might sound like a cacophonous thrum, and the right amount of repetition in writing can make a sentence sing. But in political rhetoric these modes of repetition, like anaphora and antimetabole, often dress ugly ideas in catchy language. Musical rhetoric creates a kind of cognitive anesthesia that numbs audiences' capacity for deeper thinking. National debates about important issues would be improved if more people were savvy to musical sloganeering, and pundits and commentators would be of greater service if they distinguished "a great speech" from "a great musical-rhetorical performance with vacuous or dangerous ideas at the center of it."

The same goes for stories. Heroic myths have served as the favorite narrative structure for raconteurs going back many centuries. The journey from ordinary underdog to uplifting champion offers a deeply satisfying arc that teaches audiences a lovely lesson: that failure, mediocrity, and dissatisfaction are temporary way stations en route to a happier destination. But it is precisely because great stories are persuasive that we should be cautious about which narratives to let into our hearts. The storytellers in our lives, from Hollywood kingpins to garrulous

grandparents, are all subtle instructors of cultural expectations. A great story can teach audiences that racial bias is right or wrong, that a war is necessary or abominable, that women are subservient sex objects or worthy self-determining heroes. Narrative drama is not always a moral attribute. It is more like a mercenary feature, equally adept at selling prejudice and empathy. Above all, a great story should be an invitation to think, not a substitute for thinking.

2. The upside of the unfamiliar

Another major theme of this book is the tension between neophilia and neophobia. Many people crave new products, ideas, and stories, provided that they are just like the products, ideas, and stories that they already know.

The digitization of content has yielded a world of algorithms that theoretically serve both the neophilic and the neophobic self. They organize the world of songs, shows, and articles around our prior preferences, allowing us to discover only those items that are "optimally new." There is a thrill that comes from reading a brilliant essay that makes a point the reader already agrees with or hearing a joke that elegantly summarizes one's worldview. It can provide an intellectual freshening, a kind of cognitive therapy.

But one of the downsides of people's deep preference for familiar ideas is that they avoid stories and arguments when they expect they'll disagree. Social media and algorithms, which shrink the aperture of news to only a handful of preferential stories by our peers, make it easier for people to avoid discomfiting ideas, or even to never learn of their existence. Rather than connect the world, these technologies can create millions of cults whose worldviews are airbrushed by a commercial interest in surrounding people with ideas that mirror their own.

"I don't like that man," Abraham Lincoln said. "I must get to know him better." It would be nice to treat ideas the same way. For example:

to make a list of ideas you don't like or understand and read something new on the topic every month to get to know them better. Content platforms like Facebook could purposefully offer disfluent feeds, so that a Jewish Connecticut liberal could see the media diet of an evangelical Texas conservative and vice versa. Music and theater are often meant to be cathartic, but information isn't supposed to feel like therapy. Sometimes learning about the world should hurt.

3. The paradox of scale

Soon after the surprisingly popular debut of *American Graffiti*, George Lucas told an interviewer he was working on a western set in outer space. The interviewer paused uncomfortably. "Don't worry," Lucas said. "Ten-year-old boys will love it."

Is it meaningful that the most significant secular myth of the twentieth century was designed to appeal to fifth-grade boys? Perhaps the lesson is that ten-year-olds are Hollywood's demographic goldmine. Perhaps it's that adults are more like children than most people think. Or perhaps there is no lesson: Culture is chaos, after all, and there are a million ways that this movie for middle schoolers might have flopped (particularly if Lucas had filmed one of his horrid early drafts).

But I've come to see that there is a separate wisdom in Lucas's throwaway comment. The paradox of scale is that the biggest hits are often designed for a small, well-defined group of people. *Star Wars* was for children of a magical age—old enough to appreciate movies and young enough to love medieval histrionics in space without irony or embarrassment. Facebook was initially designed to appeal to the friends of Harvard undergrads, not to connect the whole world. Vince Forrest found that his bestselling buttons have the most amusingly strange and specific messages. Johannes Brahms wrote his world-famous lullaby for one mother. Narrowly tailored hits are more likely to succeed, perhaps both because of their inherent qualities—they are focused

works—and because of their network qualities. People are more likely to talk about products and ideas that they feel unusually attached to. High school cliques, California cults, and ideological clusters are all defined by their differences from an outward mainstream. These groups have existed for a long time, but a digitally connected world of commerce means it is easier to profit from cultish hits—to be profitably "weird at scale."

4. The genius of MAYA

Last year, I was discussing this book with a friend of mine, a music and television critic for a prominent national magazine. He asked a mischievous question: "But do you account for genius?"

I did not have an immediate answer. But I recalled that, in conversations with academics, one artistic achievement had come up more than any other. "You would be surprised how often professors want to talk to me about *Kid A*," I said. From the British band Radiohead, *Kid A* is quite possibly the strangest album to ever sell one million copies. It belongs to no genre, there are practically no choruses, and on some songs there is hardly what any human would recognize as singing. Jazz trumpets trade riffs with electric guitars, walls of anxious static are punctuated by robotic beep-boops, and the title track sounds not unlike an alien dying of asphyxiation. And yet, because of or despite these musical heresies, it is unspeakably beautiful. It is the very definition of MAYA—music for a more advanced species, perhaps the one after ours.

But the psychologists and sociologists I consulted didn't talk about the album's sound. Rather, several of them made the same point, which was that there is no way that an album as hostile to melody as *Kid A* could have gone platinum if it had been a band's debut. *Kid A* was genius, they granted. But it was acceptable only because Radiohead's previous work had already bought the audience's acceptance.

Coming after several massively successful LPs, *Kid A* was Radio-

head's fourth album. In this manner, I thought, *Kid A*'s success seemed to fit within a broader pattern. Led Zeppelin's unnamed fourth album is its mythic masterpiece. *Born to Run* was Bruce Springsteen's third studio album, *Sgt. Pepper* was the Beatles' eighth, *Thriller* was Michael Jackson's sixth, *My Beautiful Dark Twisted Fantasy* was Kanye West's fifth, and *Lemonade* was Beyoncé's sixth. I thought of Beethoven's Fifth and Ninth Symphonies, *Seinfeld*'s fourth through seventh seasons, Stanley Kubrick's eighth feature film, Virginia Woolf's fourth novel, and Leo Tolstoy's sixth book.

It is self-evident that a person's best work might emerge after years of practice, as artists refine their skill. But there is something more at play here: These artists and teams produced their most resonant work *after* they had already passed a certain threshold of fame and popularity. Perhaps genius thrives in a space shielded ever so slightly from the need to win a popularity contest. Rather, it comes after the game has been won, after the artist can say, essentially, "Now that I have your attention . . ."

Raymond Loewy's MAYA theory accounted for success at the frontiers of taste. Perhaps genius is the name we give to that limit, and the greatest work comes from creators who seek something beyond acceptance, who push forward the frontier.

There were no printed books in 1400. There were no modern public museums in 1700. There were no nickelodeon movie theaters in 1900, no radio news programs before 1920, no color television before 1950, and no Facebook, Twitter, or Snapchat in 2000. This is a ragtag group of institutions, publications, and apps. But they are all inheritors of common tradition, which is the democratized distribution of information and entertainment.

Each new entry in the marketplace of attention has threatened to obliterate the status quo. But despite many warnings to the contrary,

the printed word didn't kill the art of writing, movies didn't kill books, radio didn't kill the news, television didn't kill the movies, the Internet hasn't killed television, and video didn't kill the radio star.

The landscape of pop culture is geologically active and forever growing. It is the story of new ideas slipping over the folded plate boundaries of old technologies. Although monks predicted that Gutenberg's device would obliterate the written word, the printing press increased literacy and brought millions of new writers into the marketplace of letters. Before 1960, the highest-grossing films of all time—*Gone with the Wind*, *The Ten Commandments*, and *Snow White*—were all based on books, and yet more than half of eighteen- to thirty-four-year-olds are still reading for pleasure. There are movies based on mobile games, and video games based on movies, and there will soon be broadly popular virtual reality video games based on both.

Several years ago, McKinsey published an estimate of time spent consuming messages since the start of the twentieth century. In 1900, messages came through just a few channels. People read pulp—books and newspapers—but most communication was face-to-face. In the

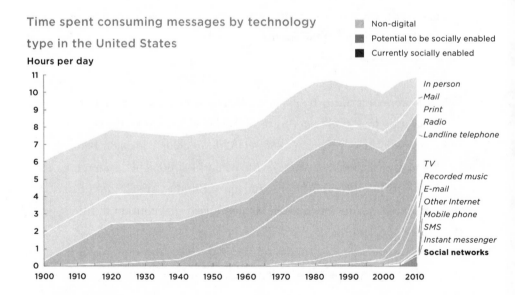

Time spent consuming messages by technology type in the United States

Non-digital
Potential to be socially enabled
Currently socially enabled

Hours per day

In person
Mail
Print
Radio
Landline telephone

TV
Recorded music
E-mail
Other Internet
Mobile phone
SMS
Instant messenger
Social networks

next century, households fell in love with the radio set, the television set, their computers, and their mobile devices. Theoretically, the most important boundary for media is time; there are still just twenty-four hours in a day. Yet each new generation spends more hours talking, reading, watching, and listening. New plates collide, and the mountain of media grows.

It is tempting to always see technological change as an agent of cultural death. In 1906, John Philip Sousa predicted that the invention of the phonograph and records would obliterate song composition and music education in America. "These talking machines are going to ruin the artistic development of music in this country," he wrote to the United States Congress. "The vocal cord will be eliminated by a process of evolution, as was the tail of man when he came from the ape."

Sousa, a white man, did not foresee that cheap music technology would give black Americans like Aretha Franklin and N.W.A. a global microphone; or that a collective audience the size of a thousand concert halls would hear recordings of his "Stars and Stripes Forever" over the next century, making him far more famous than he could have ever hoped to be in the 1800s; or that this wide availability of music would make it easier for all artists to share the influences and allusions that enrich musical creativity. The vocal cords of modern musicians reverberate in speakers and headphones around the world because of the very revolution in reproducibility that Sousa feared.

Just as some people are too willing to see death in every new thing, some technologists see a simple exponential line stretching toward utopia. But while it is easier to talk, listen, share, and watch, ease of access is not purely virtuous. Facebook is a global glue, binding companies, consumers, families, and friends together; and yet, social media makes some people feel lonelier by shining a light on the happiness that they're missing. The digital revolution in music has made songs more abundant, but it has also driven down the price of recorded music, so that many bands receive massive exposure but paltry revenue. The digitiza-

tion of music has made the rare hits more valuable than ever. In 2014, the top 1 percent of bands and solo artists earned 77 percent of all revenue from recorded music, and the ten bestselling tracks commanded 82 percent more of the market than they did in the previous decade.

This book is about the psychology of hits and the economics of media, but there is a broader lesson in these chapters, which is about humans and history. If I had to capture this metatheme in a sentence, this is the one I would choose: *Technology changes faster than people do.*

For the past fifty years, progress has marched to a hurried tempo known as Moore's law. In 1965, Gordon Moore, the cofounder of Intel, was invited to write an article for *Electronics* magazine to predict the next decade of semiconductor technology. He predicted that the number of transistors that fit on a microchip would double every year or so. For the last half century, his prediction has proved almost exactly correct. But while technology races at the exponential velocity of Moore's law, humans plod along at a leisurely Darwinian pace.

People's basic needs are complex, but old. They want to feel unique and also to belong; to bathe in familiarity and to be provoked a little; to have their expectations met, and broken, and met again.

Technology offers new tools for old jobs. In the 1950s, the television became the most popular and fastest-growing consumer product in history. It threatened to replace movies as the sole source of video entertainment, the printed word as the prime source of news, and radio as the standard piece of living room furniture.

But while television did contribute to these industries' relative decline, it also may have made them all better and more unique. Movies adapted to the rise of television by spending more on production to distinguish big-picture films from small-fry TV. Magazines and newspapers continued to produce excellent journalism while taking a lesson from television by adding more photography and graphics. Radio responded in perhaps the most interesting way: In 1940, the car radio was

a rare feature, but within thirty years 95 percent of U.S. vehicles included one. "Radio has become a companion to the individual instead of remaining a focal point of all family entertainment," the cultural historian J. Fred MacDonald wrote. The television fired radio from its old job, serving as a hearth of the home, but freed it to roam and follow users as they moved throughout the world.

Today, old-fashioned television is the technology in existential crisis, forced to answer for itself the question it once posed to the rest of media: *What can I do best?* For many years, the cable bundle was dominant in its ability to provide immediate news and information, to delight living rooms with original storytelling, and to open a universal window to sports. But today, the Internet provides more immediate news and information. Facebook provides more convenient and atomized escapism. Netflix, Hulu, and Amazon Video offer moving and meaningful storytelling. Virtual reality will soon offer more immersive experiences. It is as if by cutting the cord, young people released TV particulates into the air that are absorbing into all media, and everything is becoming television.

The future of hits will be a global stage with many narrow spotlights. This book has focused on Western culture, from European lullabies and impressionism to New York music labels and Hollywood. Some might find the Western focus egregious, but I think it's defensible on the grounds that, in the last few centuries, the West has been the world's chief cultural exporter of blockbusters and superstars. But this will change. In 2015 and 2016, at least ten films grossed $100 million worldwide with more than 99 percent of its audience *outside* the United States. Perhaps the indispensable nation is becoming dispensable.

Meanwhile, there is little doubt that the future of attention is moving to mobile, where fame is fleeting, and so is infamy. On Facebook and Instagram, pride, awe, and outrage blink in and out of existence like quantum particles. Writers used to call each fad a "nine days' wonder." In the 1960s, Andy Warhol predicted that everybody would have

just fifteen minutes of fame. The half life of notoriety is shrinking. In the new mayfly media world, where a thousand hearts and likes can flock to an ordinary person's photo or comment and then move on in the next minute, millions await their brush with the feeling of fame, their sixty seconds of celebrity.

Cultural change is impossible to plot along a straight line, because culture is Newtonian. The strongest actions provoke opposite reactions. The rise of e-books should have destroyed the smallest print-book shops. But the number of indie bookstores is up 35 percent since 2009. The growth of digital music should have destroyed physical recordings. But vinyl albums, while niche, are growing almost as fast as streaming. The frictionless publishing platforms of the Internet have allowed many news organizations to forgo subscriptions and finance themselves through advertising, making news totally free to consumers. But some of my favorite individual writers, like Andrew Sullivan and Ben Thompson, have made a living by ditching advertising and asking readers to pay with their income as well as their attention.

This final paradox is the one I find most interesting. The future of hits will be a heyday for both breadth and depth. Tomorrow's empires of entertainment can be bigger than ever. But the independent artists can be stronger, too. My last two stories are about these two futures of hits, large and small—empire and city-state.

The Walt Disney Company is a global empire of media. Like every historical empire, it is best thought of not as a single state organization, but rather a power distributed across a diverse set of global properties. In addition to the animated movies of animals and princesses that made it famous, Disney owns *Star Wars*, Marvel Comics, and Pixar. It operates ESPN and ABC with partnership stakes in A&E and Hulu. It owns eight of the ten most popular amusement parks in the world. It is not a movie company, as the name might suggest, but

rather the world's most successful theme park company, attached to the country's most profitable television company, connected to the world's most famous movie company. In the pantheon of hit makers, Disney is Zeus.

But in the beginning, Disney was not the profit-gushing king of entertainment. In his early years, Walt Disney's movies had decent cash flow, but Walt was an artist who preferred to spend every penny he could touch on his next film. His company rarely operated with strong and steady earnings in the 1920s—and those were the boom years for the U.S. economy. Then the Great Depression hit. Soon World War II would destroy the movie theaters of Europe. To go from artist to empire in the Depression, Walt Disney needed a heroic sidekick. He found one in a man named Kay.

"Kay" Kamen was born Herman Samuel Kominetzky in Baltimore, Maryland, on January 27, 1892. He was the youngest of four children in a Jewish family that had emigrated from Russia. His young life did not predict fame, fortune, or even moderate competence. He dropped out of high school and spent time in a juvenile penitentiary as a teenager. In his twenties, he finally got steady work selling mink hats in Nebraska.

Kamen quickly proved himself to be a preternaturally gifted salesman, even though his physical appearance was, on a good day, unsightly. He was a stocky gentleman with a broad face, squashed nose, round eyeglasses, and a severe middle part bisecting his thick black hair. Even his colleagues did not rise to his defense on this count. "Kay Kamen was one of the homeliest men I had ever seen," Jimmy Johnson, a Disney veteran, wrote in his memoir. "But looks are only skin deep. Kay was one of the warmest, most charming persons I ever met."

In his thirties, Kamen found success at a Kansas City marketing firm, where he specialized in developing products based on movies. His ambitions stretched westward. In 1932, he saw a Mickey Mouse cartoon and recognized that the mouse could be a star outside the cineplex. He placed a call to Walt and Roy Disney in Los Angeles with a simple re-

quest: *Let me sell your cartoon mouse.* The Disney brothers invited Kamen to drop by their Hyperion Avenue lot the next time he happened to find himself in Los Angeles. About forty-eight hours later, Kay Kamen was sitting in Walt's office. He had, by one account, cashed in his life savings, sewn the bills into his suit jacket, and boarded a two-day westbound train. For fear that somebody might steal his jacket, he did not sleep for the entire forty-plus-hour voyage.

Kamen presented his plan to sell Mickey. "Kamen's philosophy was that Disney needed to move Mickey Mouse out of the ten-cent store and into the department store, because that's where consumers were moving," said Thomas Tumbusch, perhaps the nation's leading researcher on Disney merchandising history. Kamen signed to become solely responsible for licensing Disney character merchandising worldwide.

Kamen's winning insight was simple and somewhat Cassandran: Hollywood thought that toys were advertisements for movies. Hollywood was wrong; the opposite was true. The films were proofs of concept. The future of the movie business was everything outside the movie theater.

In particular, the future of movies was in stores. Families were streaming from farms to cities, and the stores followed. In 1920, there were no Sears department stores in the United States. By 1929, there were three hundred. Annual sales of Disney merchandise went from $300,000 in 1930 to $35 million in 1935.

Kamen's most famous achievement was the Mickey Mouse watch, which made its international debut at the Chicago World Fair in 1933. This was the nadir of the Great Depression. The U.S. economy had shrunk by a third since the late 1920s, and unemployment screamed past 20 percent. Many families hardly had the means to buy food in 1933, much less toys. But the Mickey Mouse watch was an instant and astonishing hit. Its manufacturer, the Ingersoll-Waterbury Company, was rescued from the verge of bankruptcy by horology, increasing the

number of its factory workers from three hundred to about three thousand within the year to keep up with demand. Macy's landmark New York City department store sold eleven thousand Mickey watches in one day. In two years, Disney sold more than two million. The watch was then the greatest financial success in the history of the Walt Disney Company, and it wasn't even Walt Disney's idea.

Kamen infested the world with cartoon rodents. The *New York Times* described a pop culture landscape "bustling with Mickey Mouse soap, candy, playing cards, bridge favors, hairbrushes, chinaware, alarm clocks, and hot-water bottles, wrapped in Mickey Mouse paper, tied with Mickey Mouse ribbon, and paid for out of Mickey Mouse purses." The *Cleveland Plain Dealer* described an idyllic child in 1935:

In his room, bordered with M.M. wall paper and lighted with M.M. lamps, his M.M. alarm clock awakens him, providing his mother forgets! Jumping from his bed where his pajamas and the bedding are the M.M. brand, to a floor the rugs and linoleum upon which are M.M. sponsored, he puts on his M.M. moccasins and rushes to the bathroom [to] the soap made in the Disney manner, as are also his toothbrush, hair-brush and towels.

It is strange now to imagine Mickey Mouse as a symbol of anything but innocent charm and harmless rambunctiousness. But abroad he was a complex symbol, both beloved as art and derided as propaganda. The Soviets claimed he symbolized the pathetic timidity of the capitalist workforce, while the Russian movie director Sergei Eisenstein praised Disney's work as "the greatest contribution of the American people to art." In Nazi Germany, a similar divide opened between public derision and private delight. "Micky Maus is the shabbiest, miserablest ideal ever invented," declared one Nazi propaganda newspaper in 1931. But Adolf Hitler must not have hated the character as much as he

let on. In December 1937, three months before the invasion of Austria, the Nazi leader received eighteen Mickey Mouse films as his Christmas present. Incredibly, the gift was from Joseph Goebbels, the minister of propaganda.

Back in Los Angeles, Kamen's empire of fantasy gave Walt Disney the confidence to make the first full-length animated film in history, *Snow White and the Seven Dwarfs*. "Without Kay Kamen," Tumbusch said, "there would be no *Snow White*." When the movie came out in December 1937, its reception was nothing short of rapturous—not just among children, but also among the industry's most discerning grown-ups. Charlie Chaplin, who attended the world premiere, declared Dopey the Dwarf "one of the greatest comedians of all time." Within a few years, it became Hollywood's highest-grossing sound film.

Still, the movie's box office couldn't keep pace with Kamen's juggernaut. In the two months after its 1938 premiere, the movie made $2 million from the sale of toys—more than the actual film made in the United States that entire year. There were Snow White caramels, coloring books, candy boxes, cooking ware, Christmas tree ornaments, carnival chalk figures, combs, crafts, and crayon sets, and that's just the merchandise starting with the letter *c*.

Nobody in the film industry or beyond had ever seen something like this before—a film slipping off the silver screen and promiscuously impressing itself on every product category imaginable. "The picture has virtually developed a new industry from its by-products," the *New York Times* hailed in an editorial from May 1938. The *Times* predicted that Disney had invented a new business, "industrialized fantasy," that could save the U.S. economy from the Great Depression.

They were wrong. Industrialized fantasy was not the future of the economy. It was, however, the future of entertainment. Disney had developed the perfect movie-merchandising symbiosis. *Snow White*, produced with the profits from Kamen's licensing business, poured fresh

fuel right back into his merchandising machine. The movies inspired the toys and the toys paid for the movies.

Disney might not have been a born businessman, but he absorbed Kamen's lesson: *The art of film is film, but the business of movies is everywhere.* Disney described the strategy as "total merchandising." A movie was more than a movie. It was also a shirt, a watch, a game—and, soon, a television show.

In the 1940s, much of Hollywood greeted the dawn of television as newspaper publishers did: by shielding their eyes and waiting for it to go away. Disney, however, saw television for what it could be: a movie theater in every living room and a living room advertisement for the movies. For several years, he wanted to build an amusement park, a "Disney Land" for children, based on his animated characters. He was also interested in developing a television show for one of the major broadcast networks. The stroke of genius was to unite these two dreams. He told his brother Roy to sell a Disney TV series to a network only if it was willing to invest in his park, too. NBC balked. CBS, too. But ABC, the runt of the big three broadcasters, jumped at the idea. In 1952, it agreed to make a Disney TV show and to invest in one third of the park. In a move deemed "one of the most influential commercial decisions in postwar American culture," Disney insisted that the television show and park have the same name: Disneyland.

Disneyland the show became the first ABC program to appear among the year's ten highest-rated programs. About 40 percent of the nation's twenty-six million TV households tuned in each week, even though it was often little more than an advertorial, or a sneaky blend of original content and advertising. One episode, "Operation Undersea," provided a behind-the-scenes look at the film *20,000 Leagues Under the Sea* just one week before Disney released it in theaters—an elaborate movie preview. The film went on to be the second-highest-grossing movie of 1954, after *White Christmas.* "Never before have so many

people made so little objection to so much selling," one ABC executive said of the *Disneyland* television show.[1] Disney's strategy also benefited from a demographic windfall. His key market was children sitting in front of the television, and in the postwar baby boom the number of kids between five and fourteen grew by 60 percent between 1940 and 1960.

On July 17, 1955, the Disneyland theme park opened. It was such a disaster that employees referred to it as "Black Sunday." Several of the rides didn't work. There weren't enough water fountains to serve the attendees due to an earlier plumbers' strike. One-hundred-degree heat melted the fresh asphalt, which clung to the heels of mothers, like octopus ink from Ursula's lair.

But first impressions aren't everything. In its first six months, one million paying customers passed through Disneyland's gates, and the park accounted for one third of the company's revenue for the year. ABC had made the park possible, but several years after it opened, the network sold its stake back to Disney. In retrospect, this was a horrifyingly bad idea, not unlike selling a band of rebels the weapons they'll eventually use to sack your city. In 1995, the Walt Disney Company bought ABC for $19 billion, with many thanks to the profits from the very amusement park business that ABC had once financed.

By midcentury, the Walt Disney Company was no longer a movie business. Even in the 1950s, the studios produced stories that reached their largest audience through television. *Disneyland* the show constructed a mythology that families could truly inhabit only at Disneyland the amusement park, which made much of its profit thanks to something else: the sale of Disney merchandise. The Disney empire is

1. There is so much about Disney's TV strategy that echoes in modern media. Decades before Netflix clawed its way into the entertainment business by building a business around the libraries of other studios and networks, Disney used the *Disneyland* TV series to capitalize on the studio's vault of old cartoons, going all the way back to *Mickey Mouse*. His instinct to show people the wizards behind his curtains is distinctly modern. One imagines Walt would have been very much at home with technologies like Facebook or Snapchat, which give stars direct relationships with their audiences.

predicated on the principle that audiences both want to lose themselves in a fairy tale and map their lives onto it.

One might cynically say Disney's movies are proofs of concept for TV shows, which are advertisements for its theme park, which serves as a loss leader for capturing merchandising sales. But really, there is no unidirectional line of commercialization. Disney's empire is an ouroboros, an infinite nostalgia loop is which everything is selling everything else.

Like the future of the world economy itself, Disney's ambitions stretch eastward. The company's most important new creation isn't a new movie for America but an amusement park for China. Shanghai Disney Resort, which opened in 2016, is a $5.5 billion project that was twenty-five years in the making. Three hundred million Chinese people—about 90 percent of the population of the United States—live within a three-hour commute of the park by car or train. Just as Disneyland was about more than selling tickets, Shanghai Disney Resort isn't just about theme park revenue, or even selling merchandise on the park grounds. It's about building an infinity loop of awareness around Disney movies and products in China. "As Walt did with Disneyland in the fifties, enabling Disneyland to really grow the Disney brand in the United States, we believe we will have some really interesting opportunities to do the same in China," Disney CEO Bob Iger said in 2009.

The Walt Disney Company is the quintessential hit empire for three commercial reasons. First, with its television and marketing channels, it has great power to build exposure and awareness for its new and riskiest art. Second, the company is rich enough to buy the most popular franchises in the world, like *Star Wars* and Marvel, and produce lavish, familiar surprises with new chapters of old stories. Third, it converts happy audiences into high-paying devotees at its amusement parks and stores. Children, ages four through one hundred and twenty, are invited to own the fantasies that Disney has conjured, and the dolls, bed sheets, and costumes they bring into their homes become the most powerful

advertisement for the next installment of the fantasy. Umberto Eco called Disneyland "the quintessence of consumer ideology," because it "not only produces illusion," but also "stimulates the desire for it."

This is one future of hits: "total merchandising." Disney is larger, more influential, and more ever present than any company could have been in 1932 when Kay Kamen arrived by train in Los Angeles and proposed to turn Mickey Mouse into a watch. But still it operates by a business philosophy that is pure Kamen: Every channel of distribution is an opportunity for exposure and commerce. Far beyond the darkness of a movie theater, Disney's stories inhabit cable and broadcast television; its movies stream on Netflix; its franchise films cover billboards and taxis every year; and eight of its amusement parks attract at least ten million annual visitors. Disney's empire expands even to the stage, that most ancient and beautiful arena of entertainment. Eighteen years after the debut of the musical version of *The Lion King*, its productions have grossed more than $6.2 billion worldwide—more than any film—with more than eighty-five million tickets sold.

Total merchandising is powerful not only because it pushes a company's content through all available channels, but also because companies can pull insights from these same channels. BuzzFeed, a young media company that might have the best chance to become a Disney for the twenty-first century, was born as a website. But, like Disney, it is like a promiscuous vine that can live and grow in any climate. In 2016, 80 percent of BuzzFeed's audience discovered its content somewhere other than its website—on social networks like Facebook and Snapchat, publishing partners like Apple News and Yahoo, and messaging apps like WeChat. For some consumers, BuzzFeed is a digital newspaper. For others, who find it on Snapchat, it is more like a TV company programming content for different cable networks.

Content flows out and information flows in. BuzzFeed uses its distribution channels to collect information on what audiences read,

watch, and share and turns those lessons into content for some other channel. Like Arthur Conan Doyle's famous description of the crime lord Moriarty, BuzzFeed is like a spider sitting at the center of a vast web, heeding the radiations of a thousand threads. "If we see something works well on Instagram, it can be adapted for Snapchat," founder and CEO Jonah Peretti once said. "If we see something works well as a post, it can be adapted for video. If we see something works in the UK, it can be adapted for Australia. The nodes of the network are very autonomous, but they share learnings back with the larger network."

The legacy of Kamen runs through Disney and BuzzFeed. It is total merchandising—an infinity hit loop in which everything is a test of, and proof of concept for, everything else. This is one vision of the future of hits. But there is another.

The free distribution of the Internet should also empower *individuals*, untethered from the old gatekeepers that once controlled distribution, marketing, and hit-making. These individuals or small companies may not challenge Disney's domain, but they can achieve cultural renown and commercial success on their own terms, by using the Internet to build networks and reach audiences. They are not like empires, but rather like city-states.

I met Ryan Leslie—rapper, hip-hop producer, network science nerd, and start-up founder—in the Financial District of Manhattan, the southern nub of the island where the shadows of tall buildings cut demented rhombuses of sunlight in the tiny streets. It was ten a.m. when we met in the lobby of a giant luxury residential tower. Leslie had been up until four a.m. that morning at his studio, a few blocks away, working on several new songs. His bottom teeth were encased in gold grill, and he was dressed in a long cotton T-shirt and light blue skinny jeans with holes in the knees.

We rode the elevator to his floor and opened a heavy door to enter his screening room, with beige soundproofed walls and several rows of matching beige chairs. Then Leslie told me his life story.

"My parents are Salvation Army officers, straight off the rip," he began. When Ryan was born in 1978, his parents sent him to South America to live with his grandparents and the Salvation Army in Suriname. When he returned to the United States, the family moved constantly, but music anchored his home life. His mother sang and played piano. His father sang and played trumpet. Leslie attended four high schools in three years: in Richmond and Fredericksburg, Virginia, then to Daly City outside San Francisco, and Stockton, California.

By the age of fourteen, Leslie had nearly exhausted his high school's slate of advanced courses, and a guidance counselor encouraged him to move on to community college in California. Leslie took the SATs. He scored a 1600.

He applied for a Rotary International grant and gave a speech: "To do what you believe in and believe in what you do is the key to a life of fulfillment," he said with perfect antimetabole. He won the scholarship and applied to Stanford and Harvard. He chose Harvard.

Leslie arrived at Cambridge, Massachusetts, as a fifteen-year-old freshman. Hoping to honor his parents' and grandparents' example of sacrifice, he was prepared to become a doctor. Then he discovered Stevie Wonder. That was that. Leslie had to be a musician.

"My dad was confused," Leslie said. "My parents wanted to protect me from the personal and financial risks associated with pursuing a career with so many uncertainties that requires a stroke of luck and magic sprinkle dust."

He was obsessive, performing in several separate singing groups, like the Kuumba Singers and the Harvard Krokodiloes, and camped out in the Quad Sound Studios for all-nighters in the basement of the Pforzheimer House to work on beats and lyrics. When he needed a cheap way to contact recording companies in Los Angeles, he took an

ad sales job with the *Harvard Guide* and secretly made free long-distance phone calls to scouts and producers.

Although his friends told him he was crazy and he spent much of college on academic probation, he graduated on time and delivered the commencement speech for Harvard's class of 1998. But unlike the cap-and-gowned graduates in the audience, Leslie hadn't spent his senior year setting up postgrad jobs in the consulting, banking, or corporate corridors of the the economy. He graduated from Harvard University with no job, no income, no savings, and no home. His most valuable possession was a working campus key that allowed him to sneak into vacant dorms over the summer to sleep and take showers.

Leslie's early career was a series of false starts. He sold beats to gangs who wanted to anthologize their lives in rap songs and made so little money he had to live and record in a storage area behind a barbershop in Boston.

Finally, a bit of magic sprinkle dust fell. At twenty-four, on the verge of giving up and applying to law school, he was invited to participate in a one-month "beat camp" in the Bronx with the producer Younglord. The internship led to an interview with Puff Daddy, who immediately recognized Leslie's prodigious talent and provided the money and stars to nurture it. Soon he was writing beats for Beyoncé. Leslie signed a publishing deal with Universal Records for half a million dollars. He fell in love and started dating a young model—black, Filipino, Mexican, and "atomically sexy," according to *New York* magazine.

Her name was Cassie. He wrote her a song that she could give to her mother: "Me & U." When his label heard the track, they insisted on releasing it and turning Cassie into a star. The record was a commercial smash, selling more than a million digital downloads in half a year, to become one of the biggest hip-hop songs of 2006. Critics hailed Cassie as the century's next Janet Jackson.

But as quickly as everything seemed to come together, it all fell

apart. Cassie started dating Puff Daddy, who now calls himself Diddy. Leslie released two solo albums, and neither achieved blockbuster success. In 2010, he filed for bankruptcy.

Leslie paused here. He had been talking for about an hour straight. He leaned back and looked up for a while, as if the next part of the story were written on the ceiling. "All I needed," he said, and stopped. He gathered the words and rapped a verse:

> *All I needed was five racks to get up out of the projects.*
> *All I needed was some contacts but I wasn't getting no callbacks.*
> *So I put it on my back. That's my grind and my time*
> *So when I'm counting these millions, man, that's my money*
> *and my shine.*

Leslie was distraught by the economics of the music label business. For every dollar earned by a recording artist, the label often earns between three and eight times more. As a result, labels are built to live on scale, even if its artists can make a meaningful living on niche. A million dollars here and there won't make or break any label's year. But for an independent artist, a million dollars would change somebody's life.

Leslie doesn't belong to a label anymore. Instead, he built a smartphone application that helps him stay in closer touch with a smaller audience that pays him directly for his music. The app, called Super-Phone, is like an advanced messaging service. Leslie has given his direct phone number out to more than forty thousand people. He uses the app to text them directly when he has a new song, when he's performing, or even when he wants to invite them to a party. He sold out a New Year's Eve celebration in 2014 with $1,700 tickets and sold several copies of a special July 4 album for $5,000.

In total, Leslie has sixteen thousand paying customers that he can contact on SuperPhone. He knows their names, their numbers, the music they've bought, and what they paid. (The average contribution is

around $100 per year.) Less than twenty thousand buyers is not nearly enough scale to become a major artist within the label system. But Leslie doesn't need a label. For an expense of about $3,000 in text messaging fees, he was able to generate $589,000 in 2014, without a label, manager, or marketing staff.

Building SuperPhone has also taught Leslie about the mechanics of success, why some talented people make it, and why other talents fail. Leslie has the numbers of Kanye West and Ludacris on his phone. He has famous rappers, singers, and hip-hop producers in his pocket. An ordinary twenty-two-year-old has none of that. Indeed, much of what initially seemed to him like "magic sprinkle dust" turned out to be real and quantifiable. So often, the difference between success and failure, he decided, was the quality of the people surrounding the artist.

Take two young men with the same talent. One is a good-looking kid from the Great Plains with a great voice. His five closest friends are his parents and classmates. The second kid is from London, Canada. His top five includes Usher, one of the biggest pop stars in the world, and Scooter Braun, one of the biggest talent managers in music. The first kid is a gifted nobody; the second kid is Justin Bieber. The difference isn't the face or the falsetto. It's the quality of the top five, the power of the network.

The science snaps into the lyrics: *All I needed was some contacts . . .*

"I get chills thinking about this stuff," Leslie told me. "If you want to be a pop star, you need a pop star's top five. If you want to be a politician, you need a politician's top five. Your network needs to match the quality of Obama's inner circle, or Clinton's, or a Bush. If you want to be the best tennis player in the world, the five tennis people in your life have to be better than the five people around Serena Williams."

Leslie was bouncing up and down on the couch and rubbing his arms from shoulder to elbow. Now I could see them, goose bumps on his forearms.

"My thesis is simple," he said. "Your network is your power."

———

M ost hits bear the indelible imprint of not only their maker, but also some forgotten enabler along the way. Would I recognize a Monet painting if he had never met Manet, or Paul Durand-Ruel, or Gustave Caillebotte? Could hundreds of millions of people around the world hum Bill Haley's "Rock Around the Clock" if not for the music tastes of a California fifth-grader, Peter Ford? There would be no *Fifty Shades* without a fan fiction network, just as countless apps could not have achieved instant virality without piggybacking on networks of college campuses. I knew and loved Johannes Brahms's lullaby not only because of its economy of melody, but also because of a lineage of German Americans whose ancestors fled Europe at the right time. This cascade of musical influence bloomed out of Austria and Berlin, and its tendrils touched my mother's home in the suburbs of Detroit.

I found myself mapping Ryan Leslie's observations onto the lessons of Duncan Watts—the rapper and chaos theorist, artist versus scientist, growing up on opposite ends of the world, following divergent passions and goals, yet arriving at the same conclusion. Hits are morsels of meaning passed from one network to another—forged in the cluster of creators and delivered to a million little cults.

None of this is new. From ancient lullabies to modern memes, new hits serve old purposes: to fill the time, to familiarize the strange, to estrange the familiar, to infect with emotion, to create meaning. What's different today is the means—the ability of small players, like Leslie, to amass large audiences, and the power of large companies, like Disney, to achieve global omniscience.

Ryan Leslie is not the biggest rap star on the planet. He probably never will be. There is too much talent—and too little listening time—for each worthy artist, creator, or entrepreneur to claim a seat in the pantheon of stardom. So he forged another path, and now perhaps his most durable legacy won't be any one song, but an invention that allows

artists to find paying audiences without interference from the old gate-keepers that once stood between them.

Leslie doesn't know if his next thing is going to be a hit. Nobody can know that. To be a maker in this world is to sacrifice certainty for love at the altar of art. But it's that tantalizing uncertainty that keeps him up until four in the morning. *My grind and my time . . .* That's all anybody can hope to control. The rest is magic sprinkle dust.

ACKNOWLEDGMENTS

Thank you to the Potomac School, where I learned to write, Northwestern University, where I also learned to write, and *The Atlantic*, where I am still learning to write. Thank you to my agents—Gail Ross, in loco parentis, and Howard Yoon, proposal doctor. Thank you to the wonderful team at Penguin Press: Virginia, Scott, Annie, Ann, and the whole publicity and marketing squad. Thanks to those whose work inspired this book, directly and implicitly: Raymond Loewy, Stanley Lieberson, Michael Kaminiski, Chris Taylor, Bill Bryson, Malcolm Gladwell, Jonah Berger, Steven Johnson, Tom Vanderbilt, Robert Gordon, David Suisman, Paul Barber, Elizabeth Margulis, John Seabrook, Charles Duhigg, Daniel Kahneman, Steven Pinker, Oliver Sacks, Michael Wolff, Nate Silver, Dan Ariely, Jonathan Franzen, Conor Sen, Felix Salmon, Matthew Yglesias, Ezra Klein, Chris Martin, Marc Andreessen, and Umberto Eco. Thanks to those whose conversations inspired this book, directly and implicitly: Drew Durbin, Lincoln Quirk, Michael Diamond, Jordan Weissmann, Robbie dePicciotto, Laura Martin, Maria Konnikova, Mark Harris, Spencer Kornhaber, Rececca Rosen, Alexis Madrigal, Bob Cohn, John Gould, Don Peck, James Bennet, Kevin Roose, Gabriel Rossman, Jesse Prinz, Duncan Watts, Anne Messitte, Andrew Golis, Aditya Sood, Nicholas Jackson, Seth Godin, the Diamonds, the Durbins, and Kira Thompson. Thanks to my grandmother, uncles, aunts, parents, and sister.

NOTES

Introduction

3 **"a love song is being sung to her":** Jan Swafford, *Johannes Brahms: A Biography* (New York: Vintage, 2012), 338.

4 **"veiled but identifiable parody":** Paul Berry, *Brahms Among Friends: Listening, Performance, and the Rhetoric of Allusion* (New York: Oxford University Press, 2014), 63.

4 **leisurely transatlantic voyage of Beethoven's Ninth Symphony:** Ora Frishberg Saloman, *Beethoven's Symphonies and J. S. Dwight: The Birth of American Music Criticism* (Boston: Northeastern University Press, 1995), 162.

5 **immigration to the United States soared:** *Yearbook of Immigration Statistics*, Department of Homeland Security, 2008.

7 **the highest-grossing movie in America:** Box Office Mojo, www.boxofficemojo.com/, accessed March 1, 2016.

9 **according to Kodak's 2000 annual report:** *Benedict Evans Blog*, http://ben-evans.com/benedictevans/2014/6/24/imaging.

9 **world shares more than eighty billion photos:** "2016 Internet Trends Report," www.kpcb.com/blog/2016-internet-trends-report.

9 **Instagram did not invent the idea of filters:** Robert Scoble interview with Kevin Systrom on SoundCloud, https://soundcloud.com/scobleizer/my-first-interview-of-kevin.

9 **early versions of the app to San Francisco tech tycoons:** Robert Scoble, comment on "How Did Instagram Build Up Its Community in Its Early Days?," Quora, January 25, 2013, www.quora.com/How-did-Instagram-build-up-its-community-in-its-early-days.

9 **twenty-five thousand people downloaded the app:** Kara Swisher, "The Money Shot," *Vanity Fair*, June 2013.

10 **movie industry was the third-largest retail business:** Edward Jay Epstein, *The Big Picture: Money and Power in Hollywood* (New York: Random House, 2005), 6.

10 **more than five hours watching:** Robert Gordon, *The Rise and Fall of American Growth: The U.S. Standard of Living Since the Civil War* (Princeton, NJ: Princeton University Press, 2016).

10 **fell from about twenty-five in 1950 to four in 2015:** Barak Y. Orbach and Liran Einav, "Uniform Prices for Differentiated Goods: The Case of the Movie-Theater Industry," *International Review of Law and Economics* 27 (2007): 129–53.

11 **more profit from cable channels:** Derek Thompson, "The Global Dominance of ESPN," *The Atlantic*, September 2013.

11 **spent more time interacting:** "2013 Internet Trends Report," www.kpcb.com/blog/2013-internet-trends.

11 **eighty square inches for every living human:** *Benedict Evans Blog*, http://ben-evans.com/benedictevans/2014/1/3/the-spread-of-glass.

12 **technology analyst Mary Meeker reported:** "2016 Internet Trends Report," www.kpcb.com/blog/2016-internet-trends-report.

Part I: Popularity and the Mind

Chapter 1: The Power of Exposure

20 **"the least known of the French impressionists":** "Gustave Caillebotte: The Painter's Eye," National Gallery of Art, www.nga.gov/content/ngaweb/exhibitions/2015/gustave-caillebotte.html.

21 **team of researchers at Cornell University:** James Cutting, *Impressionism and Its Canon* (Lanham, MD: University Press of America, 2006).

21 **seventy of his impressionist paintings in a national museum:** "Gustave Caillebotte: The Painter's Eye," National Gallery of Art.

22 **His bequest included:** John Rewald, *History of Impressionism* (New York: Museum of Modern Art), 572. In Gustave Caillebotte's original will requesting the public exhibition of *"intransigents ou impressionistes,"* he includes Degas, Monet, Pissarro, Renoir, Cezanne, Sisley, and Morisot, "without excluding others." The art historian Kirk Varnedoe's 1987 biography of Caillebotte, however, does not list Morisot among the final "Caillebotte Collection." Instead, he includes two paintings by Jean-François Millet, whose style is not really impressionism, but whose subjects, like peasant life, may have inspired impressionist artists. As Rewald's *History of Impressionism* states, neither Morisot nor Millet was among the seven painters who were finally accepted and hung in 1897. Name checking each of the core seven, Rewald writes:

> Despite Caillebotte's provision that his collection should enter the Luxembourg Museum undivided, Renoir, as executor of the will, was forced to yield unless the bequest were to be rejected. Of 16 canvases by Monet, only eight were admitted; of 18 by Pissarro, only seven; of eight by Renoir, six; of nine by Sisley, six; of four by Manet, two; of five by Cezanne, two; only Degas saw all seven of his works accepted. (572)

 Several historians reported that, in the final gift to the French state, Renoir included two paintings by Caillebotte, himself. But they were largely overlooked by the most influential art historians, perhaps due to their last-minute inclusion. In Rewald's influential book, he notes Caillebotte for the legacy of his bequest, but hardly at all for the quality of his art. Finally, some readers might wonder why famous painters like van Gogh, Gauguin, and Toulouse-Lautrec are not considered a part of the "core" seven. They are typically considered post-impressionists..

22 **first ever national exhibition of impressionist art:** "Origins: The Musée du Luxembourg," Musée d'Orsay, www.musee-orsay.fr/en/collections/history-of-the-collections/painting.html. Manet's *Olympia*, which first exhibited in 1865, was purchased by "friends of Manet" for the state in 1890. It was first displayed in the Louvre in 1893, before paintings from Caillebotte's bequest hung in the Musée du Luxembourg. It is

NOTES

possible that *Olympia* was the first painting by any figure associated with the impressionist movement to hang in a state museum. But it is not really an impressionist painting. Therefore, I think it is fair to say that the Caillebotte bequest is the first-ever exhibition of impressionist art.

25 **What came next was quite clever:** Cutting, *Impressionism and Its Canon.*

29 **sweet foods and harmonies without dissonance:** Arthur P. Shimamura and Stephen E. Palmer, eds., *Aesthetic Science: Connecting Minds, Brains, and Experience* (New York: Oxford University Press, 2012), 238.

30 **preservation of the hunter-gatherer groups:** Conducting research into the origins of human preferences, one comes across the term "caveman" quite a bit, particularly in reference to "caveman instincts" and "caveman psychology." I'm not using that familiar term for two reasons. First, roughly half of our ancestors weren't men. Second, they didn't live in caves. If you go to East Africa in search of caves, you will be disappointed. The first evidence of Neanderthals and Cro-Magnon in Europe were indeed found in caves in the nineteenth century, which probably led to a folksy belief that our ancestors made permanent homes out of the rocks. But these groups were nomadic. It's understandable that we'd find the remains of ancient humans in a solid, covered area that's shielded from rain and wind, because nature would have washed, eroded, or covered up the other artifacts of their existence. But truly believing that our ancestors lived in caves because that's where their stuff has been preserved is like believing that mosquitos lived in amber. When somebody talks about the "caveman" brain, that person is really talking about the "hunter-gatherer" brain.

30 **composite is even more bewitching:** Judith H. Langlois and Lori A. Roggman, "Attractive Faces Are Only Average," *Psychological Science* (1990): 115–21.

31 **"pervasive Pleistocene taste in landscape":** Denis Dutton, "Aesthetics and Evolutionary Psychology," in Jerrold Levinson, ed., *The Oxford Handbook for Aesthetics* (New York: Oxford University Press, 2003). Studies of children's preferences are often controversial, and so is this one. The finding that tastes in scenery diverge throughout life—and that they, like so many preferences, can be driven by exposure—is on more solid footing than the finding that children have perfectly universal tastes in landscapes.

31 **slink away toward a vanishing point:** Ibid.

32 **The first national public museum:** "History of the British Museum," The British Museum, www.britishmuseum.org/about_us/the_museums_story/general_history.aspx.

32 **America's first modern public museum:** Liane Hansen, "Philadelphia Museum Shaped Early American Culture," NPR, July 13, 2008, www.npr.org/templates/story/story.php?storyId=92388477.

33 **"depended on its system of distribution":** David Suisman, *Selling Sounds: The Commercial Revolution in American Music* (Cambridge, MA: Harvard University Press, 2012), 58.

34 **Spotify playlist by Napster cofounder Sean Parker:** Steven Bertoni, "Why Sean Parker Is Obsessed with His Spotify," *Forbes*, December 4, 2013, www.forbes.com/sites/stevenbertoni/2013/12/04/why-sean-parker-is-obsessed-with-his-spotify-playlist/#2993655c529e.

38 **Political campaigns spend half their money:** Jörg L. Spenkuch and David Toniatti, "Political Advertising and Election Outcomes," April 2016, available at http://ssrn.com/abstract=2613987.

38 **Elected representatives spent:** Lawrence Lessig, "More Money Can Beat Big Money," *New York Times*, November 16, 2011.

38 **One third of the White House staff:** Matthew Baum and Samuel Kernell, "Has Cable Ended the Golden Age of Presidential Television?," *American Political Science Review* 55 (March 1999): 99–114.

38 **The most successful way for a president:** Ibid.

38 **Richard Nixon delivered nine prime-time addresses:** Ibid.

38 **the average presidential sound bite:** Ibid.

39 **about $140 million on television ads:** Nicholas Confessore and Karen Yourish, "$2 Billion Worth of Free Media for Donald Trump," *New York Times*, March 15, 2016.

40 **Trump had earned $3 billion in "free media":** Robert Schroeder, "Trump Has Gotten Nearly $3 Billion in 'Free' Advertising," *MarketWatch*, May 6, 2016, www.marketwatch .com/story/trump-has-gotten-nearly-3-billion-in-free-advertising-2016-05-06.

41 **When consumers don't know the true value:** Derek Thompson, "Turning Customers into Cultists," *The Atlantic*, December 2014.

41 **diluting the brand power:** Itamar Simonson and Emanuel Rosen, *Absolute Value* (New York: HarperBusiness, 2014).

42 **"free play":** E-mail from Jesse Prinz to author, July 30, 2016. Kant's theory of free play may not even be the philosopher's most apt precursor to metacognition, says Prinz. That might be his theory of the sublime. People often enjoy aesthetic experiences that involve a bit of fear—like vistas of volcanoes or the sound of thunder outside of a house. These things are not just beautiful; they are "sublime," according to Kant. "We see the danger, and start to fear it, but then realize we are safe, and thus, the intellect protects us from the fear," says Prinz, a distinguished professor of philosophy and the director of the Committee for Interdisciplinary Science Studies at the City University of New York, Graduate Center.

42 **the idea of "metacognition":** Norbert Schwarz, Mario Mikulincer, Phillip R. Shaver, Eugene Borgida, John A. Bargh, eds., *APA Handbook of Personality and Social Psychology, Volume 1: Attitudes and Social Cognition.* (Washington, D.C.: American Psychological Association, 2015), 203–29.

44 **less thinking leads to more liking:** Christopher K. Hsee, "Less Is Better: When Low-Value Options Are Valued More Highly Than High-Value Options," *Journal of Behavioral Decision Making* 11 (1998): 107–21.

44 **When something becomes hard to think about:** The less-is-more effect turns out to be a great debate tactic, too. If you want to persuade somebody of your argument, try to get him to understand one big reason he might be wrong. Trying to make people understand several complicated reasons why they might be wrong can backfire. Too many objections are hard to process at the same time. Your opponent might misattribute the discomfort of hard thinking—disfluency—to the quality of your arguments, mistaking feelings for thinking. Him: "All of these objections don't feel right, so there must be something wrong with your thinking."

Chapter 2: The MAYA Rule

46 **a French orphan aboard the SS *France*:** Raymond Loewy, *Never Leave Well Enough Alone, 1951* (Baltimore: Johns Hopkins University Press, 2002), 6.

46 **The more Loewy thought about the invitation:** Ibid.

47 **Within a few decades of his arrival:** "Up from the Egg," *Time*, October 31, 1949.

47 ***Cosmopolitan* magazine wrote:** Raymond Loewy website, www.raymondloewy.com/ about.html#7.

48 **Artisans and designers of the nineteenth century:** "Up from the Egg."

48 **it was available only in black:** "The Model T Ford," Frontenac Motor Company, www .modelt.ca/background.html.

49 **inspired the idea of "planned obsolescence":** "GM's Role in American Life," *All Things Considered*, NPR, April 2, 2009, www.npr.org/templates/story/story .php?storyId=102670076.

49 **Hekkert's grand theory begins:** Paul Hekkert, "Design Aesthetics: Principles of Pleasure in Design," *Psychology Science* 48, no. 2 (2006): 157–72.

50 **"typicality, novelty and aesthetic preference":** Paul Hekkert, Dirk Snelders, and Piet C. W. van Wieringen, "'Most Advanced, Yet Acceptable': Typicality and Novelty as Joint Predictors of Aesthetic Preference in Industrial Design," *British Journal of Psychology* 94, part 1 (February 2003): 111–24.

50 **Loewy initially felt stuck:** Loewy, *Never Leave Well Enough Alone*, 59–139.

52 **"25 percent inspiration and 75 percent transportation":** "Up from the Egg."

53 **sales curve that swept up and rightward:** Ibid.

53 **"built-in forward motion":** Loewy, *Never Leave Well Enough Alone*, 312.

54 **some livery sketches of America's most famous airplane:** Michael Beschloss, "The Man Who Gave Air Force One Its Aura," *New York Times*, August 7, 2015, www .nytimes.com/2015/08/09/upshot/the-man-who-gave-air-force-one-its-aura.html.

55 **a structure of such precise curvature:** Loewy, *Never Leave Well Enough Alone*, 201.

56 **"The consumer is influenced in his choice":** Ibid., 279.

57 **rate paintings by cubist artists:** Claudia Muth and C. C. Carbon, "The Aesthetic Aha: On the Pleasure of Having Insights into Gestalt," *Acta Psychologica* 144, no. 1 (September 2013): 25–30.

58 **most popular video game of all time:** "About Tetris," Tetris.com, http://tetris.com/ about-tetris/.

58 **second bestselling game of all time:** Tom Huddleston, Jr., "Minecraft Has Now Sold More Than 100 Million Copies," *Fortune*, June 2, 2016, www.fortune.com/2016/06/ 02/minecraft-sold-100-million/.

58 **Minecraft, where users build shapes:** Clive Thompson, "The Minecraft Generation," *New York Times Magazine*, April 14, 2016, www.nytimes.com/2016/04/17/magazine/ the-minecraft-generation.html.

59 **an "achievable challenge":** Joshua A. Krisch, "Why the 2048 Game Is So Addictive," *Popular Mechanics*, April 3, 2014, www.popularmechanics.com/culture/gaming/ a10341/why-the-2048-game-is-so-addictive-16659899/.

59 **popular online video:** Axis of Awesome, "4 Chords," YouTube, www.youtube.com/ watch?v=oOlDewpCfZQ.

59 **difference between new hits and old hits:** Derek Thompson, "The Shazam Effect," *The Atlantic*, December 2014, www.theatlantic.com/magazine/archive/2014/12/ the-shazam-effect/382237/.

60 **proposals were most likely to win funding:** Kevin J. Boudreau, Eva C. Guinan, Karim R. Lakhani, and Christoph Riedl, "The Novelty Paradox and Bias for Normal Science: Evidence from Randomized Medical Grant Proposal Evaluations," Harvard Business School Working Paper 13053, December 4, 2012, www.hbs.edu/faculty/ Publication%20Files/13-053_f32904ed-0526-4c9e-99a4-703088bb1212.pdf.

60 **most novel proposals got the worst ratings:** Derek Thompson, "Why Experts Reject Creativity," *The Atlantic*, October 10, 2014, www.theatlantic.com/business/ archive/2014/10/why-new-ideas-fail/381275/.

62 **sports network has accounted for half:** Derek Thompson, "The Most Valuable Network," *The Atlantic*, September 2013.

62 **amount of time eighteen- to thirty-four-year-olds spent:** Matthew Ball, "The Truth

and Distraction of U.S. Cord Cutting," *Redef*, October 20, 2015, https://redef.com/original/the-truth-and-distraction-of-us-cord-cutting.

62 **These fees range:** Rani Molla, "How Much Cable Subscribers Pay Per Channel," *Wall Street Journal*, August 5, 2014, blogs.wsj.com/numbers/how-much-cable-subscribers-pay-per-channel-1626/.

63 **network's New York City headquarters:** These paragraphs are adapted from my September 2013 column in *The Atlantic*, "The Most Valuable Network."

64 **reportedly referred to network president Jeff Zucker:** Hadas Gold, "Joe Scarborough: Donald Trump Calls Jeff Zucker His 'Personal Booker,'" *Politico*, June 9, 2016, www.politico.com/blogs/on-media/2016/06/joe-scarborough-donald-trump-calls-jeff-zucker-his-personal-booker-224116.

64 **the strongest rate of advertising growth:** Jesse Holcomb, "Cable News: Fact Sheet," State of the News Media 2016, Pew Research Center, June 15, 2016.

65 **the average viewership of *SportsCenter* fell:** Richard Sandomir, "Fox's Sports Network Hires an ESPN Veteran for a Reinvention," *New York Times*, May 8, 2016, www.nytimes.com/2016/05/09/business/media/jamie-horowitz-tries-again-this-time-to-revive-fs1.html.

65 **In an average week, ESPN delivers:** Paul Melvin, e-mail message to author, June 20, 2016.

66 **team of computer science researchers at Stanford University:** Himabindu Lakkaraju, Julian McAuley, and Jure Leskovec, "What's in a Name? Understanding the Interplay Between Titles, Content, and Communities in Social Media," Association for the Advancement of Artificial Intelligence, 2013, https://cs.stanford.edu/people/jure/pubs/reddit-icwsm13.pdf.

66 **the "curiosity gap":** Chip Heath and Dan Health, *Made to Stick: Why Some Ideas Survive and Others Die* (New York: Random House, 2007).

67 **eighty-one million listeners and twenty-one billion hours:** Pandora 2014 Q4 and 2014 K1.

71 **In the final pages of his memoir:** Loewy, *Never Leave Well Enough Alone*, 376.

Chapter 3: The Music of Sound

73 **Two hundred million, for example:** "Chart-Topping Songwriter Savan Kotecha Renews Agreement with ASCAP," American Society of Composers, Authors, and Publishers, June 3, 2015, www.ascap.com/press/2015/06-03-savan-kotecha-renews.aspx.

75 **If pop music were a global technology:** Ola Johansson, "Beyond ABBA: The Globalization of Swedish Popular Music," *FOCUS on Geography* 53, no. 4, www.nclack.k12.or.us/cms/lib6/or01000992/centricity/domain/519/64301138.pdf.

75 **Led by Max Martin:** Nolan Feeney, "Why Is Sweden So Good at Pop Music?," *The Atlantic*, October 29, 2013, www.theatlantic.com/entertainment/archive/2013/10/why-is-sweden-so-good-at-pop-music/280945/?single_page=true.

75 **Swedish government actively promotes public music education:** Marc Hogan, "What's the Matter with Sweden?," *Pitchfork*, March 29, 2010, pitchfork.com/features/article/7776-whats-the-matter-with-sweden/.

75 **promotes major-chord melodies over lyrics:** Saeed Saeed, "Ever Since Abba: The Swedish Influence on Pop Music Is as Strong as Ever," *The National*, May 19, 2011, www.thenational.ae/arts-culture/music/ever-since-abba-the-swedish-influence-on-pop-music-is-as-strong-as-ever#page2.

75 **Sweden has built a national industry:** Johansson, "Beyond ABBA."

75 **When geographers at Uppsala University:** Ibid.

NOTES

76 **the Michael Jordan of pop music:** Sophie Schillaci, "Meet Savan Kotecha: The Man Behind One Direction's Rapid Rise to the Top (Q&A)," *Hollywood Reporter*, February 6, 2013, www.hollywoodreporter.com/earshot/one-direction-meet-man-rapid-418682.

78 **the "speech-to-song illusion":** Diana Deutsch, "Speech to Song Illusion," deutsch.ucsd.edu/psychology/pages.php?i=212.

78 **If you can read music, it sounds just like:** If you can't read music, you can listen here: www.youtube.com/watch?v=TJe2J0NMox4.

79 **birds are considered singers:** Elizabeth Hellmuth Margulis, *On Repeat: How Music Plays the Mind* (New York: Oxford University Press, 2013), 19.

79 **The power of repetition:** Elizabeth Hellmuth Marguis, "One More Time," *Aeon*, March 7, 2014, https://aeon.co/essays/why-repetition-can-turn-almost-anything-in-to-music.

79 **listening to a song they've already heard:** Ibid.

79 **Mark Twain published a story:** Mark Twain, "A Literary Nightmare," *Atlantic Monthly*, 1876.

80 **The Billboard Hot 100:** Thompson, "The Shazam Effect."

81 *Niggaz4life* **by N.W.A. beat** *Out of Time* **by R.E.M.:** David Samuels, "The Rap on Rap," *New Republic*, November 11, 1991, https://newrepublic.com/article/120894/david-samuels-rap-rap-1991.

81 **study of the last fifty years in U.S. pop music:** Matthias Mauch, Robert M. MacCallum, Mark Levy, and Armand M. Leroi, "The Evolution of Popular Music: USA, 1960–2010," *Royal Society Open Science*, May 6, 2015, rsos.royalsocietypublishing.org/content/2/5/150081.full.

82 **the ten bestselling tracks command 82 percent more:** Thompson, "The Shazam Effect."

82 **he'll tell you about mice:** David Huron, "A Psychological Approach to Musical Form: The Habituation–Fluency Theory of Repetition," http://musiccog.ohio-state.edu/home/data/_uploaded/pdf/form.pdf..

85 **speech and music were nearly the same:** Bruce Richman, "How Music Fixed 'Nonsense' into Significant Formulas: On Rhythm, Repetition, and Meaning," *Journal of Anthropological Sciences*, June 2014.

86 **"prosthetic memory," to borrow Alison Landsberg's wonderful phrase:** Alison Landsberg, *Prosthetic Memory: The Transformation of American Remembrance in the Age of Mass Culture* (New York: Columbia University Press, 2004).

86 **an emotional and widely shared online video:** Alexandra Zaslow, "Gabby Giffords Sings 'Maybe' with Music Therapist," *People*, February 18, 2015, www.people.com/article/gabby-giffords-sings-annie-maybe-music-therapist.

86 **music therapy activates the right hemisphere's melodic intelligence:** "From Singing to Speaking: It's Amazing to See," American Stroke Association, www.strokeassociation.org/STROKEORG/LifeAfterStroke/RegainingIndependence/Communication-Challenges/From-Singing-to-Speaking-Its-Amazing-To-See_UCM_310600_Article.jsp#.V3p2hpMrLBJ.

87 **Favreau interrupted the rehearsal:** Tracy Jan, "Leaving West Wing to Pursue Hollywood Dream," *Boston Globe*, March 3, 2013, www.bostonglobe.com/metro/2013/03/03/obama-speechwriter-jon-favreau-leaves-west-wing-for-screenwriting/Evt7Rtg5ax9dwbnVjFfOgJ/story.html.

87 **Kerry's campaign had been such a disaster:** Jon Favreau, "Jon Favreau, Speechwriter," *New York*, January 12, 2016, nymag.com/news/features/beginnings/jon-favreau/#print.

87 **met Obama in the Senate cafeteria:** Matthew D'Ancona, "Jon Favreau Has the

317

World's Best Job," *GQ* (UK), December 6, 2012, www.gq-magazine.co.uk/article/gq-comment-jon-favreau-president-barack-obama-speechwriter.

87 **"What's your theory of speechwriting?":** Richard Wolffe, "Obama's Speechwriter Speaks Up," *Newsweek*, January 5, 2008, www.newsweek.com/obamas-speechwriter-speaks-87019. See also Larissa MacFarquhar, "The Conciliator," *The New Yorker*, May 7, 2007.

87 **one of the youngest chief speechwriters:** Jan, "Leaving West Wing."

88 **a phrase so simple that he once rejected it:** Amy Chozick, "David Axelrod: 'I Don't Think He's Gonna Look Back,'" *New York Times Magazine*, February 12, 2015, www.nytimes.com/2015/02/15/magazine/david-axelrod-i-dont-think-hes-gonna-look-back.html.

90 **you learn it somewhere, you hear it everywhere:** Juliet Lapidos, "The Hottest Rhetorical Device of Campaign '08," *Slate*, September 12, 2008, www.slate.com/articles/life/the_good_word/2008/09/the_hottest_rhetorical_device_of_campaign_08.html.

91 **"characterized by improvised free rhythms and idiomatic counterpoint":** William C. Turner, Jr., "The Musicality of Black Preaching: Performing the Word," in Jana Childers and Clayton J. Schmit, eds., *Performance in Preaching* (Grand Rapids, MI: Baker Academic, 2008).

91 **"start low, go slow, climb higher, and strike fire":** Bob Darden, *People Get Ready!: A New History of Black Gospel Music* (New York: Continuum, 2005), 64.

92 **presidential addresses have been more like a sixth-grader's level:** E. J. Fox, Mike Spies, and Matan Gilat, "Who Was America's Most Well-Spoken President?," *Vocativ*, October 10, 2014, www.vocativ.com/interactive/usa/us-politics/presidential-readability/.

92 **coincides with at least four positive developments:** Derek Thompson, "Presidential Speeches Were Once College-Level Rhetoric—Now They're for Sixth-Graders," *The Atlantic*, October 14, 2014, www.theatlantic.com/politics/archive/2014/10/have-presidential-speeches-gotten-less-sophisticated-over-time/381410/.

92 **passed 50 percent penetration among U.S. households:** Rita McGrath, "The Pace of Technology Adoption Is Speeding Up," *Harvard Business Review*, November 25, 2013, https://hbr.org/2013/11/the-pace-of-technology-adoption-is-speeding-up/.

92 **musical language can create the illusion of rationality:** Matthew S. McGlone and Jessica Tofighbakhsh, "Birds of a Feather Flock Conjointly (?): Rhyme as Reason in Aphorisms," *Psychological Science* 11, no. 5 (September 2000): 424–28.

93 **many of the most shared lines are musical:** Dale Carnegie, *How to Win Friends and Influence People* (New York: Simon and Schuster, 1936).

Interlude: The Chills

96 **the arrector pili muscle:** Niloufar Torkamani, Nicholas W. Rufaut, Leslie Jones, and Rodney D. Sinclair, "Beyond Goosebumps: Does the Arrector Pili Muscle Have a Role in Hair Loss?," *International Journal of Trichology* 6, no. 3 (July–September 2014): 88–94, www.ncbi.nlm.nih.gov/pmc/articles/PMC4158628/.

96 **muscles pull back:** George A. Bubenik, "Why Do Humans Get 'Goosebumps' When They Are Cold, or Under Other Circumstances?," *Scientific American*, September 1, 2003, www.scientificamerican.com/article/why-do-humans-get-goosebu/.

97 **"Art is not, as the metaphysicians say":** Leo Tolstoy, *What Is Art?* (Indianapolis: Hackett Publishing, 1996).

98 **a book is a coproduction:** Peter Mendelsund, *What We See When We Read* (New York: Vintage, 2014).

98n **aphantasia:** Carl Zimmer, "Picture This? Some Just Can't," *New York Times*, June 22, 2015, www.nytimes.com/2015/06/23/science/aphantasia-minds-eye-blind .html?_r=0.

99 **based on a thirteenth-century Norse myth:** Constance Grady, "*Hamlet, The Divine Comedy*, and 3 Other Pieces of Classic Literature That Are Also Fan Fiction," *Vox*, April 5, 2016, www.vox.com/2016/4/5/11363816/five-literature-fanfiction.

100 **a linkage between thinking about the past and feeling good:** John Tierney, "What Is Nostalgia Good For? Quite a Bit, Research Shows," *New York Times*, July 8, 2013, www.nytimes.com/2013/07/09/science/what-is-nostalgia-good-for-quite-a-bit -research-shows.html.

Chapter 4: The Myth-Making Mind I

There are many wonderful histories of George Lucas and *Star Wars*. In this chapter, I am particularly indebted to two remarkable books. Chris Taylor's *How* Star Wars *Conquered the Universe* is a delightful history of Lucas's writing process and the commercial success of the films. *The Secret History of* Star Wars, by Michael Kaminski, is like a Jedi Talmud, a deep and wonderful compilation of interviews, commentary, and analysis of Lucas and his creations. They were both essential guides for this chapter's history of Lucas and *Star Wars*, and for anybody interested in reading more, I cannot recommend these volumes more highly.

102 **a desk made of three doors:** Chris Taylor, *How* Star Wars *Conquered the Universe* (New York: Basic Books, 2015), 109.

102 **more than $40 billion:** "How Exactly Has Star Wars Made $37 Billion?," *Wired*, November 22, 2014, www.wired.com/2014/11/geeks-guide-star-wars-empire/.

102 **His goal was five pages:** Taylor, *How* Star Wars *Conquered the Universe*, 109.

102 **"I did terrible in script writing":** Michael Kaminski, *The Secret History of* Star Wars (New York: Legacy Books Press, 2008).

103 **written by hand with number 2 pencils:** Ibid.

103 **ten cents got an afternoon's admission:** Ibid.

104 *Adventures of Captain Marvel, Batman, Superman, Dick Tracy:* Ibid.

104 *Flash* **appeared on television each evening:** Taylor, *How* Star Wars *Conquered the Universe*, 24.

104 **screen wipes between scenes:** Forrest Wickman, "*Star Wars* Is a Postmodern Masterpiece," *Slate*, December 13, 2015, www.slate.com/articles/arts/cover_story/2015/ 12/star_wars_is_a_pastiche_how_george_lucas_combined_flash_gordon _westerns.html.

104 **he sought to buy the film rights:** Taylor, *How* Star Wars *Conquered the Universe*, 83.

105 **World War II dramas like *The Dam Busters*:** Wickman, "*Star Wars* Is a Postmodern Masterpiece."

105 **As Michael Kaminski writes:** Kaminski, *Secret History of* Star Wars.

106 **half a billion dollars more:** "Pottering On, and On," *The Economist*, July 11, 2011, www.economist.com/blogs/dailychart/2011/07/film-franchises.

106 **a new discipline called "psychohistory":** Isaac Asimov, *Foundation* (New York: Gnome Press, 1951).

108 **"The individual molecules of a gas":** Mark Strauss, "What Absolutely Everyone Needs to Know About Isaac Asimov's *Foundation*," io9, November 19, 2014, io9

.gizmodo.com/what-absolutely-everyone-needs-to-know-about-isaac-asim
-1660230344.

108 **second link is Joseph Campbell:** Joseph Campbell, *The Hero with a Thousand Faces* (New York: Pantheon, 1949).

109 **Frodo Baggins and Samwise Gamgee:** J. R. R. Tolkien, *The Fellowship of the Ring* (New York: Allen & Unwin, 1954).

109 **one does not simply walk into Mordor:** "One Does Not Simply Walk into Mordor," Know Your Meme, March 2016, knowyourmeme.com/memes/one-does-not-simply -walk-into-mordor.

110 **PBS show *The Power of Myth:*** "Ep. 1: Joseph Campbell and the Power of Myth— 'The Hero's Adventure,'" Bill Moyers & Company, March 8, 2013, billmoyers.com/ content/ep-1-joseph-campbell-and-the-power-of-myth-the-hero's-adventure-audio/.

110 **1985 memo from the Disney story consultant:** Christopher Vogler, "A Practical Guide to Joseph Campbell's *The Hero with a Thousand Faces*," 1985, www.thewritersjourney .com/hero's_journey.htm.

110 *Save the Cat:* Blake Snyder, *Save the Cat* (Studio City, CA: Michael Wiese Productions, 2005).

113 *prostalgic:* Walter Kirn, "The Improbability Party," *Harper's,* June 2016, harpers .org/archive/2016/06/the-improbability-party/4/http://harpers.org/archive/2016 /06/the-improbability-party/4/.

114 **above all an assembler, a master blender:** Wickman, "Star Wars Is a Postmodern Masterpiece."

115 **adaptation of the 1912 pulp fiction character John Carter:** Kaminski, *Secret History of* Star Wars.

115 **King Features said no:** Ibid.

115 **one of the most costly cinematic catastrophes of all time:** "The Biggest Flop Ever," *The Economist,* March 23, 2012, www.economist.com/blogs/prospero/2012/03/ disneys-john-carter.

115 **an echo of epics:** Vili Maunula, "Film Club: The Men Who Tread on the Tiger's Tail," Akira Kurosawa Info, November 1, 2010, akirakurosawa.info/2010/11/01/film-club -the-men-who-tread-on-the-tigers-tail/.

116 **"second viewing is always more satisfying":** Adam Sternberg, "Free Yourselves from the Shackles of Spoilers! Life Is Too Short," *Vulture,* September 30, 2014, www .vulture.com/2014/09/free-yourselves-from-the-shackles-of-spoilers.html.

116 **"Story Spoilers Don't Spoil Stories":** Jonathan D. Leavitt and Nicholas J. S. Christenfeld, "Story Spoilers Don't Spoil Stories," *Psychological Science,* August 2011.

116 **"A novel that can be truly 'spoiled'":** James Wood, "Scenes from a Marriage," *The New Yorker,* November 2, 2015, www.newyorker.com/magazine/2015/11/02/scenes -from-a-marriage-books-james-wood.

117 **left the Modesto hospital after two weeks:** Taylor, *How Star Wars Conquered the Universe,* 42.

118 **"semiotically nourished authors":** Umberto Eco, *Travels in Hyperreality* (Orlando: Mariner Books, 2014).

Chapter 5: The Myth-Making Mind II

For their respective work on the dark side of stories, I'd like to thank Maria Konnikova, the author of a great book, *The Confidence Game* (New York: Viking, 2016), and Tyler Cowen, who delivered a 2009 TED talk, "Be Suspicious of Simple Stories."

119 **popular universal myths in the world:** Paul Barber, *Vampires, Burial, and Death* (New Haven, CT: Yale University Press, 1988).

NOTES

119 **sarcastic entry in Voltaire's *Philosophical Dictionary*:** Voltaire, *Philosophical Dictionary*, Part 5, 1764, translated by William F. Fleming, http://oll.libertyfund.org/titles/voltaire-the-works-of-voltaire-vol-vii-philosophical-dictionary-part-5.

120 ***The dead can bring death:*** Barber, *Vampires, Burial, and Death*, 3.

121 **vampire hysteria gripped eastern Europe:** Ibid., 195.

121 **an old man named Peter Blogojowitz:** Ibid., 5–9.

124 **a "sensitive period" in a person's life:** "The Economics of Early Childhood Investment," White House Council of Economics Advisers, January 2015, www.whitehouse.gov/sites/default/files/docs/early_childhood_report_update_final_non-embargo.pdf.

124 **deaf kids who don't learn sign language:** Rachel I. Mayberry, Elizabeth Lock, and Hena Kazmi, "Development: Linguistic Ability and Early Language Exposure," *Nature* 417 (May 2, 2002): 38.

124 **children are born hating the flavor of broccoli:** Joe Pinsker, "Why So Many Rich Kids Come to Enjoy the Taste of Healthier Foods," *The Atlantic*, January 28, 2016, www.theatlantic.com/business/archive/2016/01/rich-kids-healthier-foods/431646/.

125 **2015 study of Spotify data:** Lara Unnerstall, "New Study Shows That People Stop Listening to New Music at 33," *A.V. Club*, April 30, 2015, www.avclub.com/article/new-study-shows-people-stop-listening-new-music-33-218752.

125 **Young people who grew up during popular Republican administrations:** Dan Hopkins, "Partisan Loyalty Begins at Age 18," *FiveThirtyEight*, April 22, 2014, http://fivethirtyeight.com/features/partisan-loyalty-begins-at-age-18/.

125 **one study analyzing gender roles in 120 popular films:** Stacy L. Smith, Marc Choueiti, and Katherine Pieper, "Gender Bias Without Borders," Geena Davis Institute on Gender in Media, seejane.org/wp-content/uploads/gender-bias-without-borders-full-report.pdf.

126 **Women accounted for just 30 percent of all speaking or named roles:** Manohla Dargis, "Report Finds Wide Diversity Gap Among 2014's Top-Grossing Films," *New York Times*, August 5, 2015, www.nytimes.com/2015/08/06/movies/report-finds-wide-diversity-gap-among-2014s-top-grossing-films.html.

126 **overwhelming whiteness, maleness, and straightness:** Hollywood's sexism problem isn't just in the stories; the industry's personnel is infamously male dominated, not to mention infamously white and straight. There is no replacement for diversity behind the camera, and I'm not suggesting that achieving more gender-balanced casts should be the only goal of a progressive reform movement in entertainment.

127 **Academy of Motion Picture Arts and Sciences were 94 percent white:** John Horn, Nicole Sperling, and Doug Smith, "Unmasking Oscar: Academy Voters Are Overwhelmingly White and Male," *Los Angeles Times*, February 12, 2012, www.latimes.com/entertainment/la-et-unmasking-oscar-academy-project-20120219-story.html.

128 **There is a precedent:** "Support for Same-Sex Marriage at Record High, but Key Segments Remain Opposed," Pew Research Center, June 8, 2015, www.people-press.org/2015/06/08/support-for-same-sex-marriage-at-record-high-but-key-segments-remain-opposed/.

130 **"Shark cartilage is good for arthritis":** Ian Skurnik, Carolyn Yoon, Denise C. Park, and Norbert Schwarz, "How Warnings About False Claims Become Recommendations," *Journal of Consumer Research* 31 (March 2005), https://dornsife.usc.edu/assets/sites/780/docs/05_jcr_skurnik_et_al_warnings.pdf.

131 **If there is a dark side to fluency:** A. L. Alter, D. M. Oppenheimer, and N. Epley, "Disfluency Prompts Analytic Thinking—But Not Always Greater Accuracy: Response to Thompson et al. (2013)," *Cognition* 128, no. 2 (2013): 252–55.

Chapter 6: The Birth of Fashion

For this chapter, I'm particularly indebted to Stanley Lieberson's magisterial work *A Matter of Taste* and the patient interviews with his former research assistant Freda Lynn, who coauthored the paper that coined that magnificent term "popularity as a taste."

134 **the country's "worst recession brand":** Sean Gregory, "Abercrombie & Fitch: Worst Recession Brand?," *Time*, August 25, 2009, content.time.com/time/business/article/0,8599,1918160,00.html.

134 **jaunty Chevy commercial featured the five-month-old song:** Andrew Hampp, "How fun.'s 'We Are Young' Scored Chevy's 'Stunt Anthem' Super Bowl Spot," *Billboard*, February 5, 2012, www.billboard.com/biz/articles/news/branding/1099054/how-funs-we-are-young-scored-chevys-stunt-anthem-super-bowl-spot.

134 **one of the one hundred best-performing songs in music history:** Fred Bronson, "Hot 100 55th Anniversary: The All-Time Top 100 Songs," *Billboard*, August 2, 2013, www.billboard.com/articles/list/2155531/the-hot-100-all-time-top-songs.

135 **the name Franklin soared in popularity while Adolf vanished:** Stanley Lieberson, *A Matter of Taste: How Names, Fashions, and Culture Change* (New Haven, CT: Yale University Press, 2000), 71, 131.

Lieberson's book is astonishing all the way through. One of his most interesting discussions is the history of black names in America going back to slavery. Before the Civil War, black names of African origin had been essentially wiped out. Slaves were often given the diminutive version of popular names (e.g., Jack or Will), and freed slaves would sometimes celebrate their dignity by adopting the formal counterpart (e.g., James or William).

By 1920, there were only subtle racial differences between black and white names. But as the century wore on, and particularly after the civil rights movement of the 1960s, blacks took on more names that reflected African and Islamic roots or honored civil rights heroes. The popularity of the name Marcus among Generation X and Generation Y, for example, could be traced to civil-rights-era interest in honoring Marcus Garvey, the nationalist who advocated for a return to Africa.

The other fascinating trend in black names is the evolution of black female names beginning with the prefix "La." (The trend is not exclusive to women: Consider the star running back LaDainian Tomlinson or LeBron James.) Exactly two "La"-prefixed baby girls were born in Illinois in 1916, according to Lieberson: one Lavera and one Larenia. But starting in 1967, eight distinct "La" names cracked the top one hundred, and they peaked in popularity in this exact order: Latonya, Latanya, Latasha, Latoya, Latrice, Lakeisha, Lakisha, and Latisha. What's incredible about the procession of "La" names isn't just their surge in the 1960s, but also the orderliness of their evolution. The step between Latanya and Latonya is one new letter; from Latonya to Latoya is one less "n"; from Lakiesha to Lakisha is one less vowel and then to Latisha is one consonant changed. It's a nice illustration of our theory of "familiar surprises." People like new names with familiar roots, and culture evolves in tiny steps that from afar might seem like giant leaps.

135 **Some names are cool today:** "Top Names of the Period 2000–2010," Social Security Administration, www.ssa.gov/oact/babynames/decades/names2010s.html.

135 **In the last decade of the twentieth century:** "Top Names of the Period 1900–1910," Social Security Administration, www.ssa.gov/oact/babynames/decades/names1900s.html.

135 **Jessica, Ashley, and Emily:** "Top Names of the Period 1990–2000," Social Security Administration, www.ssa.gov/oact/babynames/decades/names1990s.html.

135 **first names were more like traditions than fashions:** The historical data on names and the inflection point when they started to behave like a fashion comes from the work of Stanley Lieberson and several conversations with his research partner Freda Lynn, herself a sociologist at the University of Iowa. Lieberson has retired and did not respond to several requests for comment, but his book *A Matter of Taste* is one of the most interesting academic books I have ever read. It has my highest recommendation, and this chapter would not be possible without it.

136 **William, John, and Thomas accounted for half of all English men's:** Stanley Lieberson and Freda B. Lynn, "Popularity as a Taste: An Application to the Naming Process," *Onoma* 38 (2003), 235–76.

136 **Half of England's women went by Elizabeth, Mary, or Anne:** Ibid.

136 **São Paulo baptismal records:** Lieberson, *Matter of Taste*, 241.

137 **Hungary, Scotland, France, Germany, and Canada:** Lieberson and Lynn, "Popularity as a Taste."

138 **textile industries employed one third of Paris workers:** Kimberly Chrisman-Campbell, "The King of Couture," *The Atlantic*, September 1, 2015, www.theatlantic .com/entertainment/archive/2015/09/the-king-of-couture/402952/.

138 **When did clothes become fashionable:** Fernand Braudel, *The Structures of Everyday Life* (New York: Harper and Row, 1981), 317.

139 **Laver's law:** James Laver, *Taste and Fashion* (London, 1937).

140 **Parents tend to pick similarly popular names:** Lieberson and Lynn, "Popularity as a Taste."

141 **Samantha was the twenty-sixth most popular:** "Top Names of the Period 1900–1910," Social Security Administration.

142 **other people's tastes often become your tastes:** Robert Cialdini, *Influence: The Psychology of Persuasion*, revised edition (New York: HarperBusiness, 2006).

142 **"number one bestseller":** Alan T. Sorensen, "Bestseller Lists and Product Variety," *Journal of Industrial Economics* 55, no. 4 (December 2007): 715–38, www.ssc.wisc .edu/~sorensen/papers/sorensen_JIE_2007.pdf.

142 **authors to artificially inflate book sales:** Ward A. Hanson and Daniel S. Putler, "Hits and Misses: Herd Behavior and Online Product Popularity," *Marketing Letters* 7, no. 4 (October 1996): 297–305.

143 **popular might have unintended negative consequences:** Balazs Kovacs and Amanda Sharkey, "The Paradox of Publicity: How Awards Can Negatively Affect the Evaluation of Quality," *Administrative Science Quarterly* 59, no. 1 (2014): 1–33.

144 **the biggest star in American television:** Ed Cohen, "The Last Laugh," *Nevada Silver & Blue*, Spring 2007, 36–41, www.unr.edu/silverandblue/archive/2007/spring/ NSB07CannedLaughter.pdf.

144 **Douglass was born in Guadalajara, Mexico:** "Charles Rolland 'Charlie' Douglass," *Variety*, April 21, 2003, variety.com/2003/scene/people-news/charles-rolland-charlie -douglass-1117884944/.

145 **which he could play with keys:** Cohen, "The Last Laugh."

146 **just about $100:** Ibid.

147 **Hearing people laugh gave audiences license:** Kimberly A. Neuendorf and Tom Fennell, "A Social Facilitation View of the Generation of Humor and Mirth Reactions: Effects of a Laugh Track," *Central States Speech Journal* 39, no. 1 (Spring 1998): 37–48, academic.csuohio.edu/kneuendorf/vitae/Neuendorf&Fennell88.pdf.

148 **laugh tracks decreased the "mirth behavior":** Evan A. Lieberman, Kimberly A. Neuendorf, James Denny, Paul D. Skalski, and Jia Wang, "The Language of Laughter: A Quantitative/Qualitative Fusion Examining Television Narrative and Humor," *Jour-*

nal of Broadcasting & Electronic Media, December 2009, http://academic.csuohio
.edu/kneuendorf/SkalskiVitae/Lieberman.etal.2009.pdf.

150 **Literacy rates:** Max Roser, "Literacy, Our World in Data," accessed March 2016.
https://ourworldindata.org/literacy/

151 **It took less than ten years for cars:** Rita McGrath, "The Pace of Technology Adoption
Is Speeding Up," *Harvard Business Review*, November 25, 2013, https://hbr.org/
2013/11/the-pace-of-technology-adoption-is-speeding-up/.

151 **It took the telephone almost forty years:** Nicholas Felton, "Consumption Spreads
Faster Today," *New York Times*, February 2, 2010, www.nytimes.com/imagepages/
2008/02/10/opinion/10op.graphic.ready.html.

151 **eight years later, half the country owned a cell phone:** "Device Ownership Over Time,"
Pew Research Center, www.pewinternet.org/data-trend/mobile/device-ownership/.

151 **six in ten U.S. adults said they had never heard of the Internet:** Susannah Fox and
Lee Rainie, "The Web at 25 in the U.S.: Part I: How the Internet Has Woven Itself
into American Life," Pew Research Center, www.pewinternet.org/2014/02/27/
part-1-how-the-internet-has-woven-itself-into-american-life/.

Interlude: A Brief History of Teens

154 **The term "teen-ager" dates back:** Allan Metcalf, "Birth of the Teenager," *Lingua
Franca* blog, *Chronicle of Higher Education*, February 28, 2012, http://chronicle
.com/blogs/linguafranca/2012/02/28/birth-of-the-teenager/.

155 **compulsory public education for kids:** Grace Palladino, *Teenagers: An American
History* (New York: Basic Books, 1994).

155 **share of teenagers in high school:** J. Spring, *The American School, 1642–1993* (New
York: McGraw-Hill, 1994).

156 **doubled their spending on childhood "enrichment":** Greg J. Duncan and Richard J.
Murnane, "Introduction: The American Dream, Then and Now," in Greg J. Duncan
and Richard J. Murnane, eds., *Whither Opportunity? Rising Inequality, Schools,
and Children's Life Chances* (New York: Russell Sage Foundation, 2011).

158 **teenagers are chemically distinct:** Elizabeth Kolbert, "The Terrible Teens," *The New
Yorker*, August 31, 2015, www.newyorker.com/magazine/2015/08/31/the-terrible-teens.

158 **For Laurence Steinberg, a career investigating:** Laurence Steinberg, *Age of Opportu-
nity: Lessons from the New Science of Adolescence* (New York: Houghton Mifflin
Harcourt, 2014).

Part II: Popularity and the Market

Chapter 7: Rock and Roll and Randomness

Peter Ford's role in popularizing "Rock Around the Clock" has been reported else-
where, but almost all of the details in this chapter come from conversations with Ford
over the phone. I cannot go back in time to fact-check Peter's claims that he gave the
record to director Richard Brooks. For due diligence, I consulted several music his-
tory writers, including Alex Frazer-Harrison and Jim Dawson. In an e-mail, Dawson
said that although Richard Brooks separately claimed to have heard the song on the
radio, he also believed Ford's account.

163 **With more than 40 million copies sold:** Martin Chilton, "Rock Around the Clock:
How Bill Haley's Song Became a Hit," *The Telegraph*, April 17, 2016, www.telegraph
.co.uk/music/artists/rock-around-the-clock-how-bill-haleys-song-became-a-hit/.

163 **second bestselling song of all time:** Jim Dawson, *Rock Around the Clock: The Record That Started the Rock Revolution!* (New York: Backbeat Books, 2005).

163 **William Haley, Jr., grew up:** Ibid., 26–30.

163 **Blind in his left eye:** "Bill Haley," *Billboard*, www.billboard.com/artist/282385 /bill-haley/biography.

164 **the prominent kiss curl in his hair:** "Bill Haley Biography," Rock and Roll Hall of Fame, https://rockhall.com/inductees/bill-haley/.

164 **a used guitar for Christmas:** Dawson, *Rock Around the Clock*, 27.

164 **swing group called the Saddlemen:** Ibid., 34–36.

164 **pushed the boundaries of rhythm and blues:** "Bill Haley," *Billboard*.

164 **first rock-and-roll song to chart on Billboard:** "Bill Haley Biography," Rock and Roll Hall of Fame.

164 **he ripped up the music in front of Haley:** Frank Mastropolo, "The History of 'Rock Around the Clock': How a B-Side Became a Rock Classic," Ultimate Classic Rock, May 28, 2014, ultimateclassicrock.com/rock-around-the-clock/.

164 **The Comets would have to record another song:** Dawson, *Rock Around the Clock*, 73–80.

165 **The session was scheduled:** Ibid.

165 **Danny Cedrone didn't have time:** Jim Dawson, e-mail message to author, July 12, 2015.

166 **just seventy-five thousand records sold:** "Bill Haley," *Billboard*.

168 **his take on the *Mona Lisa* as the most popular painting:** Duncan Watts, *Everything Is Obvious: Once You Know the Answer* (New York: Crown Business, 2011).

168 **the most expensive insurance policy on any art piece:** Matthew J. Salganik and Duncan Watts, "Social Influence: The Puzzling Nature of Success in Cultural Markets," in Peter Hedström and Peter Bearman, eds., *The Oxford Handbook of Analytical Sociology* (Oxford: Oxford University Press, 2011), 337.

173 **the first DJ to play rhythm and blues:** Myrna Oliver, "Hunter Hancock, 88; Brought R&B to L.A. Radio Stations in 1940s," *Los Angeles Times*, August 11, 2004, www. articles.latimes.com/2004/aug/11/local/me-hancock11.

173 **The Ford family lived:** The details in this section come from conversations with Peter Ford and follow-up interviews and e-mails with Alex Frazer-Harrison and Jim Dawson.

176 **a later overthrow of the system:** Dawson, *Rock Around the Clock*, 127–43.

177 **the box office returns of about three hundred movies:** W. David Walls and Arthur De Vany, "Bose-Einstein Dynamics and Adaptive Contracting in the Motion Picture Industry," *The Economic Journal* 106, no. 439 (January 1996): 1493–514.

178 **The five most successful films:** Ben Fritz and Erich Schwartzel, "Hollywood's Banner Year at the Box Office Masks a Procession of Flops," *Wall Street Journal*, January 4, 2016, www.wsj.com/articles/hollywoods-banner-year-at-the-box-office-masks-a -procession-of-flops-1451818332.

178 **"A complex, adaptive, semi-chaotic industry":** Albert Greco, "Book Publishing: An Introduction," in Albert N. Greco, Jim Milliot, and Robert M. Wharton, eds., *The Book Publishing Industry* (New York: Routledge, 2014).

180 **one fifth of the movies took four fifths of the box office:** Walls and De Vany, "Bose-Einstein Dynamics and Adaptive Contracting in the Motion Picture Industry."

180 **60 percent of all app store revenue comes from just 0.005 percent:** Daniel Rowinski, "The Mobile Downturn: 'An App for That' Is Not a Business Model," ARC, November 11, 2015, https://arc.applause.com/2015/11/11/app-discovery-strategy-and -monetization/.

181 **Hollywood's core strategy has shifted:** Anita Elberse, *Blockbusters* (New York: Henry Holt, 2013).

NOTES

182 **visual Rosetta Stones:** Derek Thompson, "Hollywood Has a Huge Millennial Problem," *The Atlantic*, June 8, 2016, www.theatlantic.com/business/archive/2016/06/hollywood-has-a-huge-millennial-problem/486209/.

182 **thirty biggest box office bombs in Hollywood history:** "Movie Budget and Financial Performance Records," The Numbers, www.the-numbers.com/movie/budgets/.

Chapter 8: The Viral Myth

Two of the most important books that mainstreamed elements of network theory and the "virality" of information spread were Malcolm Gladwell's *The Tipping Point* (New York: Little, Brown, 2000) and Seth Godin's *Unleashing the Idea Virus* (New York: Hachette, 2000). I would also like to thank Anne Jamison, whose work on this subject, and conversation over the phone, deepened my appreciation for fan fiction's history.

185 **world's most popular erotic website for women:** Ogi Ogas, "The Online World of Female Desire," *Wall Street Journal*, April 30, 2011, www.wsj.com/articles/SB10001424052748704463804576291181510459902.

186 **"Icy" had a golden ear:** Anne Jamison, *Fic: Why Fanfiction Is Taking Over the World* (Dallas: Smart Pop, 2013).

187 **more than fifty thousand comments:** Emily Eakin, "Grey Area: How 'Fifty Shades' Dominated the Market," *New York Review of Books*, July 27, 2012, www.nybooks.com/daily/2012/07/27/seduction-and-betrayal-twilight-fifty-shades/.

187 **an Australian writer named Amanda Hayward:** Amanda Hayward, e-mails to author, September 12, 2014.

187 **It had gone "viral":** Julie Bosman, "Discreetly Digital, Erotic Novel Sets American Women Abuzz," *New York Times*, March 9, 2012, www.nytimes.com/2012/03/10/business/media/an-erotic-novel-50-shades-of-grey-goes-viral-with-women.html; also see Gladwell, *The Tipping Point*.

188 **a disease that infects more than one person:** Andrew Rice, "Does BuzzFeed Know the Secret?," *New York*, April 7, 2013, nymag.com/news/features/buzzfeed-2013-4/.

189 **the spread of millions of online messages:** S. Goel, Duncan Watts, and Daniel Goldstein, "The Structure of Online Diffusion Networks," *Proc. 13th ACM Conf. Electronic Commerce 2012*, Association for Computing Machinery, New York, 623–38, https://5harad.com/papers/diffusion.pdf.

189 **The vast majority of the news that people see on Twitter:** Sharad Goel, Ashton Anderson, Jake Hofman, and Duncan Watts, "The Structural Virality of Online Diffusion," *Management Science* 62, no. 1 (January 2016): 180–96, https://5harad.com/papers/twiral.pdf.

189 **another mechanism, called "broadcast diffusion":** Goel et al., "The Structure of Online Diffusion Networks."

190 **"driven by the size of the largest broadcast":** Goel et al., "The Structural Virality of Online Diffusion."

191 **a massive stinking cesspool of disease:** Steven Johnson, *The Ghost Map: The Story of London's Most Terrifying Epidemic—and How It Changed Science, Cities, and the Modern World* (New York: Riverhead, 2006).

191 **killing 127 people in three days:** Kathleen Tuthill, "John Snow and the Broad Street Pump," *Cricket* 31, no. 3 (November 2003), reprinted by UCLA Department of Epidemiology, www.ph.ucla.edu/epi/snow/snowcricketarticle.html.

193 **"There were only ten deaths in houses":** John Snow, *Medical Times and Gazette* 9, September 23, 1854: 321–22, reprinted by UCLA Department of Epidemiology, www.ph.ucla.edu/epi/snow/choleraneargoldensquare.html.

Note: Other accounts of Snow's methodology, such as David Freedman's paper "Statistical Models and Shoe Leather," give more weight to Snow's investigation of the water supply companies. A few years before the outbreak, one of London's water suppliers had moved its intake point upstream from the main sewage discharge on the Thames, while another company kept its intake point downstream from the sewage. London had been divided into two groups, one drinking sewage and one drinking purer water. In other words, the London cholera outbreak was the result of something like an unintentional randomized controlled trial of disease theory. Several hundred thousand people were randomly distributed water from one company and were more likely to get sick, while several hundred thousand people were randomly distributed water from another company and stayed healthy.

193 **the healthy brewers:** Randy Alfred, "Sept. 8, 1854: Pump Shutdown Stops London Cholera Outbreak," *Wired*, September 8, 2009, www.wired.com/2009/09/0908london-cholera-pump/.

193 **spread in short bursts and die quickly:** Goel et al., "The Structural Virality of Online Diffusion."

194 **"most viral video in history":** Samantha Grossman, "'Kony 2012' Documentary Becomes Most Viral Video in History," *Time*, March 12, 2012, newsfeed.time.com/2012/03/12/kony-2012-documentary-becomes-most-viral-video-in-history/.

194 **The video was shared by pop stars:** J. David Goodman and Jennifer Preston, "How the Kony Video Went Viral," *Lede* blog, *New York Times*, March 9, 2012, http://thelede.blogs.nytimes.com/2012/03/09/how-the-kony-video-went-viral/.

205 **How does popularity beget more popularity?:** Matthew J. Salganik, Peter Dodds, and Duncan Watts, "Experimental Study of Inequality and Unpredictability in an Artificial Cultural Market," February 10, 2016, *Science* 311.

206 **In a follow-up experiment:** Thompson, "The Shazam Effect."

207 **women seek the comfort of a bodice ripper:** Motoko Rich, "Recession Fuels Readers' Escapist Urges," *New York Times*, April 7, 2009, www.nytimes.com/2009/04/08/books/08roma.html.

Chapter 9: The Audience of My Audience

213 **I got an e-mail from him:** Vincent Forrest, e-mail to the author, July 17, 2015.

216 **You are like the people around you:** Miller McPherson, Lynn Smith-Lovin, and James M. Cook, "Birds of a Feather: Homophily in Social Networks," *Annual Review of Sociology* 27 (August 2001): 415–44.

216 **in many high school friendships:** Simon Burgess, "Friendship Networks and Young People's Aspirations," Research in Public Policy, Centre for Market and Public Organisation, www.bristol.ac.uk/media-library/sites/cmpo/migrated/documents/friendship.pdf.

216 **ninety-one white friends:** Christopher Ingraham, "Three Quarters of Whites Don't Have Any Non-White Friends," *Washington Post*, August 25, 2014, www.washingtonpost.com/news/wonk/wp/2014/08/25/three-quarters-of-whites-dont-have-any-non-white-friends/.

217 *The Making of a Moonie:* Eileen Barker, *The Making of a Moonie: Choice or Brainwashing?* (Oxford: Blackwell, 1984).

217 **While many cults are seen:** Derek Thompson, "Turning Customers into Cultists," *The Atlantic*, December 2014, www.theatlantic.com/magazine/archive/2014/12/turning-customers-into-cultists/382248/.

217 **an oppressive or illegitimate mainstream culture:** Ibid.

220 **various shades of self-expression:** David Packman, "May I Have Your Attention,

Please?," *The Mission*, August 10, 2015, https://medium.com/the-mission/may-i -have-your-attention-please-19ef6395b2c3#.ijawp0j6o.

220 **most downloaded nongaming apps:** Mike Murphy, "These Are the Most Popular iOS Apps and Games of All Time," *Quartz*, September 2, 2015, qz.com/492870/these -are-the-most-popular-ios-apps-and-games-of-all-time/.

220 **visual, textual, and voice:** Derek Thompson, "The Most Popular Social Network for Young People? Texting," *The Atlantic*, June 19, 2014, www.theatlantic.com/ technology/archive/2014/06/facebook-texting-teens-instagram-snapchat-most -popular-social-network/373043/.

221 **rule for popularity:** Duncan Watts and Peter Dodds, "Influentials, Networks, and Public Opinion Formation," *Journal of Consumer Research* 34 (December 2007), www.digitaltonto.com/wp-content/uploads/WattsandDoddinfluentials.pdf.

222 **"Her pitch was pretty genius":** Nick Summers, "The Truth About Tinder and Women Is Even Worse Than You Think," *Bloomberg*, July 3, 2014, www.bloomberg.com/ news/articles/2014-07-02/the-truth-about-tinder-and-women-is-even-worse-than -you-think.

222 **"The avalanche had started":** Ibid.

222 **"bowling pin strategy":** Chris Dixon, "The Bowling Pin Strategy," *CDixon* blog, August 21, 2010, cdixon.org/2010/08/21/the-bowling-pin-strategy/.

222 **more than three million users after the first fifteen months:** Steve O'Hear, "Tinder Rival Bumble Is Majority-Owned by European Dating Behemoth Badoo," *Tech Crunch*, March 25, 2016, https://techcrunch.com/2016/03/25/bumble-meet -badoo/.

Interlude: Le Panache

225 **the top ten stories from 2014:** Tim Peterson, "Ten Most Popular Stories on Twitter and Facebook in 2014," *AdvertisingAge*, December 23, 2014, adage.com/article/ media/ten-popular-stories-twitter-facebook-2014/296361/.

226 **about one third of personal conversations:** Diana I. Tamir and Jason P. Mitchell, "Disclosing Information About the Self Is Intrinsically Rewarding," *PNAS* 109, no. 21 (May 22, 2012), www.pnas.org/content/109/21/8038.full.

226 **size of the audience can shape the communication:** Alixandra Barasch and Jonah Berger, "Broadcasting and Narrowcasting: How Audience Size Affects What People Share," *Journal of Marketing Research* 51, no. 3 (June 2014): 286–99.

228 **pause for an average of two milliseconds:** Ed Yong, "The Incredible Thing We Do During Conversations," *The Atlantic*, January 4, 2016, www.theatlantic.com/ science/archive/2016/01/the-incredible-thing-we-do-during-conversations/422439/.

228 **this global recognition of ideal pauses:** Stephen C. Levinson, "Turn-Taking in Human Communication—Origins and Implications for Language Processing," *Trends in Cognitive Sciences* 20, no. 1 (2016): 6–14.

Chapter 10: What the People Want I

Note: The story about Patch Culbertson and "Ride" is adapted from "The Shazam Effect," my 2014 feature in *The Atlantic*.

231 **Dressed in his ritualistic black turtleneck:** Fred Vogelstein, "And Then Steve Said, 'Let There Be an iPhone,'" *New York Times Magazine*, October 4, 2013, www .nytimes.com/2013/10/06/magazine/and-then-steve-said-let-there-be-an-iphone .html.

232 **They said it would flop:** Jemima Kiss, "iPhone Set to Struggle," *The Guardian*,

June 29, 2007, www.theguardian.com/media/2007/jun/29/digitalmedia.news?cat
=media&type=article; also see Tom Smith, "Anytime, Anyplace: Understanding the
Connected Generation," Universal McCann, September 2007, www.slideshare.net/
Tomuniversal/anytime-anyplace-um-global-research-sep-2007-presentation.

233 **"so much better than anything else":** "Revealed: The Eight-Year-Old Girl Who
Saved Harry Potter," *The Independent*, July 2, 2005, www.independent.co.uk/
arts-entertainment/books/news/revealed-the-eight-year-old-girl-who-saved-harry
-potter-296456.html.

233 **a British TV show called *Pop Idol*:** Ken Auletta, "The Heiress," *The New Yorker*,
December 10, 2012, www.newyorker.com/magazine/2012/12/10/the-heiress-2.

233 **"Nobody knows anything":** William Goldman, *Adventures in the Screen Trade* (New
York: Grand Central, 1983).

234 **Warren Buffett's 1990 bet on Wells Fargo:** Warren Buffett, "Berkshire Hathaway
Letter," 1990, www.berkshirehathaway.com/letters/1990.html.

234 **infamous bet against the U.S. housing market:** Michael Lewis, *The Big Short: Inside
the Doomsday Machine* (New York: Norton, 2010).

235 **a cell phone app called Shazam:** Derek Thompson, "The Shazam Effect," *The Atlan-
tic*, December 2012, www.theatlantic.com/magazine/archive/2014/12/the-shazam
-effect/382237/.

237 **Aditya Sood got an e-mail:** Carla Guerrero, "Producer Aditya Sood '97 on How the
Box Office Hit 'The Martian' Came to Be," Pomona College, October 8, 2015, www
.pomona.edu/news/2015/10/08-producer-aditya-sood-'97-how-box-office-hit-
"martian"-came-be.

239 **half of all of television's programming costs:** Derek Thompson, "If You Don't Watch
Sports, TV Is a Huge Rip-Off (So, How Do We Fix It?)," *The Atlantic*, December 3,
2012, www.theatlantic.com/business/archive/2012/12/if-you-dont-watch-sports-tv-
is-a-huge-rip-off-so-how-do-we-fix-it/265814/.

240 **When *Cheers* debuted:** Brian Raftery, "'The Best TV Show That's Ever Been,'" *GQ*,
September 27, 2012, www.gq.com/story/cheers-oral-history-extended.

241 **"No segment of the audience was eager":** Jennifer Keishin Armstrong, *Seinfeldia: How
a Show About Nothing Changed Everything* (New York: Simon & Schuster, 2016).

241 **"No hugging, no learning":** Ibid.

243 **nearly one thousand original reality series:** Paul Cabana, e-mail to author, March 30,
2016.

244 **"Your strategy becomes: Let's go for quality":** Lacey Rose and Michael O'Connell,
"The Uncensored, Epic, Never-Told Story Behind 'Mad Men,'" *Hollywood Reporter*,
March 11, 2015, www.hollywoodreporter.com/features/mad-men-uncensored-epic
-never-780101.

244 **AMC was a channel without renown or money:** Ibid.

244 **AMC didn't need a blockbuster hit:** Derek Thompson, "The *Mad Men* Effect: The
Economics of TV's Golden Age," *The Atlantic*, April 3, 2015, www.theatlantic.com/
business/archive/2015/04/the-mad-men-effect-the-economics-of-tvs-golden
-age/389504/.

248 **the most illegally downloaded show in the world:** James Hibberd, "*Game of Thrones*
Piracy Hits Record High Despite HBO's Stand-Alone Service," *Entertainment Weekly*,
April 22, 2015, www.ew.com/article/2015/04/21/game-thrones-piracy-record.

249 **"When you swing":** Jeff Bezos, "Amazon Letter to Shareholders," April 5, 2016,
www.sec.gov/Archives/edgar/data/1018724/000119312516530910/d168744dex991
.htm.

249 **increased subscriptions to the premium cable channel:** David Zurawik and Chris
Kaltenbach, "'Sopranos' Drives HBO Subscriber Numbers Up," *Baltimore Sun*, Jan-

uary 19, 2000, articles.baltimoresun.com/2000-01-19/features/0001190248_1_hbo
-sopranos-new-subscriptions.

249 **network's cable fee revenue rose 50 percent:** Zachary M. Seward, "AMC Is Succeed-
ing by Breaking the Rules of Legacy Television," *Quartz*, August 13, 2013, qz.com/
114483/amc-is-succeeding-by-breaking-the-rules-of-legacy-television/.

Chapter 11: What the People Want II

For this chapter, I am particularly indebted to Bill Bryson's extraordinary book *One
Summer: America, 1927*, for its lively and data-rich history of the world of letters in
the 1920s, and to the University of Iowa for sharing George Gallup's dissertation on
the reading habits of Iowans.

253 **Every day, writers compose several million:** I could not find perfect data for average
Facebook and Twitter posts per day, so I went with a low estimate, as reported by
Business Insider; the number could easily be in the billions: Jim Edwards, "Leaked
Twitter API Data Shows the Number of Tweets Is in Serious Decline," *Business In-
sider*, February 2, 2016, www.businessinsider.com/tweets-on-twitter-is-in-serious
-decline-2016-2.

253 **trillions of gigabytes:** "What Is Big Data?," IBM, www-01.ibm.com/software/data/
bigdata/what-is-big-data.html.

254 **ten thousand unique titles:** Bill Bryson, *One Summer: America, 1927* (New York:
Random House, 2013).

254 **discovery became a fashionable problem:** Fareed Zakaria, *The Future of Freedom:
Illiberal Democracy at Home and Abroad* (New York: Norton, 2004), 215.

255 **New York City had twelve daily papers:** Bryson, *One Summer.*

256 **"the century of combination and centralization":** Matt Novak, "One Newspaper to
Rule Them All," *Smithsonian*, January 3, 2012, www.smithsonianmag.com/history/
one-newspaper-to-rule-them-all-14383197/?no-ist.

256 **nearly one third of their inches to crime stories:** Bryson, *One Summer.*

256 **New York and New Jersey alone:** List of New York State newspapers on microfilm at
New York State Library, New York State Library website, www.nysl.nysed.gov/nysnp
/title1.htm.

257 **ways to measure the demands of their readership:** George Horace Gallup, "An Objec-
tive Method for Determining Reader Interest in the Content of a Newspaper," Univer-
sity of Iowa dissertation, August 1928, ir.uiowa.edu/cgi/viewcontent.cgi?article=
5318&context=etd.

257 **private investigators to sneak up behind readers:** Ibid.

258 **a PhD program in applied psychology:** Jill Lepore, "Politics and the New Machine,"
The New Yorker, November 16, 2015, www.newyorker.com/magazine/2015/11/16/
politics-and-the-new-machine.

260 **first applied anthropologists:** Ann M. Reed, "History: Applied Anthropology," Ap-
plied Anthropology, University of Indiana, May 1998, www.indiana.edu/~wanthro/
theory_pages/Applied.htm#history; also see George M. Foster, *Applied Anthropol-
ogy* (Boston: Little, Brown, 1969).

260 **second-largest employer of anthropologists today:** Graeme Wood, "Anthropology
Inc.," *The Atlantic*, March 2013, www.theatlantic.com/magazine/archive/2013/03/
anthropology-inc/309218/.

260 **"beneath the fold":** Susan Ohmer, "Gallup Meets Madison Avenue: Media Research
and the Depression," *Milestones in Marketing History: Proceedings of the 10th Con-
ference on Historical Analysis and Research in Marketing (CHARM),* John W.

Hartman Center for Sales, Advertising & Marketing History, Duke University, Durham, North Carolina, May 17–20, 2001; also see Boris Doktorov, "George Gallup: Biography and Destiny" (Moscow, 2011).

261 **surveys, a measure of the present, and polls, a measure of the future:** Lepore, "Politics and the New Machine."

262 **from living room curiosity to household ubiquity:** Robert Gordon, *The Rise and Fall of American Growth: The U.S. Standard of Living since the Civil War* (Princeton, NJ: Princeton University Press, 2016); also see James L. Baughman, "Television Comes to America, 1947–57," Illinois History, March 1993, www.lib.niu.edu/1993/ihy930341.html.

262 **"far more fascinating, far more varied":** David R. Davies, *The Postwar Decline of American Newspapers, 1945–1965* (Westport, CT: Praeger, 2006); also see Richard W. Clarke, Speech to the Silurian Society, November 1947, quoted in George Britt, ed., *Shoeleather and Printers' Ink* (New York: Quadrangle, 1974), 326–32; also see Sig Mickelson, "Two National Political Conventions Have Proved Television's News Role," *Quill*, December 1956, 15–16.

262 **average time spent listening to the radio:** Gordon, *Rise and Fall of American Growth*.

263 **a young California girl named Kathy Fiscus:** William Deverell, "Fueled by Obsession," *Huntington Frontiers*, Spring/Summer 2009, www.huntington.org/uploaded-Files/Files/PDFs/S09obsession.pdf.

263 **"the cathode-ray tube had out-and-out scooped the newspapers":** Will Fowler, *Reporters: Memoirs of a Young Newspaperman* (Malibu, CA: Roundtable, 1991), 160–61.

263 **"the television convention":** "Television Convention," *Newsweek*, July 14, 1952.

263 **"informality, feeling, and emotion":** Karla Gower, *Public Relations and the Press: The Troubled Embrace* (Chicago: Northwestern University Press, 2007), 29.

264 **an upstart company will topple:** Clayton Christensen, *The Innovator's Dilemma* (New York: Harvard Business Review Press, 1997). My sentence here is an impressionistic reframing of Christensen's thesis. It is, without question, informed by *The Innovator's Dilemma*, but it's not really an attempt to summarize the book.

265 **newspapers sold per person plummeted:** Ken Goldstein, "Sixty Years of Daily Newspaper Circulation Trends," Canadian Journalism Project, 2011.

265 **Internet uncrossed the subsidies:** James Fallows, "How to Save the News," *The Atlantic*, June 2010, www.theatlantic.com/magazine/archive/2010/06/how-to-save-the-news/308095/.

266 **"by going directly to news providers":** "How Millennials Use and Control Social Media," Media Insight Project, American Press Institute, March 16, 2015, www.americanpressinstitute.org/publications/reports/survey-research/millennials-social-media/.

266 **It's *my news* now:** Adapted from a passage in Jonathan Franzen, "Farther Away," *The New Yorker*, April 18, 2011, www.newyorker.com/magazine/2011/04/18/farther-away-jonathan-franzen.

267 **the average U.S. consumer spends fifty minutes daily:** James B. Stewart, "Facebook Has 50 Minutes of Your Time Each Day. It Wants More," *New York Times*, May 5, 2016, www.nytimes.com/2016/05/06/business/facebook-bends-the-rules-of-audience-engagement-to-its-advantage.html?_r=0.

267 **Talking was social; radio was broadcast:** Derek Thompson, "Facebook and Fear," *The Atlantic*, May 10, 2016, www.theatlantic.com/technology/archive/2016/05/the-facebook-future/482145/.

269 **"the perfect personalized newspaper":** Steven Levy, "Inside the Science That Deliv-

ers Your Scary-Smart Facebook and Twitter Feeds," *Wired*, April 22, 2014, www
.wired.com/2014/04/perfect-facebook-feed/.

269 **the "dozen doughnuts" problem:** Steven Levy, "How 30 Random People in Knoxville
May Change Your Facebook News Feed," *Backchannel*, January 30, 2015, https://
backchannel.com/revealed-facebooks-project-to-find-out-what-people-really-want
-in-their-news-feed-799dbfb2e8b1#.srntqeuy7.

271 **"vicarious goal fulfillment":** Keith Wilcox, Beth Vallen, Lauren G. Block, and Gavan
Fitzsimons, "Vicarious Goal Fulfillment: When the Mere Presence of a Healthy Op-
tion Leads to an Ironically Indulgent Decision," *NA—Advances in Consumer Re-
search* 37 (2010): 73–76.

273 **Facebook "will be probably all video":** Cassie Werber, "Facebook Is Predicting the
End of the Written Word," *Quartz*, June 14, 2016, qz.com/706461/facebook-is
-predicting-the-end-of-the-written-word/.

273 **Forty-four percent of the entire U.S. population:** Jeffrey Gottfried and Elisa Shearer,
"News Use Across Social Media Platforms 2016," Pew Research Center, May 26, 2016,
www.journalism.org/files/2016/05/PJ_2016.05.26_social-media-and-news_
FINAL-1.pdf.

273 **88 percent of people under thirty-five:** "How Millennials Use and Control Social
Media," American Press Institute.

274 **it is a social utility:** Derek Thompson, "Facebook and Fear."

Interlude: 828 Broadway

278 **that he called OODA:** See, for example, Grant T. Hammond's lecture "On the Making
of History: John Boyd and American Security," Harmon Memorial Lecture, U.S. Air
Force Academy, 2012, www.usafa.edu/df/dfh/docs/Harmon54.pdf.

280 **"eighteen miles" of paper books:** "Strand History," The Strand, www.strandbooks
.com/strand-history.

280 *The Great Gatsby* **came out to awful reviews:** Megan Garber, "To Its Earliest Re-
viewers, Gatsby Was Anything but Great," *The Atlantic*, April 10, 2015, www
.theatlantic.com/entertainment/archive/2015/04/to-early-reviewers-the-great
-gatsby-was-not-so-great/390252/.

280 **"a memorable catastrophe":** Virginia Woolf, "How It Strikes a Contemporary," *The
Common Reader*, 1925.

Chapter 12: The Futures of Hits

Many thanks to Ben Thompson on the future of media, that inexhaustible subject of
constant speculation , Tom Tumbusch on the legacy of Kay Kamen, and Ryan Leslie
on his life story.

282 **the century between the 1870s and 1970s:** Gordon, *Rise and Fall of American
Growth*.

283 **the most visible technology changes:** Ibid.

286 **"weird" at scale:** This is a term that I first heard from *The Atlantic* website's deputy
editor Matt Thompson.

288 **an estimate of time spent consuming messages:** Michael Chui, James Manyika,
Jacques Bughin, Richard Dobbs, Charles Roxburgh, Hugo Sarrazin, Geoffrey Sands,
and Magdalena Westergren, "The Social Economy: Unlocking Value and Productiv-
ity Through Social Technologies," McKinsey Global Institute, July 2012, www
.mckinsey.com/industries/high-tech/our-insights/the-social-economy.

289 **In 1906, John Philip Sousa predicted:** Alex Ross, "The Record Effect," *The New*

Yorker, June 6, 2005, www.newyorker.com/magazine/2005/06/06/the-record -effect.

289 **"These talking machines":** Statement of John Philip Sousa. Arguments Before the Committee on Patents of the House of Representatives on H.R. 19853 to Amend and Consolidate the Acts Respecting Copyright, June 6–9, 1906.

289 **music technology would give black Americans:** Ross makes a similar point about the democratizing power of music technology for black artists in "The Record Effect."

290 **the top 1 percent of bands and solo artists:** Thompson, "The Shazam Effect."

290 **the number of transistors that fit on a microchip:** Gordon E. Moore, "Cramming More Components onto Integrated Circuits," *Electronics* 38, no. 8 (April 19, 1965), www .monolithic3d.com/uploads/6/0/5/5/6055488/gordon_moore_1965_article.pdf.

290 **humans plod along at a leisurely Darwinian pace:** Nicholas Carr, *The Glass Cage* (New York: Norton, 2014), 41. I've seen several writers juxtapose the exponential pace of technology and the methodical evolution of humans, but the first place I recall reading this construction was in Carr's book: "Where computers sprint forward at the pace of Moore's law, our own innate abilities creep ahead with the tortoise-like tread of Darwin's law."

291 **"Radio has become a companion":** J. Fred MacDonald, *Don't Touch That Dial.* (New York: Wadsworth, 1979).

291 ***What can I do best?:*** Ben Thompson, "The Jobs TV Does," Stratechery, June 3, 2013, https://stratechery.com/2013/the-jobs-tv-does/. I'm grateful to Thompson not only for this insightful piece, but also for his explication over the phone of the future of television and media.

291 **ten films grossed $100 million:** Worldwide Grosses 2015 and 2016, Box Office Mojo, www.boxofficemojo.com/yearly/chart/?view2=worldwide&yr=2016&sort= ospercent&order=DESC&p=.htm, www.boxofficemojo.com/yearly/chart/?view2= worldwide&yr=2015&sort=ospercent&order=DESC&p=.htm.

For the history of the early Disney years, I consulted several biographies, including: Bob Thomas, *Walt Disney: An American Original* (New York: Disney Editions, 1976); Neal Gabler, *Walt Disney: The Triumph of the American Imagination* (New York: Vintage, 2006); Tom Tumbusch, *Walt Disney: The American Dreamer* (Dayton: Tomart, 2008).

292 **eight of the ten most popular amusement:** Katia Hetter, "World's 25 Most Popular Amusement Parks," CNN, May 27, 2016, www.cnn.com/2016/05/26/travel/worlds-most-popular-amusement-parks-2015/.

293 **Kamen was born Herman Samuel Kominetzky:** Didier Ghez, e-mail to author, October 23, 2015.

293 **In his thirties, Kamen found success:** Ibid.

294 **Families were streaming from farms to cities:** Daniel Raff and Peter Temin, "Sears, Roebuck in the Twentieth Century: Competition, Complementarities, and the Problem of Wasting Assets," in Naomi R. Lamoreaux, Daniel M. G. Raff, and Peter Temin, eds., *Learning by Doing in Markets, Firms, and Countries* (Chicago: University of Chicago Press, 1999), 227.

294 **the Mickey Mouse watch:** Several sources, including: Alan Bryman, *The Disneyization of Society* (London and Thousand Oaks, CA: SAGE, 2004), and Tumbusch, *Walt Disney.*

294 **U.S. economy had shrunk by a third:** See, for example, Robert A. Margo, "Employment and Unemployment in the 1930s," *Journal of Economic Perspectives* 7, no. 2 (Spring 1993): 41–59, https://fraser.stlouisfed.org/docs/meltzer/maremp93.pdf.

295 **"In his room, bordered with M.M. wall paper":** Widely quoted, but see, for example, Dade Hayes, *Anytime Playdate* (New York: Simon & Schuster, 2008).

295 **pathetic timidity of the capitalist:** Ruud Janssens, *Of Mice and Men: American Imperialism and American Studies* (Amsterdam: Amsterdam University Press, 2004).

295 **"Micky Maus is the shabbiest":** Richard J. Evans, *The Third Reich in Power* (New York: Penguin, 2005), 130.

296 **the gift was from Joseph Goebbels:** Ibid., 131.

296 **$2 million from the sale of toys:** "Prosperity Out of Fantasy," *New York Times*, May 2, 1938.

296 **coloring books, candy boxes, cooking ware:** Tom Tumbusch, *Tomarts's Merchandise History of Disneyana: Disney Merchandise of the 1930s* (Dayton: Tomart, 2009).

296 **"industrialized fantasy":** Ibid.

297 **Hollywood greeted the dawn of television:** The story of Walt's foray into television draws equally from two sources: Tumbusch, *Walt Disney, and* Christopher Anderson, "Hollywood in the Home: TV and the End of the Studio System," in James Naremore and Patrick Brantlinger, eds., *Modernity and Mass Culture* (Bloomington: Indiana University Press, 1991).

297 **"one of the most influential commercial decisions":** Anderson, "Hollywood in the Home."

299 **Shanghai Disney Resort:** Ben Fritz, "Shanghai Disneyland Offers Springboard for Disney's China Ambitions," *Wall Street Journal*, June 12, 2016, www.wsj.com/articles/new-shanghai-resort-creates-high-stakes-for-disney-ceo-1465752586.

299 **"As Walt did with Disneyland in the fifties":** Ibid.

INDEX

Note: Page numbers in *italics* refer to illustrations.